BETWEEN SENSE AND DE KOONING

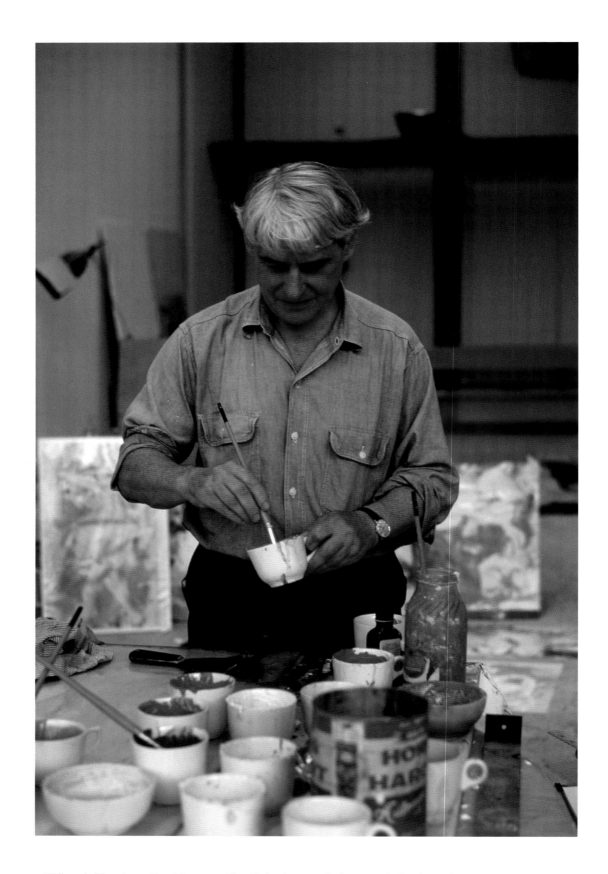

1 Willem de Kooning at East Hampton, New York, photographed in 1968 by Linda McCartney.

BETWEEN SENSE AND DE KOONING

RICHARD SHIFF

REAKTION BOOKS

For Leo Steinberg

Published by Reaktion Books Ltd
33 Great Sutton Street
London EC1V 0DX
www.reaktionbooks.co.uk

First published 2011

Printed and bound in China by Toppan Printing Co. Ltd.

British Library Cataloguing in Publication Data
Shiff, Richard.
 Between sense and de Kooning.
 1. De Kooning, Willem, 1904–1997--Criticism and interpretation.
 I. Title II. De Kooning, Willem, 1904–1997.
 759.1'3-dc22

ISBN 978 1 86189 853 1

CHRONOLOGY

1904 Willem de Kooning is born in Rotterdam, The Netherlands, on 24 April
 to Leendert de Kooning (*b* 1876) and Cornelia Nobel de Kooning (*b* 1877).
 His father owns a wine and beverage distribution company; his mother
 works in a bar primarily for seamen.

1907 Parents divorce; his mother receives custody of older sister, Maria Cornelia
 (*b* 1899).
 Leendert gains custody of Willem, but Cornelia appeals the court decision.
 The court eventually awards Cornelia full custody of her son. Both parents
 later remarry and have other children.

1916 Leaves grammar school; apprenticed for four years to Jan and Jaap
 Gidding's commercial arts and decorating firm.

1917 Begins taking night classes in fine arts and guild techniques at Rotterdam
 Academy of Fine Arts and Techniques; continues with these courses
 through 1921.

1920 Departs from Giddings's firm and begins work for Bernard Romein,
 art director and designer for a Rotterdam department store.

1924 Travels to Belgium with student friends, tours museums, and visits
 Brussels and Antwerp.

1926 Immigrates illegally to the United States with friend Leo Cohan.
 Cohan arranges de Kooning's stay at Dutch Seaman's Home; the artist
 earns a living as a house painter.

1927 Moves to a studio apartment in Manhattan.

1929–31	Meets John Graham, Stuart Davis, David Smith, dealer Sidney Janis, and Arshile Gorky, who becomes one of his closest friends (until suicide in 1948).
1934	Joins Artist's Union along with friends Gorky, Graham, Davis, and Mark Rothko.
1935	Joins mural division of the Works Progress Administration (WPA) Federal Art Project; works on a mural for Williamsburg Federal Housing Project, Brooklyn. Because he lacks American citizenship, he leaves WPA during the following year.
1936	Becomes friends with West 21st Street neighbours Rudolph Burckhardt, painter and photographer, and Edwin Denby, poet and dance critic. Works with Fernand Léger on the never-executed French Line Pier Project. Starts painting full time. Meets critic Harold Rosenberg.
1937	Meets Philip Guston and Barnett Newman.
1937–38	Meets Elaine Fried; she becomes his painting student.
1939	The exhibition *Picasso: Forty Years of His Art* opens at the Museum of Modern Art (MOMA), New York.
1939–40	Meets Franz Kline.
1942	Meets Jackson Pollock.
1943	Marries Elaine Fried.
1944	Container Corporation of America commissions a painting for the 'United Nations' series – *The Netherlands* (1944). Sidney Janis includes de Kooning's paintings in 'Abstract and Surrealist Art in America' exhibition at Mortimer Brandt Gallery.
1946	Creates backdrop for the dance 'Labyrinth' by Maria Marchowsky. Begins work on a series of black-and-white abstractions. Charles Egan and Betty Parsons open galleries.

1947	Betty Parsons shows his work in her exhibition *The Ideographic Picture*.
1948	Charles Egan Gallery gives de Kooning his first solo exhibition, featuring ten black-and-white abstractions. Meets critic Thomas B. Hess. Joseph Albers invites him to teach in the summer at Black Mountain College, North Carolina. *Art News* appoints Elaine de Kooning as an editorial associate. The Museum of Modern Art acquires *Painting* (1948).
1949	Moves to a loft studio at 88 East 10th Street, or in 1952. Contributes a statement, 'A Desperate View', at The Subjects of the Artist school. Becomes a charter member of the Eighth Street Artists' 'Club'.
1950	Robert Motherwell delivers de Kooning's lecture, 'The Renaissance and Order', at Studio 35. Completes large canvas *Excavation*; the painting is included in the Venice Biennale. Begins painting *Woman I*. Serves as a visiting critic at Yale University Art School for one semester (1950–51).
1951	De Kooning's statement, 'What Abstract Art Means to Me', presented at a symposium at the Museum of Modern Art and later published in the museum's journal. *Excavation* wins Logan Medal and Purchase Prize at the Art Institute of Chicago.
1951–52	Begins spending summers in East Hampton, New York.
1953	MOMA acquires *Woman I* (1950–52). Robert Rauschenberg requests a drawing from de Kooning to erase, subsequently known as *Erased de Kooning Drawing*.
1955	Begins series of abstract urban landscapes, including *Gotham News* (c. 1955) and *Easter Monday* (c. 1955–56). Separates from Elaine de Kooning.
1956	Joan Ward gives birth to his daughter Johanna Lisbeth (Lisa).

1957–58	Begins painting abstract landscapes, such as *Montauk Highway* (1958).
1958	Rejects MOMA's offer of a major retrospective exhibition.
1959–60	Spends the winter in Rome.
1961	Purchases a cottage in Springs, near The Hamptons on Long Island; makes plans to build a studio nearby.
1962	Becomes a U.S. citizen.
1963	Settles permanently in Springs, Long Island.
1964	Receives Presidential Medal of Freedom. Begins a series of 'Woman' paintings on door panels, including *Woman, Sag Harbor (*1964).
1965–67	Paints women, both single figures and pairs, with increasingly animated poses.
1968–69	Visits Holland for the first time since 1926 for the opening of his initial solo exhibition in the country at Stedelijk Museum, Amsterdam. Thomas B. Hess organizes de Kooning retrospective for MOMA; exhibition also travels to Tate Gallery London, Art Institute of Chicago, and Los Angeles County Museum of Art.
1969	Travels to Spoleto and Rome, where he encounters an old friend, sculptor Herzl Emanuel. Models first sculptures in clay and casts them at Emanuel's foundry.
1974	Australian National Gallery, Canberra, acquires *Woman v* (1952–53) for $850,000, at the time the largest sum paid for the work of a living artist.
1978	Elected to the American Academy of Arts and Letters.
1978–79	Resumes daily contact with Elaine de Kooning.
1983–84	Art dealer Allan Stone acquires *Two Women (1954–55)* for $1.2 million at a Christie's auction, setting a new record for a postwar work by a living artist. Retrospective exhibition, *Willem de Kooning*, at Whitney Museum

of American Art; it travels to Akademie der Künste, Berlin; and Musée
National d'Art Moderne, Centre Georges Pompidou, Paris.

1989 Elaine de Kooning dies.
 Due to de Kooning's declining mental condition, Lisa de Kooning and
 John L. Eastman file petition with New York State Supreme Court for
 their appointment as conservators of the artist's property.
 Interchange (1955) auctioned at Sotheby's for $20.8 million, at the time
 the highest price ever paid for a work by a living artist.

1993 Recipient of 'Distinguished Artist Award for Lifetime Achievement' by
 the College Art Association of America.

1994 Celebrates his ninetieth birthday on April 24.
 Paintings retrospective, *Willem de Kooning: Paintings,* National Gallery
 of Art, Washington, DC; also travels to the Metropolitan Museum of Art,
 New York; Tate Gallery, London.

1995–97 First museum overview dedicated to 1980s painting, *Willem de Kooning:*
 The Late Paintings, the 1980s, San Francisco Museum of Modern Art;
 travels to Walker Art Center, Minneapolis; Städtisches Kunstmuseum,
 Bonn; Museum Boijmans-van Beuningen, Rotterdam; MOMA, New York.

1997 Dies in Springs, Long Island, on March 19, age ninety-two.

CONTENTS

WILLEM DE KOONING preferred the ordinary. The people, objects and situations that stimulated his senses, imagination and imagery were ordinary. He was ordinary. No principle or theory anticipates his result; two ordinaries do not make an extraordinary. The de Kooning mix generates experience of such sensory abundance that viewers of his art need no abstract extras: no tragedy, no sublimity for critics of the human condition; no desublimation, no subversion of cultural norms for critics of social ideology. De Kooning's art converts the ordinary into more than enough for everyone.

De Kooning spoke of his practice plainly. His reluctance to express ideals or to mystify art made him less appealing to interpretive speculation than his New York School confrères, Jackson Pollock, Mark Rothko and Barnett Newman. Each of these painters cultivated a personal style of seriousness, even profundity; but the lighter touch of de Kooning proved the most resistant to ready interpretation. His form of resistance was passive: had he made an active point of a commitment to ordinariness, it would have provoked a theory of the everyday and a corresponding line of intellectualized critique. If, in fact, de Kooning had been consciously deflecting the more rarefied reaches of critical desire, then he succeeded. Even now, his art remains unattractive as a target of theory.

Yet, as a personality, de Kooning was remarkably attractive and engaging. He quickly developed into the most available subject of his generation with respect to journalistic anecdote. He is the one who told Mrs Rockefeller (whether Blanchette or Happy), 'you look like a million bucks'; he is the one who both amused and angered his circle by saying that Pollock 'broke the ice' of public interest; he is the one who described Rothko's style as 'blurred Albers'.[1] Despite the easy entry afforded by his acerbic, comic touch, de Kooning's work, more than the man himself, puts at risk all deeper levels of analysis. Reports of the ultimate meaning of his art – some tragic, some sublime, some comic as well – are

persistent rumours that fail to become established fact, never settling into canonical history. De Kooning made it hard for art history to know what to do with him. With regard to his art, whatever was radical and therefore noteworthy was neither self-consciously nor consistently so. Those who presented their art in a more aggressively radical mode – conceptualists, minimalists, exponents of pop, of anti-art, of new media and so on – quickly proved easy targets for classification. Critics know where such artists stand; in each case, analysis of the work follows from an articulated concept. De Kooning, who preceded these more programmatic types, remains in critical limbo.

Stop

De Kooning produced effects as if they had no cause: 'As to the painting being finished,' he said in 1960, 'I always have a miserable time over that. But it's getting better now. I just stop.'[2] The tone is ironical, the message self-deprecating. De Kooning exhibits a bad-boy attitude toward his public: he would confuse them with regard to the seriousness of what he does. He claims that he just stops – a statement barely credible. It implies a lack of direction and inverts the sense of an explanation. The artist seems to be removing any trace of motivation. Where does interpretation go when nothing identifiable, no particular force or purpose – not even a neurosis, part-hidden, part-exposed – is leading the artist and his art to a proper end?

We might decide to call de Kooning's rhetorical bluff and expose his pose as fictive, a finish neurosis that never was one. The imagined condition he announces as his reality is not a true fantasy. He must instead have calculated the effect of his statement – 'I just stop' – as an assertion of ideological independence. He had a strategy. He knew that his audience would applaud and idealize his apparent freedom: nothing directs him to stop; he just does. Even those involved with automatistic practices – such as the European surrealists and, by some accounts, Pollock – became slaves to the process, substituting the control exercised by the social value put on psychological automatism for the liberating control exercised by unconscious forces. De Kooning claimed neither determinant: no unconscious drive, no social imperative. He was neither discovering a self nor asserting one. He was making art. He was acting. He was free.

By acknowledging that an artist of de Kooning's type does as he wishes with impunity, those sharing in an American culture of conformism would have found potential relief, whether or not they realized they needed it. An artist's freedom brings freedom to all others, the welcome illusion of

freedom's availability. Art circumvents the suspicion that no individual is free unless all are free. When artists appear to be free, non-artists enjoy the security of their conformity within a society where any individual – like de Kooning – can do anything, if he or she should choose the exceptional course. Because the option to be an artist exists, others can feel free even in deciding to exercise far less freedom. Everyone chooses. Most choose a conformist mode, a logical way of thinking. De Kooning chooses a nonconformist mode, a sensory way of thinking, a practice unaffected by preexisting social or cultural patterns. His sensation comes without habit. He would begin work on a painting because he liked to paint, following no plan other than aesthetic desire. So he paints. And then he stops.

Academic minds are likely to find any number of contrary arguments more plausible. This would be so not only now but also in 1960, when de Kooning referred to his stop. Sceptical minds accustomed to exposing deception perceive no ultimate freedom in this type of artist. They would argue that de Kooning had adhered to an insidious ideological program. An artist claiming freedom may be hiding venal interests within activities designed to appear as open explorations. Within a culture of conformity (a pleonastic notion, since conformity is the corollary of culture), originality and independence form elements of a marketable brand. A critic's counter-claim unmasks this pretense: de Kooning's statements reflect a rhetorical strategy accommodating clever promotional devices suited to his historical moment.

There is a complication. To expose de Kooning in this way requires ignoring the different demands of production and marketing. An artist can develop one technique for the studio and another for the gallery – do one thing, say another thing. A painter can be more than one person, project more than one attitude. De Kooning sometimes took a cavalier approach to museums, dealers, collectors, and sales; in 1958, he declined an invitation to have a mid-career retrospective at New York's Museum of Modern Art, which would have increased his status had he accepted.[3] He was nevertheless acutely conscious of prestige and what he thought various institutions and individuals owed him.[4] Both attitudes may have been evident when, in 1965, he sued Sidney Janis Gallery for monetary damages. As the *New York Times* reported, de Kooning 'said he did not know how much money was due him or the exact number of works he had submitted to the gallery'.[5] The situation was comical. This was a person divided, conflicted, with regard to which mundane concerns he would allow to interrupt his studio practice and which he might instead wilfully ignore. To regard him as monolithic – his self-interest attuned to the prevailing ideology, guiding his actions in both the studio and the public forum – smoothes over his rough record of sometimes

following a cultural pattern and sometimes disregarding it. The smooth picture of de Kooning allows critics and scholars to contextualize his practice into the ground. The weight of the cultural atmosphere, including other artists' self-serving pronouncements on the mysteries of creativity, buries him beneath clichés that were not his. De Kooning's productivity came freighted with its context, but need not be reduced to and damned by its context.

Scepticism is healthy, and de Kooning had a lot. It is best directed at oneself. When applied to the beliefs of others and not simultaneously to one's own, scepticism becomes a dogmatic exercise, unnecessarily mean-spirited. Reviewing one of de Kooning's shows at Janis in 1962, Robert Goldwater expressed an admirable combination of scepticism and restraint. He asked himself whether the 'tentative, unfinished, probing quality' of de Kooning's work (and of the New York School in general) was 'imposed by or imposed upon the artist'. He concluded: 'I cannot . . . make out of this personal, formal struggle any social principle whose content is a critique of our society . . . If, indeed, [de Kooning's manner] is the mirror of anguish, then it is of another, more human sort' – that is, de Kooning's personal anguish, rather than his projection of an encompassing social condition.[6] On my part, I have no wish to bury de Kooning and his personal anxieties beneath whatever moral failings might be characteristic of his era. I discover little other than what one might expect in the gossip attributing to him various forms of mild sociopathy – bouts of womanizing, bouts of alcoholism. He belonged to his time and place and culture, as did the people with whom he interacted. I cannot judge him; I would risk mistaking him for his culture.

Although context is crucial, events are singular. As with his art, the nature of de Kooning's self-revelatory statements was usually more ironic ('it's getting better now') and humorous ('I just stop') than philosophically ambitious or self-aggrandizing. He often expressed doubt over the validity of his own values and practices. Critic Dore Ashton noted that de Kooning 'contradicted himself publicly with the deliberate intention of throwing off the rhetoricians'.[7] His rhetoric did not collude with art-world rhetoric, and he often directed his complaints at the pretentiousness of other artists. When he mixed genres in his imagery, he was trying to shock himself, not the public. He did not see himself as a revolutionary or corrective force within his culture, a positive opposing the negative. He was no more, no less, than a singular event.

De Kooning was moved by his art as he made it, and he was willing to admit that its presence puzzled him, a situation that many of his recorded comments reflect. There is danger in being overly sceptical concerning his understanding of – or rather, professed lack of – a motivating cause and final

meaning for his works. In distrusting de Kooning, we would be rejecting the possibility that an artistic or sensory practice might actually reach areas of experience as yet uncodified rationally and ideologically. We would be writing off the possibility of discovery and change before any attempts were ventured. Mere change was sufficient to interest de Kooning, who had no need to equate change with innovation, with progress, or even with the furtherance of an existing tendency: 'At one time it was very daring to make a figure red or blue [as in Henri Matisse or Fernand Léger]. I think now it is just as daring to make it flesh-colored.'[8] To return to a lost sensation (flesh-coloured flesh) is to effect change with the energy of a new sensation, though this newness is differential and cannot be called progress. Progress is a concept, a doctrine, a foregone conclusion, whereas change is no more than a sensation, movement sensed as such without need of a direction.

Perhaps change for the sake of change is a shallow value. To believe that culture and society gain something from mere change, from a mere shift in sensation, may be naive. But to reject this notion is to risk confusing disenchantment with truth (to paraphrase de Kooning's contemporary Jean-Paul Sartre, as he questioned the validity of his own professions of ideological sophistication).[9] Those who expose the enchantments and mythologies of others feel that their own beliefs must, by comparison, be enlightened truths. But one mystifying enchantment may be hiding another, and removing the one serves only to disclose the other. We can replace a cult of creativity with a cult of psychoanalysis, replace psychoanalysis with a cult of the archive, replace the archive with a cult of social relations . . . and the professions of disenchantment continue.

Despite his ironies – daring to paint flesh flesh-coloured rather than blue – de Kooning may have succeeded in reaching beyond mythologies and enchantments to the truth of *his* experience, which he did not expect to be a truth for others. But others ought to be free and open enough to take interest. He worried that the singularity of his sensation would vanish from social consciousness if it were absorbed within a general method or concept. Whether approving or disapproving, applied concepts destroy what they assimilate. In the case of de Kooning's art of sensation, its public existence was at stake, not its acceptance. This was his concern when he issued a warning to his fellow New York School artists: 'It is disastrous to name ourselves.'[10] A name for the group would amount to a marketing strategy. It would convert separate bodies of work into a common commodity, raising the collective commercial value even as it reduced the degree of singularity among the different artists and among each artist's various creations. Avoidance of naming would leave the works of art as is, helter-skelter – a difficulty for the market, but not for the art. No-naming was de Kooning's

idea of a favourable situation, even if it made writing hard for a supportive critic. Using words directed at words, we dissect a name far more readily than the practice it names.

Plan

Like de Kooning, I worry over naming. I will grant him the benefit of his tendency to doubt words and their formulations. Signs ambiguate. I will accept de Kooning's 'I just stop'. Its irritating irony does not make the statement false. De Kooning could hardly be anything but ironical when speaking, yet entirely direct when painting. His painting itself becomes ironical only in contexts that may not have concerned him as he worked in the studio. I will try to preserve the sensory possibilities of this art, which would have been his aim, if he had allowed himself to have one. I will think as he thought, not with his mind but with divided attention, without a plan.

As I write this essay, I cannot avoid feeling pressured by the critical indoctrination that has prevailed during the later decades of the twentieth century and to the present time. It leads me to be extraordinarily wary of many of the claims of the modern artists active during the decades preceding. We demonize our immediate predecessors even as we idolize them. My purpose is to learn from de Kooning's art through a combination of viewing it, considering its circumstances, considering its creator's circumstances, and writing an interpretation. Attaching words to this art is an uncertain exercise. It cannot be made more secure by exposing some presumed ideological error on de Kooning's part or a cultural failing reflected by his imagery. To try to beat this culturally wary artist at his own critical game would become an indulgence in ego on my part, all too easy for the person who enters the hermeneutical loop at a later moment. De Kooning himself was a debunker by nature, not someone seeking glory. His interminable irony testifies to this. To the extent that I may seem to support his claims about himself and his art, taking insufficient critical distance, a reader has at least two choices. One: accept the possibility that direct sensation – what would *count* as direct sensation is another issue – can be represented without undue reliance on convention, and that de Kooning did it, for whatever it may be worth. Or, two: regard my account of de Kooning's actions as if this were no more than a historian's contextualization, the refiguring of past fantasies and intellectual constructs that we should now take pains to avoid rather than admire and emulate. The first alternative is to accept my account at face value; the second alternative is to view it at one remove from reality. Either way, it is the same account, with or without

various degrees of ironic distance. I, too, am free to regard this presentation from a certain distance. The choice of interpretive direction will reflect the reader's own cultural and ideological indoctrination, his or her intellectual and emotional habits. For each reader, there will be a point at which feeling departs from reason and reason from feeling, except for those who experience no divide at all. De Kooning was as close to being a no-divider as it gets.

I perceive sense, both reason and feeling, in de Kooning's practices and statements; but to articulate this sense requires interpretive effort. This would be so even for a situation far less problematic. Verbally, de Kooning often seems either contradictory or nonsensical. How willing are we to accept his abuse of reason for the sake of ineffable feeling? When he says 'I just stop', the reasoning he offers to explain his practice is no reason. His painting is finished when it happens, he seems to say – not when complete or resolved, but when it happens, as it comes to pass that it stops. *De Kooning stops; the painting stops.* This is what ought to be called coincidence, demonstrating no causal relationship. Nevertheless, as I write the sentence – even lacking the implied conjunction *and* – the beginning appears to entail the end, one event following the other in the syntactical and spatial sequence of the words. The sentence makes sense. It has direction. The effect of entailment would be mitigated only by interrupting the syntactical order to introduce some ambivalent clausal byway, a subsidiary consideration. It might be that the painting ended at the instant it found its expression, the instant before de Kooning thought to stop. If every new painting is a disturbance within an established studio routine, then eventually each singular disturbance settles into the routine. The painter stops, recognizing that conditions have just changed in some peculiar way – not that *he* has changed, but conditions have, though these conditions are changing *him*. If his stopping has a cause, the cause is his recognition that something has changed. This is not much of a cause, for things are always changing. Being conscious of change, sensing it, is a different matter.

De Kooning regarded logical entailment of any sort as bondage. He had an odd way of talking, as if he were dodging the control of his own order of syntax. The interview conducted by his friend, critic Harold Rosenberg, begins with the somewhat redundant statement, 'I am an eclectic painter by chance.'[11] The elaboration immediately following this opening indicates that de Kooning practices his eclecticism in an unsystematic fashion. He is not making a point of using eclecticism as a theory or method, nor is he claiming that he became eclectic because of a fateful event beyond his control. No, he seems to be eclectic by default. He simply accepts what chance puts before him, and the results are mixed. His sentence, even though explained by discursive context, lingers in the mind as somehow

improper. 'Order, to me, is to be ordered about', he had said previously.[12] As a painter, he did not want to be the servant of his own method or style, just as a writer might balk at being held to the customary rules of a genre or even a well-formed sentence.

De Kooning preferred to doubt rules and reasons and to accept feelings. He would be reluctant to admit that he might set about to do something and that when he had done it, it would truly be done. How would he know? A moment later he might decide the matter otherwise. 'I never was interested how to make a good painting', he told David Sylvester in 1960; 'I was interested in that before but I found out it was not my nature.'[13] The slight contradiction here ('never', and yet 'before') probably marks a distinction between de Kooning's years of artistic maturity and a period of youthful desire that preceded, when he aspired to master reliable standards. 'Good painting' was standard; it was orderly. But the only order toward completion that the mature de Kooning knew was, 'I just stop.' Do not ask why.

Array

'He normally paints seven hours a day, seven days a week, sketching on into the evenings in front of his TV': this is de Kooning as the arts column of *Time* presented him, worthy of a national news item for 17 November 1967.[14] Our immediate inference: this painter was an aesthetic workaholic. His studio assistant John McMahon remembered him as someone who hardly took a break. Even as he relaxed with television through the evening hours, de Kooning kept at his art; he was painting by day, drawing by night. He needed the continuity of multiple beginnings. When the late-night programming ended, he might continue to watch the interference patterns of television 'snow' – dancing screen-figures having been replaced by a screen that was dancing.[15] It was interesting enough. De Kooning could convert virtually any act of looking into an act of drawing or painting. And he could convert any act of drawing into a picture. During the 1940s, he had often sketched the letters of a word across a blank surface, then developed the loops and bars into more complex forms, as in *Orestes* (illus. 2): 'You have to start somewhere.'[16] Like the moving, blurry screen-image of the 1950s and '60s, a course of lettering in the 1940s did not have to mean very much, if anything. Interesting enough as is, it had no obligation to refer. De Kooning was a painter of as is.

'To paint so fast you couldn't think': if de Kooning had a goal, this was it.[17] During the 1960s, a television habit could advance this end. The

Orestes, 1947, enamel on
paper mounted on plywood,
61.2 x 91.7 cm.
Private collection.

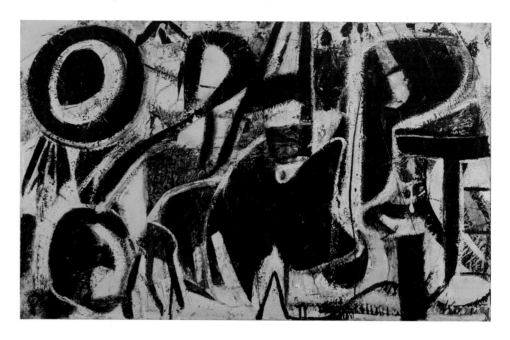

painter would experience mental distraction even as he enjoyed the visual
stimulation of the screen.[18] As reason blurred, the senses focused and
became more acute. To draw from the passing phosphorescent image
required a compensating speed.[19] De Kooning's deftness fulfilled his
mission; his hand was far too fast for thinking to arrest it. So much the
better for the art, if it were to be released from the hold of all applicable
concepts, all inhibiting principles. De Kooning, everyone agreed, had a most
impressive intelligence; it qualified him to question the authority of the
intellectual authorities.[20] In 1958, he stated that Sartre's thinking, though
brilliantly presented, was 'derivative and fake'.[21] Yet de Kooning resembled
Sartre with respect to intellectual ethics. He shared a suspicious attitude with
a number of the most sophisticated critics of his generation, who (unlike
himself) operated as professional intellectuals. Perhaps the best summation
of their common attitude came from one of de Kooning's early advocates,
though as a relatively late remark: 'When it comes to art, watch out for
thinking', Clement Greenberg warned, seeming not to include himself.[22]
The critic may have believed that only philosophers on the one hand,
and artists on the other hand, suffered from mixing conceptual ideas with
experiential aesthetics. For the skilled art critic, this was business as usual.

In any event, de Kooning himself showed no signs of the problem;
he was loath to pontificate, quick to hit on the flaw in any comprehensive
argument, its inevitable turn toward absurdity. When he addressed the
existential theme of 'desperation' in 1949, giving a talk with a title Newman

19

chose, 'A Desperate View', he immediately suggested that desperation concerned him as a personal experience, not a philosophical abstraction: 'My interest in desperation lies only in that sometime I find myself having become desperate.' Next, came the absurdity: 'Very seldom do I start out that way [desperate]. I can see of course that, in the abstract, thinking and all activity is rather desperate.'[23] Like so many of de Kooning's remarks, this at first seems to scramble, then to engage reasonably, the type of critical speculation that his intellectual friends are likely to have been discussing at the time. For example, the writing of Søren Kierkegaard was a common topic; and despair, all-encompassing as opposed to the limited nature of abstract thinking, was a particularly Kierkegaardian theme: 'There is scarcely any means as dulling and deadening as abstract thinking . . . Despair is an expression of the total personality.'[24]

Whatever principled thoughts – desperate thoughts – de Kooning entertained were there to satisfy his personal needs, not a general philosophy or his public's need to know: 'I don't paint with ideas of art in mind. I see something that excites me. It becomes my content . . . I have a vague idea – that's a kind of image. As I paint, I find out what the clear idea is.'[25] From vagueness to clarity was, for de Kooning, an ironic passage. The clear version of the 'idea' – initiated by seeing something – would evolve from an inkling to a specific material form. Working toward the image, de Kooning never knew how it should look on paper or canvas until it appeared. Nor was he certain that it ever reached its completion, not so much its perfection but its fullness.[26] Somewhat paradoxically, he admired Gustave Courbet for his concreteness from start to finish, for being 'overcome with reality [seeing] something that is really there'.[27] When friends asked de Kooning how he was doing, the question elicited a vague reply with phrasing that amused him every time he uttered the words, clear enough in themselves: 'Still working for the same company.'[28] The company in question can only have been himself and the work continual. The mental and physical state that de Kooning entered in the workplace was of his creation, self-induced. Nothing was clear about the imagery he was developing until it was. This is how he must have wanted it. This was his reality.

A small charcoal sketch now titled *Reclining Woman* is likely to belong to the late 1960s, more or less the moment of *Time*'s de Kooning report of November 1967 (illus. 3). The irregular disposition of the figure within this sheet is characteristic of de Kooning's television drawings, for which, after all, he had his eye fixed on the screen, not the paper.[29] His sensory concentration went into the act of drawing, not his model's appearance. This would have to be the case, since the essential feature of his television subjects was their movement; their instability provided their interest.

3 *Reclining Woman, c.* 1965–70, charcoal on paper, 20.3 × 24.2 cm. Collection Georg Baselitz.

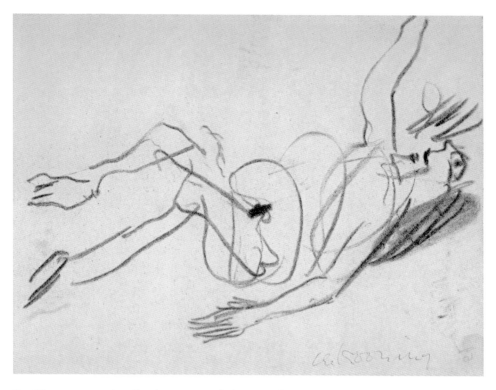

De Kooning was hardly the victim of the age of television and its passivity; he bent this electronic medium to his practice, just as he would bend a drawn line. A woman reclining makes a poor television performance; the form would hardly move, if at all. It remains one form, not many. Yet, all bodies are equal in both existential and pictorial potential: 'A body still is taking up just as much space and time as a body moving.'[30] Most likely, de Kooning's sketch received the designation *Reclining Woman* only because he chose to sign the sheet as a horizontal – a judgement that may have belonged to a subsequent moment, for the signature is in ink, not charcoal. In this instance, the drawing as artistic sensation (horizontal) was better – not better drawn but better viewed – than the drawing as representational observation (vertical). The depicted body was equally alive either way.

Is it too speculative to argue that a figure captured from television, standing when on the screen, has been turned on its side to recline on the paper? Whether turned or not, the drawing is equally a projection of the artist's eye and hand. De Kooning treated vertical and horizontal as if these foundational senses were interchangeable rather than opposed. When he inserted a fragment of a second drawing or painting within a first, he often turned this collage element into a diagonal, a neither-nor position. Rotating an image was a common feature of his practice. For an exhibition in 1965,

he decided to sign a number of recent transfer images or monotypes – imprints made by lifting sheets of newpaper from the wet surfaces of paintings in progress. The newspaper functioned to keep a layer of paint from drying too quickly; it also drew off any unwanted excess. De Kooning could use the newspaper sheet to rub and blur a painted form for effect, a feature of his pictorial rhetoric analogous to visible erasures and smears in many of his charcoal, chalk, or pencil drawings. Sheets of newspaper have a normative orientation because they consist of lines of legible print; but when de Kooning deployed them for transfer and blotting, he ignored this feature. When a transfer sheet itself becomes an independent pictorial image, the columns of print read every which way; they cede their authority to the orientation of the configured representation, the traces of a standing or seated woman, usually a vertical figure counterproofed from the primary surface in process. Ever manipulating, de Kooning converted some of the verticals to horizontals at his whim, as in the case of *Eddy Farm* (illus. 4), where the signature, not the design, establishes the definitive horizontal orientation.

With a drawing sheet, as with a sheet of newspaper, de Kooning could shift the position of the image-surface for his convenience in the course of working. Whatever the conditions of origin for the drawing *Reclining Woman*, it relates to its paper in what seems a similarly arbitrary way, as if the framing rectangle were an inconvenient limitation rather than a reliable compositional guide. *Reclining Woman* has the look of having been drawn by *feel* – by touch more than by sight – as de Kooning turned his eyes to the external subject, not its pictorial format. By feel, every position in a wheel of rotation is a possible orientation from which to draw. We might say that de Kooning's subject on the television screen took its place less in the representational format and more within him; he internalized this body in the moving touch of his hand.

In relation to a plane of drawing traversed by lines, touch is a matter of extension and successive displacement – line by line, one touch upon another. Vision, to the contrary, operates by scanning up, down and across; it tends to integrate rather than fragment. Imagine rotating de Kooning's drawing into a vertical orientation; the reclining figure now strides or even dances, as it may well have been seen on a television screen.[31] The three or four loopy, rhythmic lines that constitute the torso become a skimpy dress, a simple shift. Whether circumscribing flesh or fabric, these lines move. Friends of the artist at the time recall what a survey of his images indicates, that when drawing from the television screen or from casual real-life observation, a woman dancing or any comparably animated female figure was a favoured de Kooning view.[32] Yet seated figures, motionless, were also a preferred theme for drawings, possibly even more so. They acquired

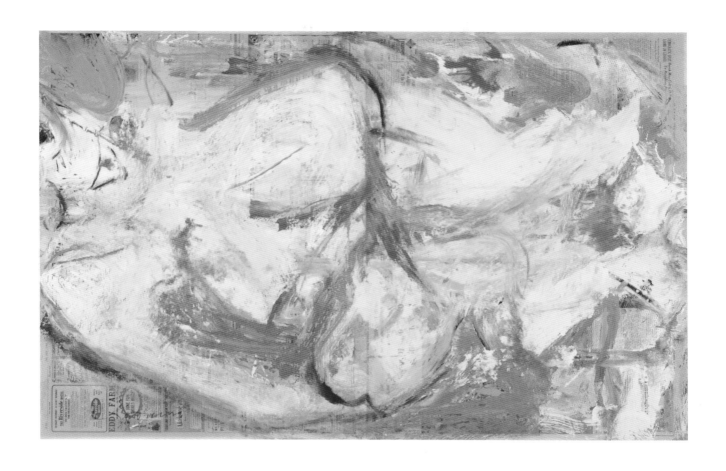

4 *Eddy Farm*, 1964, oil on newsprint, 76.2 × 114.3 cm.
McNay Art Museum, San Antonio, Texas.

their movement as de Kooning rendered their image. An inactive reclining figure can dance when drawn: 'A model can take every kind of pose, but all that matters is how the hand sets her on the paper. . . . I draw while watching TV.'[33]

Reclining Woman pivots around a dark spot at the centre of the sheet, as if its extremities – feet to the left, head to the right – were being generated by a centrifugal force located at this origin. De Kooning, not geometry, is the origin. Analytical custom only slowly changes and adapts. We still incline to analyse a drawing of this sort in terms of horizontal and vertical vectors, potentially graphed on an underlying grid, a preexistent raster. We accede to deeply internalized conventions of a static picture rather than acknowledge a process of drawing in which free rotation occurs. In de Kooning's representation, long hair flows from the area of the figure's head as a set of loosely parallel, dark strokes; their sequence extends to the similar line that defines the left shoulder and arm. This is organic 'composition', whether or not it can be mapped onto an imagined gridlike pictorial field. The strokes of hair on the reclining figure's right side (toward the top of the sheet) detach from the form of the body, as if occupying a position where hair ought to be, without much pretence as to how hair is likely to look. The lines and their position have been felt, not seen. Gravity centres in the artist's hand as it occupies the centre of drawing; here, gravity is no illusion. This is drawing for itself, acted out in relation to the artist's experience of seeing and touching simultaneously. What he touched (the paper), he did not see; what he saw (if a television drawing, the screen), he did not touch. So the drawing establishes no accord with a unique spatial orientation and its coordinating illusions, because eye and hand register differently sensed realities: eye-space, hand-space. Each has its scope; each has its reach.

De Kooning accepted this indeterminate distance between his senses; he allowed the separation to stand. He could look one way, touch another way. To pursue an ideal image of unreal coordination was hardly his interest. Packed with experiential common sense and savvy, he withheld common sense of a different kind – a ruling sense (*sensus communis*) that would pass definitive judgement over the bits of information deriving from any number of immediate contacts with externals. 'Things in life – a horse, a flower, a milkmaid': this was his off-hand listing as he explained how his painting depended on ordinary sensations of trivia that might belong to either the living environment or the world of pictorial art from which he liked to derive his imagery.[34] From this complex of sensation, he chose not to eliminate the many contradictory indications. His perception failed to integrate.

Yet it would be wrong to conclude that de Kooning's chaotic mode of observational drawing resulted in chaos. The view expressed in 1956 by one

of his friends took this route: 'De Kooning's paintings suddenly became prolix and violent [with] no picturesque detail vignetted out of chaos, but the very disorder, the very chaos.'[35] Drawing a line where it takes you, following the force of its gravity, its pull: this is not chaotic, even when the line finds no place in a recognizable order. Singularity happens. To invoke chaos amounts to too oppositional a summation, crediting de Kooning's art for some putative negativity, valuing it as anti-art. To say that de Kooning 'structured chaos' errs from the other side.[36] It was not a chaos of sensation that he allowed to remain but the factor of sensory spontaneity, an array of experience of no particular order. An array of anything – say, an array of numbers, or of recorded events – if presenting no discernible logical sequence, still remains a gridlike configuration of possible sequences. And any array has its unique character, like a human face, familiar or not. A unique face has many expressions, shows many faces. It is its own array. 'If the picture has a countenance, I keep it', de Kooning said in 1950: 'If it hasn't, I throw it away.'[37] Bits of an artist's spontaneity, bits of ordinary experience, constitute an array – neither orderly nor disorderly – ordinary.

Cliché

'Paint so fast you couldn't think' was de Kooning's technique: to paint not just adeptly and quickly, but so *very* fast that the body fails to register its internalized patterns of movement, its self-cultivated nature. Such action leaves an external trace but no internal trace. It is movement to be forgotten rather than remembered: alien movement that does not become yours to appreciate; your doing but not your expression, individual or social. This may be some of the reason why de Kooning developed elaborate systems of recording his own passing imagery, making manual tracings on vellum and creating monoprint transfers on newsprint as he traversed the successive stages of work on a painting.[38] His results surprised him, so he needed to study them at later moments, learning from them over time. He seemed to believe that his arrays of spontaneity would undermine habits of perception and behaviour as quickly as they might form. This state of instability was as he wished it. He was not particularly introspective; he sought no essential, unchanging self. His paintings were as changeable as the television screen. So drawing from television was a suitable exercise in a proper de Kooning technique. Despite its stereotypical presentation, he could never predict what the screen would show him. When he chose to draw it rather than watch it, he was catching the visual incidents rather than following the predictable narrative programme; and whatever the TV showed quickly

disappeared from view. His drawings were material, yet insubstantial, perceptual traces – eye to hand to eye.

Describing the situation of his art in this manner, I slip into a formulaic account, flirting with cliché, approaching a claim that the artist was like the flickering screen, creating and destroying images in the rapid passage of marks. The problem, more specifically, is this: I have implied that de Kooning's array of form constituted neither order nor disarray. My cliché is the cliché of the third way, denying the more conventional logic that preserves antithetical exclusion (if this, then not that). How can de Kooning's art escape the many oppositional, dialectical terms that it seems to evoke? What is its third way? Is its order merely hidden, like the hidden meanings that interpretation keeps seeking out?

As if inspired by Ludwig Wittgenstein (who, in fact, intrigued him), de Kooning spoke in words that caught up with themselves; his phrasing eliminated the distance between sense as feeling and sense as meaning.[39] This happens when language trips over its customary syntax, startles its speaker and spoils the illusion of detached, direct reason – reason independent of the feelings of the moment. The prosaic becomes the poetic. Many of the statements we utter have such potential for internal contradiction that they threaten to abandon all ordinary, logical sense. 'Once you're dead, you're dead for a long, long time', de Kooning was fond of saying, attributing to the notion of being dead a temporal dimension that – as we see from the structure of his statement – can never fit.[40] For whom does death last a 'long, long time'? Who is keeping time? The humour and irony in this statement interfere with the simple logic of passing from premise to conclusion.

Like time catching up to death (as the latter's meaning changes over time), criticism attempts to catch up with its object, art criticism with its art object. Sometimes critics ignore the contradictions and self-denying antitheses evident in their descriptions; but modern critics and theorists are just as likely to treat these nihilistic features as if they were productive. What we cannot explain, we often represent indirectly through the contradiction itself, as if this ironic gambit were resolving the issue.[41] This is the modern critic's rhetorical strategy, not the artist's.[42] While the critic works by indirection, the artist strives to be direct, as Newman explained to an interviewer of 1969, indicating that the point applied as well to his colleague de Kooning, despite their evident differences: 'The distinction between what Bill and I were trying to do and what preceded us is the distinction between an art that is depictive and an art that is direct.'[43] The more direct, the less in need of commentary, or rather, the less that commentary has any effect. Paradoxically, Newman enjoyed talking about painting because the truth of it would never be touched by coherent discussion; so he could talk indefinitely without fear

of spoiling the experience of his art. A note to himself stated: 'We should talk about only what you cannot talk about.'[44] Here was contradiction in the service of directness: Newman the artist became his own critic and explained things as best he could but to little effect. The lack of thematic depiction typical of the art of the New York School made it that much more difficult for critics to find words of description both suited to appearances and able to generate an engaging narrative account.

Perhaps critics of New York School painting had three options. (1) They might inventory colours and shapes, relating the result to modes of pictorial presentation; this would introduce an analytical, empirical element, otherwise absent. (2) They might resort to projective fantasy, discovering a hidden image, psychological syndrome, or social cause; this would introduce a thematic element, otherwise absent. (3) They might stress inherent contradictions, developing a perverse logic; this would introduce an element of philosophical reason, otherwise absent. With this third approach, the verbal response becomes interesting in itself, like the art to which it refers: challenging, puzzling and, when taken to extremes, mystifying. The critical cliché of internal contradiction – call it oxymoron, or note the frequency of chiasmic reversal in twentieth-century interpretive writing – compares to the fascination that the abstractions of Eastern thought have long held for the West, in both popular and academic imagination, as a body of philosophy capable of flourishing outside dialectical reasoning. The West regards the East, perhaps phantasmatically, as a philosophical refuge where antithetical concepts can remain in tension devoid of either transcendent resolution or annihilating synthesis. When a quality and its opposite seem to apply equally well to an object or a situation – like a de Kooning figure, equally standing and reclining – we describe it both ways, juggling the terms, indulging in a rhetoric of indeterminacy. The rhetorical response satisfies the intellect, easing its friction with the senses. Finding the right phrasing brings relief from emotional insecurity, from not knowing what is what. It produces a feel-good moment.

Consider an example from a collection of theoretical essays that approach the more shadowy reaches of art, Jean-Luc Nancy's *Les muses*: 'Man began in the calmly violent silence of a gesture . . . At this, man trembled, and this trembling was him.'[45] Beginnings are hard to conceive. The origin of man is difficult; the origin of art (the gesture) is nearly as much of a problem; both elicit complex thoughts. 'Calmly violent' is oxymoron, and not very different in sense from *violently calm* when modifying *silence*. Oxymoron readily converts to chiasmus: imagine a calmly violent act that produces a violent calm. Is this sense or nonsense? 'Man trembled . . . this trembling was him' is chiasmus.[46] In French, the grammar is agreeable

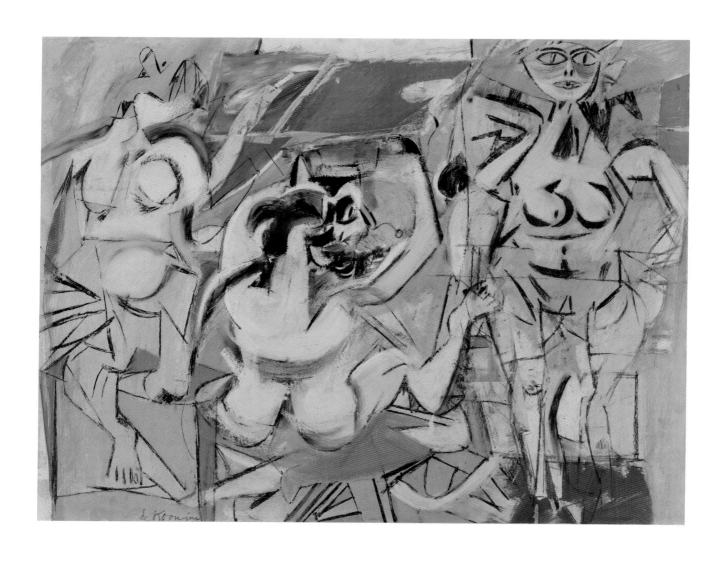

5 *Untitled (Three Women)*, *c.* 1948, oil, charcoal, and crayon on paper, 50.8 × 67 cm.
Frances Lehman Loeb Art Center, Vassar College, Poughkeepsie, New York.

enough (*ce tremblement, c'était lui*), but not in English, where an experienced translator has allowed herself a mistake. It should, of course, be, 'This trembling was he.' The slip occurs because the existential verb *was* is improper in this context, mushing the thought. It establishes too strong an adequation; although it is metaphorical, it disguises this function through the implied equivalence of the two reversible sides of the chiasmus. More accurate would be, 'This trembling defined him', or 'This trembling represented him.' The translator senses that something is happening to 'man', that there is an action or at least a change of state, so this 'man' becomes 'him', not 'he', an object not a subject. Here, language trips over itself, stumbling without falling. Rhetoric is doing its work. It seduces the writer as much as the reader, leading both on – poetically, not logically. Chiasmus suppresses a difficulty that often arises in assigning agency. Do you make the gesture, or does the gesture make you? To be more explicit: do you make your gesture because of who you are, or does your gesture make *you* who you are? The direction (sense) of the action would seem to make sense of (bring reason to) the situation, but the rhetorical form of chiasmus, because it plays relationships both ways, commits to nothing. Whether we have acquired an analytical habit or are physiologically hard-wired to the same end, our mental practice of dividing the agent (noun) from the action (verb) causes intellectual blockage commensurate with whatever intellectual movement it enables. We insist that motivation must operate *somewhere*. So when in doubt as to what is motivating what, we reverse the terms and have it both ways. This is chiasmus. Regard it as a statement of doubt rather than belief, though the rhetorical form leaves an impression of assurance.

If I were to grant de Kooning's art its own soul or sentience, I would conclude that it was acknowledging and wrestling with the agent-action, noun-verb problem: does a good person produce a good result? Does a good result produce a good person? De Kooning's characteristic line is at once curving and angular – a contradiction, an oxymoron. Is it moving of its own inertial momentum – a runaway, loosed from the canon of contour drawing – or is de Kooning perversely articulating its every irrational quality? His line seems incapable of determining its essence, even when describing an identifiable feature, such as a breast or a buttock, an elbow or a knee, as in the wavering anatomical forms of *Untitled (Three Women)*, an intense oil and crayon figure study of around 1948 (illus. 5). De Kooning renders rounded parts of the body with both curving and straight-edge elements, sometimes continuous, sometimes disjoined, thickening and tapering. Perhaps at all times in all segments, his line passes between the two most obvious descriptive categories, curved and angled, neither here nor there. Let me make this type of observation, whenever I do, not in acceptance or celebration

of some quasi-rational trope of mutual contradiction, some third way that follows a current rhetorical cliché, but in acknowledgement of the evidence of the senses. Despite the difficulties it may present to description, de Kooning's line, like every other aspect of his art, is direct (as Newman would affirm). The observation of its contradictory qualities – we do see them – nevertheless threatens to become formulaic. Discussing this art, I feel myself slipping into oxymoron, even as the rhetoric strikes me as one of the discursive clichés of my era, a trap I should avoid. At least this failing is de Kooning-like. He was conscious that his immediate gestures, however genuine – *because* they were genuine – threatened to rigidify into habit, if only for being tempered by his acquired skill. 'Bill was very irritated with his facility, and he was constantly struggling against it', his wife, painter and critic Elaine de Kooning, noted.[47] His skill conflicted with his intuitive invention, or at least he believed so. Nevertheless, becoming skilled at being naive was not a proper path for his aesthetic. It was not his way, despite serving other modern painters as a route of escape from both the pretensions of the cultural elite and the banality of the popular.

As wordy as the writing of the influential editor of *Art News*, Thomas Hess, often became – quick to slip into oxymoron and chiasmus – he deserves credit for acknowledging that dialectical synthesis held no appeal for his friend de Kooning. In 1968, Hess argued that de Kooning flourished in ambiguity, 'within the dialectical tensions of a syllogism without synthesis'. Regarding himself as both common worker and inspired artist, de Kooning 'will choose neither antinome nor accept their opposition within a closed system. He is open to any concept except that of exclusivity . . . The perfect anti-Hegelian, he will have it both ways and work within the contradictions.'[48] For whatever reason, de Kooning had a constitutional aversion to conclusion, closure and certainty. Hess was good at capturing this aspect of the artist's mentality. Yet despite this degree of understanding, his statement did not go far enough. It was true that de Kooning kept all possibilities under consideration, rejecting nothing, transcending nothing; but this attitude applied even to the idea of rejecting exclusivity, itself the principle of eliminating possibilities. De Kooning did not want to eliminate elimination. A few years previously, in 1964, Hess had occasion to say to de Kooning, 'You don't like ideas that are exclusive', ideas that remove all alternatives from consideration. In response, de Kooning insisted that he doubted even this: 'Well, but that doesn't mean that I'm right about it.'[49] And this remark came within the context of de Kooning complaining about eliminators like Ad Reinhardt who were excluding possibilities from their art.

De Kooning was an extreme case but of his time. The journal *trans/ formation*, which in 1951 published his lecture 'The Renaissance and Order',

contained in the same issue an essay on Paul Cézanne, associating his art with 'the pragmatic attack on "absolute truth."'[50] A year later, *trans/formation* also published a translation of Werner Heisenberg's lecture on quantum theory and the physicist's 'uncertainty relation' – a principle limiting the truth of an observation to the situation of the observer and the nature of the means of observation. Heisenberg's summation – 'The new quantum theory . . . had no immediate relation to nature itself but rather to our knowledge of nature' – runs parallel to de Kooning's sense that he would understand what he saw through a process of representing it.[51] The truth of an object would be in an artist's picture and all of its idiosyncrasies, rather than in the otherwise unapproachable object itself. There could be no synthesis or summation of knowledge, given that no representation would be final; de Kooning would continue to make images of the same type of model, the same theme, over decades, without establishing a hierarchy of successes. He also knew how to express this condition, the situation of art, more directly than Hess: 'Nothing is positive about art, except that it is a word.'[52] *Art* is a word and a conceptual entity, a category of objects and actions. Yet the concept has no definite referent in reality, no certifiable truth. This was de Kooning's point: do not generalize; do not conceptualize. As he used the terms, an art not positive does not become negative. By *not positive*, de Kooning meant *not certain*, not secure. With de Kooning, Greenberg said early on, 'there is a refusal to work with ideas that are too clear.'[53] Ideas as concepts, ideas as forms: neither should be certain.

Subject to illusion, vision cannot be certain. De Kooning would argue the contrary: vision is indeed certain – as certain as sense. Yet everything a person might conclude about visual experience remains uncertain. We know what we feel but are uncertain as to what to think about it. Like conceptualization, the kind of perception that most people consider clear is actually vague. During a group discussion in 1950, de Kooning made this claim: 'Geometric shapes are not necessarily clear. When things are circumspect or physically clear, it is purely an optical phenomenon. It is a form of uncertainty.' Not surprisingly, his fellow artists found his position confusing, if not alarming, and the exchange grew agitated. Painter Robert Motherwell moderated the situation: 'What de Kooning is saying is plain. He feels resentful that one mode of expression should be called more clear, precise, rational, finished, than another.' If geometric shapes were 'a form of uncertainty', this was because every logical inference derived from them was uncertain. Only the moment's experience brought certainty. De Kooning continued by arguing that Piet Mondrian's straight lines were, first, not so straight, and second, could not be clear, for they were 'changing in front of us'.[54] This was no optical illusion: the perception of a changing phenomenon

was actually occurring and true-to-life at every instant. Like all sensation, it was as it seemed and could be no other way. But the ensuing interpretations of Mondrian's art, if ventured, would be illusory.

I have referred to those moments when a particular use of language brings attention to itself and 'spoils the illusion of direct reason'. As in the case of optical phenomena, however, neither a *feeling* of reason nor a *feeling* of absurdity is illusory. What a person feels is no illusion. The emotional states associated with an intellectual process of reasoning represent the way things are at an instant of appearance or cognition. De Kooning could be very insistent in this respect. The conversation that Harold Rosenberg recorded in 1971 reads like an elaboration of the comments the artist made two decades previously in 1950: 'The optical illusion isn't an optical illusion. That's the way you see it.' A stick extended into water does not present the illusion of being broken; rather, de Kooning says, 'it's broken while it's in the water'. This is either a reasonable inference or a reasonable absurdity. The sensory phenomenon no longer contradicts what reason indicates; the effect no longer requires an explanatory cause. And similarly, 'All painting is an illusion . . . [which reduces to] the way you see it.' As the interview progresses, de Kooning presents the more puzzling case of fabricating a sphere, say, out of plaster. He argues that you would never be able to determine by eye that the mass of plaster had in fact become a sufficiently perfect sphere: 'That's what fascinates me – to make something I can never be sure of, and no one else can either. I will never know.'[55] Part of the problem – or rather, for de Kooning, it was no problem at all but a point of great interest – was the distance between what hands might discern in holding a sphere and what eyes might discern in viewing it. The dilemma was analogous to deter-mining how to think about what you feel. Hand versus eye, sensation versus reason: you have to balance incommensurables without anticipating a fully satisfying outcome. 'Try following a straight line from top to bottom. It makes you sick. The idea of flatness is so old fashioned. Nothing is that stable.'[56] Reason conceives of absolute flatness, straight lines, regularity. Sensation knows otherwise.

Convergence

Hand and eye grow closer when an artist handles a stylus or a brush while looking at the traces it deposits. Senses converge. Sensations converge. Despite a certain gestural likeness – a sympathy of forms between a de Kooning image and the active body of a woman or man, the nominal model – descriptive likeness is not the motivation for his art. At times, it seems that the form

follows the characteristics of the studio materials and instruments as much as these materials yield to perception. De Kooning demonstrates that mimesis is inherently reciprocal. Reciprocity works its way through incommensurables. The object the artist renders becomes the object seen through the means of rendering – the object felt through the materials and instruments that work to represent it. This is why the hair surrounding the face of *Woman* (illus. 6), especially at the upper right, amounts to one colour brushed over another with the effect of leaving traces of thin bristle marks, which are the hairs: brush-hair imitating, or conflated with, human hair; hair emerging from a brushmark. We do not know whether de Kooning used this effect of marking to render hair he had seen or, to the contrary, because of the formal analogy, the marks added an effect of hair to a head that might otherwise have lacked it. Many of de Kooning's early male figures have no hair; he regarded hair as one of a number of 'impossible' objects of rendering.[57] Yet brush marks – and, in a drawing, the marks of a stylus – could finesse the problem. In fact, a compelling metonymic association of *brush* with *hair* causes the image of *Woman* to look more naturalistic than it is. (It also seems wrong to say this, because naturalism amounts to a look, a matter of appearance. So de Kooning's picture can appear neither more nor less naturalistic than it actually is.)

De Kooning's confusion of brushmarks that represent hair with brushmarks that represent brushing – we cannot definitively separate them – is an instance of the way his art resists categories and classification. From the rendering of hair, depiction readily passes to the rendering of hands – de Kooning's hands drawing a figure's hands. The fingers of *Woman* resemble the phantom strands of hair, save that they are far more explicit. The hands are curving yet angled linear elements that relate to the act of drawing as the hair relates to an act of painting (the brush having been used broadly); these figured hands draw out, extend, their own form (the brush having been used to line). Recall the hand in the drawing of *Reclining Woman*; it also has an affinity to its figure's hair. Drawing and painting perform similarly in de Kooning's practice; they converge, just as senses do.[58] Add to this convergence the diverse parts of a body, affected by reciprocal resemblance. But the organicism of muscle and bone is not what unifies the anatomy of a de Kooning figure within its rendering. The integrating factors are material and physical qualities of the artist's technique.

Seated Man (illus. 7) is another pertinent example from relatively early in de Kooning's long career. Near the top of the figure's trouser leg, at the hips, the painter structured a compact set of creases and folds. These correspond to forms developed in a more rudimentary way in the figure's outstretched hand, as if one gesture or shape were breeding another, its likeness. Did de Kooning

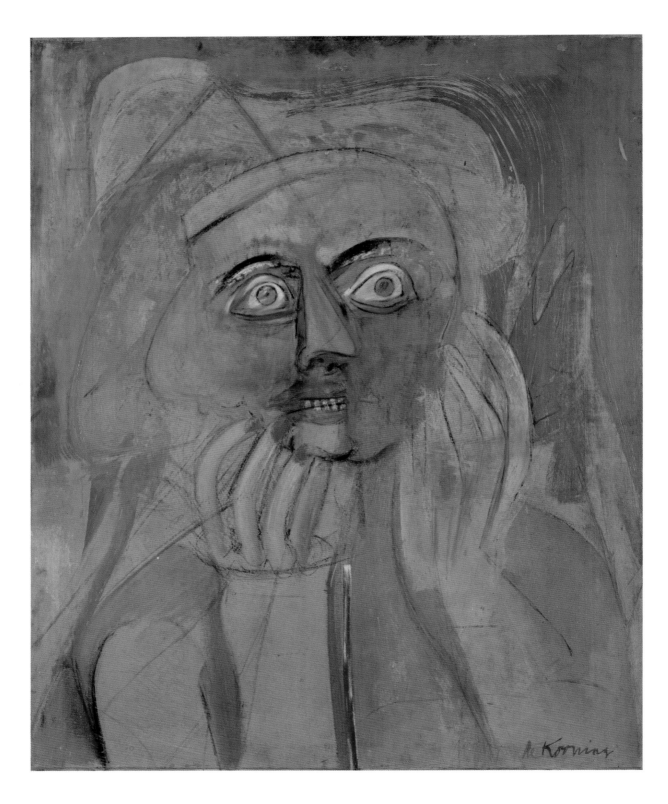

6 *Woman*, 1943, oil on board, 71.7 × 58.5 cm. Seattle Art Museum, Seattle.

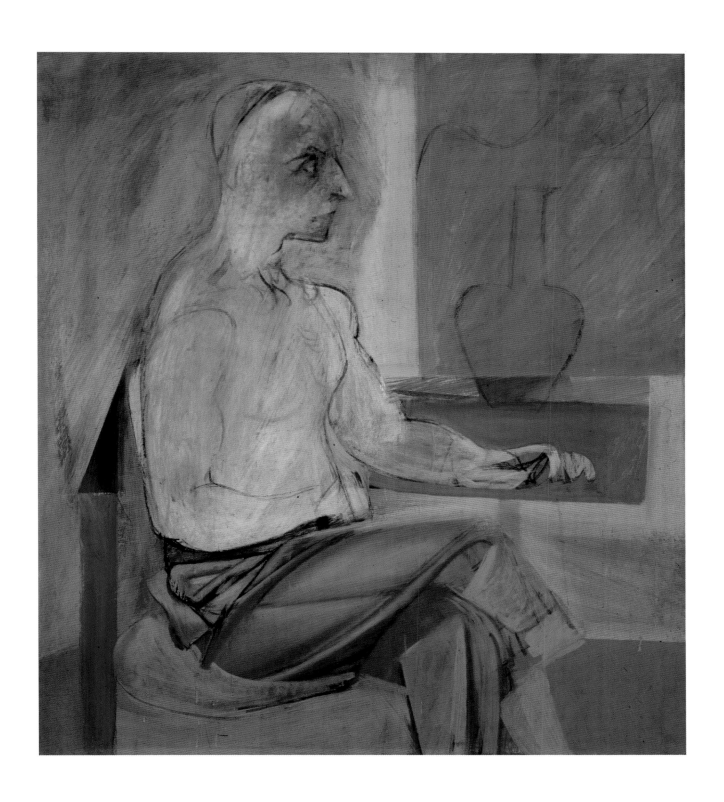

7 *Seated Man*, *c.* 1939, oil and charcoal on canvas, 97.1 × 86.9 cm.
Hirshhorn Museum and Sculpture Garden, Washington, DC.

perceive an affinity between hip-and-leg and wrist-
and-thumb? Did he grasp some organic analogy?
Perhaps he could feel it in his own movements.
Or was it revealed to him gradually as a product
of his marking, whether backed by anatomy or not?
A suggestive detail appears just below the figure's
knee, where de Kooning brushed the trouser leg in
a way that echoes the extended hand above it – a
hand extended not by anatomy but by marking.
The hand's long reach amounts to a play of overlaid
planes of colour, positive and negative.

Implicitly, my account describes a shift in
the play of representation: consider it as a shift from
what a person knows to what a person senses, the
reverse of what happens when we apply reasoning
to what we feel. The same turn had occurred when
Cézanne painted figures, forty or fifty years before
de Kooning. His *Seated Peasant* (illus. 8) has grossly
extended, elongated fingers. This is a product of
sensation, the artist's hand feeling how the model's

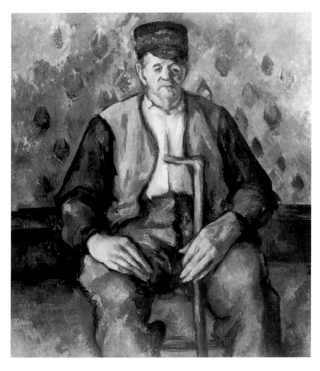

8 Paul Cézanne, *Seated Peasant*,
c. 1900, oil on canvas, 72 × 58.5
cm. Musée d'Orsay, Paris.

hand might feel within the situation of the picture. The distribution of marks
and the sequence of adjacent colours in the model's right hand coordinates
better with the structuring of the folds of the trousers than with a plausible
anatomy. Cézanne's play of material marks leads the standard anatomical
features into a configuration specific to the pictorial moment – the moment
of sensation detached from the customary appearances that reason, with its
categories and habits of analysis, would expect. This pictorial specificity may
be what de Kooning appreciated in his idiosyncratic French predecessor,
whom he took to have had a kindred respect for the spontaneity of sensation.
Appearances happen: an artist does not plan them. De Kooning believed that
Cézanne had been wise enough not to 'build an aesthetic beforehand' (more on
the de Kooning–Cézanne connection below, 'Cézanne').[59]

The shift from a referential order to an inventive array of material
spontaneity (my awkward phrasing, an attempt at labelling the de Kooning–
Cézanne condition) has often been noted one way or another. Here is
playwright William Inge's version, spurred by de Kooning's art in 1965:
'They were not paintings *about* life. They were paintings created *out of* life.
They did not represent anything; they *were* something.'[60] To repeat one of
de Kooning's statements already quoted ('Array'): 'A model can take every
kind of pose, but all that matters is how the hand sets her on the paper.'[61]

36

Theory

On three occasions around 1950, in response to invitations to speak before an audience, de Kooning committed his ideas about art to paper.[62] In retrospect at least, he regarded these composed statements as no more definitive than his paintings and drawings. He bristled at having the terms and the merits of his products of a particular moment debated long after the fact, as if they represented his current emotional and intellectual state. He might already have changed his view on an issue, just as he would have seen a model in a different light. Things keep changing; this was reality. He too changed. In a Dutch interview of 1968, he complained of quotations being taken from his 1951 essay on the topic of 'What Abstract Art Means to Me'. 'I spoke in no definitive terms', de Kooning insisted: 'I'm not one to make fixed statements about my work.'[63]

Here is what de Kooning seems to want: whatever he has done, whatever he has said, if we are to respect his attitude and his function as an artist, we must refrain from converting his actions and opinions to a rigid hierarchical order complete with categories and classifications. We cannot conclude that what he appears to believe at a later date must supersede a stated belief from an earlier date. Even time proves to be no more than an array, a sequence of moments that lacks a preferential order – a set of effects without causes. If, as it may seem, a shift is involved when de Kooning creates a mimetic image – a turn from knowing to sensing – then let it not establish a hierarchy. The shift itself will shift. Through its material directness, de Kooning's practice reveals features that may apply to any process of representation, any imagistic abstraction, any picturing. He adds his idiosyncratic gestural energy to the rendering of a model, rather conventionally conceived – 'everything ought to have a mouth', he would say, this is just ordinary – but in the course of working and reworking the surface, a different model might well appear within the configuration of his marks.[64]

Jean-Claude Lebensztejn offers a description of the situation by invoking the semiological terminologies of C. S. Peirce and Ferdinand de Saussure: 'The icon, mimetic sign of an object (the woman), and the index, existential or dynamic sign of the subject (the painter), become one and the same thing . . . [It is] as if the Saussurean bar between signifier and signified were effaced, calling forth a monstrous hybrid.'[65] Lebensztejn was referring to identifiable functions that we ordinarily locate in our analysis of the constitution of an image. On the one hand, we differentiate the icon, the sign of resemblance, from the index, the sign of causation; on the other hand, we differentiate the signifier, the mark that represents a model, from the signified, the state of the model as represented. With de Kooning's art,

these distinctions cease to be effective; each of the various material and pictorial elements serves multiple purposes at odds with each other. The pictorial function slides into the material; the material function slides into the pictorial. We cannot tell what is what, even in a finished work. Nor could de Kooning. This suggests why he had such a difficult time determining when his painting or drawing had reached its proper end. He might as well just stop.

In 1953, in a series of photographs with commentary, Hess restaged the development of what quickly became the most canonical of de Kooning's images of Woman, *Woman I* (see illus. 37). He evoked what a more theoretically oriented writer might have discussed as a problem of dysfunctional categories and hierarchies. Hess thought of it instead as a problem of finishing, ending: 'The stages of the painting . . . are neither better nor worse, more or less "finished", than the terminus . . . Some might appear more satisfactory than the ending, but this is irrelevant.' At the end – at the moment that constitutes the end – the painter's 'exploration . . . simply stops'.[66] Two years later, George Huntington Hartford II – heir to a supermarket fortune and self-appointed guardian of American aesthetic values – composed a screed against obfuscation in modern art and criticism. He chose Hess's analysis of de Kooning as primary evidence that art criticism was becoming critical nonsense: 'It was irrelevant [to Hess] whether the painting was better when completed than when it was begun.'[67] This was a distortion of Hess's claim, extracting from his argument a corollary he would not have pursued; yet Hartford's reading captured what many others must have concluded – de Kooning's art lacked a purpose or end that would explain and justify it. What Hess said in 1953 de Kooning himself would say in 1960 ('I just stop'), and this was not the only repetition. In 1965, *Time* reported on de Kooning at work: 'Only when a friend, painter Philip Guston, cried, "That's it! That's it!" did [de Kooning] stop endlessly revising one large nude. [This] creative indecision . . . makes viewers often feel that his moment of supreme victory has been painted over, or else is yet to come.'[68] Victory requires a plan; victory is a future projection of a degree of success determined in the past. De Kooning's art of sense had neither past nor future. So no stage of *Woman I* could be more finished than any other. For de Kooning to reach the end of a painting – or rather, to happen on it – chance, fate, or a friend (same thing) would need to intervene.

De Kooning's dilemma often appeared as no more than feckless indecision. But I wonder if an artist who has already eliminated the standard bases for making decisions can actually suffer indecisiveness. De Kooning left quite a few of his more informed critics mystified because their criteria, like the standards of the clueless Hartford, no longer applied. Rather than

questioning their own mode of reasoning, critics attributed the problem to the artist. Lawrence Alloway exemplifies this type of response: 'His refusal to accept an arbitrary form or system, however improbable, as a means by which to create art seems to have left him in the air . . . De Kooning's position [makes] his pictures, early and late, run together in a melee of suspended possibilities which, instead of celebrating freedom, perpetuates indecision.'[69] Apparently, Alloway had a very limited view of what might count as 'an arbitrary form or system'. It was the critic who was left 'in the air', at least as much as the artist – left to evaluate by standards the artist had abandoned. At the root of Alloway's critical impasse is the assumption that the secondary medium – here, the critic's language of rational analysis – can attribute a fixed meaning to the primary medium, a painting practice, which otherwise lacks a meaning to direct its production as well as its consumption. If the secondary medium is representing the primary medium, as a signifier relates to an object of signification, then the second might reveal more by remaining as indeterminate as the first, as if the best critical commentary were unfocused imitation. De Kooning understood this condition, at least intuitively, by refusing to develop any greater fixity in his image than what he could perceive in whatever model was inspiring his representational effort. When he switched to representation by words – passing from his experience to the form it assumed in his practice, and then to its reference in his language – he was just as averse to settling on a single point of view as when he painted or drew.

Sense

De Kooning's art orients to sense, solicits sense: sense as sensations of the visual, the tactile, the kinaesthetic. I resist claiming that this art 'speaks' to sense, for the metaphor will be understood too literally. It will bring decisiveness to indecision. This it-speaks-to-us is already a cliché, something to be said of any art that a critic appreciates (rhetorically, the metaphor of it-speaks degenerates to catachresis). To say that a work of art speaks implies a degree of conceptual order and discursive rationality that de Kooning's studio practice denied.

What quality of experience might motivate this denial? Sense as sensation is both irregular and vague. Sensation is an event. It comes and passes. It happens, yet makes no sense. Its source may be evident or not, or both evident and misconstrued. We hardly know whether one sensation is the same as another even when the same descriptive terms suit both. Our application of descriptive terms occurs after the event and is arbitrary, like all

judgements. When we encounter a surface and sense its brightness and opacity, its warmth and solidity, we cannot comprehend how bright, opaque, warm or solid the surface is in relation to analogous experiences so long as we remain occupied with what we feel. 'A feeling is a state of mind having its own living quality, independent of any other state of mind': this is Peirce, as he outlines three fundamental but interlocking categories of experience – Feeling (presence), Sensation (reaction) and Habit (conceptualization).[70] 'A feeling [has] its own living quality': using Peirce's categories, we understand what Inge was suggesting about de Kooning's art when he contrasted the condition of representing to that of being (the pictures 'did not represent anything; they *were* something'). Stated in more fluid terms – avoiding an absolute distinction likely to be more rhetorical than real – this becomes a question of distance, of how immediate the sensation feels. Do you feel you are in contact with the sensation (no distance), or do you feel in judgement of it (some distance, some degree of representation or referral)? For Inge, an image by de Kooning offered an immediate feeling, or a sensation close enough to Peircean Feeling to *be* (relatively) just that. Feeling is unitary, elemental – oblivious to the set of distinctions expressed by separating subjective from objective qualities. Perceptual context, the degree of excitation and fatigue of the sense organs, emotional mood, and any number of other factors will affect objectivity as Peircean Feeling passes into Sensation, which is our awareness of our relation to Feeling. But objectivity was not de Kooning's issue, nor was subjectivity, nor did he worry very much over degrees of distance. If he became conscious of distance, if he felt it, he would stop: 'I lose sight of what I wanted to do [in a painting], and then I am out of it.'[71] In 1950, this was his way of expressing the experience of stopping (as opposed to finishing); in 1960, it became 'I just stop'.

We have no reliable gauge of feeling. Every sense experience is unique – but loses its uniqueness once we think about it, applying categories of experience. Each work of art, if oriented to sense (not to thinking, not to criticism), would project a feeling with all the sensory specificity and conceptual vagueness that the colloquial term *feeling* connotes. De Kooning's drawing of a woman known as *Reclining Woman* – whether the figure reclines horizontally or strides vertically – is accurate with respect to what it most directly represents: his experience. The *act* of drawing was de Kooning's sensation. From his perspective, rotating the image ninety degrees has no effect on the status of the act; it becomes an aspect of the act. Working against this specificity, any critical discourse generalizes. Conventional 'landscape' (horizontal) and 'portrait' (vertical) formats become classifications that overrule other differences. Critics describing art, even when asserting the uniqueness of an object, do so in reiterative ways, with a standard vocabulary

and its customary metaphors. To use Peirce's terminology, critics respond with Habit.

For Peirce, sensations proper are 'Sensations of reaction'. Sensation occurs 'when any feeling gives way to a new feeling. Suppose I had nothing in my mind but a feeling of blue, which were suddenly to give place to a feeling of red; then, at the instant of transition, there would be a shock, a sense of reaction, my blue life being transmuted into red life.'[72] Perhaps a person can become inured to feeling, but not to sensation, which is a feeling that marks a disruption in feeling. A statement by de Kooning (previously quoted, 'Stop') resonates by chance with Peirce's allusion to redness and blueness: 'At one time it was very daring to make a figure red or blue. I think now it is just as daring to make it flesh-colored.'[73] In this case, flesh colour would mark the change; within the context of de Kooning's discussion, it would also signify a resistance to avant-garde practice, which in his view had become a standard, virtually a convention. Yet an artist need not strive to generate shock by countering convention or expectation. Any change – change alone, the Peircean 'instant of transition' – shocks.

De Kooning configured transition as shock by any number of means that this book will come to investigate. One example is his use of masking – most often by paper, sometimes by tape – to create an abrupt juxtaposition of strokes and forms that bear no organic connection despite their contiguity. In the pastel and graphite drawing *Study for 'Woman I'* (illus. 9), at the neck and shoulder height of the figure, a precise edge forms an apparent barrier, the effect of a sheet of cleanly cut paper having masked one side of this visual boundary from the other. The bar that results separates representational lines and colours above it from those below it. *Study for 'Woman I'* has the look of collage, but dematerialized – visible yet invisible collage. An analogous effect, though less dramatic, can be seen in the painting *Woman* (see illus. 26), where truncated strokes of green abut a straight-edge bar of red to the right of the figure's head, a result of this blind-sided, collage-like approach to linking forms. At the bottom edge of the same painting, near the lower left corner, similarly truncated residues of black seem to result from stroking paint over a cut edge of paper.

The effects of masking become visible only after the fact. Adjustments do not belong organically to the initial process but come as subsequent, discontinuous gestures, one violent change after another. Across each side of a masked edge marks of colour and the forms they constitute remain unrelated generatively. Yet because they exist side by side, they relate by their shared context – perhaps a forced relation, but real nonetheless. It is odd to call movement across the invisible divide, this passage of vision across a masked edge, a form of transition. Literally, however, this is so; the generative

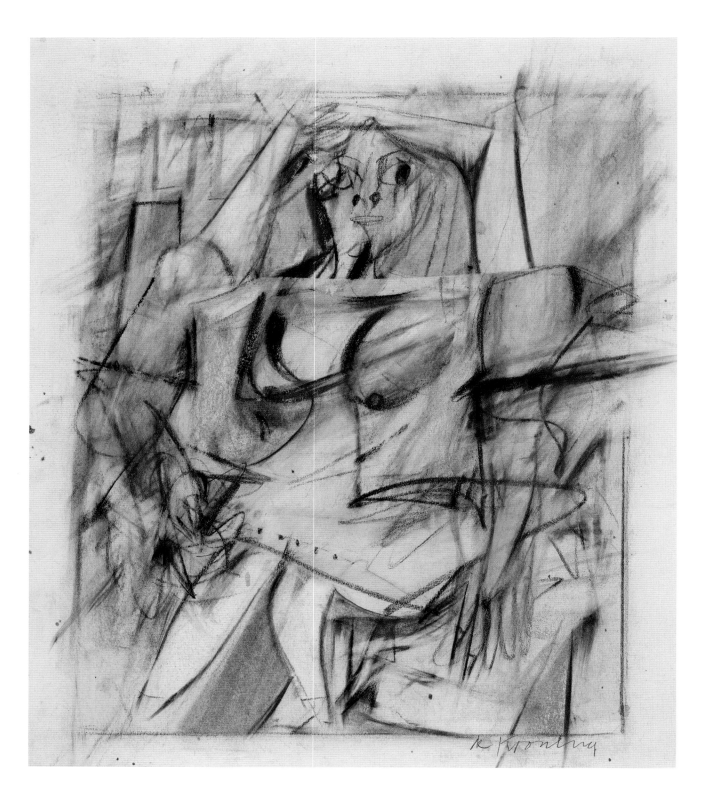

9 *Study for 'Woman 1',* 1952, graphite and pastel on wove paper, 31 × 29 cm.
National Gallery of Canada, Ottawa.

barrier that results from the technique of masking blocks no aspect of the picture. Vision 'goes across' the barrier; it transitions or transits the divide. What the hand produces as discontinuous appears to the eye as an integrated whole – oddly disparate in its wholeness. Are we faced here with Peircean Feeling or Peircean Sensation?

The situation merits reviewing. When de Kooning used the simplest of masking devices, laying a sheet of newsprint over a section of a surface in progress, marks would pass from one surface to another physically above it (or from above to below). With the separation of the two surfaces, the mark would lose both physical and visual integrity, even as the artist's hand and arm retained a motor memory of experiencing the stroke as continuous and whole. The abutment of organically unrelated strokes on the primary painting surface produces an effect analogous to what Peirce described as the passage from Feeling to Sensation, the moment at which one feeling supplants another: 'There would be a shock . . . my blue life being transmuted into red life.' Whatever else de Kooning's technique was doing, it was providing him with a shock of sensation. Masking, collage, cutting and other related procedures forced the artist into a condition of perceptual acuity tantamount to self-induced intuition (we might consider it as a parallel to dreaming – conscious rather than unconscious dreaming). De Kooning was willing himself into a state of involuntary psychosomatic activity. Just as Peirce defined the awareness of sensation as a perceptual shock, he defined intuition analogously: 'a cognition not determined by a previous cognition of the same object . . . There is no evidence that we have this faculty, except that we seem to *feel* that we have it.'[74] An intuition is something we sense abruptly, like the spontaneous passage from 'blue life' to 'red life', but we cannot trace its existence to an origin in logical reasoning or anywhere else. It just happens, and we feel when it does; we know intuition when we experience it. But intuition is itself a state of knowing. So we know what we know. This is a tautology: an intuitive tautology, or the tautology that inheres in intuition. And even this, de Kooning doubted.

The enemy of intuition is intellectual habit or conceptualization. Peirce: 'When we think [that] we are conscious that a connection between feelings is determined by a general rule' – when we realize that certain sensations have become familiar and predictable – 'we are aware of being governed by habit. Intellectual power is nothing but facility in taking habits.'[75] Reasoning by established principle follows patterns of thought; habits grow as an individual's distinct feelings begin to cluster and associate, first in the reaction known as sensation, then, far more generally, as concepts. If this process constituted the natural order of mental development, de Kooning wanted little part of it when it came to finding his images. Mental facility in

forming habits and their associated concepts was parallel to the technical facility he distrusted in himself. As Elaine de Kooning and many others close to him stated, he was aware that habits of the hand (which he surely possessed) could be as dangerous to his aesthetic intuition as conceptualized pictorial conventions: 'Bill was very irritated with his facility and he was constantly struggling against it.'[76] Their mutual friend Rosenberg referred to de Kooning's longstanding effort 'to break up the order that his hand tends to impose'.[77] The habit experienced as facility would lead de Kooning to experience red to blue as a reliable colour harmony, not a transition in shock. When he used masking, it was one of his devices to resist dexterous fluidity – or to exploit it in an unconventional manner.

The tension between Peircean Feeling and Peircean Sensation, experienced both perceptually and conceptually – this shocking transition – makes it difficult to avoid the easy recourse to oxymoron and chiasmus. A 'shocking transition' is slippery. A transition should not be shocking; a shock should not be transitional. But there it is. The struggle against one's own facility, the resistance to forming a Peircean Habit, mirrors another common artistic struggle: the effort to liberate expressiveness, or rather, to express what the forces of culture suppress. In a review of de Kooning written in 1978, Hess began by quoting the cultural critic Theodor Adorno on this issue: 'How much trouble and exertion, what an effort of will, it requires to command involuntary expression.'[78] In itself, the statement reads ironically, as if Adorno were saying that such command is either futile (the involuntary cannot be controlled) or a sham (the effort is a rhetorical facade, the mere staging of expressiveness). Hess lifted the text out of its specific context. Adorno was referring to the effort that psychoanalysis exerts on its subject, as an analogy to the problem facing a surrealist, an artist seeking a 'pictorial language, freed from the trimmings added by the conscious ego'. The methods of psychoanalysis and surrealism, Adorno argued, bring too much rationality to the feelings they would release, so that the otherwise hidden expressive content is forced 'into a few patterns . . . into a few limited categories'.[79] Psychoanalysis proves not to be the best theoretical model for surrealist practice, but the ramifications of Adorno's argument had little to do with Hess's interest in this statement. It may have been the implicit oxymoron that caught his attention: an 'effort of will' was being directed at 'involuntary expression', that is to say, an act of will was ferreting out the non-willed. Control was generating its opposite, letting the genie out of the bottle. Once the genie is out, what controls it? This is ironic. If a critical writer represents the surrealist effort through a rhetoric of self-contradiction, the form of the argument sustains the logic of the critique, which has no logic, no reason. It has only its proper syntactical form (X commands not-X).

Hess seized on Adorno as a foil to affirm de Kooning's success in breaking the spell of his own skill and habit, analogous to breaking through a protective shell, whether psychological or cultural. The limitations of psychoanalysis and surrealism notwithstanding, de Kooning in his seventies was continuing to 'bypass virtuosity', without turning his art into a phantasmatic monster and without making virtuosity out of its opposite.[80] Hess was claiming that it could be done, and de Kooning did it. Why was this artist immune to the ironies that affected others?

In 1964, Sartre, only one year younger than de Kooning and similarly advanced in his career, presented a parodic account of his childhood ambitions and the subsequent development of his thoughts on literary and philosophical writing, which included this remark: 'I came to think systematically against myself, to the extent of measuring the obvious truth of an idea by the displeasure it caused me.'[81] The sentiment is close to de Kooning's, who distrusted the products of his cultural formation, including his skill at his art, even as this formation kept forming. In habit, a Peircean would say, there is at least the promise of perceptual progress. It begins with the shock of sensation, becomes a 'gain of experience' (like passing from blue life to red life) and ends in 'a general conception': 'When a disturbance of feeling takes place, we have a consciousness of gain, the gain of experience; and a new disturbance will be apt to assimilate itself to the one that preceded it. Feelings, by being excited, become more easily excited, especially in the ways in which they have previously been excited. The consciousness of such a habit constitutes a general conception.'[82] But any habitual exercise of the senses and intellect masks the potential of its alternatives in the way that being attuned to one phenomenon causes you to ignore another. Habit is antithetical to ambiguity and multiplicity, inimical to spontaneous, intuitive alternatives. And it has its consequences, as Peirce indicated: 'Ideas are apt to reproduce themselves. . . . Deadened by the development of habit … the state of things in the infinite future is death, the nothingness of which consists in the complete triumph of law and absence of spontaneity.'[83]

De Kooning had a penchant for alternative endings – for life or liveliness, we might say. When he would 'just stop', this was not termination, not the death of the process, for stopping did not prevent him from returning to the same work to start again. Another consideration introduced by Peirce seems relevant to de Kooning's practice: 'No thought, however simple, is at any instant present to the mind in its entirety, but it is something which we live through or experience as we do the events of the day.'[84] A thought does not remain single. It expands and contracts and expands; its aspects change as the thought is being thought. De Kooning's usual practice was to scrape down a canvas at the end of the painting day, then resume work the following day,

taking hints from the traces of aesthetic thought that remained. This was neither an entirely new beginning nor a stage in the completion of a continuing composition; either of these possibilities would have appeared too definitive and formulaic to satisfy de Kooning's need for openness and insecurity. The process was instead something to be lived, like a Peircean thought, as opposed to the habits of thought that would lead an artist or critic to say, 'Watch out for thinking.' Conclusive thoughts were deadening, sapping their own energy. A thought-event would survive within a family of similars, an array of alternatives. As already noted, de Kooning found any exclusivity, even the exclusive rightness of an intuition, suspect.

Accident

De Kooning had a way of experiencing many alternative 'ends' in many separate pictures as well as in one and the same picture. He would study and often preserve the casual monotype prints that resulted from his practice of laying sheets of the daily newspaper over the surfaces of wet oil paintings as they progressed (see also 'Array'). Pragmatically, the newsprint slowed the natural drying process, facilitating the very liquid, wet-on-wet manipulation of paint that the artist preferred. Aesthetically, experientially, each sheet could be pulled up to reveal the negative or reverse transfer of the positive but incomplete image beneath it. Each 'pull' of this type was a unique gesture in itself, even though uniqueness was hardly a concern. The paint image that appeared on the newsprint resulted from a combination of subtle directional forces generating degrees of smearing, blurring and blotting. In addition, the actual upward force of the pull would cause the more viscous deposits of paint to form slightly textured peaks (both of the two surfaces in contact were affected by this action – the original painting in progress and its pseudo-double). Each newsprint sheet became, de facto, a unique work, a thought among thoughts, differing even from what it presumed to mirror. It also differed from other de Kooning products in being an event occupying no time rather than endless time – it began and ended in its single action of pulling. It required no further graphic contribution, although in certain instances the painter as well as others added supplementary marks.[85]

Peter Schjeldahl has designated the more casual among these works 'accidental monotypes'. Having received one directly from the studio, probably in summer 1975, he recalled the circumstances in a statement of homage to de Kooning after the artist's death in 1997.[86] The two had spent a day together, and de Kooning wanted Schjeldahl to have a souvenir of their exchange, something aesthetically suitable, preserved from the morass

of material of indeterminate status left temporarily orphaned on the studio floor. Here is Schjeldahl's account:

> 'You shouldn't leave here with nothing.' Kneeling, he tossed sheets left and right. 'That's no good. That's no good. Hey, this one's not bad. You like it?'
> 'Very much.'
> 'Me too. Which end do you want up?'
> 'I'm supposed to tell *you* that?'
> 'Okay, this way.' He signed it 'to Peter/Bill de Kooning' in charcoal and handed it over.

10 *Blue Stroke, c.* 1975, oil on newsprint. Private collection.

It seems that this unexpected but authentic de Kooning has acquired an unofficial title, *Blue Stroke*, as a result of Schjeldahl's description of it, selective as any description must be (illus. 10). It is a 'pleasantly smudged sheet', Schjeldahl writes, 'its chance composition oddly stately . . . starring pink and yellow, and the ghost of one blue brushstroke . . . vertical . . . about 18 inches long and two inches wide . . . sinuous, with two slight bends and an abrupt veer . . . liquid and speedy . . . tensile . . . The veer makes space . . . I don't know how it does this.'[87]

This 'accidental monotype', the trace of an action, was more than a trace. It did what it ought to have done: just as it showed Schjeldahl something he could not understand, it may also have shown de Kooning something – the action itself – that he would never understand *after the fact* in the way he had experienced and understood it while performing it. As he made the mark, de Kooning must have understood how to do it, how the action felt, even if not fully comprehending toward what end he was moving. He had made the initial stroke too quickly to consider the possibility of its succeeding or even its being. His blue stroke represented Feeling in the process of becoming Sensation, with no hint of Habit. No Habit

because no rational order controls or limits a de Kooning stroke – there can be no repetition, save through imprinting. But here the process differs, involving pulling, smearing, and blurring. So the stroke does not repeat; instead, its very being must alter the quality of the painting surface from which it draws.

Each de Kooning stroke is peculiar, even when it imitates the familiar contour of a body. Where the blue stroke featured by the monotype takes its 'abrupt veer' (Schjeldahl's description), this is one of its peculiarities. Turning this way, it follows no order. Similar strokes by another artist may be far more restrained, self-consciously so – relying on Habit, shy of intense Feeling. A stroke can exist as hardly more than an abstraction of a stroke, a generic stroke already so familiar that it lacks its proper immediacy. Such a stroke abstracts its presence from experience; it becomes more passive shadow than active trace. De Kooning had been selective in offering Schjeldahl the gift: not every stroke was a 'stroke'; not every mark held its own as experience, even among his. 'It is the compulsion, the absolute constraint upon us to think otherwise than we have been thinking that constitutes experience', Peirce wrote.[88] When de Kooning rummaged around for a 'good' stroke, he was seeking a moment of Peircean compulsion. The monotype pull did as de Kooning's other techniques were doing. His painting over other areas of painting, his scraping down to an anterior trace, his masking procedures, his use of collage: all were feelings interrupting or displacing other feelings. They were gains in experience, each a Peircean Sensation.

As he drew, de Kooning would often poke at the paper, making marks as if without purpose but in expectation that something of visual interest would emerge.[89] 'For myself', he said in 1969, 'I make things by accident.'[90] 'He likes accidents', one of his close friends confirmed.[91] In 1949, an accident had occurred in *Attic*, a large abstraction (illus. 11). It involved a newsprint pull, but no corresponding monotype survives. At a certain point, de Kooning must have known intuitively that this canvas had become sufficiently resolved. Yet by every conventional category of understanding, *Attic* continued to present ambiguities and signs of indecision. To ask what result de Kooning had been seeking is an improper question. More to the point would be the nature of his process. He desired to continue adjusting his multiple results with the greatest flexibility. To maintain a necessary wetness as he worked, he spread sheets of newspaper over areas of the canvas soon after they received paint (he chose newspaper as opposed to some other kind of paper because, in essence, it cost nothing).[92] If, back in 1949, such sheets inadvertently became monoprints, they did not enter the artist's oeuvre as their counterparts from the 1960s and '70s did. Occasionally, however, solvency caused the newspaper to monoprint in the reverse direction, leaving transfer imprints of these offset surfaces visible in areas of lightly

11 *Attic*, 1949, oil, enamel, and newspaper transfer on canvas, 157.2 × 205.7 cm.
The Metropolitan Museum of Art, New York.

12 *Untitled,* 1958, oil on paper on masonite on wood, 58.5 × 74 cm. Peggy Guggenheim Collection, Venice.

coloured paint (Hess: 'Offset newsprint images appear in his abstractions from 1948 to 1956').[93] De Kooning appreciated the haphazardness of the imprint process and allowed many of its fortuitously placed, ghostly traces to remain visible as details within the expanse of *Attic*. Also within this expanse – which was itself an abstraction – any local area might yield up organic shapes readily evoking body parts or an entire human figure. But such figures had already been abstracted out through the process; they were absent as much as, or more than, they were present. At the lower left of *Attic*, an 'absent' figure of this kind contains a transfer image of a seated bather within its space, as if this fully detailed, but relatively tiny image were there to compensate for a studio model gone missing. By accident, de Kooning's process substituted a printed figure from popular illustration for its high-art prototype. Had the effect not pleased the artist once it appeared, he would have reconstituted the area. This would not be a matter of incremental refinement, for reworking the surface in this way would amount to composition, a resolution. Instead, de Kooning would most likely use some dramatically transformative gesture. It might succeed; it might fail. The odds were the same for each successive attempt. At every moment of its production, every de Kooning painting offered its painter a new chance.

A decade later, a journalist writing for *Time* recorded de Kooning expressing his concern for accident and chance: 'Every time I paint a picture I'm throwing the dice. I can't "save" anything. That would be like doctoring it. It's a new game. It's not like playing poker where you can trade a card for another one; it's playing dice.'[94] By 'save', de Kooning meant improving or correcting a painting that had lost its edge; saving is a calculated manipulation in search of a known standard of order or completion. Because he worked without standards, it was to his advantage for each work to be open to absolute accident, as if each played dice with a single throw. The occasion for the article in *Time* was de Kooning's new show at Sidney Janis Gallery, where he exhibited a set of works customarily identified as 'landscapes'. *Untitled* (illus. 12) is an example of the type: freely brushed wet-on-wet oil colours on a standard sheet of Bristol board. De Kooning extended his strokes off the edge of the paper, producing the appearance of speed, if not impulsiveness ('it's playing dice'). He was either beating the odds or not, producing sensation – an experience – or nothing. If nothing, he would reject the stroke, scraping the paint off the heavy paper in order to reuse the surface. How much of a gamble was this? There is calculated chance (poker) and there is pure chance, chance in the extreme (dice). De Kooning rolled the dice against himself, resisting any habitual calculations of his own. He needed to surprise or even shock himself into accepting what his hand could do. Or what his eye could see, perhaps as the subject of representation: 'I see things I like, I don't fight them. Maybe it's only a puddle. Four or five months later they come back to me.'[95]

Turn

The reversal inherent in the monotype process automatically produces an alternative ending. Each of de Kooning's canvases might generate numerous chance encounters with its primary yet transient image – one unique imprint after another. These alternatives would be similar in appearance, linked by shared features. A historian might use them to record a sequence of choices and changes, the developmental history of the work; but they served no such purpose for the artist. Instead, each became a sensory moment in his experience, a source of stimulation valued for its qualities. Complete in itself (like Peirce's Feeling), each represented the termination of a transition – a shock fated to be supplanted by another shock.

Apart from the monoprint process, de Kooning cultivated the shock of mirroring in a number of different ways. Certain drawings, such as *Woman* (illus. 13), indicate that he conceived of the various poses of the human body as reversible. He deployed the standards of the genre and destabilized them ('A model can take every kind of pose, but all that matters is how the hand sets her on the paper').[96] In the case of *Woman*, the reversal is not a left-to-right turnabout but front-to-back. With an overlay of gesso, de Kooning virtually erased the pencilled presence of the figure's breasts, which nevertheless remain visible as a trace image. The frequent appearance of trace imagery in his drawings and paintings may have been a way of keeping his back-and-forth decisions – already tentative and subject to his reversals – all the more reversible. Given the visibility of the trace, a viewer remains free to imagine the image in an anterior state.

In the drawing *Woman*, a characteristically ambiguous form – a *J* connected to a backwards or mirrored *J*, an instance of internal reversal – forms a graphic indication of buttocks with thighs extending back into space. The same form might have been used – and, given the trace image of breasts, at some stage of the process ought to have been used – to indicate thighs extending outward from a seated figure facing forward. As an example of this possibility, see the deliriously ambiguous figure (by the scale of it, a child) at the bottom right of *Pink Angel* (illus. 14), where legs and arms appear to project both forward and backward, and the head seems to turn from both front to back and back to front. The distribution of colour enhances the effect of torsion in the figure as a whole: the leg extending to the left is red, like the arm extending to the right, whereas the arm extending to the left is pink, like the leg extending to the right. In this instance, de Kooning's double-*J* appears to describe a back view (spine and buttocks) rather than a front view (torso and vulva), but the heightened potential of this figure to turn and twist casts doubt on any definitive perspective.[97]

13 *Woman*, c. 1945,
pencil on gesso on paper,
32.1 × 21.9 cm.
Private collection.

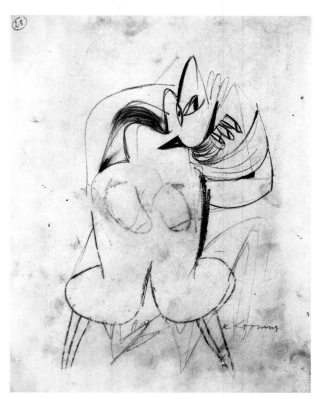

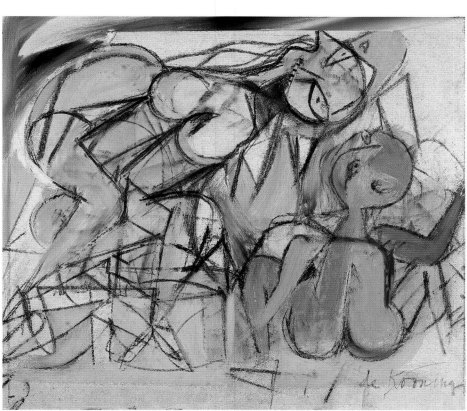

14 *Pink Angel*, 1947,
oil on paper, 29.2 × 33 cm.
Private collection.

Nature has loaded human anatomy with mirroring and reversal. We might argue that de Kooning was merely following nature's indications. Yet there is more to the situation.

The uncertainty of the drawing *Woman* corresponds to the uncertainty of natural appearances. Beyond the fact that the posture held so tentatively by this figure suggests that it might turn either to the front or to the back, we realize that de Kooning's hand has turned the figure and might as well turn it back again – nothing has stabilized, including the artist's own response. To become familiar with de Kooning's art is to accept extremes of tentativeness as his desired state. At the figure's right side, a curving thigh, extending back into space, bends at a knee, linked to faint lines that extend downward, as if indicating a leg. At the left side, a single, broken diagonal indicates the corresponding thigh; and below it, beneath the *J*-form of a buttock, a hand-like foot emerges (compare de Kooning's rendering of two hands in proximity to the figure's head, one with fingers extending upward, one with fingers extending to the right). The figure's head, like the head of the 'child' at the right of *Pink Angel*, might be turning from back to front or from front to back. If this head were already in place when de Kooning decided to eliminate the figure's breasts – converting a torso-with-breasts-and-vulva into a back-with-spine-and-buttocks, changes in the perspective of the head would not necessarily be required. Each feature of the body has assumed so many aspects that issues of consistency and correspondence fail to apply. We can discover either consistency or inconsistency as a result of comparing the anatomical parts. Take your choice.

The combination of perspectives within a single rendering evokes the art of Pablo Picasso and, more generally, what critics called late-cubist practice (see below, 'Cézanne'). Along with others in the New York School, de Kooning acknowledged Picasso's mastery, learned from his example, and sought either to better him in some respect or at least to circumvent his achievement. Like his colleagues, he feared that his own practice would be lost in Picasso's shadow. Picasso, de Kooning said, was 'the guy to beat'.[98] He nevertheless remained close to Picasso by devoting so much energy to representational motifs as opposed to 'pure' abstraction: 'I don't really feel like a non-objective painter at all', he said in 1960.[99] During the 1930s, when the issue may have been more acute, Picasso had expressed a similar sentiment: 'There is no abstract art. You always need to begin with something. Then you can take leave of all likeness to reality.'[100] As much as the contortion of anatomy and distortion of standard features visible in a de Kooning may resemble analogous elements in a Picasso – heads with one eye turned vertically, the other horizontally, would be an obvious point of comparison – a phenomenological distinction can be made. For de Kooning, the various

turns occur as possibilities created through the act of drawing. They have a material foundation in a hand's physical manipulation of marks on a surface, as if the artist were wrestling with graphite, pastel, oil and paper as resistant, alien substances. De Kooning's graphic medium was anything but neutral; he struggled with his drawing and painting rather than with the appearance of his model. The turns of Picasso, to the contrary, occur as possibilities in visual conceptualization. 'Vision takes pleasure in what surprises it', he said, referring to discovering strangeness in things observed.[101] When Picasso took 'leave of all likeness' to the human body, he was still assessing ways of rendering his perception of its features. He would draw the experience of seeing the body, or of touching it; but he was not assigning primacy to the experience of touching his own pictorial surface.[102]

When applied to Picasso, this is a tenuous distinction, not to be set in stone. In certain respects, what I have just claimed seems incorrect. Picasso was a sculptor with paper and canvas and could be just as physical as de Kooning when he impressed marks into his chosen material, bending it to his will. If the object of my comparison were an artist other than de Kooning, I would describe Picasso in a manner more in accord with de Kooning. My distinction has no absolute validity. Like de Kooning, I want to make a statement: his is inventive, mine is interpretive. But such a distinction cannot be sustained; I need to avoid any generalization that would falsely stabilize what ought to remain loose. If de Kooning managed to dodge the long shadow of Picasso, it was because he caused a difference to appear. He did it by transiting his feeling, passing from visual sensation to tactile sensation. At the expense of whatever model he was viewing or imagining, he stressed the nature of his drawing. We cannot verify the logic of a de Kooning figure by returning to the model to determine what corresponds to what. To state the matter more accurately, de Kooning drew by putting his drawing under the same stress he experienced in his body, the stress of sensation. Throughout the process, he respected how the pictorial surface felt to him; it had a certain amount of extension (up, down, across), and the plane was flat. He would allow a represented body to become compressed: front to back, back to front – flat.[103]

Not always, but at least in 1956, Picasso made clear his desire to defeat the kind of planarity that interested de Kooning (as well as others, not only in New York but also in Europe, such as Jean Dubuffet). His statement came in conversation with Alexander Liberman, one of de Kooning's American contemporaries: 'The problem is how to pass, to go around the object and give a plastic expression to the result. [My work] is my struggle to break with the two-dimensional aspect.'[104] De Kooning would go across; he would transit or transition. Picasso would go around. 'To go around' a figure in his way would

involve a tactile memory of the experience of objects. Yet Picasso aimed to convey this spatio-temporal passage as a single, integrated visual image. How would he proceed? A drawing from 1941 (illus. 15) represents the front of a figure observed from behind. To Picasso's eye, such a rendering involved none of the insecurity, none of the ambiguity and tentativeness of de Kooning's *Woman*, with its shift from front to back – breasts you see, breasts you no longer see (almost). To the contrary, Picasso causes everything to show at once. His drawing indicates hair at the pictorial centre of the model's head, with side-profile and lost-profile views of the face to the left and right respectively. To judge by the position of the figure's raised left arm, she is reclining, resting her head against the arm. Just as the two sides of her face – anatomically accessible to touch but not to ordinary visual experience – have been rotated around to the front, so her left breast has been rotated from underneath her torso to be

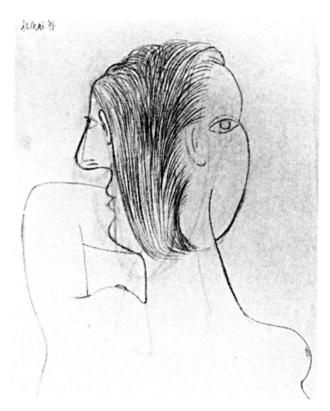

15 Pablo Picasso, 'Study for *L'Aubade*: head of a woman with double profile', 20 May 1941, pencil on paper, 27 × 21 cm. Musée National Picasso, Paris.

revealed as another form in profile along her shoulder. A protrusion at the right of the figure doubles as the second breast and second shoulder. Picasso pictures the model in full volume, even though most of the standard features, because they occupy a body's front side, ought to have been unavailable to this view from behind. In acknowledgement of his force of control, Picasso stops upon achieving a complete representation. This is no 'I just stop'.

If de Kooning – beyond merely distinguishing himself from Picasso – in some respect bettered his nominal better, he did so by preserving a greater degree of phenomenological immediacy within his practice. Picasso had little cause, little interest, in doing the same. If de Kooning's art profited from this immediacy, its lack was no loss to Picasso's. One artist had an urge to do and undo interminably, the other to finish.[105] The personalities of the two were different, and their interests diverged. I should not be comparing them. To some extent, however, each compared himself to the other. Supposedly, when Picasso first viewed photographs of de Kooning's work – probably shown to him some time during the 1960s because de Kooning, recognized for his images of women, was Picasso's counterpart in this regard – the older man dismissed what he saw from his competitor as 'melted Picasso'.[106] The response need not have been as negative as this. Neither artist had a penchant

for theorizing, but some of Picasso's remarks recall de Kooning's: 'Ideas are no more than simple departure points', he told his friend Brassaï during the 1940s; 'it's rare that I'm able to get them down as they come to mind. As soon as I start to work, others flow forth from my [drawing] pen . . . To know what you want to draw, you have to begin [the process of] doing it.'[107] Just do it, Picasso said, as if to invoke de Kooning's notion of painting so fast that there exists no time to think, no time to form habits. Do something, and inspiration will come. No preset standards, no styles demand adherence, not even your own style. Given materials, hands do much of the thinking.

Do I now push Picasso too far in the direction of de Kooning? Some of Picasso's other reflections are equally de Kooning-like. When interviewed during the 1960s, he remarked: 'Style is often something that restricts the painter to a single vision, a single technique . . . You see me here and I have already changed, I am already elsewhere.'[108] To this, compare de Kooning in 1968 and 1971: 'You can't build an aesthetic beforehand. . . . I can change overnight.'[109] These are hardly unusual thoughts on the part of twentieth-century minds. Artists tend either to constancy (I have my own style) or the opposite (I have every style, I have no style: the de Kooning type). More interesting is the fact that the two painters shared a sense of gender in pictorial flux. Picasso, sometime during the 1940s: 'If a man comes forth, I make a man . . . If a woman comes forth, I make a woman.'[110] Here his words suggest de Kooning's capacity to transit gender – if I may put it so – to pass over gender in the way that a masked edge allows passage or transition between two conditions that should have little or nothing to associate them so closely. 'There isn't so much difference when you paint between a man and a woman', de Kooning said in 1970, approaching the matter objectively, reducing it to a principle.[111] He had been more subjective in 1967, and perhaps a bit facetious: 'You can't always tell a man from a woman in my painting. Those women are perhaps the feminine side of me – but with big shoulders.'[112] And all the more subjective in 1975: 'Many of my paintings of women have been self-portraits. I never thought very much about what sex they were. They look more like men because they're colossal. They have big shoulders and the stature of a man.'[113]

Title

Should a man's self-portrait in the form of a woman bear a correspondingly specific title? Matching the significance of de Kooning's titles to the significance of his subjects often yields little reward. In many instances, the titles are generic, indicating no more than the nature of the representation in the

broadest sense: *Woman*. To my knowledge, there is no *Woman Self-portrait* or *Woman as Self-portrait* or any other title that might capture de Kooning's perception of his male body as related to his images of Woman ('big shoulders . . . the stature of a man').[114] In his oeuvre, a picture titled *Two Women* – for him, a very common designation – depicts two women, no metaphors or ironies involved. For paintings made during his mature years, he only occasionally used a live model. This was far more likely in the case of drawings, from which many of his paintings derived.

With certain exceptions, the titles that de Kooning's works acquired, by one means or another, are either quite literal or quite arbitrary. On the literal side, *Two Women* will apply even when one of the women is a mere representational fragment, as in the painting *Two Women* of 1964 (see illus. 69). Here, one figure is complete but the other appears as an inverted head in the upper left corner of the rectangular format, as if it were a small part of a missing composition oriented in the opposite direction. Apparently, this extra head was sufficient for de Kooning, or someone else, to regard the painting as of two figures, not just one figure supplemented by a leftover fragment. The title is generic, literal and unrevealing. In another curious case, a title appears to have changed in order to correct a mistaken identification. A drawing that bears de Kooning's handwritten inscription 'Charleston Pose' reveals underneath this title an erased, but still visible inscription in the same style, 'Fox Trot Pose' (illus. 16). The figure in question, with crossed arms and oddly positioned legs, may actually represent a woman sitting in a chair;

16 *Charleston Pose,* 1969, pencil on paper, 45.6 × 60.8 cm. Collection Jasper Johns.

displayed vertically and lacking the chair, she appears to stand and, given the arrangement of her limbs, she 'dances'. If she is indeed dancing, the performance ought to be named. Either de Kooning or a friend thought of the foxtrot; after this initial identification, someone else must have recognized the Charleston in the figure's crossed arms. So de Kooning made the correction. It was all the same to him, one dance or another. He would have considered any suggestion of dance movement in a seated figure to be far more intriguing than the formulaic differences between the various dances. His interest was in bodies, even trivial details of bodies, but not cultural trivia.

At times, because of happenstance negotiation, a more pointed, yet arbitrary title might replace a neutral, generic one. This was the situation in the case of *Attic* of 1949 (illus. 11; see also 'Accident'). Many of de Kooning's paintings of the late 1940s are portraits or images of the human body, as we might expect. There are also 'abstractions'. Of what? The rather indecipherable look of *Attic* is common to de Kooning's works of its time. It leaves an overall impression of organic, gestural abstraction, even as it yields traces suggesting that it developed from a base in representational figuration. The lower left quadrant contains what appear to be remnants of a seated, twisted figure, and a head-like form faces upward at the left centre. This can be imaginatively linked to shoulder- and breast-like forms just below it. Still farther down toward the baseline of the canvas, angled and curved lines evoke buttocks, which complete the (now absent) figure of a woman, one of at least three, and perhaps four or five figures that might have filled out the horizontal format in an initial stage of composition. To judge by other paintings of the time, de Kooning is likely to have used additional representational elements, such as features of his studio environment, to complement the figures and fill the surface. He rendered details of this sort schematically with a caricaturist's touch: a chair, a window, an architectural corner, a hat. Typically, his forms were too ambiguous to be associated with a unique item; and often they became so displaced from a legible context that viewers would doubt the presence of any representation at all. When the moment came to title this painting for exhibition, de Kooning thought of 'Interior', as if its animated forms were depicting the material life of his studio, which is probably where these forms originated. Elaine de Kooning considered his suggestion uninspired and asked instead for a specific room. This spurred de Kooning to think of 'attic, because you put everything in it' – things, bodies, representations, abstractions, the paint itself.[115]

In certain instances – far more the exception than the rule – de Kooning's subjects and titles match (or profess to match) with full specificity, leaving the impression that he began the work with a particular experience in mind, reflected by the associated words. 'I want to grab a piece of nature and make

it as real as it actually is', he told Irving Sandler in 1959, at a time when he was trying to break his existing thematic habits, especially his Woman habit. The result was a set of extraordinarily broadly brushed abstractions that in de Kooning's terms were representations, even if no particular stroke corresponded to any particular vision: 'like in my Merritt Parkway picture', he said, referring to the work by this name, *Merritt Parkway* of 1959 (illus. 17). It took its title from the scenic highway leading New Yorkers to the Connecticut suburbs and countryside. 'How the hell can you paint the Merritt Parkway – a ribbon of gray in green and it stretches for miles and miles. Then in the Fall when the colors change, it's positively crazy. For years I had an idea of it, and then I painted it, and it is real.'[116] Real in what respect? If *Merritt Parkway* resembles the Merritt Parkway during the green season – its palette is green, blue, yellow, orange-brown – then *Montauk Highway* (Long Island) and, despite the title, *Suburb in Havana* (Cuba), two paintings of the *Merritt Parkway* type from the previous year (illus. 18, 19), must look like the Merritt Parkway during the brown season, 'when the colors change'. The two 'landscapes' from 1958 have the palette of *Merritt Parkway*, minus its green.

We have to stretch our minds to keep de Kooning's thought from lapsing into contradiction – his having 'an idea of it', then 'paint[ing] it', then discovering 'it is real'. The antecedents for the three instances of *it* are ambiguous. We can make sense of this thought, but just barely and not without a degree of ambiguity persisting. Imagine that de Kooning was making the painting he would call *Merritt Parkway*; at some point, either after stopping or along the way, he was struck by some factor of resemblance to his experience of the particular roadway in Connecticut. Could Long Island's *Montauk Highway* have just as well been *Merritt Parkway II*, or *Merrit Parkway, Autumn*? Despite the difference in terrain, this is plausible, given that an extremely loose quality of resemblance appears to justify the titles of these 'landscape' works, most of which occupy a vertical format rather than the more conventional horizontal. The titles could have been otherwise but are not. For de Kooning, the Merritt was the Merritt, and Montauk was Montauk, even though anything can resemble anything. It hardly mattered one way or the other.

By insisting on a 'landscape' reference, whether specific or merely generic, de Kooning's primary interest at the time was to ensure that he would not lapse into Woman – that he did not become a victim of habit, that he could change. Yet, how certain could he be of an anatomical or landscape identity? He had already disabled the conventional semiotics that would differentiate a horizontal landscape from a vertical figure; in his imagery, orientation signalled little of certainty. Both earlier and later, there are

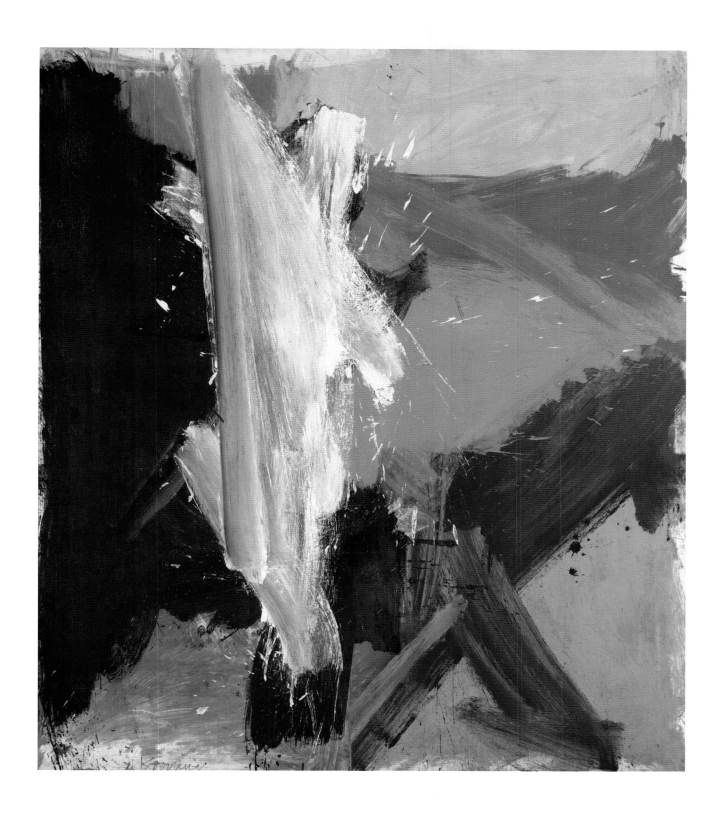

17 *Merritt Parkway*, 1959, oil on canvas, 203.2 × 179.1 cm. Detroit Institute of Arts.

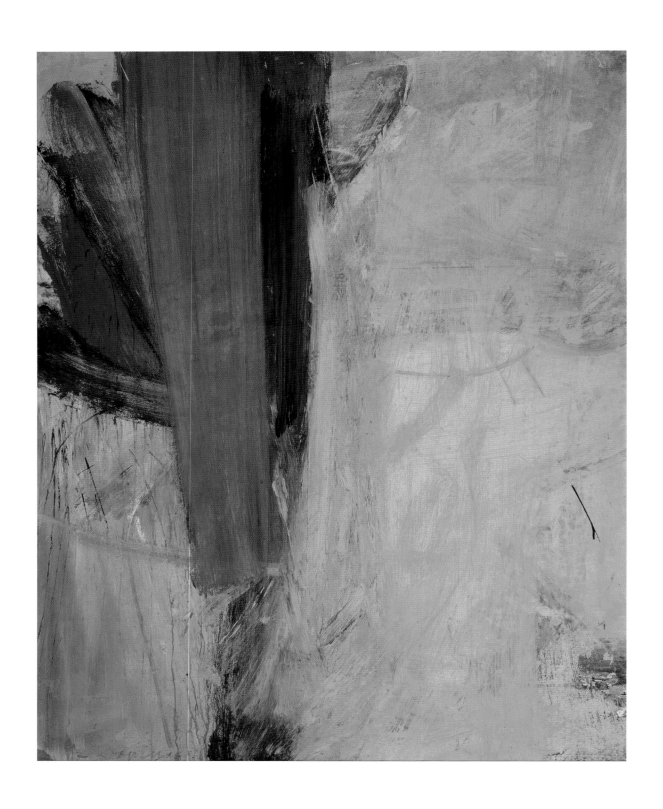

18 *Montauk Highway*, 1958, oil and combined media on paper mounted on canvas, 149.9 × 121.9 cm.
Los Angeles County Museum of Art.

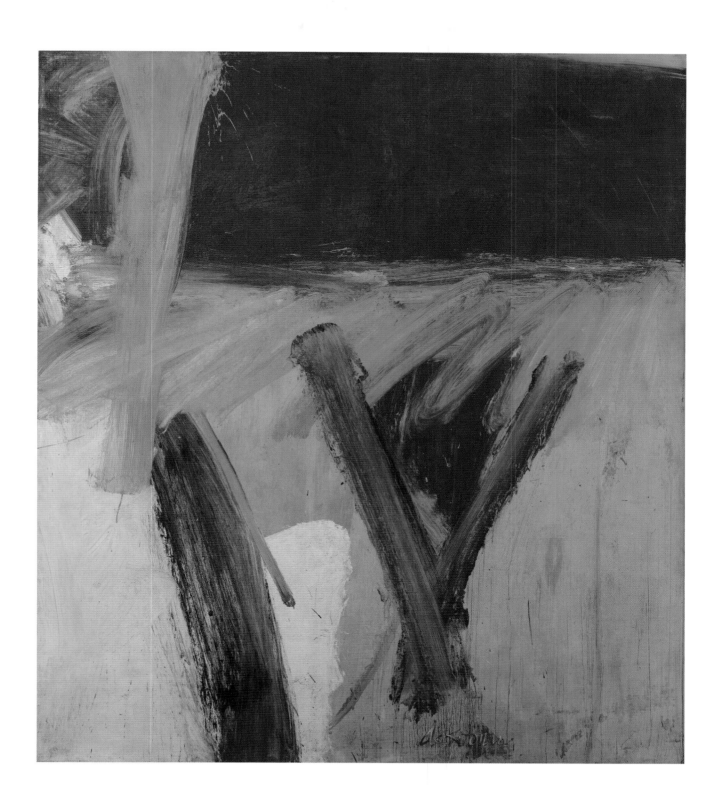

19 *Suburb in Havana*, 1958, oil on canvas, 203.2 × 177.8 cm. Private collection.

combinatory titles such as *Woman as a Landscape* (1954–55) and *Woman in Landscape III* (see illus. 82). These works may represent moods unrelated to the late-1950s moment of *Merritt Parkway*, and their signs of human anatomy are clearer than any suggestions of landscape. Yet we cannot be certain of the degree to which de Kooning thought differently at different stages of his career; and it may be wrong-headed to apply a notion of stages, with its implication of progressive development. He had a way of undermining chronological distinctions. In 1953, when he would seem to have been absorbed in creating pictures of the body, he told Hess that *Woman I* (see illus. 37) reminded him of a landscape, 'with arms like lanes and a body of hills and fields, all brought up close to the surface, like a panorama squeezed together'.[117]

If de Kooning's titles sometimes developed into what he, at least at a certain moment, regarded as confirmation of a specific sensation associated with a specific place – for *Merritt Parkway*, the way the changing sensation extended 'for miles and miles', at once the same and different – at other times the connection of title to sensation began and ended as an abstraction, an arbitrary functional exercise. In March 1965, at the Paul Kantor Gallery in Los Angeles, de Kooning first exhibited imprints on sheets of vellum and newspaper. These derived from the series of images of Woman he had been developing during the previous year in his new studio in Springs (a community on eastern Long Island, adjacent to the Hamptons). Either he or those around him made an arbitrary decision to title the works on vellum generically. For example, two different works illustrated in the gallery catalogue have an identical designation: *Woman*, 1964. In contrast, the imprints on newspaper received unique titles. These consist of single words or phrases that remained visible near the margins or corners of the newsprint sheets as they became laden with paint: *Big Gains* (illus. 20) derives from 'Big Gains Scored by Carolina Klan', a column heading at the upper left corner of the corresponding monotype; *Grand Opening* derives from 'Grand Opening: New Korvette Stores', an advertisement at the right margin; *Summary* derives from 'Summary to Date', at the right margin, but sideways; *French Wire* derives from 'French Wire Shapes the Bra for Fit', advertising text at the upper left (presumably more interesting than the news column title above it, 'Williams Leads Delaware Race', though 'Delaware Race' might have worked just as well as 'French Wire' as a phrase in isolation); *High Point* derives from a phrase visible at the top margin of the monotype it names; *Eddy Farm* belongs to an advertisement at the lower right corner, but sideways; *Section 10* is visible at its upper right corner; and so forth.[118] In the case of *Belle Bay*, the primary support for this complex imprint is vellum, but the 'head' of the figure consists of newspaper collage; and 'Belle Bay' appears prominently, though sideways, at the upper left corner of the applied fragment.

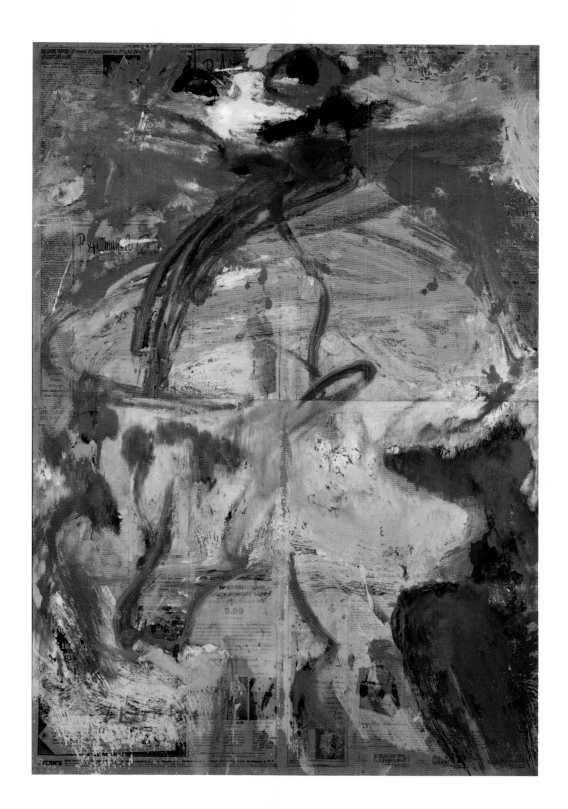

20 *Big Gains,* 1964, oil on newspaper with collage, mounted on board, 114.3 × 76.2 cm. Private collection.

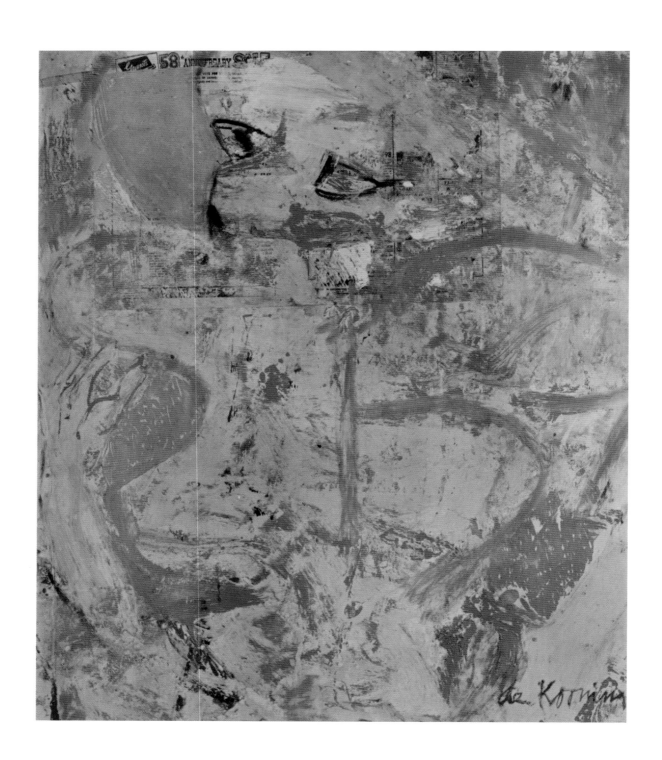

21 *Anniversary*, 1964, oil and collage on vellum, 101.6 × 88.9 cm. Los Angeles County Museum of Art.

When isolated from the newsprint ground, certain arbitrary titles might seem less indexical and more metaphoric than they were intended to be. In such instances, interpretation strays from the conditions of production. The imagery of the monoprints of 1964 is unambiguously of Woman, corresponding to the theme occupying the artist at this time. Yet, with the reversal, fragmentation, and attendant blurring of the imprint, the specific form of Woman, with all its material distortions, may come as something of a surprise. Titles like *French Wire* or *Section 10*, applied to images of this type, mark a break in the expected logic of production: if these images remain representational, the titles should refer to this condition. Of course, the titles in question do refer, but not to figuration. Instead, they signify an existential link that fills a gap in discourse. Just as the image, as a counterproof, repeats certain features of its configured source, the title repeats certain features of the text printed on the material support of this same image. Image and title do not refer to each other but establish parallel lines of signification. For example, the title *Anniversary* derives from the printed advertisement at the upper margin of its rectangle: '58th Anniversary Sale' (illus. 21). Despite our awareness that the title may have been applied not by the artist but by those arranging the Paul Kantor Gallery exhibition, we nevertheless think first of a wedding anniversary or some other commemorative or celebratory event. A commercial 'anniversary' at an unrelated location would seem beside any narrative or thematic point.

Even with consciousness of the source as an advertisement, our temptation is to consider the title *Anniversary* as a pun and to project a double meaning in preference to no meaning.[119] Interpreters need meaning. Perhaps the temptation is irresistible when studying de Kooning, because doubleness always held an attraction for him. But so did nothingness. Comfortable with twos and zeros, it was the possibility of one – the single meaning, the definitive solution, the instance of permanence or fixity – that would spark de Kooning's anxiety. 'There is no plot in painting', he told Rosenberg in 1971. 'It's an occurrence which I discover by, and it has no message . . . Yes, I have no message. My paintings come from other paintings.'[120] The context indicates that here the 'other paintings' were reproductions in art magazines. In the case of the monoprints, the 'other paintings' were de Kooning's own. And often he blotted a fresh monoprint back onto the surface of a painting in progress; this is how *Two Women* received its second woman (more on this painting to come, 'Unwhole').

Subject

In October 1948, curator Alfred Barr negotiated the acquisition of de Kooning's *Painting* (also known as *Painting 1948*) for The Museum of Modern Art, New York (illus. 22). The purchase factored into what, two years later, Barr himself called the 'sudden rise to fame' of this artist.[121] Along with several of de Kooning's friends – in particular, the critic Renée Arb – his dealer Charles Egan had been lobbying to encourage Barr's interest. Simultaneously Egan struggled to convince de Kooning that his art had matured to a level meriting increased public attention.[122] Many of de Kooning's paintings of this moment were – or at least looked as if they were – examples of abstract art, which Barr, given his curatorial inclination to set aesthetics in order, regarded as a natural outgrowth of earlier twentieth-century modernism. It was as if de Kooning had a place in the history of modern art already reserved. He had only to step into it.

Yet Barr's comprehension at this point must have been skewed, for de Kooning had been painting recognizable images of women and other figural works along with those canvases lacking readily discernable representation. The artist and his dealer had decided to present his work during spring 1948 with a group of black-and-white paintings that were among his most 'abstract', as abstraction was then understood. Providing no titles, an advance notice of the exhibition reproduced two paintings of 1947 (now known as *Bill-Lee's Delight* and *Orestes*), commenting that 'the personal progression of [de Kooning's] style has been marked by an increasing abstraction.'[123] So the intended message, or some version of a strategy, was being broadcast to the public. According to de Kooning, a narrow selection had been the only possibility: 'Your first one-man show can't look like a mini-retrospective; it has to be one state of mind and have a unity of style.' Titles for his as yet untitled black-and-whites were determined by the artist, the dealer, and Elaine de Kooning, who was a skilled writer and as clever with words as her husband – both knew how to pun, how to obfuscate, how to benefit from deadpan. By the rules of their game of titles, a nominee would be elected only if receiving a unanimous vote.[124] This was the first of a number of 'picture-naming parties' that de Kooning held shortly before exhibitions.[125] Apparently, the informal committee of three in 1948 left *Painting*, the largest work in the Egan exhibition, unencumbered by words. 'Being untitled increased its impact', Arb later commented.[126] She chose this work to illustrate her *Art News* preview of de Kooning's show.[127] Lack of a title did not motivate her choice of *Painting* at the time, yet this feature may have subtly distinguished it as the one work that either needed no explanation or could have no explanation.

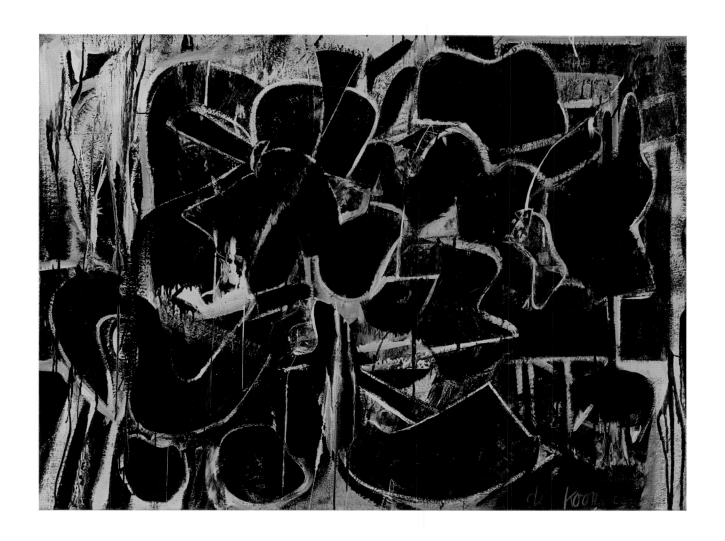

22 *Painting*, 1948, enamel and oil on canvas, 108.3 × 142.6 cm. The Museum of Modern Art, New York.

Whatever the case, Barr decided to acquire *Painting* for MOMA; and in early October, with the work present in the building (probably in the room) during a conference of experts on modern art, Greenberg used it to make a rhetorical point about the humanistic value of abstraction. Lack of explanation became a positive factor. Greenberg argued that such a painting was charged with feeling of the most affecting kind: 'The emotion in that picture reminds me of all [serious] emotion. It is like a Beethoven quartet where you can't specify what the emotion is but are profoundly stirred nevertheless.'[128] Greenberg's point received tacit support from the title, *Painting*, which bore no meaning save a tautological one. As meaning, or even as subject, Greenberg too suggests nothing. He lacked a theory that would have differentiated any one of de Kooning's abstractions from the others, except by formal description, which was not enough to arrive at a psychological generalization. He may have realized that in this instance his limited insight corresponded to critical restraint and avoided trouble. Had Greenberg linked the painting to a specific emotion – hard to avoid if the work had had an expressionist title like Edvard Munch's *Cry*, or a referential title like Picasso's *Guernica*, or a title with the appearance of reference like de Kooning's own *Black Friday* – he would have prevented others from responding directly to the image before them. Commentators continue to be caught in the verbal snare. In 2004, a writer referred to 'the melancholy *Dark Pond*', one of the black-and-whites, which is neither more nor less melancholy than de Kooning's other paintings in this manner.[129] Here, the title determined the feeling, blinding the writer to whatever might be more specific to the image.

A verbal interpretation of feeling interferes with the experience of feeling; it becomes a conceptual instruction for viewing the source of stimulation. If words have been applied to a picture and this is known, then the conditions of viewing have changed. Of course, many factors, not only words, change the conditions of viewing. But the point is this: when we know in advance the feeling that a work should be generating – or when we have an easier, rival path to interpretation, such as a title that identifies meaning – we are unlikely to have the feeling in its full, specific intensity. What should be a relatively passive experience – we bring ourselves before the work, but the feeling happens *to* us, we are its object, we suffer it – becomes instead an active experience. We master the feeling by interpreting it in advance of ever feeling it. Even a poetically charged, mystifying title can be counterproductive in this way. Paul Gauguin was fully committed to sensation: 'Emotion first! Understanding to follow', he said.[130] He referred to creating his paintings 'by fantasy' and would 'find the title long afterward'.[131] In certain cases – they are the minority of Gauguin canvases – titling was not an arbitrary game but an investigation into verbal aesthetics parallel to the art of line and

colour. In a kind of magical turn, Gauguin's verbal title would express his visual experience with utter completeness. This type of evocative title – *Where Do We Come From? What Are We? Where Art We Going?* – becomes the most authoritative guide to looking, even if not literally descriptive. And this, potentially, is its drawback. We concentrate on the feeling or mood that the cryptic title evokes, which becomes an identifying concept for the picture, existing between us and the image. We are left to judge whether we are experiencing and have experienced what we now believe we *should* experience.

Attending to titles, we abstract the feeling, inverting what Greenberg took to be the purpose of de Kooning's *Painting* as a distinguished example of abstract art. Abstraction was supposed to make feeling concrete, not abstract. Among its supportive critics, this was their theory. More often than not, to judge by the verbal response, the theory failed. Yet we have no way of knowing whether a theory that posits form (sensory stimulation) as the primary force affecting feeling is correct. Whom would we ask? The more an individual viewer tells us, the further from experience we get. If the proof must come in having people articulate their experience in words, the best answer may be Greenberg's non-answer: 'You can't specify what the emotion is.' Some find this answer helpful; others do not. Gauguin, who had instincts as good as anyone's with respect to presenting feeling in pictorial form, tried to coordinate the forms with words that he found equally emotional – a poetic rhetoric, not expository prose. It remains a vexed question.

One of Greenberg's colleagues at the MOMA meeting in 1948, James Johnson Sweeney, a former curator at the museum, was slow to come around to Greenberg's position on de Kooning, if he did at all. His response is unclear. His instinct was to look for representation, even without a title's words to guide him. Viewing *Painting*, he offered this: 'I feel that it may be a crowd, a group of heads. It may not be.'[132] Sweeney seems to be juggling alternative representational possibilities in his imagination. But would the psychological feel of discerning a crowd – or a hill of ants – be different from ignoring the call of representational reference entirely, discerning only the turns of black and white in this painting, representing 'nothing'? Apparently, Greenberg thought that the two emotional experiences were distinct. The desirably deep feeling ought to be felt in visual form as the artist himself had sensed it, feeling his way through it, exercising both visual and tactile sensibility. Ironically, de Kooning's abstractions of 1948 did have a basis in representation, but this is a different issue, yet to be explored. Eventually, once Greenberg began to ponder the matter of figuration in de Kooning, it lowered his opinion of the artist's significance. One of the most level-headed, even-handed responses to the issue came some years later from a journalist: '[de Kooning's] real subject is the aesthetic sensibility as it responds to the shock of the beautiful

buried forms and rhythms in the objects and processes of the world . . . He has never been exclusively an abstract or figurative artist.'[133] 'Shock' was the true subject.

In April 1950, about a year and a half after Greenberg and Sweeney exchanged thoughts at MoMA, Barr moderated an artists' forum that included de Kooning and asked of him: 'Do you think it is possible to enrich the painting by words?' De Kooning replied in character, with a nearly indecipherable answer: 'I think that if an artist can always title his pictures, that means he is not always very clear.'[134] De Kooning seems to be saying that if an artist thinks there must always be some equivalent in words to what has been painted, this is a tactical error. Such an artist will merely introduce a further layer of ambiguity by using a title; titles do nothing to remove the inherent ambiguity of the form. This is the implication: if you do use titles – as de Kooning, in 1948, used them for works exhibited at the Egan Gallery but not necessarily otherwise – then use them with the understanding that you increase ambiguity rather than clarify meaning. A comment de Kooning made in 1960 can be misleading with regard to this attitude toward words, naming and meaning. When asked about the importance of establishing a representational theme for his painting, he replied: 'The very fact that it had a word connected with it – "figure of a woman" – made it more precise. Perhaps I am more of a novelist than a poet; I don't know; but I always like the word in painting.' With his metaphor 'the word in painting' – an implied analogy – de Kooning invoked a specific object, explicitly indicated, a kernel from which a painting might grow. He would work with something specific, just as a novelist would use a proper name to designate a specific character, or a particular word to name an object of significance to the story. The novelist's word contrasts with the poet's word, which is amorphous. De Kooning was saying that he liked to begin a painting with something concrete and entirely ordinary – 'I am very happy to see that grass is green' – though he typically moved on to ambiguity, to an open range of feeling and sensation.[135] Green grass, greenness, was his point of specificity, his 'word'.

A decade later, de Kooning referred back to his metaphor, which had appeared in several publications during the 1960s. He was clarifying his position on starting a painting with concrete clarity. More in line with his inclinations, he was registering a change of mind: 'A novel is different from a painting. I have said that I am more like a novelist in painting than like a poet. But this is a vague comparison' – he hedges his former position – 'because there is no plot in painting. It's an occurrence which I discover by, and it has no message.' I quoted this passage in a somewhat different context above ('Title'). We now have a context for de Kooning's metaphoric use of *plot*. He needed to backtrack on his statement about the novel because the

plot of a story is its order, the bearer of its message. His painting has no plot, no order, he says: 'Yes, I have no message.'[136] But this statement too must prove metaphorical. It hardly need be mentioned that denial, negation and absence all send a message.

What can be done about titles, the subjects they indicate, the meanings they project? Do they interfere with sense? We cannot deny that titles work wonders with respect to taking inventory, compiling indexes, and the like. Nor can we blame verbally adventurous people for playing with titles by attaching them to works of art capriciously. The existence of titles licenses imaginative interpreters to play on their own, invoking meanings drawn from the abundant web of cultural discourse that beckons. No context is sufficiently rigid or tight to establish definitive meaning. The titles attached to the works in de Kooning's 1948 exhibition – even the non-designation *Painting* – were decidedly arbitrary and capricious. Each came after the fact of the painting, never as a theme to be addressed.[137] But they became, and they remain, suggestive in a literary sense. *Light in August* (illus. 23) alludes to William Faulkner's novel, and perhaps we also think of the atomic bomb dropped in August 1945.[138] Bearing all manner of auxiliary reference at the time, the 1948 titles tended to weaken any interpretive conclusion that de Kooning's form of abstraction was pure abstract art, that it made no reference whatever. Most likely, this was as he wished it. He was avoiding a formalistic absolute. As interpreters, we should avoid passing from the sense (or sensation) of form to a sense that the conceptualized meaning must be paramount, as if a rule of either-or were in force.

The natural response of an interpreter is to ponder a title when it seems other than generic and perfunctory. A scholar writes: 'Presumably de Kooning would not have used the title if it had nothing to do with the painting or its subject matter, whatever that may be.'[139] Well, presumably, but perhaps not. Rather than identify a single origin for each work or a proper emotional resonance, de Kooning's titles – more precisely stated, the titles of his works, which may or may not be *his* titles – often establish a contrary direction. They add further connotational slippage to the ambiguities of the mute visual forms, ensuring that debate over the 'meaning' of the work extends into a boundless interpretive future. This type of analysis quickly becomes self-absorbed, a self-sustaining mental exercise. It distracts from the sense or feel of de Kooning's work rather than heightening it. Like other forms of language, when the title is the primary, not the secondary or subsidiary medium, and when the words speak as a text rather than merely point as an index, they introduce interminable difference into the sense – a set of differences in both sensation and meaning. From the very start, the visual and kinaesthetic feel of de Kooning's works, along with their emotional affect, seemed indeterminate

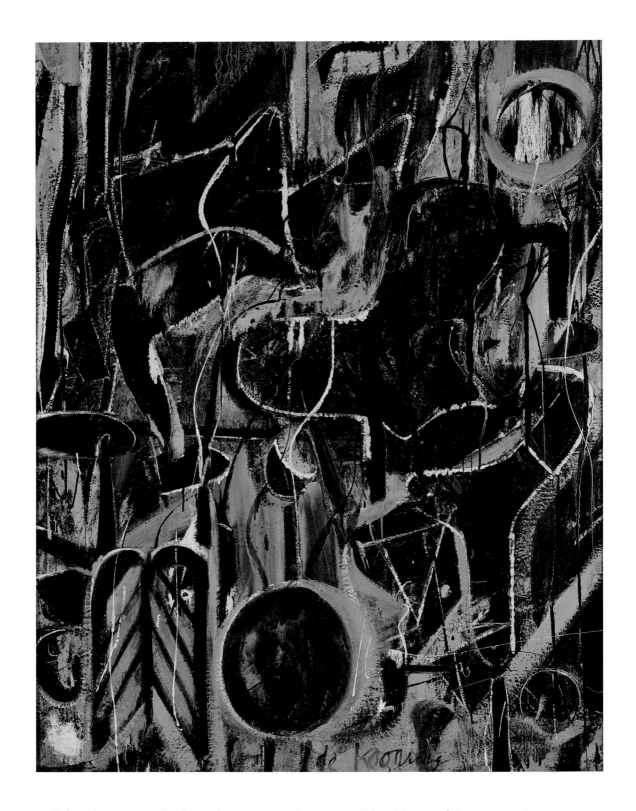

23 *Light in August*, 1946, oil and enamel on canvas, 139.8 × 105.5 cm. Tehran Museum of Contemporary Art.

and open – as the earliest commentators, Arb and Greenberg, implied. The literary sense of the titles also proved indeterminate whenever interpreters chose to focus on these evocative words.

Around 1948, then, de Kooning presented two lines of sense (visual and verbal) each without fixed sense (meaning) and not necessarily consistent with each other. He had no objection to a degree of consistency if conditions favoured it; no bias guided his choices, either for relevance or for irrelevance. *Valentine* (illus. 24) is an abstraction with a title that seems to make sense. The painting contains a pink heart-like form near its centre, sign of one's love for one's 'valentine'. Yet the composition also has the general configuration of a human figure seated in a chair, facing right to left within an interior environment. Another work of the late 1940s, *Figure* (illus. 25), has the same type of composition with a seated woman facing left to right. De Kooning's process may have converted a hidden 'valentine' into an indecipherable abstraction. So we have at least two possible frames of reference for the title, one rather overt, the other rather covert. And still we remain uncertain as to who was responsible for titling. The circumstances of acts of naming de Kooning's paintings, the number of people involved, their relation to the artist and many other factors in the causal history of how the names came to index the images – all this was extremely irregular.

When de Kooning was first becoming a public figure, few cared. The artist's initial viewers usually discussed other matters.[140] Titles only gradually became a concern as art historians began to operate at more rarefied levels of interpretation, ferreting out potential messages, the meanings hidden by the art or by the artist, to which they assumed the associated names and phrases must be clues. In search of meaning, interpreters also began to read the fragments of newsprint left exposed as transfer on the wet oil surfaces of paintings, as well as the bits of newsprint text remaining legible on the support surfaces of the many 'accidental monotypes'. In such cases, the putative message may be either overt or covert. However obscure the source, you cannot disprove a hidden meaning by failing to perceive it; it is, after all, hidden. But when some of the more probing critics of de Kooning's early exhibitions complained that he lacked a reasonable degree of coordination or synthesis of elements, they were not searching for meaning within his obscurity. The problem lay in the form and imagery rather than in the coherence of a defined subject or topic, a social allegory or literary allusion. There was more wisdom than evasion in Greenberg's response of 1948: 'You can't specify what the emotion is.'[141] Interpretive difficulty was the interpreter's problem. De Kooning himself might have regarded an element of incoherence or an utter lack of evident meaning as a valid critical observation, but hardly cause to lodge a critical complaint.

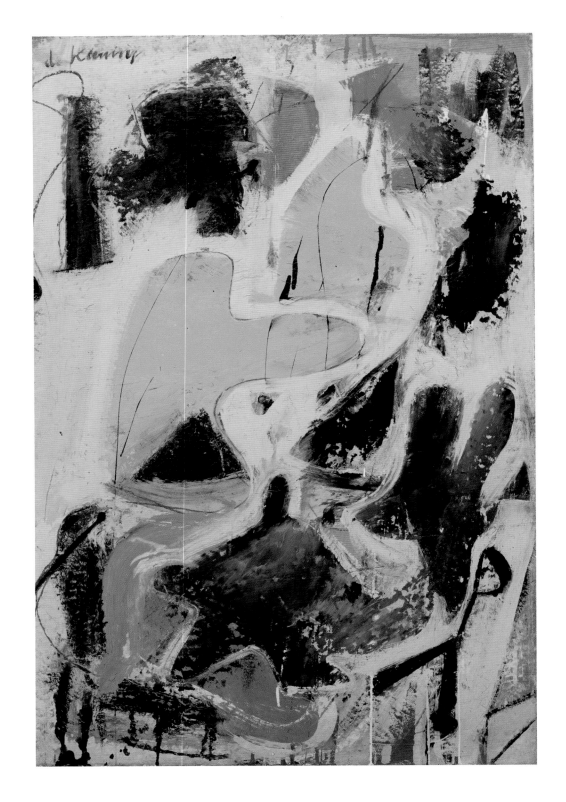

24 *Valentine*, 1947, oil and enamel on paper, mounted on board, 92.2 × 61.5 cm.
The Museum of Modern Art, New York.

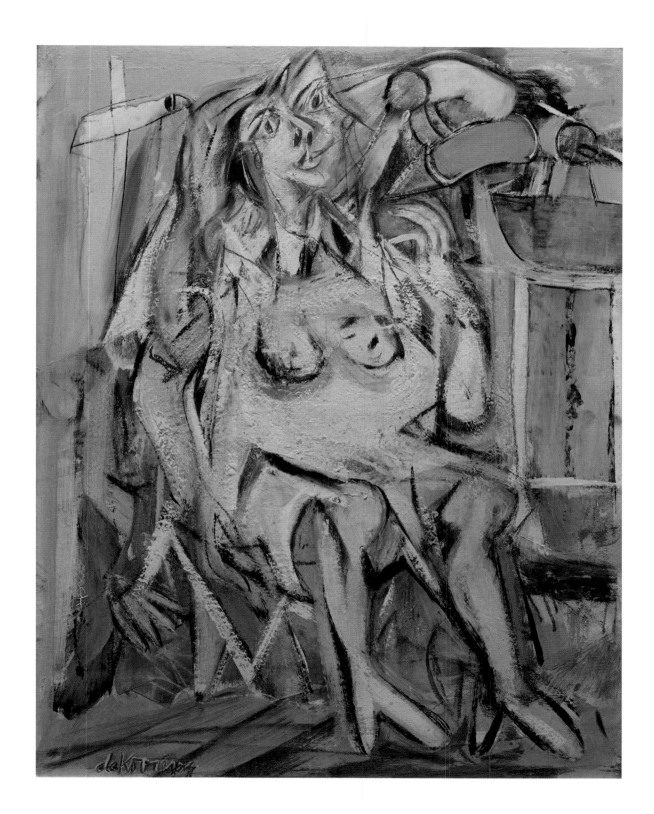

25 *Figure*, 1949, oil on cardboard, 46.7 × 36.8 cm. Cleveland Museum of Art.

Avant-garde

De Kooning's failure to impress certain critics, especially sophisticated ones, marks either his aesthetic and cultural success or his sincere resistance to success. My bias is to take this to de Kooning's credit, either way. Some of the more serious among the initial reactions to his art demonstrate that he remained on the edge of what avant-garde critics could tolerate. He genuinely challenged the sense of his peers, confounding both their reason and their sensibility. Their commentary often went astray, led along by their own rhetorical devices, which made little contact with the object of their description. Some, capable of better, let their observation lapse.

Manny Farber is an example. He reviewed a Sidney Janis Gallery exhibition in autumn 1950, 'Young Painters in the u.s. and France'. Like many artwriters, Farber was an artist himself – at that time, an abstractionist. He knew Pollock, Motherwell, and others of the New York School; he understood the materials and techniques of painting. Farber restricted his account of the Janis show to its American participants, to whom he attributed a collective 'speed fetish' according to the general look of their work. They would 'use every line and color as a speed-up connection in an endlessly linked journey over anonymous terrain'. Within the group, which included Franz Kline and Hans Hofmann, de Kooning was the first to whom Farber devoted an exclusive paragraph of critique. He referred to a 'maelstrom of black lines which lends a false excitement to a static, familiar composition'.[142] He was accusing de Kooning of posturing, a charge that a diverse group of critics would continue to make in the years that followed, as they complained that the painter grafted his gesturing onto clichéd topics and formats.[143]

For Farber, the specific painting at issue was *Woman*, 1949 (illus. 26), a type of image de Kooning was producing during the same period to which his black-and-white 'abstractions' belonged. (Oddly, the critic's description would have better fitted a nearly contemporaneous *Woman*, illus. 27.)[144] Farber drew an initial analogy: de Kooning's frontal presentation of a female figure at majestic scale suggested the iconic style of the early Renaissance master Cimabue. The comparison ignored the specific material character of de Kooning's surface. Yet Farber persisted by linking his two visual observations causally, the one compensating for the other: de Kooning had added his 'maelstrom of black lines' to resuscitate the 'static, familiar composition' of his female model. The compositional allusion to a Cimabue Madonna was an associative stretch to begin with, a generalization doing little more than demonstrating that Farber had an education in museum-grade art. But once it was in place, the 'excitement' that de Kooning generated

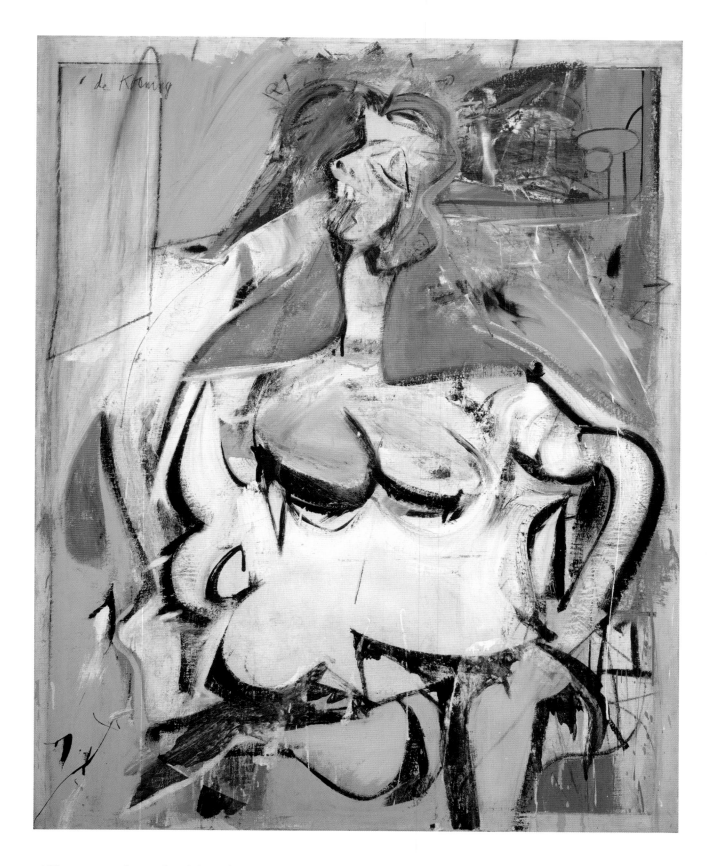

26 *Woman*, 1949, oil, enamel, and charcoal on canvas, 152.4 × 121.6 cm. Private collection.

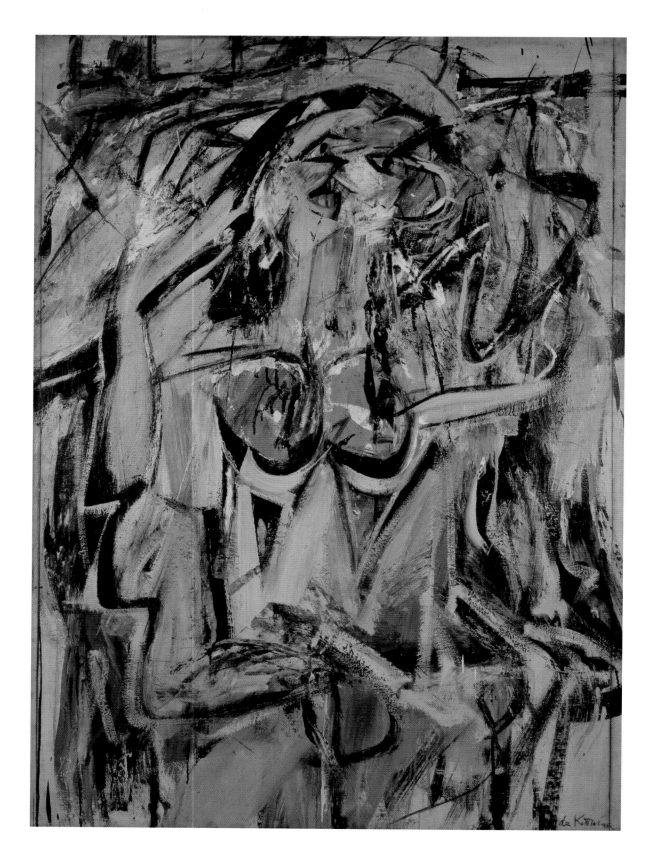

27 *Woman*, 1949–50, oil on canvas, 162.9 × 116.8 cm. Weatherspoon Art Museum,
The University of North Carolina at Greensboro.

could only be 'false' because Cimabue and a maelstrom constitute an
improper mix.

Farber's sense that de Kooning had pulled a fast one – the painter's
'too quick glib completion' – was self-induced. He experienced a de Kooning
sensation and, in a flash, conceptualized it. There are sense data, and there are
concepts that exist both before and after we sense. Do sense and concept pre-
serve a divide, even as they combine or intermingle in consciousness? I cannot
say that sense can be free of conceptualization, that we can know Peircean
Feeling in the way that we know Peircean Habit or even Peircean Sensation
(an active consciousness of one's feeling). But surely de Kooning's black lines
need not have been viewed through the metaphor of a maelstrom, nor did his
straightforward presentation of a woman's image, vague in its representational
details, need to conflict with his 'black lines' as something static against some-
thing agitated. Nothing about this figure is stable – it is not Cimabue, unless
you want it to be. An image has the meaning we bring to it, the meaning
we desire. An image is our satisfaction even when its sense lacks our approval.
This is its ruse. Farber needed more order than de Kooning was providing.
So he found this order in Cimabue, imposed Cimabue on de Kooning, and
then noted the dereliction of Cimabue in de Kooning's black lines.

De Kooning was hardly one to be concerned with resolving matters
as a quick completion. If he had a speed fetish ('to paint so fast you couldn't
think'), it applied to details, not the whole.[145] Our collective habit is to
distinguish the thematic subject – in this case, Woman – from the perceived
character of its rendering. For Farber, de Kooning's technique amounted to
'split-second decisions and minimal torment . . . startling swiftness . . .
replacing sensuality with shallow shock.'[146] The habit of separating form
from content generated the negative turn in Farber's commentary: first de
Kooning presented his conventional subject; then he attempted to dress it
up with impressive handwriting. But de Kooning himself had little sense
of of thematic order or integrity; he was remarkably loose in this respect.
Within his practice, an iconic image of Woman amounted to the novelist's
'word', the concrete element: a basic image-thought, something to 'get hold of',
as he said, and, on reflection, not 'such a bright idea'. No idea of de Kooning's
own seemed quite so bright to him after the fact; but the thoughts of other
artists, he believed, fared no better.[147] His iconic Woman assumed the
function sometimes served by lettering during the 1930s and '40s: 'You have
to start somewhere.'[148] His Woman-type could be painted in any manner,
and so could his black-and-white abstractions, which often showed traces
of the brilliant colours of the Woman pictures.

Like de Kooning with his picture, the critic with his text also needed
something to 'get hold of'. Farber invoked an early Italian compositional

type to initiate and ground his analysis, a standard against which to judge the new work, which then did not appear new enough. (This was a complaint that would follow de Kooning no matter what he did – as peculiar as his art might be, a significant number of critics demeaned it as never new enough to be new.) In *Woman*, the 'maelstrom of black lines' must be those defining the torso and arms, set against white – a black-and-white abstraction within the brilliant hues of the representation. Here de Kooning set two modes of painting in coarse juxtaposition, as if an effect of masking without the use of paper or tape (see the previous reference to this painting, 'Sense'). When Farber used the metaphor of a maelstrom to describe de Kooning's marks, he divorced them from the range of organic arm and hand movements to which they properly belong, attributing them to physical chaos – turbulence in water, in air, in particles of stuff: turbulent paint marks. His maelstrom connotes a recklessness that leads his critical assessment to verbal vagary. The critic may be thinking precipitously, as opposed to the artist painting too fast. 'These lines,' he wrote, 'caught between illustration and ferocity, hide their glibness with an excess of shock and movement.'[149] Speed was indeed the effect; and once Farber had perceived it, his perception hardened his judgement. He had settled the question of subject by association: woman as static icon. Now he settled the question of technical presentation just as presumptively: a fetish for speed.

Appearances of speed can be deceiving. Appearances of anything are deceiving, as deceiving as they are revealing, depending on what a viewer desires to see. Accounts by those who witnessed de Kooning, not only during the late 1940s but during other periods as well, stress his care and deliberation, even though quickness might characterize any single gesture of the brush. A visitor to his work on *Attic* in 1949 (see illus. 11), a nominal abstraction virtually contemporaneous with *Woman*, reported that the painter 'would erase parts, redraw it . . . It was not throwing his guts on the wall.'[150] Accidents were to be pondered. In 1955, de Kooning described his studio routine this way: 'I spend most of the time sitting there, studying the picture, and trying to figure out what to do next.'[151] Ideas for pictures, imaginative glimpses of pictures, often derived from glimpses of trivial elements of the painter's immediate environment. If the vision was unexpected and transient – and in this sense disjunctive, like effects of masking and collage – then de Kooning might investigate it all the more intently. But the condition of the glimpse would have passed. Such unplanned vision could only be incidental, an accident. When it occurred in a painting, it put de Kooning in his viewing chair and kept him there, wondering.

Most critics shortchanged the complexity of de Kooning's aesthetic experience and his working process. They received an impression of speed

without the accompanying slowness. Farber objected not only to what he regarded as graphic histrionics but also to the fact of de Kooning's converting painting practice into drawing practice, 'tending to skim color over shapes, stretching forms into directional lines' – composition made quick and easy.[152] A critical dilemma arises: Is de Kooning an unrepentant, naive sign painter; or is he perverting the art of figure painting by introducing an inappropriate populist touch? Farber might have approved of the latter position but not of the persistent ambiguity. De Kooning's nominally abstract lines were as arbitrary in relation to his nominally representational *Woman* as his titles were to his 1948 pictures. Ironically, the situation of de Kooning's art proved offensive to both conventional and 'advanced' taste. 'To skim', as a movement, is 'glib' – both Farber's verb and his adjective impute to de Kooning's results an absence of gravity, a lack of moral seriousness. The maelstrom encountered no resistance to its formless energy. De Kooning failed to resolve his painting's tensions in a satisfying synthesis of its tame 'illustration' and wild 'ferocity', the 'glibness' and the 'shock'. Farber's account implied that the antithetical qualities evident in this art were remaining just as they were; this was the core of his objection. De Kooning was getting nowhere, although doing it fast. I can only infer that Farber expected more of a dialectic, more of a synthesis, the sort of effect that Hess, years later, explicitly warned viewers *not* to expect.[153] Farber anticipated a dynamic play of opposing forces, a resolution of tension in mutual negation. Instead, the features of de Kooning's images drifted off into a mere array, without consequence – a quality here, a quality there, abstraction there, representation here. Dark linear strokes at the left and right sides of de Kooning's *Woman* might be describing human arms or the arms of a chair. Curving strokes around the breasts and knees resemble the phantom lettering of *Orestes* (see illus. 2). The marks amounted to little more than graphic effects for their own sake, one way or the other: 'The painting never probes deeper than a hand-written declaration.'[154] Farber seems to have judged the marks 'glib' because their abstract drama so outweighed their descriptive function, to which the colours – garish perhaps, or simply bright – lent no rational support.

Farber's brief review merits sustained attention because, to my reading at least, it is prodromal, the symptom of a coming cultural phenomenon – not so much a crisis in painting, more of an impasse in criticism. It demonstrates how difficult it was for critics to extract 'critical' sense from de Kooning's art within its context. His painting failed to fit even a rather liberal kind of art discourse. The given categories hardly touched it: subject, theme, meaning, style, composition, resolution. Perhaps Farber's restraint in his own abstract paintings prevented him from engaging more empathetically with de Kooning's sensory qualities.[155] When David Sylvester, eventually to become de Kooning's

advocate, reviewed the Venice Biennale – it was September 1950, two months before Farber's commentary in the same journal – he was either unfavourably impressed or hardly impressed at all. De Kooning barely registered. Sylvester included him with Pollock and other Americans as having 'fallen prey to a Germanic overestimation of the importance of self-expression . . . frenetic automatism . . . hysteria . . . undirected and undisciplined exuberance'. You would assume that de Kooning, guilty by association, was all speed and no sitting in the studio chair. Recalling his critical commentary of 1950, Sylvester confessed to having been 'utterly obtuse'. What did receive his approval in Venice? He admired sculptures by Henri Laurens – 'component forms [that] function together' – and those by Alexander Calder – 'his constructions . . . make things work.' Sylvester was partial at that time to polished composition, surely not de Kooning's mode.[156]

De Kooning was not making art to make things work, but to make things be. From his perspective, it was beside the point whether he had reduced painting to drawing (one of Farber's complaints); by whatever means at his disposal, he was obviating the development of a composition of forms. With its evocation of illustration – cartoonish eyes, mouths, hands, shoes – his repeated image of Woman parodied the high drama of American popular culture, low culture, conformist culture, ordinary culture. The *ordinary* was de Kooning's subject, the target of his imagistic explorations. And if the subject was ordinary, so was its presentation – like Cimabue, straight-on like a billboard. Here was consistency of a sort, with neither a critical manifesto to announce it, nor back-up links to theories already in operation (for example, the revelation of some psychoanalytically determining factor). Entry into de Kooning's subject eluded many within the circle of his avant-garde viewers, who probably would have been helped by more of a verbal barrage, which Hess's writings began to provide when he discussed *Woman I* in 1953, followed by Rosenberg's several contributions, as well as by Sylvester's important interview of 1960. By 1968, it was clear that de Kooning's pictures of Woman had 'shocked the bourgeoisie through their violence [just as] they shocked the avant-garde through their commitment to a traditional subject'.[157]

It may be that de Kooning – more than the neo-Dada artists of the 1950s, more than the Pop artists of the 1960s – eliminated any workable distinction between the emotional response of the bourgeoisie and that of the elite avant-garde, whoever might constitute the two groups. The prevailing theories of these social classes had their points of failure. Perhaps, throughout the entire modern period, the more adventurous and experimental art practices effected a cumulative cultural levelling – from the stress on individual sensation among the early European and American Romantics (very de Kooning-like), all the way through to the ironic conformism of Andy Warhol (also very de

Kooning-like). 'I want everybody to think alike', Warhol said in 1963; 'Everybody looks alike and acts alike, and we're getting more and more that way . . . Millions of painters and [they're] all pretty good.'[158] De Kooning knew that his vision was unique. But every vision was unique, which is why he could admire so many forms of art that had preceded him. With respect to uniqueness, he was just like everyone else: one among millions and all of them 'pretty good'. His aesthetic was high, and it was low. He accelerated a levelling process already in operation, to which the indiscriminate nature of the series of works he exhibited between 1948 and 1953 – a series, an array, not a development – contributed in a major way. His art caused the avant-garde to act bourgeois in response, while he himself belonged to neither class. When sophisticated observers viewed his paintings, their bourgeois sense of consistency (their sensitivity to its lack) appeared within their ranks. To criticize de Kooning for putting disorder into art would be analogous to criticizing Warhol for too much repetition. Each had an economy, making something of unpromising material.

As much as anyone else, avant-garde viewers were shocked by de Kooning's linear 'maelstrom', extending it to a judgement of violence. Although they were less likely than truly naive viewers to succumb to attributing flesh wounds to brush marks (a version of the pathetic fallacy), they followed Farber by alluding to violence where they could have referred more judiciously to a play of aesthetic energy. Greenberg was well aware of the problem; he described works of the New York School in 1950 as 'look[ing] too new – new beyond freshness, and therefore violent'.[159] The response of most critics passed too quickly to verbal metaphors that hardly pertained to the realities of painting, even as they recognized that the new generation of artists had been establishing 'pure paint [as] their subject matter'.[160] This last conceptual generality, quoted here from Farber's 1950 review, was common knowledge. The first serious notice de Kooning received already included a version of it: 'The process of painting becomes the end.'[161]

The informed avant-garde felt the shock of de Kooning far more when responding to his representational paintings than when engaging with his abstractions. An abstraction could be 'pure' in the same way that paint could be 'pure': it could be itself, whereas a representation – always something other than itself – could not. Around 1950, de Kooning's representational painting shocked his avant-garde public into bourgeois stupor. It was not only de Kooning who produced this effect, but also Newman, though by a different route: Newman shocked through abstraction (*The Promise*, illus. 28), while de Kooning did it through representation.[162] It happened in the case of his *Woman* of 1949, even before *Woman I*'s public appearance in 1953, which, by chance, generated far more scandal (see below, 'Identity', 'Projection').

28 Barnett Newman,
The Promise, 1949, oil on
canvas, 130.8 × 173 cm.
Whitney Museum of
American Art, New York.

Nothing

If de Kooning's painting had the effect of a parody of the commercial, middle-class culture of advertising and fashion illustration, it might also appear to parody the elite culture of abstract art. From the responses that de Kooning received, he knew that his paintings could be regarded as abstractions and evaluated in comparison with works that were less ambivalently 'abstract'. The reaction to his art reflected a general uncertainty. Elements of the public commentary surely must have been irritating, yet also confirming for someone with the attitude that all approaches to a given painting are valid. Sooner or later, anything can mean anything. 'In art, one idea is as good as another', he stated in 1949, in the lecture 'A Desperate View'. 'If one takes the idea of trembling, for instance, all of a sudden most of art starts to tremble . . . Cézanne was always trembling but very precisely.'[163] The notion of 'trembling' was a way of referring to uncertainty. Here was Cézanne, known to art history for the most subtle means of organizational control, and yet he failed to complete his compositions. As he made his precise choices of stroke and colour, nothing was certain and the need to reconsider and possibly change remained. The experience of trembling alludes to sensation in the act of painting as well as to the sense of the image painted. Typically, de Kooning's language leaves his referent open, using a term that can become nominative subject, verbal action or adjectival description.

Like desperation, trembling was a handy choice from a list of conditions that might accompany artistic anxiety; it aligned with the vogue for the writings of Kierkegaard.[164] De Kooning could be ironical about how readily his fellow artists and literary and academic friends followed intellectual fashion – 'all of a sudden most of art starts to tremble'. This irony was without bitterness, for fashions were hardly permanent. De Kooning was comfortable with slippage from one fashion to another, one idea to another. In connotation, his techniques slipped from avant-garde to bourgeois and then slipped back again. The slippage itself stimulated his musings, or at least amused him. To the contrary, a fixed rule or order was unnatural, deathly. De Kooning resisted the inclusion of his paintings of the late 1940s within the permanent art-historical category of abstract art, itself a grand conceptual abstraction from which his works might find no means of escape, no way of slipping out. It may have been useful for him to exhibit *Woman* in 1950 for this purpose, since he was quickly becoming known for his abstractions. Sidney Janis, his primary dealer during the 1950s, encouraged him to produce more purely abstract work because the avant-garde market perceived it as the future, making it easier to sell. Needless to say, de Kooning denied this kind of demand as well as the abstraction/ representation distinction itself.[165] *Time* commented in 1953: '[He] makes jokes about the word "abstraction" . . . Some pained partisans of abstract art pointed out that de Kooning was attempting to ride two horses (representation and abstraction) at once, and thought he failed.'[166]

The jokes were there to be made. The differences embedded within the word *abstraction* are subject to metonymic slippage. Abstraction is an abstract notion that designates a practice as much as an art-historical *category* of practice. Speaking of the one, you drift into speaking of the other. De Kooning understood that abstraction had inherent flexibility. For him, it constituted more of a verbal action than a categorical judgement in the form of a classifying noun. With respect to abstract art, the process or object most often was an abstraction *of* something, and the something could be any representational motif. 'Even abstract shapes must have a likeness', de Kooning said in 1951: 'The idea of abstraction [is] something extra [that is, inessential]. . . . For the painter to come to the "abstract" or the "nothing", he needed many things. Those things were always things in life.'[167]

Why did de Kooning refer to the 'abstract' as the 'nothing'? He explained: 'The "nothing" part in a painting [is] the part that was not painted but that was there because of the things in the picture which *were* painted.'[168] In this regard, the motivation, stimulus, or catalyst for each of de Kooning's paintings would be something he observed in life, something experienced, rather than something he conceived as his creative end. A predetermined end would be an abstraction formed of abstract elements. By de Kooning's estimation,

such summation would come to nothing – 'nothing', because neither the parts nor the whole would have concrete existence. The colour blue is a Peircean Feeling, but also a kind of abstraction, at least when we refer to it detached from a situation of experiencing it. The colour sky-blue or sea-blue is something else, a real something. Better still would be to identify a colour as this-sky-blue-now. With such a designation, we grasp the two-sided character of Feeling as Sensation: I am seeing this blue (Feeling), and I know that I am (Sensation). In de Kooning's art, the process or execution would never be subservient to an abstracted conceptual end – say, an ideal blue that no one had seen or felt – because the end was a feature of the process. The blue would exist only with respect to being present to the artist as he manipulated it.

The object of de Kooning's motivating experience need not be a thing occupying the immediate external environment. It could be something envisioned in memory or even visualized as forms emerging and accumulating on the canvas. The object of experience could become the process representing it, with the subject emerging along with its representation, interdependently. 'I'm not interested in "abstracting" or taking things out or reducing painting to design, form, line or color', de Kooning said around 1950. 'I paint this way because I can keep putting more and more things in – drama, anger, pain, love, a figure, a horse, my ideas about space.'[169] If we take him at his word, he was adding colours, lines, shapes, whatever, not as a slew of superfluities to a compositional concept already abstracted (which is how Farber had imagined him working from his Cimabue-like foundation), but as the means of evoking a full range of observation and feeling. De Kooning's friend, artist Herman Cherry, later commented that his paintings were 'not abstractions but real experiences . . . [de Kooning] never thinks in abstractions'.[170] Understanding this remark in the most literal way, we gather that de Kooning was incapable of a generalization. Well, he was capable of it; but it made him anxious.

'I asked [de Kooning] whether he thought of his *Women* as primarily figurative or abstract. He bridled at the question. "They are images of women. If I wanted to paint abstractly, I would have."'[171] This report is Irving Sandler's, probably referring to the 1950s. Turning the situation around, we realize that de Kooning's 'abstractions' of the late 1940s contain numerous shapes easily identified with the female figures he so often rendered during those years. Just as his representations of women were loose enough to impress viewers as abstract art, his nominal abstractions were figurative enough to suggest that they derived from representation. I have already mentioned this effect with respect to *Valentine* ('Subject'). *Fire Island* (illus. 29) offers a similar demonstration. At the middle left, one of the white forms is recognizable

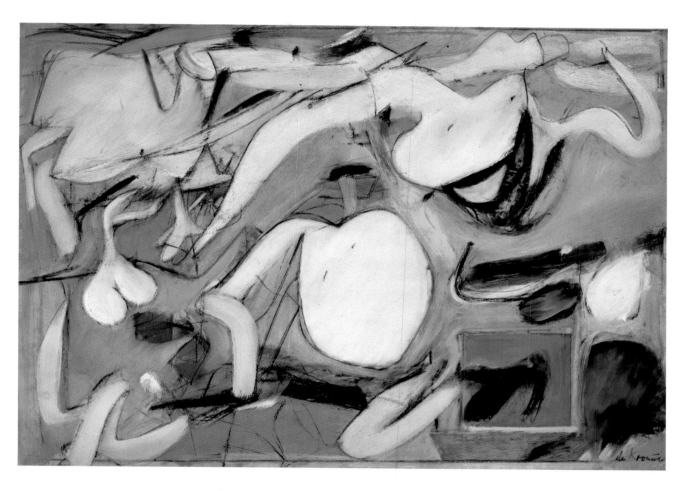

29 *Fire Island, c.* 1949, oil on
paper, 48.3 × 67.3 cm. Collection
of Martin Z. Margulies.

as a breast-and-throat configuration seen in such representational works as
Woman (illus. 30) and *Pink Angel* (see illus. 14). Given its recurrence in
many paintings and drawings from this period, in both abstractions and
representations, each instantiation of the form could be the result of tracing
or transfer from another work, or an isolated reduction from a more complete
configuration. It might also emerge from de Kooning's store of motor memory,
as a form he could rely on to incorporate the kind of material and bodily
torsion that interested him.

For their book on de Kooning of 1960, Harriet Janis and Rudi Blesh
included a two-page spread with the caption 'From Realism to Biomorphism
to Geometric Abstraction: Phases in the Development of a Symbol-Form'.
It reproduced six analogous shapes, each vaguely thigh-like, details of works
dating from the late 1930s to the late 1950s – two taken from paintings clearly
of women, including *Woman I*, completed, or at least ready for exhibition
in 1952 (see illus. 37), and four taken from nominal abstractions, including

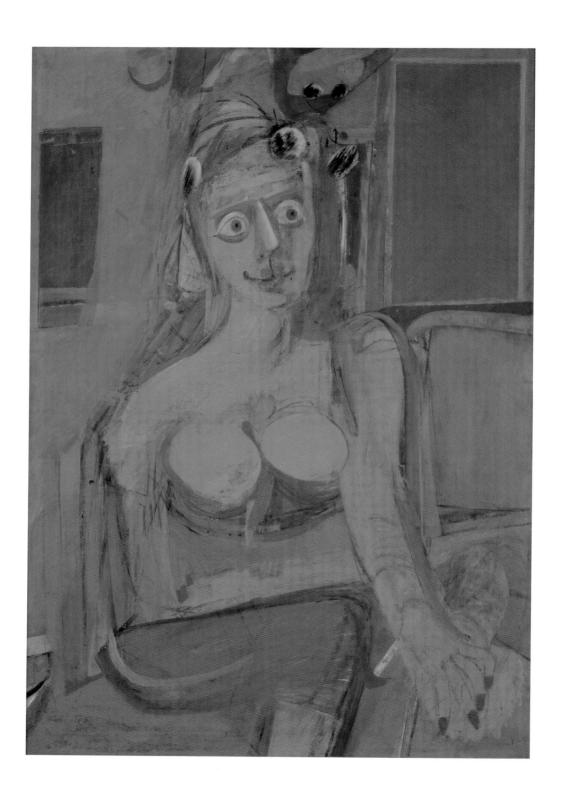

30 *Woman*, *c.* 1944, oil and charcoal on canvas, 116.8 × 81.3 cm.
The Metropolitan Museum of Art, New York.

Painting, completed for exhibition in 1948 (see illus. 22).[172] We might wonder whether all of these forms are sufficiently thigh-like – perhaps only when set into the context of a body, as is clear enough in the two cases of representational figure painting (a category that applies in a literal sense, yet will always seem vaguely inappropriate for this artist). Every shape, no matter how 'abstract', has the potential to represent. To say it again: anything can figure anything; anything can mean anything. A figure painting of 1948, *Woman* (illus. 31), appears at first to lack its right eye (viewer's left); but this 'eye' is present as a projecting form analogous to the multiple points of a star or sunburst at the upper left of the picture. One form answers the call of another. The star itself forms a concentric circular motif like that of an eyeball with an iris – one form generating the other. Similarly, the figure's left breast, which projects to the picture's right (complementing the turn of the head), has a double outline and a dark mark within it; it resembles an eye contained by an eyelid. Just below the double outline of the breast is a second double outline, which may represent the fold of a dress or a waistline – or just a double line. The configuration becomes a band of pink both bordered by black and set over blackness, if we view this juxtaposition of pink and black with the spatial ambiguity that de Kooning allowed to remain.

Anything can be what it can be. Hess, explaining de Kooning's own notion of the 'no-environment' that *Woman 1* and his previous figure paintings occupied, wrote as follows: 'The modern image is without distinct character, probably because of the tremendous proliferation of visual sensations which causes duplicates to appear among unlikes.'[173] To paraphrase: dissimilars begin to look like similars, even the same; anything can be anything else. Hess also recalled that de Kooning regarded as an arm any shape attached to a shoulder.[174] This is representation by metonymic contiguity: the location in the general structural order determines the referential identity – a very abstract way of representing. And what is a shoulder? It must be anything to the left or right of a head, and slightly lower. Rather than butchering representation, as some viewers decided he was doing, de Kooning was showing how representation comes to be.

Any permanent distinction between a shoulder-and-head form and a breast-and-throat form, or between a breast and an eye and a star, or between one thigh and another – or between one abstraction and another – proves evasive. De Kooning was working from such open experience that his project determined no specific forms and no specific end. The alternative position would be this: to keep the conceptual sense of a project fully in mind – mind over matter. With the latter attitude, you might paint an allegory of justice for the courthouse. You might even paint an abstraction, having determined a conceptual or philosophical need to coordinate a set of 'circles and squares'.[175]

31 *Woman* (one side of *Woman / Untitled*), 1948, oil and enamel on fibreboard, 136.1 × 113.2 cm.
Hirshhorn Museum and Sculpture Garden, Washington, DC.

Because de Kooning worked without this kind of plan, a warning to viewers was in order. In a brief article of 1950, Barr issued a version of it. His primary purpose was to affirm the new prominence of three Americans – Arshile Gorky (already deceased), Pollock and de Kooning. The latter's art, Barr advised, was likely to appear 'abstract or cryptic'. For the general viewer, and perhaps for Barr himself, the open-endedness of this art, its indeterminacy, translated into abstract, indecipherable qualities – cryptic because the subject was inapparent. On de Kooning's behalf, Barr moved to a compensating consideration, though not necessarily in sympathy with it himself: contrary to the look of utter abstraction, 'de Kooning insists upon the importance of the latent subject'. Barr spoke as if he had a psychoanalyst's inside information and was passing it on to the reader. The term *latent* was not de Kooning's but Barr's. It hedged on the nature of the work that illustrated the article, an abstraction at grand scale, *Excavation* (see illus. 35).[176]

Commentators have been discussing the 'latent' content of *Excavation* almost from the time it left de Kooning's studio (I will say something as well: 'Movement', 'Flexible'). None of the suspicions as to subject has led an interpreter to categorize this painting other than as abstract art. This alone should demonstrate what de Kooning always knew – the categories create more confusion than clarity. For de Kooning (in his talk of 1951), if a picture was abstract, it was 'nothing'. Barr's brief account indicated that *Excavation* was 'just finished this May'. He was writing about a month later. To use Barr's own phrase, this work crowned de Kooning's 'rise to fame'.[177] Barr chose it for the Venice Biennale of 1950; and later, in 1951, the Art Institute of Chicago awarded it a purchase prize. Latent subject or not – as with hidden meaning, how would one know? – those following modern art now recognized de Kooning not merely as a painter who did abstractions, but as one of a select few leading the advance of abstract art.

Cézanne

However de Kooning's general project might be defined, viewers were often unable to perceive in any single work a theme of consequence, a subject suited to discussion, one that made discursive sense – representational, abstract, something, nothing. In this respect, de Kooning joined an odd group of predecessors in the history of the reception of modern art: those who, by default, became known for qualities of the 'abstract', the 'cryptic', because their work manifested nothing better defined. These artists made interpretation difficult while also tending to deny the difficulty; they claimed that their ideas and ideals were hardly unusual. De Kooning had many

subjects that to him were ordinary: 'drama, anger, pain, love, a figure, a horse, . . . ideas about space.'[178] The problem was that his professed subjects flowed into each other – in his list as well as in his pictures – like the part-representational, part-abstract figures in the series of images chosen by Janis and Blesh for their demonstration of formal development. Representational subjects that make little headway toward thematic sense might as well be seen as formal abstractions.

This had happened to Cézanne. He had become a heroic figure in the story of modern art, although celebrated in ways that worked against his will or at least against his better judgement. One of de Kooning's art-world friends, painter Erle Loran, authored the most widely read study of Cézanne's art to come from their common generation. *Cézanne's Composition* (1943) established at the outset the irony of Cézanne's historical status: 'It is certainly doubtful that Cézanne would have welcomed a development like the later phases of Abstract art' – for which, of course, he had received credit.[179] Whether or not de Kooning perceived the connection to Cézanne in these terms, he joined his predecessor in recalcitrance. Cézanne, who inspired others to abstraction, ironically insisted that he merely followed what he saw: this was his sensation. Painters of the twentieth century would become fascinated by the patterns of animated marks as if made for their own sake – for example, the sequences of strokes constituting a landscape featuring undergrowth (illus. 32) – but Cézanne himself justified the technique as his response to a fleeting quality of light or colour, or the visual instability of a contour.[180] Like de Kooning, he never started a painting from nothing (the 'nothing' of abstraction), but always from something. In Cézanne's case, it was something directly observed.

So de Kooning had a father, or grandfather, in Cézanne – a so-called post-impressionist faithful to impressionism, an inadvertent guide to abstraction who was representing nature. As contrary as de Kooning, Cézanne was also as wary of intellectual pretence. Late in life, exasperated by the ideas younger artists were applying to him and suspicious even of his own words, he exclaimed: 'No more theories! Let's paint.'[181] Whatever words could teach with regard to art, paint would do better. De Kooning once argued that Cézanne had taken up the method of Stéphane Mallarmé's 'use of the multiple meanings of words [so he could] paint a tablecloth that also would be a mountain'.[182] In Cézanne, de Kooning saw his own imagination at work: his multiplicities, his ambiguities, his indeterminate incompletion – a double negative of this kind was a positive for him, remaining just as it was without synthesis or resolution. Had he known the thinking of Cézanne's earliest acolyte and imitator Gauguin, he might have recognized something of himself in the way that Gauguin linked the representation of nature to

32 Paul Cézanne, *Sous-Bois*
(*Interior of a Forest*), *c.* 1885,
oil on canvas, 46.4 × 56.1 cm.
Art Gallery of Toronto, Ontario.

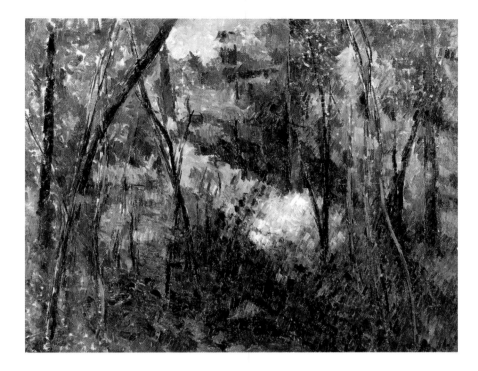

artistic abstraction, putting the emphasis on the process, not the final product
(this is what Cézanne ought to have said himself, but did not): 'Art is an
abstraction; draw it out from nature in imagining [or dreaming: *en rêvant*]
in view of nature, and think more of creation [the process] than of what will
result.'[183] If either Cézanne or Gauguin had been making 'abstract art', it was
abstraction so intimately linked to the experience and representation of
nature that any firm distinction became pointless. This was de Kooning's
implicit belief about himself – no more theories, no more categories.

Connecting de Kooning to Cézanne is to skip over cubism, one of the
big art-historical categories. When critics set about to classify de Kooning's
style, however misguided their effort, they tested it by the rigours of cubism.
'Late Cubist' was Greenberg's own verdict in 1955, announced with relatively
kind intent, for de Kooning was continuing cubism 'without repeating it'.
In 1950, the critic had said something similar, even more benignly, when
he indicated that de Kooning and others of the New York School did 'not so
much break with the Cubist and post-Cubist past as extend it in an unforeseen
way'.[184] Greenberg would apply the late-cubist label less benignly in 1958,
when he revised his statement of 1955; at that point, he emphasized the con-
servatism of de Kooning's 'insistence on sculptural firmness . . . underneath the
flung and tortured color'. Here, Greenberg's reservation was not far removed
from Farber's in 1950; both critics questioned the coordination of what they

took to be de Kooning's composition with the various marks and colours that elaborated on it. Either Greenberg was now slipping into a less perceptive view of de Kooning (more like Farber before him) or it was de Kooning who was deteriorating. In 1958, Greenberg acknowledged the painter's degree of success but only backhandedly, suggesting that his art served 'to reassure a lot of people who still find Pollock incomprehensible'.[185] His late-cubist designation tended to stick, and others repeated variations of it. In 1963, Ben Heller used it to explain why, despite extraordinary mastery, de Kooning was losing his attraction for new generations of painters: 'What was taken to be a revolutionary style in the late forties [when Greenberg himself had been most approving] was, in reality, the logical extension, final flowering, and summation of an era: the post-Cubist art of Europe.'[186]

As de Kooning was 'late', so Cézanne had been 'early'. Twentieth-century critics projected his variant of impressionist style as the precursor to cubism. Loran noted what had become the cubist view, 'their opinion of Cézanne as a mere beginner, one who shyly pointed the way to higher, more advanced ideals'.[187] This was hardly de Kooning's understanding. He inverted the usual progressive order: 'I think Cubism went backwards from Cézanne [by] laying it out beforehand. You are not supposed to see it, you are supposed to feel it . . . Cézanne said that every brushstroke has its own perspective[,] its own point of view.'[188] Every brushstroke was responding to its immediate conditions, either in relation to the sensation it was recording or the sensation it was generating; every brushstroke was what it was and neither categorically representational nor categorically abstract.

Categorically dissimilar things often appeared similar to de Kooning – a thumb could become a thigh, or perhaps a nose – just change the perspective, or let the form have its own perspective, like a Cézanne brushstroke. Accordingly, de Kooning converted back into irresolvable difference the stylistic similarities discerned by others. In his view, Cézanne was no cubist. Concerning his own imputed link to cubism, he introduced a distinguishing factor: the cubists started from a concept; they pursued their art through it, 'laying it out beforehand'. This was just the type of determinate practice that de Kooning, like Cézanne, resisted. Lodging this complaint with Rosenberg in 1971, de Kooning kept its target vague, neglecting to specify which cubists and whose theories were culpable. It would be odd for him not to have regarded Picasso as cubist, yet this was a cubist who avoided theory and whose imagery hardly arrived in predictable order. De Kooning admired Picasso's inventive genius, manifested in works he had contemplated during his formative years in New York, especially *Guernica*.[189] And he had set the historical phenomenon of cubism in a favourable light in the talk he gave in 1951 at the Museum of Modern Art, where *Guernica* was then housed.[190] Picasso's various studies for

Guernica – along with works by de Kooning's friend and mentor Gorky (illus. 33) – are probably the closest cousins of his characteristic linear configurations, simultaneously angling and curving. A study for *Guernica* dated 28 May 1937 has the distorted, cartoon-like facial features and the broad, stubby hands and feet of the figures de Kooning was drawing and painting during the 1940s, as well as dense linear tangles and overlays of brilliant colour – elements of abstraction that characterize these representations.

Perhaps the motivation for de Kooning's anti-cubism of 1971 derived from a grudge involving his critic Greenberg. Despite being enthusiastic about the black-and-whites of 1948 and maintaining certain lasting points of appreciation, Greenberg characterized de Kooning's art in an increasingly demeaning manner as the 1950s progressed: 'I happen to find de Kooning's *Women* pictures [of the early 1950s] inferior by and large to his previous work.'[191] Greenberg later claimed that he had censored the potential harshness of his critique because he hesitated to offend de Kooning's hypersensitivity.[192] On the other side of the relationship, de Kooning viewed Greenberg as an annoying know-it-all, tactless enough to tell an artist within his own studio how to improve a work in progress.[193] When Greenberg responded to the Woman paintings of the 1950s, he was addressing a complicated situation. He himself felt that de Kooning had rapidly retreated from the radical initiative of the abstractions of 1948. Yet, if it was de Kooning's abstract painting that had been avant-garde and therefore challenging,

33 Arshile Gorky, *One Year the Milkweed*, 1944, oil on canvas, 94.2 × 119.3 cm. National Gallery of Art, Washington, DC.

while his representational painting pandered to a bourgeois market, this was not the opinion of the bourgeois market. The broader public – certainly not everyone, but those with an interest in modern art – were more directly offended by the Woman images than by the odd abstractions. The offence registered consciously because representation was something the public believed they understood. They may have objected in principle to abstract art but could hardly explain how any particular example failed. When judging representational art, to the contrary, they felt they had everyday observation on their side.

In 1962, new writing by Greenberg compounded the misgivings and the slights of the 1950s. He attacked de Kooning's staunch ally Rosenberg for conceiving of abstract expressionism as action painting in which 'every-thing lay in the doing, nothing in the making'.[194] Here, 'doing' signalled Rosenberg's existentialist orientation, whereas 'making' signalled Greenberg's pragmatism, his interest in the ultimate strength of the finished product. At this point, a decade after *Woman I*, he identified de Kooning with what he called 'homeless representation': 'plastic and descriptive painterliness that is applied to abstract ends, but which continues to suggest representational ones'; the ambivalence of 'large facet planes [that] seem to grope for . . . a model in nature'.[195] Why would this have been a failing in de Kooning's art? After all, by his sense of experience, art ought to have its 'model in nature'. Clearly, Greenberg was taking the representation / abstraction divide far more seriously than de Kooning ever did; and, if proof of 'homeless representation' were needed, the painter's so-called landscape works of the late 1950s and early '60s provided it. They strayed so far from existing pictorial models – representational or abstract, it hardly mattered – that many critics thought they were landscape in title only.

In 1971, then, when de Kooning asserted that he was 'really much more influenced by Cézanne than by the Cubists', he was countering Greenberg's accumulated negativity.[196] His statement put the lie to recent Greenbergian history and did so with Rosenberg, Greenberg's antagonist, as interlocutor and witness. Cézanne had become de Kooning's moral choice, even if not as convincing a family relation as Picasso in terms of painting technique.[197] If a writer for *Time* quoted de Kooning correctly in 1965 – 'Art is the thing you cannot make' – this, too, might have been a statement against Greenberg (the maker), in favour of Rosenberg (the actor).[198] 'You are supposed to feel it', de Kooning said. Just do it: more process than product. When he suggested that each of Cézanne's strokes had 'its own point of view', he was giving the stroke a licence to act. With a stroke, as de Kooning said, Cézanne came 'face to face with his "little sensation".'[199]

De Kooning sought an analogous situation of immediate encounter. In their 1971 interview, Rosenberg epitomized de Kooning's attitude as moving from 'Don't think, look!' to 'Don't look, paint!'[200] In the spirit of Cézanne, each of his lines or brushstrokes was felt, not conceived, at the moment of its appearance ('Don't think, look'). Each mark took 'its own point of view' – paint did the looking – as the painter applied the stroke and simultaneously responded to it ('Don't look, paint'). To enhance disjointedness, to keep the independent sensations coming mark after mark, de Kooning would arbitrarily yoke different studio techniques or different pictorial sources and see – or feel (with all the ambiguity of this term) – what might happen. Hence the breaks in the texture and density of his applied paint, the severe variance in the quality of line, and the diverse ranges of chroma to be seen in individual pictures. Throughout his career, including his last decade of painting, the 1980s, he commonly traced forms from both the exterior inward and the interior outward, a technique he had mastered for rendering letters and numerals crisply in commercial sign painting. It simultaneously produces an articulated shape and an ambiguous space, a condition of inherent change. The net result is hardly a result. De Kooning's array of forms would be motivated by vectorial forces propelling the elements in several directions simultaneously. He regarded multiple points of view as entirely proper and desirable; his distinctive marks translated into a multiplicity of effects and feelings. This was a Cézannean brand of multiplicity, not the cubist variety – the transience of feeling, not a theory of transience. Its operation required no transcendent principles of form, space or perspective, not even the principle of a stable self. 'I can change', de Kooning always said; and 'I'm still working out of doubt.'[201] As for Cézanne, he 'didn't know . . . what he was doing'.[202] This had been his advantage: not knowing afforded more doing.

Anachronism

If we were not already aware of de Kooning's affinity for Cézanne, we would nevertheless have recourse to a metonymic connection via the word *doubt*. It was one of the simple terms that de Kooning favoured: *doubt* rather than *ambiguity*.[203] The link to Cézanne through *doubt* is circumstantial and arbitrary: an essay by Maurice Merleau-Ponty with a memorable title, 'La doute de Cézanne' ('Cézanne's Doubt'). Soon after publication in France in 1945, it enjoyed transatlantic and cross-disciplinary popularity. In its wake, it became harder than ever not to believe that Cézanne doubted. An English translation appeared in 1946 in *Partisan Review*, the journal for which

Greenberg wrote much of his early criticism. Merleau-Ponty's statement began: 'He needed one hundred working sessions for a still life, one hundred and fifty sittings for a portrait. What we call his work was, for him, only an essay, an approach to painting.'[204]

Parallels are apparent. Both Cézanne and de Kooning kept labouring over particular images; they worked slowly toward a finish, even though particular strokes might be quick and impulsive. Both failed to bring their eccentric pictorial orders to any traditional resolution; both had trouble attaining a satisfying end. 'Will I reach the goal I've sought so much and so long pursued', Cézanne asked himself about a month before he died: 'I'm working from nature as always, and I think I'm making some slow progress.'[205] Here the analogies break down. De Kooning might have referred to 'slow progress', but not in such a general way; his slowness applied only to his indecision over specific works, such as *Asheville* of 1948 (illus. 34), an abstraction on which he spent an entire summer, and *Woman I*, which required at least two and a half years.[206] De Kooning had no belief in progress. His aim was to change, not to advance; he would change even if it meant reversal. When he said, 'I can change overnight', he was referring beyond individual paintings to his general way of working and beyond that to his general conduct.[207] The appearance of doubt arose as a feature of his attitude toward just about everything.[208] This doubt was genuine, but it may also have become a projection, a pose. When we realize that our quirks and failings work to our advantage, we feel we can indulge and even exaggerate them. An admiring acquaintance reported that Cézanne behaved strangely in order to keep people from interacting with him; it protected his working time.[209] Professions of doubt allowed de Kooning inconsistencies in both his thinking and his practice, which he had no obligation to explain. Corresponding to the inconsistencies were freedoms.

Merleau-Ponty's meditation on Cézanne suffers from anachronism. Interpreting the painter and the painter's doubt, he was actually approaching the position of de Kooning, his true contemporary.[210] Unaware of de Kooning but in some respects much like him, Merleau-Ponty believed that finality and certitude were false desires that blunted the sensation of life. He defined the successful picture as one that 'makes movement [or life] visible by its internal discordance'.[211] The description fits the instability in represen-tational paintings by either Cézanne or de Kooning. As a phenomenologist and an existentialist, Merleau-Ponty wished to counter interpretations that derived the meaning of a work from a given ideology, an artist's programmed psychological state, or even some inner essence; he believed that the vague outlines of a life derived from immersion in and responses to the flux of perception.[212]

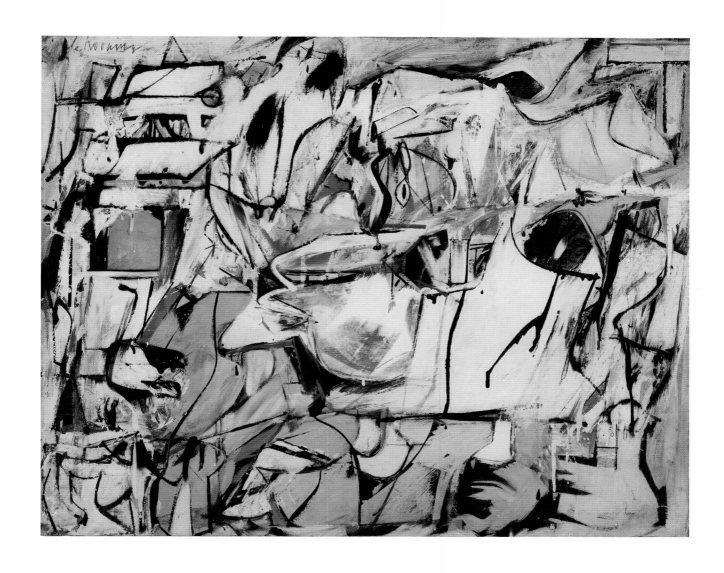

34 *Asheville*, 1948, oil and enamel on cardboard, 64.9 × 80.9 cm. The Phillips Collection, Washington, DC.

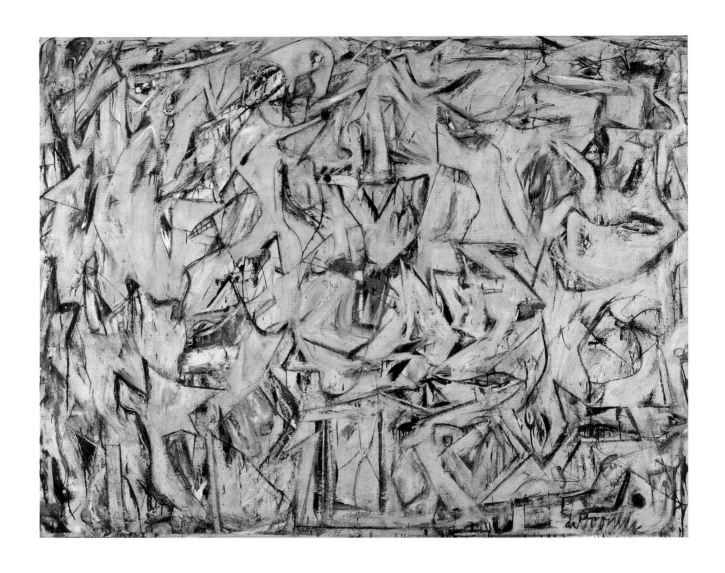

35 *Excavation,* 1950, oil on canvas, 205.7 × 254.6 cm. The Art Institute of Chicago.

A parallel to de Kooning's 'I can change overnight' exists in Picasso, in Françoise Gilot's remarkable reconstruction of his thinking. Picasso was explaining how he differed from Cézanne: 'I don't choose anything [such as a specific motif]; I take what comes.' To paraphrase: Picasso's project, whatever it is, limits neither his initial choices nor his action. He continues:

> My trees aren't made up of structures I have chosen but structures which the chance of my own dynamism imposes on me. Cézanne meant that in looking at nature, to receive the sensation of an object outside himself, he sought what corresponded to a certain aesthetic demand that pre-existed in him . . . I have no pre-established aesthetic basis on which to make a choice.[213]

Picasso, like de Kooning, was free of himself.

Movement

The year 1950 was a golden one for abstract art among the emerging New York School painters; Newman, Pollock, Rothko and Franz Kline each did some of his best work. During the first half of that year, de Kooning was struggling with the canvas eventually titled *Excavation* (illus. 35). Like his other paintings before it, this one had no expectations to meet, except that if it failed to present serious difficulties (doubts, changes), it would not be worth the effort. As in the case of many – perhaps even all – of de Kooning's other 'abstractions', he is likely to have been thinking of aspects of the human figure while proceeding. He generated complex curves and angles of the sort he associated with human anatomy: details of shoulders, elbows, knees, hips, breasts, a thumb. All this became his abstraction: in this instance, his *Excavation*.

During the 1930s and '40s, de Kooning had mastered versions of these representational elements, imprinting them in his corporal memory. Drawing from this store did not amount to representation in a normative, illustrative sense. Through the gestures that came naturally or even unnaturally to *him*, to his own range of movement, he altered the regularity of the anatomy on which he concentrated his vision, converting forms that could be traced from a distance by eye into those generated by the intimate tactile sensations of drawing and painting. This is an expressionist mode, hardly uncommon in the twentieth century. But de Kooning was especially adventurous in the way he accentuated his expressive gestures, allowing them to follow his painter's equipment rather than direct it. The contour of a shoulder

might be twisted by a certain type of line specifically induced by the use of a particular kind of brush. As much as any external object he observed, as much as his own gesturing body, de Kooning felt the presence of his materials and tools. He freely repeated whole forms and fragments of forms by transferring them (either by tracing or imprinting) from his antecedent paintings and drawings. Each time the sensation was distinct, because decontextualized and immediate. This was an effective way to intensify the materialized images already invested with his energy, raising this material-physical energy exponentially.

The tactile twist of one of de Kooning's agile forms might compensate for a view of the body that lacked sufficient visual interest. It might also compensate for difficulties he claimed he experienced when rendering problematic features, such as hair and shoulders.[214] Difficulties according to what standard? – it must be the prevailing look of illustration, a standard de Kooning was willing to discard. To put this another way, there was no view, difficult or easy, that would fail to acquire interest in de Kooning's hand. When he struggled, he was developing his picture-making rather than capturing anatomical structure. *Excavation* looks 'abstract' because it sets physically evocative strokes into oppositions impossible to correlate with any normative system of anatomical rendering.[215] A sense of the body nevertheless remains, a set of sensations that seems to escape anatomical limitations, including a viewer's own. You feel something intimately human in de Kooning's unidentifiable – and therefore 'abstract' – forms. His abstraction does not prevent empathy. Abstraction and representation hardly differ here, as de Kooning knew. He recognized that his own strangely abstracted organicism appeared in other situations, notably in the dance of Vaslav Nijinsky, who would do 'just the opposite of what the body would naturally do'.[216] Unnatural body movement morphed into abstraction, a fantasy lifted out of a real situation. But as the dance rendered this movement just as possible as its natural counterpart, it too became natural. The proof was in the appearance: it happened; it could be seen; it was real. The same applied to movement in visual representation. Once the unnatural appeared – as evident as anything else – it became the natural.

Merleau-Ponty considered something analogous: 'Movement is given, says Rodin, [by portraying] the body in an attitude which it never at any instant really held and which imposes fictive linkages between the parts, as if this mutual confrontation of incompossibles could, and could alone, cause transition and duration to arise in bronze and on canvas.'[217] Movement is a fiction in relation to the appearance of the body at any moment, just as the appearance of the body at any moment is an illusion in relation to the reality of the body's continual movement in the continuity of space and time. De Kooning's attitude toward finishing a work, ending it, accorded with Merleau-Ponty's

understanding of Auguste Rodin as well as of Cézanne. To finish a work is to present it as an illusion, since it should, in its reality, continue to change and grow, not in a progressive sense but as a transit from one state of mobility to another, each of them real. 'He is not just concerned with how it *looks* but how it *feels*', Ashton commented, considering the entirety of de Kooning's career to 1976: 'De Kooning's space and light demand that we perceive how it feels to move through these created spaces and how entities moving through such charged spaces are reformed, deformed, metamorphosed.'[218]

Tensile lines accent the surface of *Excavation*, evoking bodily movement beyond appearance – feeling beyond seeing. This canvas is unusually large within de Kooning's oeuvre, approximately 7 × 8 feet (213 × 143 cm), but not so large that he failed to relate its scale to the moving reach of his arms. Did he have its forms in mind as he worked? It would be wrong to assume so, even though many are recognizably typical of him. The phrase 'in mind' would imply that he kept such evocations of anatomy categorized and filed in memory, available to be reanimated for use in his pictures. De Kooning's memory was not mental or logical in this instance but corporal, more a system of immediate response than speedy retrieval. Each memory had its separate file rather than a collective category; each occupied a shifting place corresponding to its shifting perspective. *Excavation* presents an array of layered, intersecting textures, interfering with and complicating the various conceivable orders of shape and colour. The sensory complexity keeps experience immediate, because compositional generalities fail to take hold. Raised edges sometimes result from the thickness of de Kooning's brushed paint and sometimes from the action of a knife, spackler or other device for scraping. He could modify a scraper by filing it, giving an unexpected quality to the traces of paint removal.[219] These texture-forms are specific to the tools in use, the movements of the artist's body, and perhaps, in his memory, the bodies of others. The complications mount.

The density of de Kooning's imagery proves imponderable. It led Ashton to comment: 'How different painting man is from writing man. Painting has its reasons which reason knows not.'[220] De Kooning internalized the other's body in his, so that painting amounted to acting out, or acting through, bodily forms that could belong either to him or to someone else.[221] Most likely they belonged to both, multiplicitously, even though this man's attention was so often directed toward women – 'I guess because I'm not a woman', he said.[222] De facto, this is de Kooning's theory of gender difference. He gave the plain-spoken, obvious answer. It confounds critical thinking by reducing sexuality and gender – two abstractions now increasingly encumbered by theory, like epicycles on planetary orbits – to mere difference of an ordinary sort, as a brush-mark differs from a scrape-mark. The sensation of this material

difference is far more engaging than the conceptual meanings customarily appended to it. This is difference we feel, physical rather than cultural.

Abstract

Despite its acknowledged evocations of the body, we persist in labelling *Excavation* 'abstract', as if we were seeing nothing more than the marks – the marks as abstract, disembodied signs, not Cézannian nodes of phenomenological intensity. The categories we apply may not fit the nature of our experience. How abstract – how abstracted, how 'nothing' – is *Excavation* or, for that matter, other paintings of the late 1940s sharing many of the devices it accumulates? Perhaps no answer would get past de Kooning without a contrary indication. In 1971, at a moment when the Minimalism associated with figures as diverse as Donald Judd, Richard Serra and Robert Smithson captured the attention of younger critics, when this new artistic phenomenon was already being reduced to a buzzword, de Kooning did the unthinkable. He identified Bernini's baroque with the same concept – in a fashion. 'If I ever saw Minimalism, there it was. It says nothing.'[223] As usual, he intended his remarks to be taken quite literally. He explained that Bernini's art was all feeling and no idea; if there was an idea, the intense feeling generated by baroque form eclipsed it. By implication, fashionable Minimalist sculpture – or rather, the critics' conception of it – was also saying nothing, but now without the feeling. By de Kooning's definition, *he* was the true Minimalist of 1971: all feeling, no concept.

De Kooning did not issue provocations of this sort merely to be difficult; rather, he was protecting the freedom every artist should have from being inhibited by a theory, another's or even one's own. His practice reflected such freedom. It meandered through realms of representation and abstraction. As we know, although de Kooning painted the theme of Woman throughout the late 1940s, in 1948 he excluded obvious images of the figure from his first one-man exhibition, which consisted nearly entirely of abstractions in black and white. This was a tactical decision, an attempt at giving the presentation coherence; it did not mean that abstraction held more worth than representation. De Kooning's abstract and representational practices were so intimately related that two signed paintings of 1948 – one Woman, one abstraction – exist as recto and verso of a single canvas (*Woman*, illus. 31; *Untitled*, illus. 36). Yellow strokes applied rather casually across the otherwise black-and-white image of the verso may indicate that the artist could not resist returning to a finished work to change it. Apparently, he had his typical doubts, which may have led in short order to the Woman of the recto. His friend Rudy Burckhardt recalled that

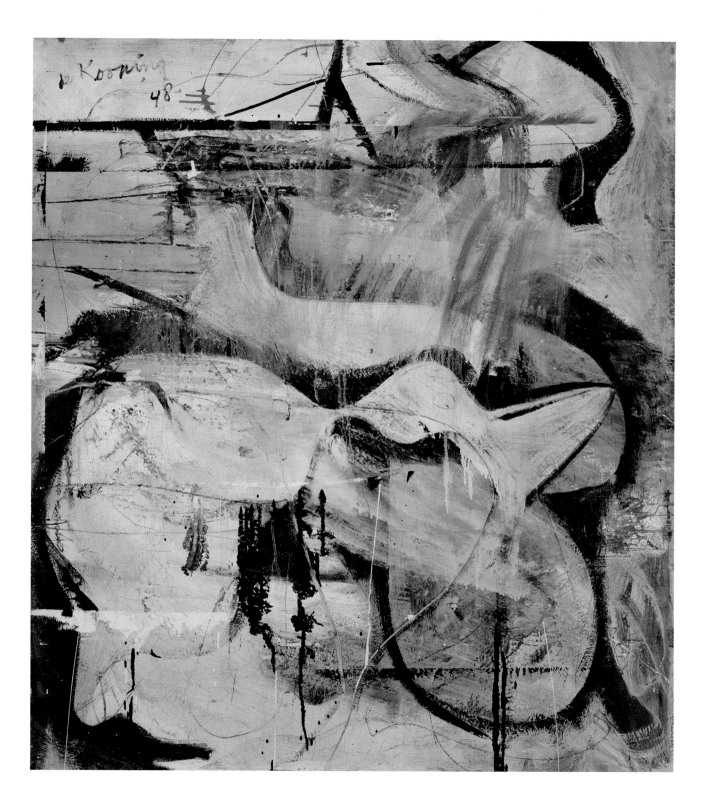

36 *Untitled* (verso of *Woman / Untitled*), 1948, oil and enamel on fibreboard, 136.1 × 113.2 cm.
Hirshhorn Museum and Sculpture Garden, Washington, DC.

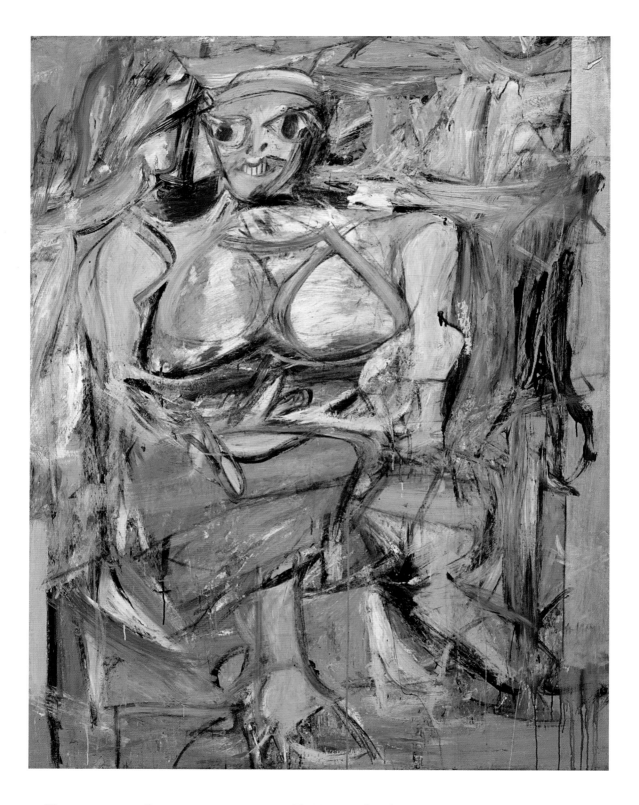

37 *Woman 1*, 1950–52, oil on canvas, 192.7 × 147.3 cm. The Museum of Modern Art, New York.

'there might be a terrific painting on his easel, [but] next time, you'd find a totally new picture painted over the earlier one' – or perhaps a back side mounted forward, where there had previously been the front.[224]

Abrupt turnabouts from one genre of imagery to another were characteristic; 'I can change overnight', de Kooning would say. In June 1950, having finished *Excavation*, he began work on the large canvas that would become, a long two years later, *Woman 1* (illus. 37). The Woman pictures of the early 1950s were followed by the dense, gritty abstractions of around 1955 (*Police Gazette*, illus. 38) and the more open, sweeping abstractions of around 1957–60 (*Merritt Parkway*, illus. 17). According to Hess, *Police Gazette* began as a figure painting that succeeded the last of the representational works of the early 1950s; the painter released it from the studio not because it was 'finished', but because he felt he could take it no further.[225] De Kooning shaped many of the larger segments of *Police Gazette*'s bright colour (yellows, reds, greens) by using thick linear strokes (blacks, whites, other greens). These linear elements conjoin in ways that evoke the joints of the body, with their corresponding capacity to rotate and twist. This is especially true of those typical de Kooning shapes defined by both angled and rounded contours. Think of how a fleshy arm curves into an angle at the elbow, or how a thigh does something analogous at the knee: this is a de Kooning line. So *Police Gazette*, an abstraction loaded with bodily physicality, is to *Woman 1* as *Woman 1* is to *Excavation*. It appears to inaugurate a definitive shift, which on inspection proves not so definitive. And this shift – which is not one – proves unreliable not only looking backward but looking forward. During the 1960s, de Kooning would return to the Woman. This, too, was not definitive. By the 1970s, he appeared devoted to abstraction once again – or rather to works in which the human figure became so submerged in the movements of paint that most viewers saw nothing other than abstraction. Yet a certain number of works, especially those from the beginning of the decade – *Untitled* (illus. 39), *Woman in a Garden* (illus. 40) – are clearly something less than fully abstract. Hands and feet are easy to locate. Through the logic of their placement within the vertical format, these obvious anatomical features begin to reveal others, even though the configuration in its entirety never amounts to a coherent body. In place of the body that ought to have appeared, there are diverse feelings of a body – de Kooning feelings of a de Kooning body, conjoined with a vision of others' bodies and the tactile sense of paint.

To gain familiarity with de Kooning-type feelings through *Untitled* and *Woman in a Garden* is to become sensitive to the factor of representation in the artist's later abstractions. With further familiarity, a work such as *Amityville*, 1971 (illus. 41), reveals feet, hands and a central torso. When *Amityville* is rotated into a horizontal format, a different configuration of

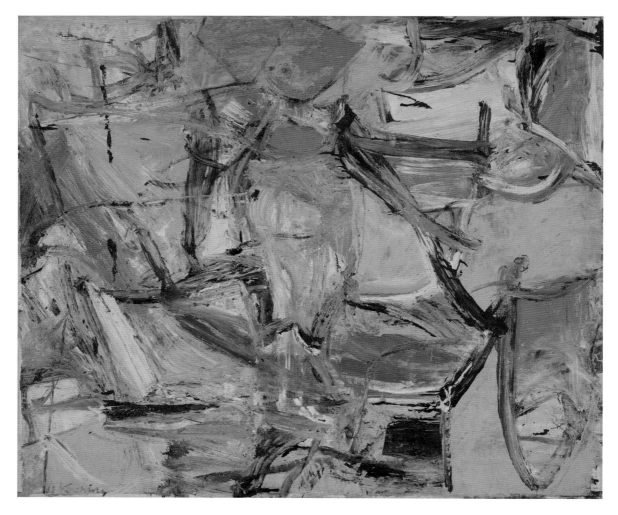

limbs appears – more of them – perhaps indicating two figures, two women, not one. Test this viewing procedure on other nominally abstract works and the results may well be similar. In de Kooning's art, the vague sense of a body remains vague but also, strangely, becomes clear. Once we notice it, this representational quality grows insistent, perhaps at the expense of the abstraction. De Kooning's use of squarish formats (most often in the proportion of 8 to 7) facilitated his shifting from vertical to horizontal and back, as if he had doubts about committing to a proper orientation. With each rotation he would conceivably have been changing one figure (vertical) into two (horizontal), or two into one. When the longer dimension, 8, is not so different from the shorter, 7, a vertical orientation seems very like the horizontal. So one figure readily slips into two, and two slips back into one.

38 *Police Gazette*, 1955, oil, enamel and charcoal on canvas, 109.9 × 127.6 cm. Private collection.

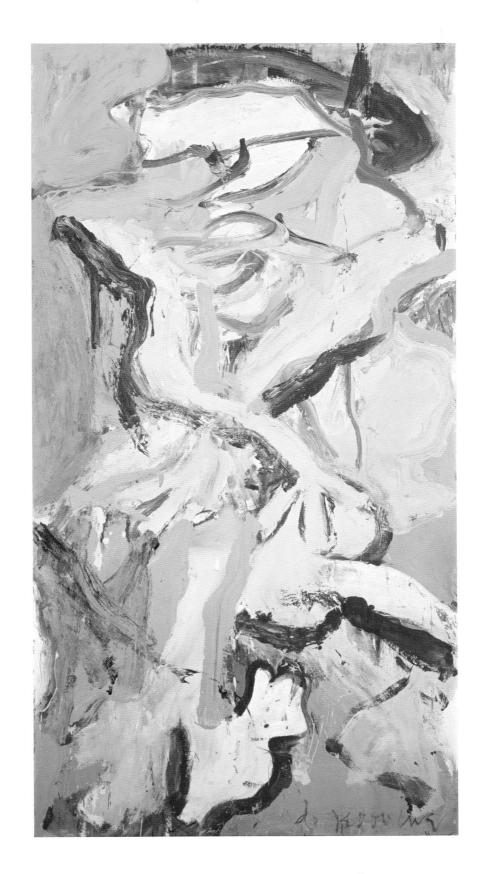

39 *Untitled*, 1970, oil on paper on canvas, 180.3 × 93.4 cm. Private collection.

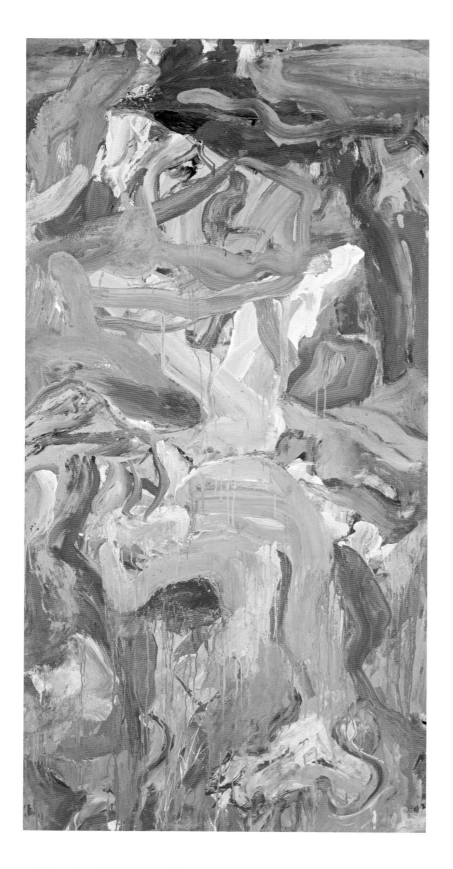

40 *Woman in a Garden*, 1971, oil on paper on canvas, 184.2 × 91.4 cm. Private collection.

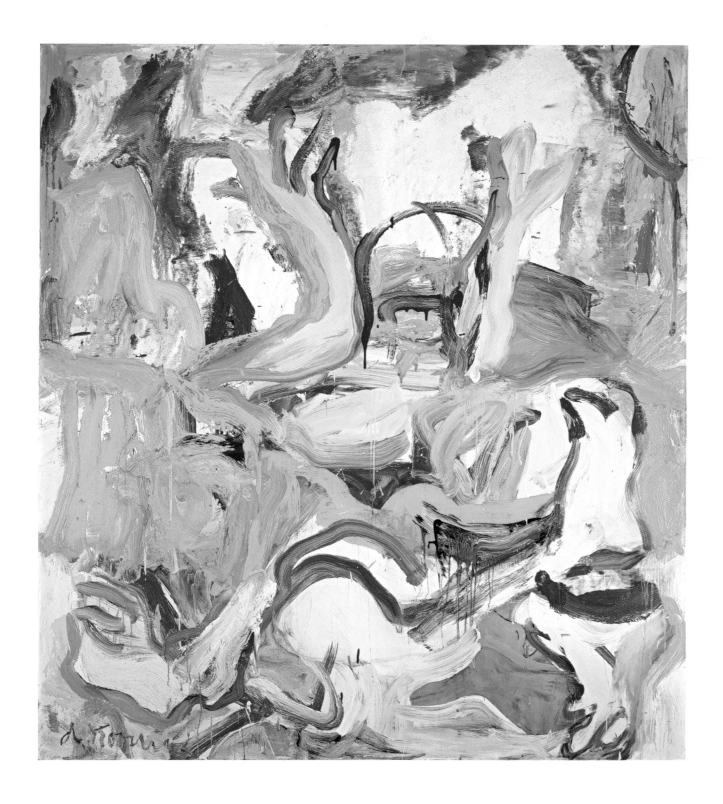

41 *Amityville*, 1971, oil on canvas, 203.2 × 177.8 cm. Private collector.

The paintings known as 'landscapes' or 'highways' are the most remote from human anatomy. They were inspired, de Kooning said, by the experience of being a passenger in a car, watching 'the metamorphosis of passing things'.[226] From the moving car, nature itself was slipping – slipping by the painter's point of view in a way that particularly pleased him. He sought the sensation of slipping not only through rotations of his format and observations conducted under conditions of movement, but also in the tactile feel of his moving paint medium. This was the most immediate and intimate form of slippage. With a novel mixture of oil and water, de Kooning contrived to maximize fluidity. He got his paint to *feel* slippery, so it would *look* slippery – a case of the convergence of the senses, or (like Cézanne) of putting feeling before seeing to redress a hierarachy of habit that interfered with sensation. De Kooning slipped as well by setting his body off its steadying centre: 'When I am falling . . . when I am slipping, I say, "Hey, this is very interesting."' The format slipped; the view slipped; the paint slipped; the painter slipped. Famously, he called himself a 'slipping glimpser'.[227] To have the sensation of slipping and falling while seeing: this guarantees a changing art (see also below, 'Slip').

With all the change, the feel of a body, the physicality of the representation, remained a constant in de Kooning's art. Accordingly, the poet John Ashbery identified the grand 'highway' and 'landscape' abstractions not only as 'topography' but also as 'woman looked at too closely to be legible as such'.[228] The landscape was in the body, and everything was resembling everything else. If what Ashbery wrote has no direct logic, it nevertheless mimicked the metaphorical logic de Kooning had conveyed to Hess: *Woman I* had 'arms like lanes and a body of hills and fields . . . like a panorama squeezed together'.[229] Ashbery's version of this notion feels right. De Kooning said that he wanted big things like the landscape to look small – landscape reduced to Woman.[230] He kept a reducing glass in his studio to assess his large paintings, which had the qualities of some of his smallest paintings and drawings.[231] He was abstracting in reverse. A passing glimpse of flesh is small. A passing glimpse of paint is also small: how much can you see just in passing? In this respect, the view from the highway, the view of the body and the feel of paint are exchangeable, if not the very same – touch by touch, mark by mark.

Flexible

Painter and writer Louis Finkelstein, an occasional visitor to de Kooning's studio around the time of *Excavation*, evaluated his enterprise not long after he had completed this grand abstraction. Finkelstein knew from observation that in its early stages, *Excavation* had contained images of Woman; he distinctly remembered the presence of two or three figures.[232] He may also have been aware that de Kooning painted Woman throughout the time of abstractions like *Attic* and *Excavation* and had just returned to Woman in a major way (the result would be *Woman 1*). Reflecting on his experience, he offered a critical proposal: 'De Kooning can hardly be called a representational painter in the ordinary sense of the word . . . Instead of painting objects, he paints situations . . . What binds his pictures together is a sense of gesture, of dramatic purpose animating all the picture elements.' It was a good solution: call the pictures 'situations'. Or 'contexts': 'We never see what [an object] actually is, but only what it lends of itself to a given context. It is as if de Kooning were painting the context.'[233] With its existentialist aura, the term *situation* was the better option. It would suit both of the rival critical categories, abstraction and representation. (I myself resort to *situation* as an appropriate word; our context continues to encourage it.) Taking cues from de Kooning's doubts, Finkelstein referred to the continuity of the studio process, its succession of states of transience; with respect to this instability, classifying the final product would have been unilluminating.

In February 1950, deeply into *Excavation*, de Kooning spoke at the artists' club known as Studio 35, where he addressed a friendly audience of New York School colleagues. His statement, 'The Renaissance and Order', may have puzzled those present who knew his work primarily through the black-and-white abstractions of his 1948 exhibition. This presumed abstractionist, coming before a forum of fellow abstractionists, chose to praise representational art at its acme in Renaissance painting. Painters of the Renaissance, de Kooning argued, were neither academic idealists nor academic realists; they produced a thoroughly subjective image, its measured forms being independent of any objective science. It seems that Renaissance renderings could change just as arbitrarily as de Kooning's own, despite what appeared to be an orderly perspective. Given the public for his statement, de Kooning was sending out barbs in two directions, targeting two different types of abstract artist: to those who prided themselves on their expressive subjectivity, he implied that their originality was overrated; to those who were discovering universal, objective value, he indicated that their aim was misguided. The Renaissance artist 'shifted, pushed, and arranged things in accordance with the way he felt about them . . . In those days, you were

subjective to yourself, not to somebody else.' Renaissance order was personal and idiosyncratic. An artist would understand the face he was painting 'because he himself had a face'. The artist was the measure – an arbitrary, accidental one. De Kooning concluded his talk with an anecdote about a 'village idiot' obsessed with measuring, because the practice offered certitude. When this man observed himself, however, he discovered nothing final or fixed but only that 'his length changed'.[234] Relative to what? Presumably, like a painter with a brush, the change would be relative to the measurer's feeling for the measuring stick. Perhaps he, or it, was slipping.

Representational practice – drawing and painting to take the measure of things seen – reinforced a certain humility in the Renaissance artist: 'The marvel wasn't just what he made himself, but what was there already. He knew there was something more remarkable than his own ability.'[235] De Kooning's moral: an artist should appreciate the ordinary things that already exist; invention and fantasy are hardly required. A year later the same sense of banal representation became the theme of another of his public statements, this time for the Museum of Modern Art symposium on 'What Abstract Art Means to Me'. At this point de Kooning had finished with *Excavation* (May 1950: he stopped) and was involved with *Woman 1* (June 1950 and forward). His shift in practice – dramatic, but only one of many analogous changes – hardly affected his message. He stressed the painter's need to observe the little things 'already here', the very real things that kept slipping by one's eyes and through one's hands. Abstraction was 'extra' (compare above, 'Nothing'): '[In art] the idea of abstraction became something extra . . . For the painter to come to the "abstract" or the "nothing", he needed many things. Those things were always things in life.' De Kooning meant that abstraction in art was the insubstantial thematic or conceptual element that could be grafted onto a more straightforward representational practice – its essentialism was inessential, 'extra'. But by the twentieth century abstraction had evolved into the dominant presence. This 'extra', this 'nothing', came to be identified with highly generalized aesthetic concepts such as beauty, form, space and balance; and painters enlisted pure geometries of 'circles and squares' to convey the conceptual content.[236]

De Kooning was dubious. He had previously remarked with regard to Mondrian: 'A picture to me is not geometric – it has a face.'[237] He was responding indirectly to Greenberg. In 1949, probably already feeling uneasy about de Kooning's unabated interest in figure painting, Greenberg warned him that it was now impossible to paint a face; for ambitious artists, history had made abstraction inescapable, the only proper choice. This was not a theoretical principle but Greenberg's empirical and pragmatic realization: paint no more faces. De Kooning undercut the argument in his typically transversal

manner: 'That's right, and it's impossible not to' – you do not plan on representing a face, but a likeness appears nevertheless.[238] De Kooning also objected to the idea of using a negative (no faces) as what certainly seemed to be a principle, an order, the critic's attempt to shape practice by prohibiting some aspect of it.[239] These thoughts accorded with his way of divorcing Renaissance art from any exclusive canon of beauty; he associated the Renaissance portrait with the banality of a type of self-portraiture – representing the human face on the basis of the experience of your own. Nothing should be excluded as a possible face. Art was as ordinary as being yourself. What, then, could 'abstract art' mean to the creator of *Excavation* and *Woman 1*? 'If I *do* paint abstract art' – he did not say that he did – 'that's what abstract art means to me. I frankly do not understand the question'.[240] Representation and abstraction were the same to him. A circle was a face was a circle, and whichever thing it was, it was ordinary. Yet this realization of the ordinary was a marvel. Asked around the time of *Woman 1* what he had been doing of late, de Kooning replied: 'Oh, well, I suppose I've been doing stuff to make the other guys furious.'[241]

Such was the social and intellectual context of de Kooning's practice around 1950. What was the *situation* of an individual work? How did the mix of representation and abstraction *feel*? As Finkelstein recalled, de Kooning had launched the abstraction of *Excavation* from a base in representation. And then it must have changed. The positioning of two or three vertical figures in a horizontal format of this type is easy enough to imagine. But a more concrete trace of the past of *Excavation* exists, albeit small, along the bottom right edge of the canvas. At some stage de Kooning masked this edge with tape. After removing the tape, a narrow strip of incongruous colour remained – we see it today – slices and bits of saturated greens and blues unrelated to the light, warm hues elsewhere. For de Kooning in 1950, these greens and blues were the colours of landscape and water. This residue of colour anchors what the painter once said of *Excavation*, that – whatever else it was – it was inspired by the contemporary Italian film *Bitter Rice*, which happens to be a story about women in a landscape with water (labourers in flooded rice fields). De Kooning recalled that the scenes of workers digging into the wet earth had particularly impressed him.[242] Silvana Mangano, the female lead in this cinematic critique of post-war social conditions, must also have impressed the painter. The image she projected would have attracted him for its sexuality, but perhaps all the more as an aesthetic and cultural ambiguity: the glamorous actress, an accomplished vocalist as well as a pin-up type, was representing the working class and the dispossessed. Despite the neorealist designation for director Giuseppe de Santis's genre of filmmaking, *Bitter Rice* was pure Italy as pure Hollywood, complete with numerous tracking and panning shots of young women's bodies.

Bitter Rice appears to have been but a piece of the *Excavation* puzzle. There was also a factor of whatever-else-it-was. A recent study acknowledges *Bitter Rice*, but then relates the forms of *Excavation* to imagery from Picasso, Titian and Pieter Bruegel the Elder's *Triumph of Death*. Like all evidence in the service of interpretation, whether visual or verbal, the accumulation here remains circumstantial. The examples from Picasso, Titian and Bruegel share themes of suffering, violence and death, in which de Kooning apparently took interest. More specifically, Elaine de Kooning recalled that her husband showed her a black-and-white reproduction of Bruegel's *Triumph of Death* when they were in the studio shortly after he ceased work on *Excavation*.[243] So, if all the evidence is reliable, de Kooning told Elaine one thing; and then, some years after the fact, he told another thing to curator Katherine Kuh, who had arranged details of the acquisition of *Excavation* by the Art Institute of Chicago. We owe knowledge of the *Bitter Rice* connection to her. All this is puzzling, but everything may be in order – or in the disorder proper to de Kooning. The use of diverse pictorial sources, a collage of disjunctive imagery, was typical of him. He was proud to be 'eclectic', passing from one impulse to another.[244]

In *Woman I*, painted immediately after *Excavation*, a female figure with greens and blues, the landscape and the water, returns.[245] The greens and blues at the base of this picture caused one of de Kooning's friends from Holland to recall an old Dutch song about a woman and a brook. De Kooning was amused by the accuracy of the reference: '*Woman I* . . . reminded me very much of my childhood . . . It's just like she is sitting on one of those canals there in the countryside.'[246] At one stage in its progress of back-and-forth, forth-and-back, *Woman I* may have been wearing either a Dutch bonnet or an Italian field worker's sun hat.[247] At the arbitrary point at which de Kooning stopped, it seems that *Woman I* had acquired, or was retaining, features that had once been intended for *Excavation*, at least at its inception. De Kooning referred to *Bitter Rice* (women in water) as the 'idea' for *Excavation*.[248] Or, to avoid this degree of conceptualization, I would rather say, not the idea for, but the start for the picture, a first sense of its feel, a feeling the artist wished to pursue in paint. Apparently, he ended with the *Triumph of Death*. *Bitter Rice* in Italy, Bruegel of Antwerp going to Hell, Woman of Rotterdam by a country canal: representation, abstraction, representation, abstraction, representation. 'I can change overnight', de Kooning said.

A certain type of theorist might have appreciated de Kooning's attitude, even though it frustrated critics of the day in search of a reliable classification; and even though it frustrates scholars now as they seek definitive sources for his imagery. Had de Kooning known his fellow

European émigré Theodor Adorno – I imagine them together at a Manhattan gathering of artists and intellectuals with Greenberg as the go-between – the one might have appreciated the other. In an essay of 1954 on how to watch television, a cultural distraction that occupied de Kooning as much as any, Adorno inadvertently indicated the social value of the painter's inconstancy:

> Since stereotypes are an indispensable element of the organization and anticipation of experience, preventing us from falling into mental disorganization and chaos, no art can entirely dispense with them. [The] functional change is what concerns us. The more stereotypes become reified and rigid . . . the less people are likely to change their preconceived ideas with the progress of their experience. The more opaque and complicated modern life becomes, the more people are tempted to cling desperately to clichés which seem to bring some order into the otherwise ununderstandable.[249]

Like de Kooning, Adorno indicates the value of a capacity to change. Accept the stereotype to the extent that you must, but without allowing it to become an utter cliché. In de Kooning's terms, accept the traditional pictorial themes, but do something to liberate them from your own expectations. Adorno saw the danger of the stereotyped conventional image, but also its need. Total negativity, followed as a principle, would be counterproductive. For de Kooning, analogously, it was impossible not to represent a face. To adopt a principle of abstraction, suppressing the natural tendency toward organic metaphor, would amount to blind dogmatism – an extreme position for the sake of being extreme. A face or figure appears if only because the artist needs something with which to start and then hold on to. 'I have a green that's just like water; now I have to push it to the abstract, and then it can be water again.'[250] The attitude was not restrictive but liberating. De Kooning's necessary bit of ordinariness could be a colour, an iconic woman, a bit of lettering or the tracing of a fragment of the previous day's work.

Rather than fold under the pressure of what Adorno called the 'ununderstandable', de Kooning tolerated it, may even have enjoyed it. He remained free of systems of control arbitrarily established. Like a Renaissance portraitist taking his own measure, de Kooning followed *his* sense of the arbitrary and remained unaffected by all others: social ideologies, cultural conventions, intellectual fashions. Hardly a political type, perhaps he was oblivious to the social significance of the example he set. His shift from *Excavation* to *Woman 1* demonstrated how to be flexible in thought and feeling. He embodied the 'functional change' that was Adorno's concern. His fellow citizens of the

conformist Cold War era might have learned to be less self-certain had they felt the doubt this working painter was feeling. To recall the thinking of Peirce: 'When a disturbance of feeling takes place, we have a consciousness of gain, the gain of experience.'[251] De Kooning was offering to revive experience – first for himself, then for anyone who would pay attention. His art encouraged flexibility, opening people to being disturbed, to being moved, to feeling their own feeling.

Identity

De Kooning found far more value in the suggestion of possibilities than in reaching the final delimitation of a form. He undermined hierarchies, any sense of logical development and the notion of advancement. In his later years, he tended to express his attitude in the reduced form of aphorisms: 'If you want to do something extraordinary . . . try doing something very ordinary.'[252] He thought the idea of an avant-garde, progressive by definition, was silly, as was avant-gardism with respect to political or social organization. Because de Kooning is now such a known quantity, art historians may not notice how deviant his practice was. He had dodged categories around 1950, when his work kept slipping out of them, neither quite the abstraction some critics expected to see, nor quite the figure painting others would have preferred. During the course of the 1950s, the situation became clearer, though this was not de Kooning's aim. He became famous as the painter of Woman, and in particular as creator of one of the canonical images of modern American art, *Woman 1*. In effect, *Woman 1* created de Kooning – the de Kooning we come to know when we consult the historical surveys. Collectively, these studies have solidified an identity that the long-lived artist continued to work against. To regard him as a painter of the body was, and is, as correct as anything; and female bodies outnumber male bodies in his oeuvre. But it was identity itself that irked him, being labelled one way or another – even if more or less correctly – with the implication that you would be betraying your identity if you failed to maintain it. With identity, you become a sign in the public domain. You can be read, interpreted and imitated. You can even be falsified.

Critics obsess over identity. Whichever way a critic is inclined, de Kooning's personality – its projection through his way of life, his art and his critical pronouncements – complicates any evaluation of his nature. His actions encouraged contrary assessments. Many viewers considered it obvious that his energetic, expressionist style, in both abstract and representational imagery, must indicate more than the glib speed that Farber perceived

in 1950. Not glib, but angry, even violent. The impression of speed was correlative to the intensity of the violence. Here was an artist who presented himself as a very ordinary type, identifying with the common man and joking around a lot. Yet to many his art seemed angry, at least when dealing with Woman. Why was he, or his art, so agitated? Perhaps he was adept at representing the conventional signs of psychic disturbance while nevertheless of a different temperament and fully in control of his effects. This would make him an expressionist in style only, not in temperament – someone acting out an American social problem in which he may not have participated directly. An expressionist-in-style-only might connote violence to expose a hidden social pathology beyond his individual person. As the painter of Woman, de Kooning may have been reflecting – some would assume it was conscious, others unconscious – a rampant misogyny within American society. The suppression of overt signs of the collective dysfunction contributes to maintaining the condition, while an artist's expressive gesture acknowledges the undesirable social reality. By exhibiting his paintings of Woman, de Kooning (whether intending it or not) was confessing to the American woman problem (whether a part of it or not) and presenting it for free critical discussion. It could be argued that a painting like *Woman 1* demonstrated de Kooning's subtle resistance to the social disorder, exposing its truth in a parody of visual violence – the violence done to ordinary bodies when presented as ideal, ideologically charged stereotypes. There are other, more convoluted possibilities to be imagined. Each social interpretation generalizes, removing our emotions ever farther from the experience de Kooning was undergoing as he developed *Woman 1* over a period of almost two years.[253]

If we take de Kooning at his word in 1964, a decade after *Woman 1*, it seems that his personal choices facilitated every conceivable interpretation, most of them inadvertent: 'In a way, I feel the *Women* of the '50s were a failure. I see the horror in them now, but I didn't mean it. I wanted them to be funny and not to look sad and down-trodden like the women in the paintings of the '30s, so I made them satiric and monstrous, like sibyls.'[254] Hess, intimately familiar with de Kooning's process of representation, resisted interpreting the series of increasingly notorious images of women as expressions of misogynist hostility; like the artist, he perceived the comedy. A de Kooning Woman was a parodic inversion of the typical advertising image of the all-American girl, where the female body assumed its most culturally sanctified form.[255] If there was a politics to de Kooning's Woman imagery, it inhered in his wilful transformation of the postwar American ideal of ordinary beauty. His imagery is not anti-woman but anti-conformist, that is, anti-cultural. Yet it is not countercultural; if it were, it would belong to another culture. To a great extent, de Kooning, saturated with cultural allusions, was culture-free.

As we know, after the 1950s Woman imagery, came urban and suburban 'landscapes', such as *Gotham News* (illus. 42) and *Montauk Highway* (see illus. 18). Lacking a central, frontal figure that would suggest the representation of a body, these works resembled expressionist abstractions; their movements proceeded without the restrictions of mimetic demands. De Kooning's assessment of the loosest of his broad-brushed abstractions of the late 1950s invoked early failures at representation: 'I was never good at landscape as a young man . . . You have to find a substitute or imitation to really see the real thing . . . All the images inside [me] are from nature anyway.'[256] As he had explained to Hess in 1953, it was all the same as far as he was concerned – Woman, landscape, abstraction: 'The landscape is in the Woman, and there is Woman in the landscapes.'[257]

Hess was a good listener for de Kooning, willing to accept his thoughts and extend them through his own, often very similar, metaphors. Greenberg, not so much, not such a good listener: 'Even in 1948, when he wanted to applaud Bill, I don't feel he really liked him.'[258] An intimate, insider's view of de Kooning held little attraction for Greenberg; what mattered was the overt image and the terms of its reception. To understand the latter, however, required having an insider's view of postwar American society, its collective psychology and system of values. When Greenberg reviewed de Kooning's abstractions in 1948, he undermined in advance the potential complaint that abstract artists of this ilk lacked a traditional painter's skills. De Kooning was resisting the comforts of his hand for the sake of a higher form of human feeling:

> Emotion that demands singular, original expression tends to be censored out by a really great [technical] facility, for facility has a stubbornness of its own and is loath to abandon easy satisfactions . . . There is a deliberate renunciation of will in so far as it makes itself felt as skill.[259]

Greenberg implied that de Kooning should be credited for having struggled through a conflict of will over the way things were – 'easy satisfactions' of a material kind – versus the way they might be – 'original expression' of an emotional kind. It was typical of the critic to set up this kind of opposition.

Not long before, in 1946, Greenberg had dealt with three roughly parallel cases, although they were well-established figures from an earlier era: Cézanne, Vincent van Gogh and Henri 'Le Douanier' Rousseau. In their different ways, they too seemed to avoid technical perfection, but not so wilfully as a later figure like de Kooning.[260] Each came up short according

to prevailing standards of draftsmanship and painterly finish, yet each forged ahead as if oblivious to the failings others perceived. I think of them as precedents for de Kooning not only in this regard, but also because each had a similarly conservative respect for the achievements of an eclectic group of past masters. Paradoxically, to judge by the look they achieved, established standards had little influence on them: Cézanne, too coarse a paint surface, strokes overly disjunctive; Van Gogh, paint applied too thickly; Rousseau, contours rendered too crudely. For a range of reasons, the more flexible modernist critics (not necessarily the greatest intellects) accepted the work of all three artists, sometimes featuring them together in a single piece of writing.[261] This is where Greenberg enters the argument. With the formal merits of the three early modernists having already been demonstrated by specialists of an earlier generation – Roger Fry praising Cézanne, for example – Greenberg accepted the challenge of accounting for the breadth and depth of these three painters' recent public acceptance, especially Rousseau's, who seemed to appeal to avant-garde and bourgeois taste alike.[262] Greenberg sought the social condition that would account for the three pioneering modernists appearing equally prophetic of the art of their future. In other words, why had these three proven so influential? De Kooning arrived as the human proof – a postwar master whose release of pictorial emotion dominated a display of technical skill that would have been all too easy for him to feature. In his account of Rousseau and the other early modernists, Greenberg prefigured de Kooning's coupling of high emotional impact with eccentric, seemingly deficient technique.

In 1953, when de Kooning showed his new Woman series rather than a group of new abstractions, Greenberg remained for a while in the painter's camp, agreeing to compose an appreciative introduction for the exhibition. But in 1955, as we know, he went public with his disappointment: 'I happen to find de Kooning's *Women* pictures inferior by and large to his previous work, but that's an *ad hoc* judgment that has nothing to do with anybody else's figure paintings.'[263] He was tacitly retracting statements he had made not only in 1948, in response to the artist's first one-person show, but also for the show of 1953. In 1948, Greenberg stressed de Kooning's identity as 'an outright "abstract" painter' who used black as a strategy ('refined himself down to black'); this was particularly effective in the case of a painter having a 'lesser gift as a colorist'.[264] To the contrary, in 1953, he described de Kooning as an underrated 'colorist' who also 'wants in the end to recover a distinct image of the human figure, yet without sacrificing anything of abstract painting's decorative and physical force'.[265] This phrasing constitutes the critic's attempt to make the most of an unfortunate turn of events. With regard to aspects of de Kooning being 'underrated', Greenberg might as well have been criticizing himself, but was not.

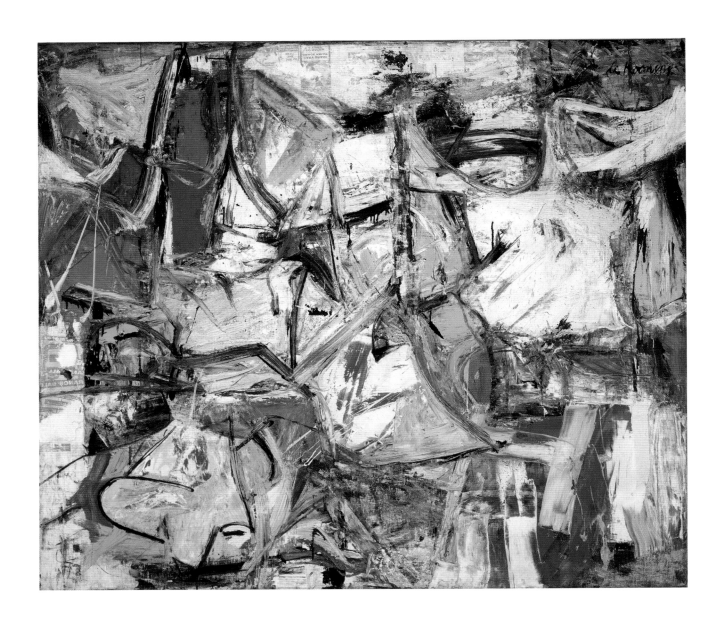

42 *Gotham News,* 1955–56, oil, enamel, charcoal and newspaper transfer on canvas, 175.3 × 200.7 cm.
Albright-Knox Art Gallery, Buffalo, New York.

Underlying Greenberg's evaluations was his sense of a cultural war being fought between those who confront the taste of a philistine public and those who appease that taste ('original expression' versus 'easy satisfactions'). Around 1950, figuration appealed to the philistines, while abstraction confounded them. Philistinism was an avant-garde phenomenon as well as a bourgeois phenomenon. Greenberg knew that an artist could appease bad taste and yet make a progressive aesthetic advance: Rousseau had done this. Arising from this perverse cultural situation was the craziness, the paranoia, that Greenberg discerned not only in Rousseau, but also in Cézanne and van Gogh. These representational painters lived before the advent of abstraction; for them, the matter of choosing a subject might have been complicated in a personal sense but was unproblematic within the culture at large. It was simply expected. Greenberg believed that in de Kooning's case, as opposed to Rousseau's, a genuine choice could be made. With the choice came a possibility of moral failing. Having struggled over abstraction, de Kooning appeared to have taken the easy way out by his return to the human figure. We can explain Greenberg's increasingly harsh judgement of de Kooning as the critic's sense that the painter was acting in bad faith. He was consciously giving the public what it already knew and wanted – historically, the wrong choice.

Yet Greenberg did see some continuing merit in de Kooning. After all, with respect to appearance, his Woman hardly offered what the public wanted. She lacked the good looks of Silvana Mangano. *Woman I* was no fantasy woman; the figure showed the material reality of paint. In 1955 Greenberg credited de Kooning with being the only artist at that moment to advance the formal discoveries of cubism. Such praise could only be double-edged. De Kooning's 'Late Cubist' rigours of form, Greenberg suggested, worked to 'reassure' the knowledgeable public that his 'savage dissections' of the human figure still belonged to a painting tradition with a viable structural logic. Here, the identification with violence – 'savage dissections' – took a historical turn to aesthetic non-violence. Within the context of this characterization, it is not a body that becomes mutilated but a picture – dissected in the analytical sense that cubist practice tore apart the conventional signs of pictorial unity, such as linear perspective, which had been developed to work in tandem with referential representation: pictures had perspective, just as nature had perspective. Cubist practice replaced these conventional unifying systems with newly fragmented elements of structure, unifying only in a pictorial sense. In 1950, this condition of fragmentation appeared far less violent than it had in 1910; viewers had become conditioned to the new condition (by Peircean Habit, as it were). Despite his analytical, compositional savagery, on balance de Kooning served the conservative end of taste by holding to the past rather than projecting the future:

If de Kooning's art has found a readier acceptance than most other forms of abstract expressionism, it is because his need to include the past [humanistic figuration] as well as forestall the future [maintaining cubist practices] reassures most of us. And in any case, he remains a late Cubist.[266]

This was de Kooning's historical identity, if not a personal one.

Projection

Today it may seem irritating, or at least odd, for a critic to refer to an artist's 'savage dissections' of what appears as a woman's body, without immediately appending commentary on psychoanalytic or gender factors. We expect such considerations, quick to join those of de Kooning's time who regarded his art as the reflection of misogynist America and the hypermasculinity of Cold War posturing.[267] We can page through the various possibilities of cultural critique to be derived from regarding *Woman I* as a symptom of something systemically amiss in the social order. The example of de Kooning then becomes one sign among many. If a male artist appears to be 'dissecting' a female body, we ask whether the motivation would have been fascination and desire or anxiety and hostility – these may be the most obvious interpretive choices. The question that follows is whether the particular manifestation of the psychopathology speaks only of this individual or of the entire society. Either way, we fall into projecting.

It can be sobering to take de Kooning at his word. In 1971, he told Rosenberg that if he actually were a misogynist, 'I wouldn't show it off in my paintings.'[268] He had a point: friends of the small-town murderer or rapist invariably say they had no suspicion, no clue. The perpetrator of a serial crime does not advertise his criminality. In 1975, de Kooning registered an elaborate complaint:

> People don't see the humor in my 'Women.' They talk too much
> of their tragedy and violence. As for me, I've found them comical,
> but with a bit of pathos because they're so ugly. I had the same
> attitude that a caricaturist has. You know that I've always loved
> comic book art. It's both true and funny, serious and silly.
> My 'women' are like caricatures. I'm not a misogynist and I've
> never had problems with women. Many of my paintings of
> women have been self-portraits.[269]

And a decade earlier, having been asked to comment on his Woman image, he also gave it a bemused, parodic content: 'He calls them "cousins" of billboard bunnies and film frails, but they also will remind him of a girl who passed by in the street.'[270] Whether it was violence acted out, American beauty parodied or just a visual joke, the final gesture had been directed by the artist for himself, against himself: on the one hand, he 'wouldn't show it off'; on the other hand, it was a revealing 'self-portrait'; and, one way or the other, it was merely his passing view of a 'girl in the street'.

Commenting on himself, de Kooning typically presented a slew of interpretive paradoxes. 'I wouldn't show it off in my paintings', he insisted. Fighting fire with fire, his critics countered with interpretative gestures premised on the notion that an artist's actions and images reveal not only what he wishes to show but also what he would hope to conceal, no matter what the ratio of conscious to unconscious expression. Criticism treats works of art as personal and societal lie detectors. The truth of the artist – his or her psychology, cultural formation, fantasy life – all comes out.

Interpretation identifies a painting or any made thing, any fiction or manufacture, as if it were a text that speaks of its maker and its context. Pursuing such interpretation, 'we take the *fictional* text to be *nonfictional* relative to the culture'.[271] How ironical: who is the critic – who are we – to presume to read an artist's signs, either as truths or as falsehoods that reveal deeper truths through lying? Even the plainest of utterances leaves us with a troubling question from Wittgenstein: 'Imagine that someone unconscious (anesthetized, perhaps) were to say "I am conscious" – should we respond "He ought to know"?'[272] Rather than investigating the ways in which a particular representational fiction might reflect a preexisting condition in a person or a society, we stand more of a chance as interpreters when we probe the effect of this fictive thing within our encounter – how it alters our mentality as we perceive it, as we bring ourselves and our cultural formation to the work in question. The encounter has the potential to reveal more about our own fictive reality than about the other's 'hidden' truths. Our interpretive (re)invention of the other's fiction manifests no more than our mentality, unless ours happens to correspond to the other's, whether by cultural proximity or historical coincidence. The fiction is ours first. Here I merely validate the experiential specifics of art criticism over the theoretical generalities of cultural criticism. There ought to be a way of doing better on the cultural criticism side of the interpretive enterprise. A de Kooning-like intellectual modesty and self-doubt would help.

One of the motifs of historical accounts of twentieth-century American culture during de Kooning's lifetime was the changing social mores and status of women. There was a 'woman problem' in American culture, but

not necessarily a condition to cause grave concern. On the contrary, many
of the popular accounts – perhaps in recognition that the audience for a
particular publication was at least half female – converted the state of the
woman problem into a moment to celebrate. The lot of the American woman
(the argument went) had progressively improved as various restrictions
on activity and standards of comportment ceased to matter. The issue of
Life for 2 January 1950, to which de Kooning referred in his lecture 'The
Renaissance and Order', presented a variant of this story but from a self-
declared 'prejudiced writer' – or, to use the terminology of the following
decades, a male voice, distinctly patriarchal.[273] Americans remained
hypersensitive to a range of indications of gender difference and quick to
pass judgement on appearances. Any but the most banal of images of
woman were likely to elicit comment, so the provocative disagreeableness of
de Kooning's *Woman I* became a magnet for this sensitivity.[274] To use a less
clichéd metaphor, *Woman I* was an outlet into which cultural critics could
plug their preferred notions about the sexuality of women and their place in
the social order. The painting was there to receive and satisfy both male and
female fantasies about social exchange between the sexes as well as a transfor-
mative exchange of gender roles. For de Kooning, the Woman figure may
have been 'the woman in *me*', as he told an interviewer in 1956: 'Art isn't a
wholly masculine occupation.'[275] He also said that he would like to experience
being a lesbian.[276] He was fantasizing making love to a woman *as* a woman,
as if to double down on his imaginative entry into the body of the other sex
– the other not so much as the missing part that would make him whole
(too metaphysical a notion), but as an alternative to what he was, providing
a different range of sensation. This was either a statement of profound
empathy or mere lust. We have no reason, other than our current prejudices,
not to accept the strong possibility of the former.

 When de Kooning began to exhibit his Woman paintings of the early
1950s, some critics spoke of the pictures as if they had come alive like pagan
idols. The writers could not resist personifying. With psychological projections
of their own fantasy, they fetishized the Woman even if de Kooning himself
did not. Fetishization was not the only obvious interpretive possibility in
relation to the social context. As I have suggested, de Kooning's cartoonish
Woman could be seen as a parodic critique of American postwar conformity,
with its advertising image of the all-American girl: part pin-up, part cheer-
leader, part housewife, part mother. This was the view of Hess and also
Elaine de Kooning, more intimately informed and more sympathetic
commentators on the artist than Greenberg was.[277] In the same vein, Ashton
considered the later Woman images, those of the 1960s, as 'high parodies'
loaded with visual puns on the canonical postures of pin-up girls, which,

after all, derived from high art.[278] The typical pin-up image was a form of advertising, not so much promoting the starlet depicted, but rather the commercial enterprise that offered the image as an inducement to maintain its company name in view (as on a calendar). Pictorial advertising is inherently parodic, a populist, bourgeois revenge on elitist art – bourgeois imagery created for the bourgeois class by the bourgeois class, with the elite claiming the bulk of the profits.

Interpretations of the figure of Woman, whether they turned psychological or sociological, hardly interested Greenberg. He directed his analysis to the immediate materiality of de Kooning's painting rather than to the sexuality and pop-culture references of its subject. Like a good cubist, his de Kooning 'dissected' form and composition, but left untouched the imaginary social body with which most viewers, male or female, were identifying. When Greenberg commented on late cubist form in 1955, he was implicitly resisting opinions like that of fellow critic James Fitzsimmons, who projected the 'savage dissections' onto specific anatomical parts. Fitzsimmons took representation seriously: each picture was as alive as a real person; at the least, his animated critical narratives made it appear so. He could not resist motivating the work. It seduced him by its psychological presence, which suggests that some kind of self-seduction was occurring – the writer was leaving himself in the control of his projected fantasies. It could be argued that all interpretation of images amounts to self-seduction – we convert the image into the realization of what we already believe must be reality – except in the case of genuine shock, when the experience of the art object (its sensation) breaks through the existing ideological orders of reason and fantasy. A state of self-seduction may take hold all the more readily when we acknowledge the art as a product of our own culture, made by a person whose motivation we assume we understand because he or she is a person much like ourself. We become judgemental and moralize.

When Fitzsimmons observed three conspicuous dabs of red paint on the torso of *Woman III* (illus. 43), he called them 'three bloody stab wounds on the chest'.[279] This is projection. Here was a sign of violence; Fizsimmons assumed that it must result from a deliberate act, even if only symbolic, like a fetishist doing violence to a sacred fetish object. Though he may well have been aware of it, he never mentions the possibility that de Kooning added the three red marks to enliven a part of the pictorial surface – not in aggression, hostility or anger, but as animating, painterly rhetoric. The critic's description is an odd combination of the literal and the metaphorical – perhaps not so odd, just confused, as if ignorant of the immediate implications. If the woman were viciously stabbed, according to the implied narrative, she ought to be reclining, not standing vertically or, rather, seated upright as her broadened thighs indicate she is. But with a de Kooning representation-

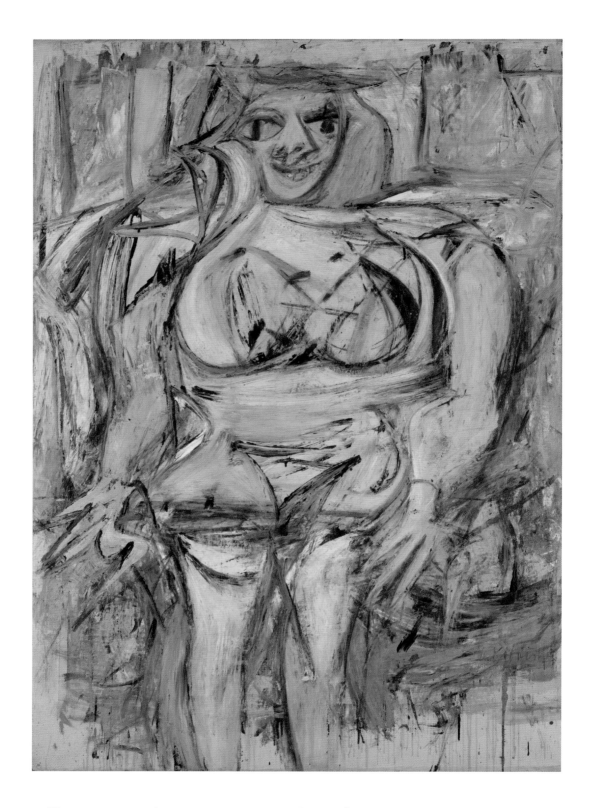

43 *Woman III*, 1952–53, oil on canvas, 172.7 × 123.2 cm. Private collection.

abstraction, it remains hard to determine what is what in any narrative order and easy enough to forget the paint, as Fitzsimmons did, converting its deposits into punctures in the 'skin' of the canvas. Fitzsimmons writes as if it is the artist, not the critic, who fantasizes the pictorial woman into living flesh, all the while attacking his divine creation. 'Look, de Kooning is wounding her with blood': these are Fitzsimmons's words as recalled by Grace Hartigan, a friend of both the artist and his critic. She strongly disagreed: 'The violence is in the paint. De Kooning's women are very loving . . . I have done a lot of painting in which I use teeth and it has nothing to do with wanting to bite anybody.'[280]

Though Fitzsimmons was more or less a fan of de Kooning's art, he never hesitated to express specific reservations: 'De Kooning is an obsessive painter and in this instance [a Woman shown in 1954], unable, it would seem, to lay down his palette knife, he almost worried the life out of the poor girl with it.'[281] Did Fitzsimmons himself entertain violent misogynist fantasies? More concerned with psychoanalytic speculation (both Freudian and Jungian) than with what he called 'academic criticism' – 'I am not a formalist', he said – Fitzsimmons aimed to write 'at the level of feeling'. 'Whatever I write will be about myself', he confessed to readers in 1958. What were the critic's feelings worth to others? They 'will have value, if any, only because I too am a human being and a fairly average one, so that what I will have to say about these paintings may also hold for others.'[282] We must all feel the wounds – if we are 'average' enough (or, in de Kooning's terms, ordinary). Sidney Geist, another reviewer, seemed to share in Fitzsimmons's 'average' opinion of the condition of women: 'In a gesture that parallels a sexual act, [de Kooning] has vented himself with violence on the canvas which is the body of this woman.'[283] This is fantasizing on the part of the writer – self-seduction, self-projection – a type of critical response that may have belonged more to the culture of violence than the art did. It exposes itself. At the very least, the critic shows himself to be conversant with – perhaps participating in – the presumed fantasies of the artist.

Fitzsimmons indicated that the implications of de Kooning's image of Woman for society were, or should be, frightening: 'I have heard her described as the American woman of the future . . . This female personification of all that is unacceptable, perverse and infantile in ourselves, also personifies all that is still undeveloped . . . It is to the unconscious (and to the American unconscious in particular, I fear) that [de Kooning's] *Woman* appeals.' Distancing himself from Greenberg's approach, Fitzsimmons added: 'It is exceedingly difficult to evaluate these paintings on a formal aesthetic basis.'[284] Greenberg found feeling (not enough of it) in de Kooning's painterly abstraction; Fitzsimmons found feeling (too much of it, or the wrong kind) in the representational reference.

Fitzsimmons's problem was twofold. First, by conventional standards de Kooning's mode of formal composition not only seemed 'obsessive' – would *excessive* be the more tempered term in this context? – but the Woman paintings also verged on incoherence. Incoherence in itself would not necessarily invalidate a work. For the sake of expressive feeling, critics tolerated signs of impetuousness and abandon in paintings of the 1950s. In fact, Greenberg had already observed an element of incoherence in 1948 where no figure had been apparent in de Kooning's imagery.[285]

Fitzsimmons's second issue was this: de Kooning's representations conveyed a psychological and physical 'horror' (the critic's word), which added significantly to the formal confusion, to the point, as Fitzsimmons said, that he could no longer pay serious attention to the form.[286] Greenberg was positioned to understand the unease Fitzsimmons experienced, for the terms of his criticism allowed him to explain de Kooning's art as an unfortunate aesthetic compromise between form and subject matter. I have noted ('Cézanne') that Greenberg eventually gave the condition of de Kooning's art a special designation, 'homeless representation', defining it as 'plastic and descriptive painterliness . . . applied to abstract ends, but which continues to suggest representational ones.'[287] This formulation implies that the figure of Woman interferes with the abstract material form of the painting, rather than the reverse. Allusions to the body reverse the direction of the violence, now suffered by the abstraction, rendered impure by the image of a woman. Fitzsimmons's attitude, if coupled with Greenberg's, completes a symmetry. When a critic regards three red marks as 'three bloody stab wounds', representational fantasies are spoiling the sensory appreciation of abstract art. Representation violates abstraction (the Greenberg plaint); abstraction violates representation (the Fitzsimmons plaint).

De Kooning had an all-purpose defence. For him, of course, the image of Woman was no fantasy but a real aspect of the painting he was creating. He was expressing his independence of the value being put on abstraction, which he accepted only as critical fashion. He refused to take a side in this war waged on behalf of an avant-garde in which he had no faith. He was merely being a painter, pursuing the course he chose to pursue, as he suggested in 1951, while *Woman I* was in progress in his studio: 'If you paint your whole life, you take that for granted, and after a while all kinds of painting become just painting for you – abstract or otherwise.'[288] He would never confuse the painting of a woman with a real woman nor the act of painting a woman with generalized feelings about women. He regarded his representational painting in terms of the experience of making it, eliminating much of the difference between abstraction and representation. This approach allied him with those who valued the expression of sensory experience through an engagement with the physicality of materials, no matter what the artistic subject.[289]

Here, as elsewhere, were political implications, though de Kooning probably had little direct concern. In 1958, the sociologist C. Wright Mills would cite the material experience of art as an antidote to the philistine consumerism and repressive conformity that characterized contemporary American life in the Cold War era.[290] In 1957, Mills's colleague at Columbia University, art historian Meyer Schapiro – who had encouraged de Kooning to exhibit *Woman 1* – wrote similarly of the cultural value of handmade aesthetic products.[291] And a decade earlier, in 1946, the point of Greenberg's discussion of Rousseau's crude but colourful style of painting had been to connect its popularity to the American public's desire for forms of direct experience that required little subsequent analysis. But the styles of Cézanne, van Gogh and Rousseau were extreme in this respect, and this led to their unintended effect on the culture of imagery: posthumously, these artists gave a sensory shock to twentieth-century viewers through colours and forms reduced to elemental qualities, so elemental that representation became abstraction. Greenberg suggested that a hyper-materialist art of this type – art that could be appreciated only by confronting and attending to its material, sensory qualities – would force bourgeois American viewers to confront in turn their shallow, consumerist brand of materialism.[292]

Splash

If Greenberg perceived a meretricious impulse in de Kooning's use of the human figure, a retreat from the position that even the unwilling Cézanne had long before attained, others questioned his material sincerity when he worked in what looked like a purely abstract mode, as in *Montauk Highway*. De Kooning kept switching his imagery – a way of demonstrating his continuing independence. Yet by the late 1950s, a significant number of critics and younger painters were arguing that his newer works, both abstractions and figures, lacked the intensity of his earlier ones.

Each work of the *Montauk Highway* type seemed to have been reduced to five or six sweeping strokes. De Kooning, whose hand was comfortable holding sharpened pencils and other refined instruments of representation, was using a broad six-inch brush.[293] Hess succinctly captured several possibilities by calling these works 'abstractions with wide landscape sensations', despite the fact that the large versions of the type were vertical in orientation and, although imposing in scale, not what would normally be described as wide – so it was the 'sensation' that was wide, like landscape abstracted, its panoramic width having been extracted, drawn out by de Kooning's brush.[294] Perhaps the painter was dodging social and psychological issues by escaping into spontaneity, absolute

immediacy – hence the appearance of speed and an attendant reductiveness, further aspects of the abstraction. He often insisted that a painter's concentration on the act of painting blocked all other considerations. Refusing any fundamental distinction between abstraction and figuration, de Kooning implicitly rejected one of the prime reasons to make an abstraction; according to Barr, an abstract work 'confines the attention to its immediate, sensuous, physical surface far more than does [representation].'[295] For Barr, as for many others around mid-century, what counted most was 'the primary reality of paint on canvas', however it became evident.[296] Even though Hess offered a cultural reading specific to de Kooning's *Woman* (parody of the ideal American female), and beyond that, enjoyed speculating on the political and social causes of general aesthetic trends, he claimed that the merit of any great painting – Titian was his example – would be discovered 'independent of references to anything except to its physical existence'.[297] We know how commonplace this notion was ('avant-garde'). An additional example from 1948: 'One of the stronger currents of abstract art today has become an obsession with the medium of paint itself for its internal dramatic possibilities.'[298] If the intense experience of material presence entailed a liberated expressiveness, so this material engagement led to psychological release and political and social freedom – all this was familiar in concept, whether or not practice confirmed the theory. Adorno, Mills, Schapiro, Greenberg, Hess, Rosenberg, Ashton: common knowledge. Such knowledge is correct by virtue of its commonness, correct by common consent.

Even if the value of de Kooning's art were confined to the immediacy of his mark, anyone who knew him would suspect that something more must lie behind the reductiveness of paintings like *Montauk Highway*. He was not one to finish an image quickly and easily. Finish itself raised difficult questions for artists concerned with spontaneity. To understand a work as finished would require a standard for artistic resolution, which amounts to a precondition; and preconditions defeat spontaneity. In April 1950, when a group of New York School artists met at Studio 35 to discuss this issue, de Kooning made one of his typical dead-end contributions: 'I refrain from "finishing".' In other words, resolution was not his problem; he had no desire to finish. Of course not: he just stopped. The refined technique of School of Paris painters, de Kooning believed, automatically brought with it a sense of finish as procedural polish: 'They have a touch which I am glad not to have.'[299]

Along with the 'fast' touch that was his, de Kooning also had delaying tactics. He would scrape down a painting whenever he felt dissatisfied with its progress; but, even when things were proceeding well, he might scrape down at the end of a working day to ensure a fresh start at the next session.[300] He might have laboured for months over a canvas that looked fast to critics

when exhibited. This is true of paintings of the *Montauk Highway* type; their outermost skin, seemingly fast and assured, records only a single day's work. Yet every erasure or removal of previous markings becomes part of an integrated template, either remaining visible – as in the bottom right corner of *Montauk Highway* – or guiding the forms above it, so that the formal benefits of a day's labour are preserved. The scrapings or erasures create a permanent gritty stain in either canvas or paper, like stains on New York's pavements, which de Kooning enjoyed observing.[301] The stain, a magical memory trace – both material and immaterial – was familiar to de Kooning from the commercial work he undertook during the 1940s, where he tested out images by drawing with inks that he could remove without violating the underlying pencil study.[302]

Especially when de Kooning used pencil or pastel on paper, his acts of erasure – smearing, smudging, rubbing – assumed the character of a positive gesture, a decisive move as fast in appearance as any of his techniques of marking. *Two Women* (illus. 44) and *Two Women* (illus. 45) are typical works in this respect, constructed as much from the removals as from the additions. Every element of de Kooning's technical practice, from the most positive to the most negative, can become its opposite: the marks are both direct and indirect, spontaneous and controlled. They changed their character as de Kooning twisted and turned them from concave to convex and back. In his view, to finish was to reach a satisfying condition of ambiguity.

In 1959, *Time* gave its review of de Kooning's current work an appropriately clever title: 'Big Splash'. The phrase captured both the look of the paintings and their effect on the market, for despite the exaggerated scale of these new gestures, they quickly sold out. De Kooning's success generated ambivalence, at least a professed ambivalence: 'There's no way of astonishing anyone any more', he told *Time*'s reporter, as if he felt disappointment: 'I'm selling my own image now.'[303] At this point in his career, aged fifty-five, the contrarian had to accept public acceptance. Critics were acknowledging him as the most influential member of his generation: 'Today young painters blow-up enormous pictures after a glimpse of small de Kooning sketches.' This was Hess's observation, as he concluded the first monograph written on the artist. It happened to use *Montauk Highway* as one of its illustrations and was published shortly after the exhibition of this painting in 1959.[304]

De Kooning's high rate of approval affected his most immediate public of fellow painters as well as himself. Hess's comment indicates concern that such a clear paradigm would exert undue influence on younger artists. It would inhibit their capacity to invent images and methods according to their personal expressive needs. De Kooning, like any fashionable model, was supplying the others' needs and desires for them. On his part, he worried that success would induce

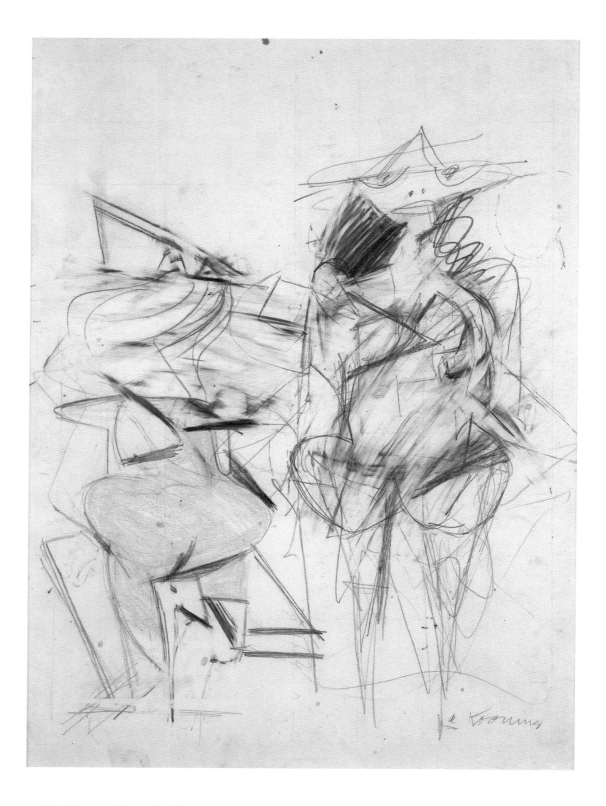

44 *Two Women*, 1948, pencil and crayon on paper, 48.3 × 35.6 cm. Private collection.

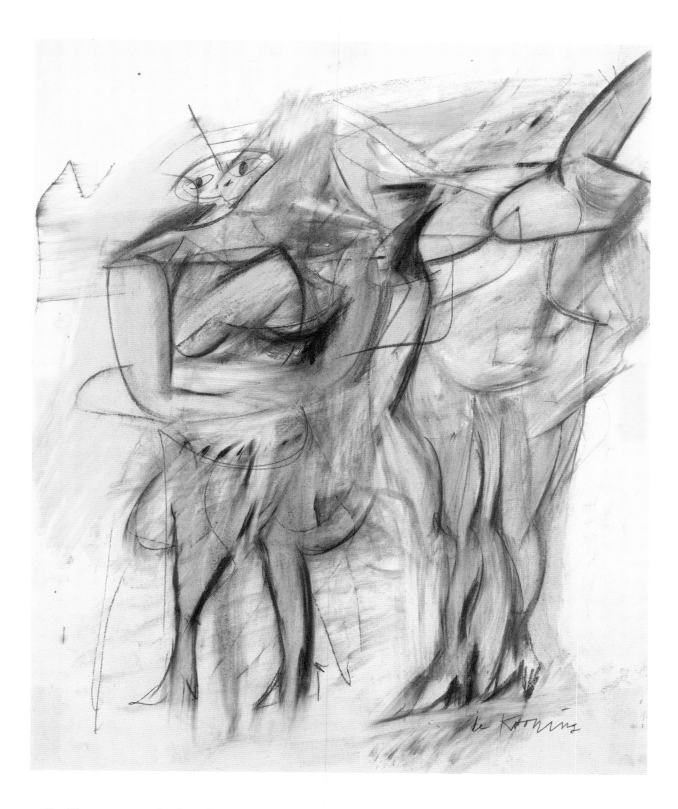

45 *Two Women*, 1951, pastel and pencil on paper, 54.6 × 44.5 cm. Collection of Steve Martin.

him to repeat himself. He would become his own imitation, hardly better than the art school graduates making their 'blow-ups'.

Around 1959 resistance to the de Kooning paradigm congealed. Younger artists decided that derivations from his manner were generating a new kind of academicism, a 'slickness of the unslick', to quote painter Helen Frankenthaler.[305] She represented a new generation of abstract artists, 'color field' painters, whom Greenberg regarded as having led the materiality of the painting process beyond the achievements of the New York School.[306] As much as de Kooning was a hero, he had become the figure to be resisted or circumvented. His gestural strokes tempted imitators, but the imitations lacked the original intensity (as Hess implied in his monograph). De Kooning's concerns did not derive from groundless paranoia, for some suggested that he, too, lacked the original intensity. If I interpret Newman's anonymous references correctly, he shared this opinion, believing that de Kooning fell into the trap of plotting out 'spontaneous' effects. Most likely, Newman was describing de Kooning and his ally Kline when he complained to an interviewer, probably late in 1961: 'There is such a thing, you know, as contrived spontaneity. There are those who work with great deliberation and calculation from sketches that they enlarge or from a variety of sketches that they swing together . . . correcting and correcting.'[307] Enlargement was Kline's device (illus. 46); the phrase 'swing together' probably referred to de Kooning's practice of tracing elements of one of his images onto the surface of another in progress, to create an unforeseen configuration alien to both sources.

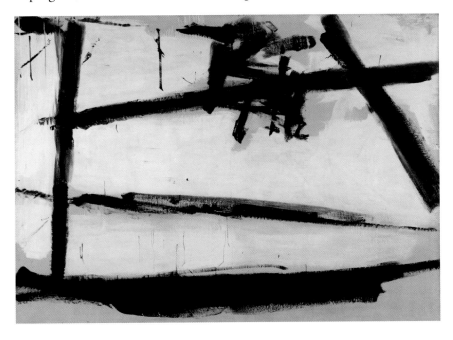

46 Franz Kline, *Painting Number 2*, 1954, oil on canvas, 204.3 × 271.6 cm. The Museum of Modern Art, New York.

47 Barnett Newman, *White Fire II*, 1960, oil on exposed canvas, 243.8 × 193 cm. Kunstmuseum Basel.

Newman (*White Fire II*, illus. 47) insisted that he was the one who 'never worked from sketches, never planned a painting, never "thought out" a painting'.[308] De Kooning was not really so different; he may have deliberated during the course of generating a painting, but he too never planned, was never one to 'think out'.

We can assume that de Kooning was striving for creative and emotional spontaneity as much as anyone else and was aware of this kind of carping about his studio tricks. We then have a context for remarks he made in 1959 within the space of about two months, thoughts that would apply not only to the splash of *Montauk Highway* but also to the famous figure paintings, such as *Woman I*, more iconic in appearance, perhaps even a bit rigid, though hardly fully fixed. To the *Time* reporter in May 1959, de Kooning said, 'I'm not trying to be a virtuoso, but I have to [paint] fast.'[309] Interpreted superficially, he seems to be validating Farber's instinctive reservation. And to an interviewer who was having him filmed during the summer of that year, he addressed the same issue but in a more complicated way: 'When I am falling, I am doing all right: when I am slipping, I say, "Hey, this is very interesting." It is when I am standing upright that bothers me. I'm not doing so good. I'm stiff, you know.'[310] On the one hand, de Kooning strives for speed – painting 'fast'. On the other hand, he strives for a self-induced lack of balance – 'falling', 'slipping'. Both features of his technique ensure that his painting remains spontaneous, inventive and, for him, an adventure. What he wants to avoid is virtuosity: 'I'm not trying to be a virtuoso . . .'. Virtuosity is a habit.

Virtuoso

Yet de Kooning *was* a virtuoso. He possessed remarkable motor skills and an unsurpassed knowledge of painter's materials. 'The brush is handled . . . with great virtuosity, of course, for there is probably no one around who knows more about the techniques of painting', wrote Fitzsimmons, regardless

of his misgivings about de Kooning's 1953 show of Woman paintings.[311]
To escape virtuosity, de Kooning would have to suppress or disguise what
was already present. The situation seems to have been grasped immediately
with respect to the artist's 1948 exhibition of abstractions. The largest work,
Painting (illus. 22), was an elaborate construction of marks made by tools
for both brushing and scraping. With the hand being used so many different
ways, surface sensuality dominates compositional logic. In her brief review,
Arb aptly wrote of 'virtuosity disguised as voluptuousness'.[312] Sensuality
dominated all other sense or judgement. De Kooning's skill, his virtuosity,
was embodied knowledge, understood as if from the inside – an exercise of
the hand and eye involving intense concentration and control, a control
saved from itself by its own excesses. This is virtuosity that exceeds its
boundaries, passing out of control.

De Kooning could demonstrate such skill, but critics were at a loss to
describe it. John McMahon, who became acquainted with the artist during
the late 1950s and began his work as studio assistant during the 1960s,
recalled de Kooning instructing him in how to sharpen a pencil to a perfect
point with a knife, and then how to roll the pencil while drawing a straight
line, to avoid allowing the line to become thicker as the self-sharpening
pencil moved along.[313] Conrad Fried – who was, by his own description,
de Kooning's 'informal apprentice' during the late 1930s (beginning 1938),
and who also worked occasionally in the studio during the 1940s and early
'50s – remembers that with his knife and extreme dexterity de Kooning
would produce a pencil point nearly an inch long. Fried also reported on
de Kooning's fabrication of brushes with extra-long floppy hairs (Hess
alluded to this in 1953).[314] These homemade, handmade tools were inter-
changeable with the commercial liner brushes that de Kooning used to
similar effect – designed to make whiplash lines and tapering spreads of
ink or pigment, both with a single stroke.[315] It was the nature of these
devices to bump dexterity up to a higher level, provided the difficulties
of the tool could be mastered.

These various techniques are evident in an untitled drawing – or
should we call it a painting? – of about 1950, for which de Kooning applied
black enamel to off-white wove paper (illus. 48). Thick, organic lines of deep
black extend into broadened forms of a greyer tone and thinner consistency.
It seems that de Kooning dragged or blotted puddled areas of the enamel
to produce a dry, rough edge in one direction. To accomplish this effect, he
might have used the liner brush or even a dry, stiff brush applied to pigment
already on the surface; he might also have used a second sheet of paper or
composition board as a makeshift scraper to spread and thin the blackness.
The edges of some of the curving forms appear to have been reworked with

48 *Untitled*, 1950, black enamel paint on paper, 48.5 × 65.1 cm. The Art Institute of Chicago.

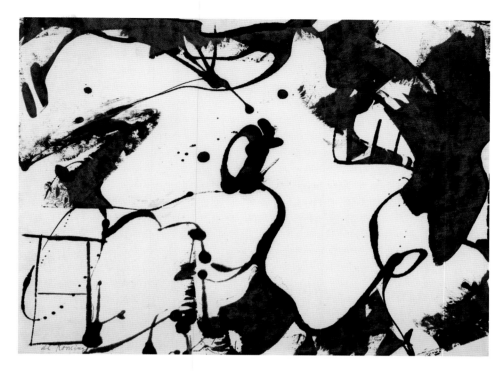

additions of heavy enamel. Reworked or not, every feature of this drawn painting has the appearance of speed and spontaneity, one visual and tactile impulse following another. A series of adjustments to an existing pictorial condition do not necessarily result in a loss of freshness or an increase in polish. Probably no viewer of 1950 would have regarded this work as other than an example of abstract art. Despite this, as nearly always with de Kooning, the organic curves are likely to evoke parts of the human body; and there are characteristic references to an interior studio environment, such as the window- or door-like form in the lower left corner. Just as doubt would remain as to whether representation factored into this abstraction, the categorization of a work of this type as either painting or drawing remains an open question.

Hess made the relevant comment: 'Some drawings could be considered paintings . . . The wonderful black enamel drawings of 1950 are made with exactly the same medium as the black and white paintings of 1948–50; they are all done with a house-paint enamel (called Sapolin) on paper, the only difference being that in the 'drawings', the white is bare paper, while in the 'paintings', the white is paint'.[316] In *Excavation*, de Kooning's black oil paint replaced enamel, while pale yellow or buff-coloured oil gave the effect of an underlying paper. In this work on canvas, however, the paint-colour and the paper-colour could be intermixed layer upon layer, under and over, as often

141

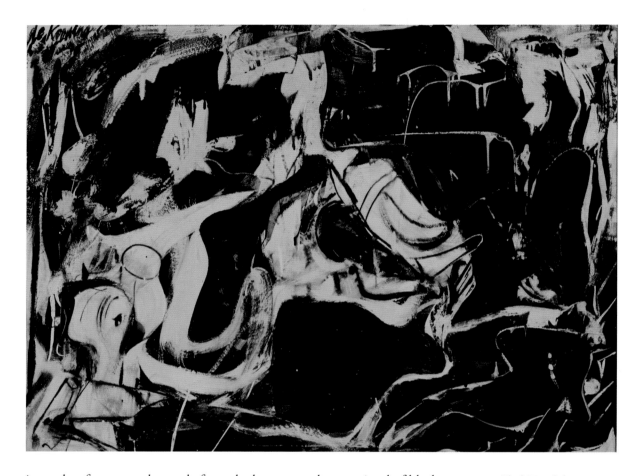

49 *Black Untitled*, 1948,
oil and enamel on paper
mounted on wood, 75.9 ×
102.2 cm. The Metropolitan
Museum of Art, New York.

in works of more modest scale from the late 1940s that consisted of black
and white enamel on paper, eventually mounted on canvas or panel to
provide more permanent support. *Black Untitled* (illus. 49) is a work of
this type. It mixes black and white with such ambivalent edging that nearly
every segment of the surface may seem either convex or concave, viewed as
white on black or black on white. *Black Untitled* is one of many examples
of de Kooning's lettering technique, where edges are traced from inside out
and from outside in, repeatedly. The technique acts to self-correct and refine
when applied to commercial sign painting, whereas in 'abstract' painting,
it becomes self-ambiguating. *Black Untitled* once belonged to Hess's own
collection of de Kooning's art, perhaps selected as an excellent demonstration
of the ambiguities about which he enjoyed writing. His understanding of
early twentieth-century theories of literary modernism had prepared him
for de Kooning's indeterminacy.

The embodied skill that surfaced in a work like *Black Untitled* derived
from de Kooning's early experience with commercial techniques while a

teenager apprenticed to a decorating firm in Rotterdam; he also followed a rigorous programme at the city's Academy of Fine Arts. Hess, in his first commentary on the painter (a section of his 1951 book on American abstraction), referred to the Rotterdam period as the time of 'the perfect square made freehand'.[317] I suspect that Hess never would have mentioned this near-obsessive element of training had it not remained evident in the painter's later work, no matter how loose it became – precise in the ambiguousness of its imprecision. In his mature years, de Kooning sought looseness with the same concentrated effort that he had learned to direct toward tightness during his apprentice and student years.

In New York during the 1930s and '40s, de Kooning had often earned money by doing lettering for commercial purposes on stiff paper known as signboard. He also did illustration for magazine advertising, a more subjective enterprise, for which the approval of a client, who might be aesthetically unsophisticated, determined when the work was completed; add to this the complication of the artist's own sense of perfectionism.[318] Here, de Kooning devised a strategy, a system. When designing an advertisement or a display, he would prepare a piece of heavy cardboard with chalk gesso, creating an absorbent white ground for a nuanced drawing in pencil. Then he would apply a transparent coat of shellac. He could subsequently work with tubed printer's ink on the shellacked surface without damaging the pencil drawing underneath. The greasy printer's ink dried extremely slowly. If still wet, de Kooning could wipe it clean; if dry, he could remove it with solvent, restoring his original sketch, clearly visible under the protective shellac. So a painted image could be changed indefinitely with no loss of the initial drawing.[319] The back-and-forth possibilities inherent in this procedure suited the contingency of the client's approval, and all the more the artist's perpetual ambivalence. Whether he should move an image this way or that was better left as an open question – a point of practice, not principle. The sensation of the moment determined the moment's decision.

Throughout his career, de Kooning maintained procedures parallel to his shellac-and-printer's ink technique: for example, scraping an oil surface down while leaving its forms faintly visible as a template for developments to follow – a procedure leaving him free to repeat the forms or not, depending on sensations to come. He also never abandoned his early practice of adjusting a form from both sides of an edge, leaving its spatial orientation ambiguous. We see its results in paintings of de Kooning's final decade of work, the 1980s. In *Untitled xxx* (illus. 50), a horizontally disposed, curving band of white at the bottom centre of the composition articulates the convex red shape above it, while also cutting dramatically into what becomes a concave area of red below it. De Kooning developed this white band by making

a negative gesture, scraping a path through the existing area of red. He followed with two positive acts, at first filling the path with white, and then retracing the contour of the larger shape above it with additional red. He was limning the border between red and white from both sides, just as he had done years before when lettering signs, making it impossible for a viewer to determine whether the white encloses the red or the red encloses the white. Having a distinct shape of its own, the white band, hardly a mere background colour, also connects to a bulbous form located at its left and to a fold-like form located at its right. Whether these three areas of white are independent of each other or are all of a piece becomes undecidable, just as their position within the allusive space of the picture does.

In figure paintings, de Kooning often constructed forms occupying a position corresponding to 'background' as convex shapes adjacent to a concave edge of the body. The nominal background – 'background' by pictorial convention – becomes an advancing shape rather than a receding one. We see this effect in one of the mates to *Woman I*, the painting *Woman V* (illus. 51), where the play of convex and concave is particularly evident at the left side of the figure's head and in the area of the legs. In fact, a curious asymmetry affects many of the figures of this period, especially in the area of the head, despite the central, iconic orientation: *Woman III* (see illus. 43) and *Seated Woman* (illus. 52) are examples. Each figure seems pulled to the right by convex 'background' shapes to the left of the head, coupled with concave 'background' shapes to the right. Or, to observe the figure itself, its head (or crown of hair) is concave at the left and convex at the right, instead of being convex all around. As a result, the figure never advances from its nominal ground (to think in terms of abstraction), nor from its spatial environment (to think in terms of representation). It remains a set of marks adhering to each other, rather than projecting a volume.

Typically, de Kooning's figure or 'foreground' element does not acquire a shape any more aggressive than that of its adjacent 'background' element, nor do the juxtaposed colours establish a spatial hierarchy. Hess referred to such effects as among the artist's abrupt, '"impossible" passages' of form and colour, some of which would result from his use of masking.[320] Techniques of multiple adjustment – and, in effect, great precision – were producing results far outside accepted orders of representational figuration, with the connotation of superficial speed and an attendant imprecision, at least with respect to the coherence of the whole. To viewers of the time, it may have seemed that the hand was in control but not the eye, having abdicated its judgement, its reason. By default, de Kooning's capacity for controlling his hand became a factor of validation, analogous to the critical cliché of pointing out that Picasso could draw conventionally when he wanted. Wary of virtuosity and

50 *Untitled* xxx, 1983, oil on canvas, 223.5 × 195.6 cm. Private collection.

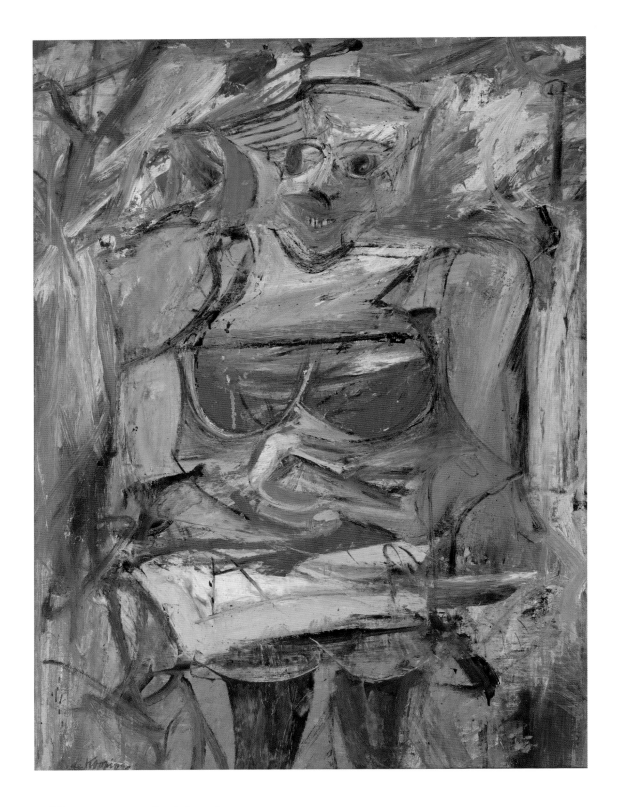

51 *Woman v*, 1952–53, oil and charcoal on canvas, 154.5 × 114.5 cm.
National Gallery of Australia, Canberra.

52 *Seated Woman*, 1952, pastel, pencil and oil on cut and pasted paper, 30.5 × 24.1 cm. The Museum of Modern Art, New York.

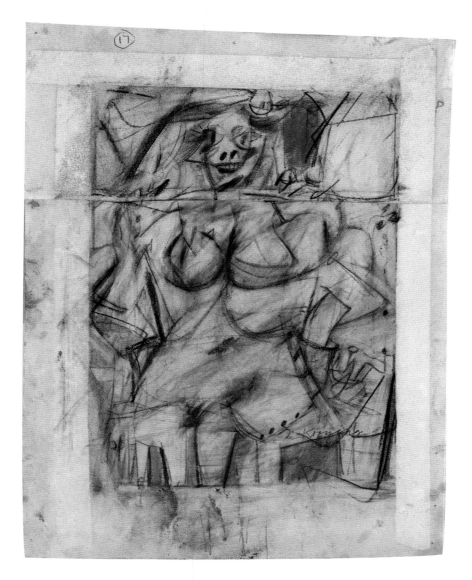

contrary as ever, de Kooning subjected his control to both self-control and capriciousness. Among the modifications to his brushes, some created tools particularly hard to handle – anything to make the situation more of a challenge and therefore unpredictable, potentially a shock to the artist. He could also force himself into shock by sheer wilfulness. Late in his career, he still recalled advice he had received from Arshile Gorky: 'If your initial impulse is to use red, then you should try green, or if you think that you should work on the lower left, than go to the upper right.'[321] It seems to me that de Kooning typically placed his odd crescent shapes – part convex, part concave, like the forms that often border the heads of the Woman image – in precisely the

147

orientation that would work against our internalized sense of how such a form should appear in the particular context. You never get used to forms as counterintuitive as these; they resist habit no matter how often they appear.

Observing one of his broad abstractions at the Sidney Janis Gallery exhibition in 1959, de Kooning remarked to Hess: 'You know, I think I might want to do some Women now.'[322] This was another in a long series of reversals. It would be wrong to intellectualize the situation by reasoning that de Kooning was engaged in a dialectic of representation and abstraction. It was not dialectic but metanoia – change of mind, change of mentality – and the change was frequent. Should we conclude that de Kooning's art amounted to repeated indulgence in whim – an art with neither strategy, programme nor purpose to direct it? Or does history show that he suffered sincere confusion as to where his art ought to have been going, strategizing but to little avail? Nothing he did or said resolved the situation for his critics, except perhaps for the most sympathetic ones, Hess and Rosenberg, who were content with a unity of contradictions. De Kooning did return to Woman during the 1960s, and Hess spoke frankly of the limitations on analysis that the new works enforced: 'To split such an image into components, even for a superficial analysis, is to destroy it in over-simplifications, because de Kooning's whole enterprise aims at fusions.'[323] Well, for Hess, there was at least an aim.

De Kooning's ambivalence prevented the majority of critics from confronting his art directly because, no matter whether they chose to laud or condemn him, his next move was likely to embarrass the judgement. His persistent use of the image of Woman, whether overt or submerged, made matters all the more difficult. Such an art provoked those predisposed to demonstrate the extremes of American misogynism, those anxious to explore the psychological aberrations that might relate to it, or those inclined to indulge in fantasies of sex and violence (the likes of Fitzsimmons and Geist, among other early writers). The bulk of the biographical facts and witness accounts gathered in recent years fails to support this line of interpretation, save when it becomes so generalized that the exceptional artist becomes a man merely typical of his generation. Yet to a great extent de Kooning was, or seems to have been, typical, if only because the passage of time causes his entire generation to look much like each other. The mere identification of an artist with his or her generation, his or her socialization in a particular era, does not explain the art. Turning his hand between abstraction and representation without ever stabilizing, de Kooning disabled every good-faith critical projection. His virtuosity could be acknowledged, yet seemed to lead his art nowhere. His attitude disabled his interpreters along with himself. When he perceived that everything in one of his late paintings 'fits pretty

good', he responded to his own realization: 'That's the problem; there's no contradictions.'[324]

Twist

'Occasionally, he would just go at it with his eyes closed, hoping for something unexpected': this observation was Tom Ferrara's, de Kooning's primary assistant during most of the 1980s, concerning the artist's practice at the time.[325] The hope did not derive from desperation (de Kooning's term in 1949) but from years of experience. De Kooning's eyes-closed method must have served him, for he had been using it at least since the 1960s: 'I do these [drawings] with my eyes closed. I . . . let the pen do what it wants, without my looking – and without my thinking of anything. It's funny the things that come out.'[326] Around 1966, he encouraged his assistant McMahon to add the method to his own drawing practice, which McMahon did.[327] Drawing blindly was not unusual among artists of the twentieth century; and de Kooning may well have experimented with it during earlier periods, along with left-handed drawing, and drawing with both hands simultaneously. To some extent, closing the eyes was a device of visualization that liberated both hand and eye from an artist's internalized restrictions – the inhibitions and absolute vetoes resulting from habits of composition as well as standards of mimetic accuracy. Accordingly, for the sake of sensory and expressive intensity, Matisse had advised his students in 1908: 'In painting a landscape you choose it for certain beauties – spots of color, suggestions of composition. *Close your eyes* and visualize the picture; then go to work.'[328] Such a process pushes conventional representation in the direction of abstraction. Artists younger than de Kooning have continued to explore the advantages of removing visual control from the drawing process. Richard Serra has been drawing by pressing a blunt stylus against the reverse side of a sheet of paper, which has been laid face down over melted paintstick: 'I don't see the drawing I am making until the paper is pulled off the floor and turned over' (*Black Tracks*, illus. 53).[329] The process relates to de Kooning's production of monoprints with respect to a tolerance for chance effects but is far more active and manipulative. Serra's works are not representational, but to call them abstractions suggests that they would fit an existing category of image. He does not make an image – either representational or abstract – in any familiar pictorial sense. It would be more faithful to the effect of his use of paintstick to call his drawings phenomena or material situations; we respond primarily to their materiality and physicality, the indexical sign-properties more than the iconic ones.

Most often, de Kooning used his blind-
sided, closed-eyes technique for representa-
tions of the human figure, both female
and male, especially during the 1960s.
This followed his relocation in 1963 from
Manhattan to Springs on the south fork of
eastern Long Island. Drawing without look-
ing did not mean drawing without the factor
of mimesis, for de Kooning could render a
human figure by coordinating the touch of
charcoal on paper with a set of visual experi-
ences internalized as sensations within his
own body. He was drawing something
between the other and himself. If this was
an image, it existed only as he drew it; its
effect was its physicality, at least its implied
physicality. You would be unable to appreci-
ate the body de Kooning drew by relating the
form to how bodies look; you would need to

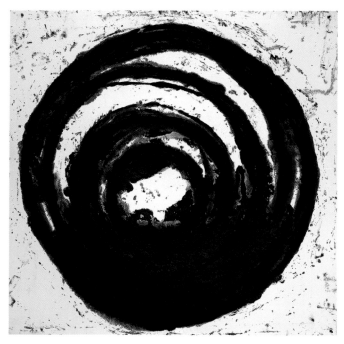

feel this body within your own body. This action – whether experienced by
the artist-as-viewer or by an external viewer – lends another meaning, another
possibility, to Hess's reference to '"impossible" passages'.[330] The passage was
now a transfer or transit of feeling in space and time, as well as a disjunction
of form on a continuous surface of figuration.

53 Richard Serra, *Black
Tracks*, 2002, paintstick
on handmade paper,
130.2 × 127 cm.

Previous to 1963, Long Island residents and weekend visitors had
sometimes provided de Kooning's imagery; during the summer of 1953, he
spent some weeks as a guest of the art dealer Leo Castelli in East Hampton
and worked on Woman images, mostly small versions on paper, which may
have taken cues from anonymous women observed at the time. In 1963,
real-life subjects became much more of a primary source (as opposed to
images lifted from art books, newspapers, and magazines). De Kooning
viewed Long Islanders in their typical postures – dancing at parties, sitting
in gardens, lying on the beach. Active or passive, it was the 'ordinary' that
caught de Kooning's attention (his term, as we know), from the formulaic
animation of fashionable dance to the relaxation ritual of sunbathing. Even
the crucifixion figures that de Kooning frequently drew during the 1960s
(illus. 54) were to him ordinary, because the religious imagery was common-
place not only in art books but in Long Island homes, and he chose to depict
Christ as Jesus, a common man. Despite his increasing affluence, de Kooning's
way of life remained ordinary. Although his building plans for the new studio
were ambitious, he had chosen a site in Springs, traditionally a working-class

community. The idea of moving into one of the more fashionable neighbourhoods of East Hampton would take him out of character. Interviewed in 1976, he noted proudly: 'Other than this house, I still have the exact same lifestyle that I had in the time I was poor.'[331]

When de Kooning, closing his eyes, facilitated the spontaneity and freedom of his drawing – freedom from both pictorial composition and representational exactitude – he acted like an entranced dancer. As much as attending to his hand, he concentrated inwardly on his body, poised to represent another's body, centring and intensifying his sensation. The action he engaged entails a paradox: it causes not only a centring of sensation but also a disjoining, because the eye removes itself from the hand's creation of an image intended for vision. The two senses, one would think, lose

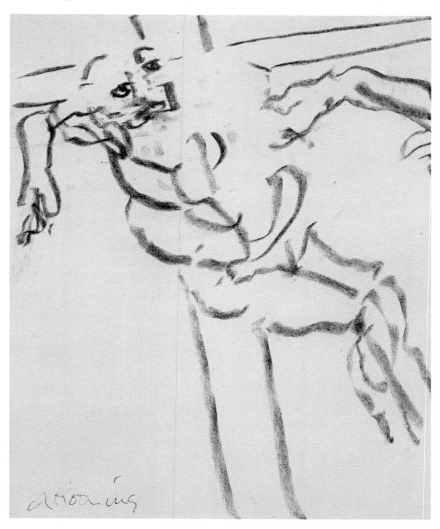

54 *Untitled*, *c.* 1966, charcoal on paper, 25.4 × 20.3 cm. Collection of Sante D'Orazio.

synchronization, ceasing to operate in mutual support. A book of 1967 reproduces 24 charcoal drawings of the human figure made with the eyes-closed method, all dated 1966 according to an editorial note. De Kooning contributed a brief, matter-of-fact explanation that admits no paradox. He justified his procedure as an aesthetic aid:

> I am the source of a rumor concerning these drawings, and it is true that I made them with closed eyes. Also, the pad I used was always held horizontally. The drawings often started by the feet . . . but more often by the center of the body, in the middle of the page. There is nothing special about this . . . but I found that closing the eyes was very helpful to me.[332]

De Kooning was correct in insisting that there was 'nothing special' in what he was doing, that the procedure was ordinary enough for a studio artist; yet, in his case, it inaugurated years of extraordinary results. *Untitled* (illus. 55) is an example from the 1966 series, an image of two young women dancing who, conceivably, might also be cheerleading. He might have recalled such figures from among all the 'marvelous girls walking around' during the 1960s – the inspiration, by his own account, for many quickly rendered images of the period.[333] He was impressed not only by the movement and posturing of younger bodies, but by their (to him) outrageous fashions; his untitled drawing appears to represent women wearing extremely short party dresses or skimpy shifts. Yet, given the moment, all this was ordinary.

We know that de Kooning's view of dancers often derived from variety shows on television; this brought a Manhattanite quick-change sense of activity to the relative quiet of Springs.[334] He drew dance movements and other figure motifs from the moving black-and-white screen. Hinting at parallels, his most knowledgeable critics tended to conjoin his practice of eyes-closed drawing to his television drawing. Rosenberg grouped several practices together as he stressed the contradictory nature of de Kooning's de-skilled skill: the Woman images of the 1960s,

> in their beach settings . . . are products of his latest devices for circumventing his willful mind and his trained hand, which are bound to assert themselves in any case within the very process by which they are circumvented. He has practiced drawing the figure with both hands, with his left hand, with two or more pencils simultaneously, with his eyes closed, while watching television.[335]

Like Hess in analogous statements ('kicking away an encyclopedia of craft [he] ends up perfecting a new technique'), Rosenberg implied that no matter

55 *Untitled*, 1966, charcoal
on paper, 25.4 × 20.3 cm.
The Over Holland Collection.

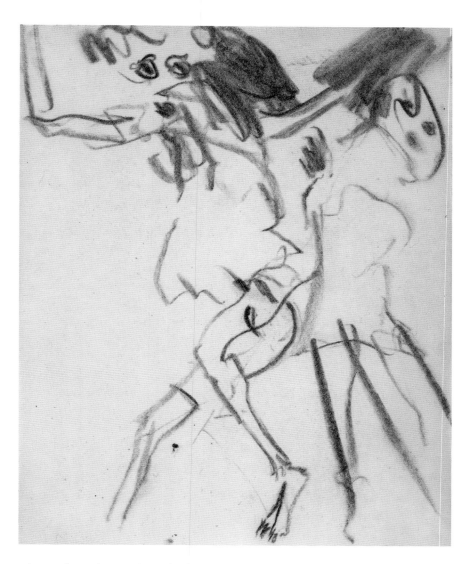

what technical procedure de Kooning tested, no matter how unpromising
with regard to control, he would in some recognizable way control it.[336]

Without intending to diminish the particularity of de Kooning's
achievement, Rosenberg applied what amounts to a critical formula: success
despite all the resistance to what would ensure success. We might ask in
response: was de Kooning controlling, mastering, or perfecting anything?
Is resolution the only reason to consider his art accomplished? I recall the
insight that Hess never thoroughly pursued, that de Kooning would balk
at any synthesis and 'choose neither antinome nor accept their opposition'.[337]
My concern does not extend to this type of statement; but a similar, earlier
statement from Hess is worrisome, if only for its self-indulgent use of oxymoron:

153

'De Kooning's paintings are based on contradictions kept contradictory in order to reveal the clarity of ambiguities.'[338] This is too clever for its own good, and de Kooning (I would like to think) would reject the formulation for the same reason he rejected his own compositions when they appreared to have fallen into place. A critical language that manipulates contradiction to the point that it acquires sense, as if it were a rhetorical strategy, causes de Kooning's resistance to his pictorial skill and his search for a more intense visual-tactile experience to appear commonplace. He may be the best of the lot, but he is just another modernist painter doing his thing as life goes on. The artist succeeds in spite of himself. I suppose that the critical notion of an act of circumvention transcending its own evasions ('his willful mind and his trained hand . . . bound to assert themselves') seemed less common when Rosenberg wrote his lines. What he said, however, was true to an existing inclination of critical writing to fuse antithetical notions – a strategy calculated to shock or at least irritate those committed to more conventional patterns of reason.

Artists themselves have delighted in the ironies of a purpose or a practice that turns into its opposite, as when only the most sophisticated are able to be sufficiently naive. Previous to de Kooning's efforts at whatever it was he was doing, several generations of modern artists cultivated the imitation of a child's manner of drawing; their purpose was to reverse the educational process, removing their acquired expressive inhibitions. On viewing an exhibition of children's drawings, Picasso confessed to Herbert Read: 'When I was the age of these children I could draw like Raphael. It took me many years to learn how to draw like these children.'[339] De Kooning was not interested in being a child, but he admired the illustrative style of animated cartoons and comic books, including the old Katzenjammer Kids and Krazy Kat; viewers have perceived bits of Betty Boop and Minnie Mouse in a number of his paintings of the early 1970s.[340] By claiming the commonplace as his domain – he spoke of his admiration for Norman Rockwell's illustrations – de Kooning took refuge not only from aesthetic pretension but also from critical pretentiousness.[341] *This* manifestation of the common or ordinary does not present the same problem as something common in the critical response, whether positive (mastering antithetical impulses, successfully combining contradictory cultural signs) or negative (playing expression for effect, acting out of misogyny). The problem in criticism is that its nature is to generalize, associating the new with the known, as its variant. Conceptual generalization converts mere description into explanation. When we view de Kooning as making some kind of perverse sense of contradiction as his means of transcending mental habits, we adopt a twentieth-century critical cliché, which is not the equal of twentieth-century material practice. The critical record causes me to

be wary of identifying certain qualities of de Kooning's practice as the essential ones. Rosenberg and others were sufficiently adept at this. I would prefer to think that de Kooning's practice had no essence, made no sense. Between sense and de Kooning, where does analysis go?

Like de Kooning, testing the process, searching for an acceptable result, I can try this: during the 1960s, in his studio refuge in Springs, he sometimes fixed on the fleeting model that television provided, letting the screen distract his eyes while he drew the subject, or, more likely, combined the immediate stimulus with traces of previous sensations. This would be parallel to his shellac-and-printer's ink method and his re-tracing of images he had scraped down to a trace. Whatever the disposition of his eyes, his hand was taking somewhat independent action, following the feeling of the line being drawn (or painted) or the feeling of another's body in his own. Watching television and working blindly were two devices that served the same purpose, allowing de Kooning to circumvent his practiced eye. (I just resorted to Rosenberg's evasive term *circumvent*: apologies.) Vision was de Kooning's more analytical and regulative sense; he strove not to allow it to inhibit his touch, his more physical, instinctive sense. His eyes-closed and television art originated within the fixed margins of a sheet of paper, the hand's domain, as opposed to some indeterminate space inhabited by a model and traversed by the eye. As a loss of control controlled by the conditions under which de Kooning set himself to work, his method caused skill and chance to become indistinguishable. Both of these conceptual abstractions were reduced to, or fell back into, sensation – feeling.

De Kooning had many ways of accomplishing his desired disjoining of perception – what the hand could feel – from preconception – what the eye would automatically adjust to an existing standard, counteracting the effect of chance and the skill that enabled it. But there may be an immediate objection: is it not likely that hands embody regulative habits as much as do eyes? Yes and no: because our culture has such a long tradition of privileging the eye as the dominant and most mental of the senses, we tend to ignore the possibility that in circumventing its authority, we do no more than substitute one aesthetic tyranny (the tactile) for another (the optical). In fact, de Kooning sought to defeat any conventional habits of his hand as much as those of his eye. His various techniques each involve something more complicated than a turn or reversal in the hierarchy of eye and hand. Maintaining hand and eye in dis-coordination (an oxymoronic neologism: inexcusable) furthered de Kooning's search for uncompromised irregularity. We would be particularly hard pressed to invent rules for his compositions even though they display repetitive features. Such features resulted from his liberal use of tracing and transfer, which also generated 'accidental monotypes' as a byproduct. His was a twisted aesthetic.

I must generalize because words generalize. I will call de Kooning's characteristic technical move a twist – a twist rather than a turn because twisting is a bit less abstract, a bit more physical, yet a bit more ambiguous. If turns occur in two dimensions – left, right, up, down – twists do the same in three.

The word *twist* resonates with memories of a dance of the early 1960s, which involved twisting the body at the waist and hips. It enjoyed great currency, albeit briefly, for popular dance is instant but fleeting fashion, momentarily ordinary for those engaged with it. To observe party-goers 'twisting the night away' (as a song of the era put it) was to experience infectiously the impulse to imitate these dance movements, internalizing the others' actions. De Kooning's twist, performed by line, was a draftsman's, not a dancer's. If dancing with a twist was to be learned by dancing, did de Kooning learn to draw with a twist by drawing? Within the context of the de Kooning of the 1960s, when virtually all of his work constitutes representations of the body, were his mimetic actions and twists of line representing his view of another's body, a sensation within his own, or the nature of an intensely physical linearity? Of course, these three possibilities do not exclude one another.

Whatever the mimetic object, methods such as de Kooning's distance a drawing from proper proportion and conventional form. The direction of this distance – whether, for example, a particular feature might be stretched or compressed – appears as an effect of wilful chance. Choice as chance. A twisting movement of the hand can turn this way or that without losing the sense of representation; this is its inherent ambiguity of active intention and passive bodily inclination. A line suspended between active and passive direction becomes all the more conscious because unpredictable. Its movements intensify and enliven the act of drawing as it happens; they heighten the artist's self-consciousness as well as the viewer's sense of a novel skill being developed and applied. But de Kooning's specific skills are too hard to define to be subject to development or application. His line does the unexpected – it is not just rendering contours or suggesting shading – and yet it seems adept at its own unforeseen action, at once exploratory and assured. Of his eyes-closed technique, de Kooning said this: 'I feel my hand slip across the paper. I have an image in mind but the results surprise me. I always learn something new from this experience.'[342] Slipping it is. When you slip, you lose control but not your centre of gravity, which continues to answer to the slip.

Centre

Neither automatism, nor the unconscious, nor conceptualized abstraction properly accounts for the enlightening 'surprise' of the 'new' that de Kooning generated using his eyes-closed technique. Because his concentration was directed at something external to himself, his act retained an element of traditional mimeticism – closer to the practice of working from a studio model (like Matisse and Chaim Soutine, both of whom he admired) than to the more subjective techniques of either surrealism (André Masson and Joan Miró) or radical abstraction (Wassily Kandinsky and Mondrian).[343] Despite the interest in a live model, the object of de Kooning's attention must have been internalized, for his imitation of visual appearance was occurring while he avoided looking. Usually, drawings would start 'by the center of the body, in the middle of the page', he said.[344] In typical eyes-closed drawings, an isolated dark spot often appears at or near the centre of the sheet (illus. 56). This marks the initial orientation of the hand. De Kooning sometimes kept one hand fixed on this centre in order to anchor the other that made the drawing.[345] The active hand would be able to return to the centre by touching the passive, stabilized hand; and the distance between the two (one fixed, the other in motion) could always be felt through the medium of the artist's body, through its internal sense of spacing and direction as well as its centre of gravity. Tension and movement in the muscles and nerves would compensate for the absence of overseeing eyes.

The anatomical positions that we observe in de Kooning's art may be impossible in a body but not in the analog drawing or drawing-out of a body. How far from 'you' do your feet feel? This is not an objective, measurable distance, but a felt distance. 'You' is the person you imagine somewhere, but not specifically in your feet, certainly. So where are the feet, how far from 'you'? This is a question to which de Kooning's art replies, not to provide a specific, definitive answer, but to acknowledge the seriousness of the initial query. In 1969, a journalist quoted him on the practice of drawing with eyes closed: 'It's better that way. You think about your eyes, your ears, your nose and mouth. When I finish, it's so real, the guy seems to be walking up to me.'[346] De Kooning imagines – feels – the distances in his own body and draws these proportions rather than the systematic perspectival relationships a draftsman is taught to observe and render. He draws from internal feeling as opposed to external vision, reaching a visual image all the more real in emotional effect.

The same journalist's unpublished notes contain condensed or paraphrased commentary in which de Kooning refers to 'the contraction of the body that great artists are aware of. Everything returns to the center, the figure floats from the center'. He followed this remark – in the freely associative way

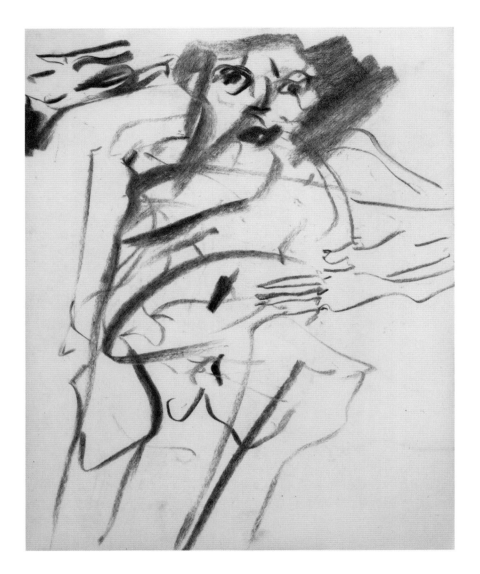

56 *Untitled*, 1966, charcoal
on paper, 25.4 × 20.3 cm.
The Over Holland Collection.

that was typical of him – with a reference to the leaping dancer Nijinsky.
Perhaps like the artist himself, Nijinsky was 'never graceful' (de Kooning's
words) but 'always had this constriction', that is, the dancer always held to his
centre. Nijinsky, de Kooning seems to be saying, maintained his sensation of
a centre of gravity, which made his astounding trajectories possible, his dance
progressing by 'a kind of feedback' felt in the body.[347] By studying photographs
of Nijinsky, probably attempting to assume the poses himself, de Kooning
learned about all bodies, their sense of movement and countermovement,
and how the associated feelings might be represented.[348] The knowledge
was kinaesthetic.

'I feel my hand slip across the paper': de Kooning implies that the centre of the paper and the centre of a dancing body (the model for many of his drawings) acquire a common centre of gravity intuited and even felt by the artist-observer. The two centres occupy a single gravitational field, shared also by the active draftsman. This field – physical and concrete, neither conceptual nor abstract – is not the pictorial field of conventional drawing. Perhaps this is why de Kooning referred to a figure floating *from* the centre (of a physical, gravitational field) as opposed to floating *in* the centre (of a dematerialized, pictorial field). In de Kooning's hands, the art of drawing risks losing its culturally constructed centre of gravity – identified with the normative practices of image production – as the artist projects himself outside the boundaries of artistic convention. He uses his skill to enter a situation in which he chances becoming incoherent and incomprehensible. What he gains is intensified animation, liveliness, alertness.

The concept of 'centre of gravity', closely associated with the physical and mechanical sciences, also relates to philosophical and theological speculation on the nature of 'movement' in the human soul. In a suggestive passage, philosopher Emmanuel Levinas links heightened self-consciousness to a destabilizing movement of the centre of gravity: 'Presence to oneself as a living presence to oneself, in its very innocence, casts its center of gravity outside itself.'[349] It might be argued that a person casts his centre of gravity 'outside' or ahead of himself in the mere act of walking – ordinary life is risky in this way – and the seeming unnaturalness of a dancer's leap exaggerates the effect. Recall Merleau-Ponty's interest in Rodin: 'Movement is given, says Rodin, [by portraying] the body in an attitude which it never at any instant really held and which imposes fictive linkages between the parts.'[350] A body is in flux; its linkages are transient, present in the moment to be experienced, to be felt. We lose contact with bodies, including our own, when all movement seems programmed and habitual. To act – merely to walk, to sit, to stand – is to assume a degree of risk. An analogous risk of the loss of balance and stability, a loss of centring, comes when a person speaks or gestures: the individual never knows whether the communicative act, having been ventured, will be understood as intended. Often the reception determines the intention; the reaction lets the speaker know what he or she must have meant. To draw as de Kooning did was to take communicative risk to an extreme.

There was precision in de Kooning's method. In 1984, Elaine de Kooning reflected on her husband's somatic technique: 'He knew exactly where, he remembered where his hand had been.'[351] Such memory was as much muscular as mental. The disposition of figures in drawings from the 1966 eyes-closed series indicates that de Kooning felt his way to the edge of the paper, compressing anatomical elements whenever the given dimensions imposed a material

limit – sensed but not seen. His drawn figures no longer inhabit the world's conceptually limitless Cartesian space; they make no pretence of extending beyond the paper's framing edge. To the contrary, as his forms approach the margins, they often back up and become denser. With these simple, rapidly executed drawings, de Kooning attained a quality of compression that had required much more time and material presence when he developed it in paintings of the late 1940s (*Painting*, illus. 22). Conditions change somewhat when the momentum of a particularly forceful stroke of an arm or leg results in a gesture that passes beyond the sheet, as in another untitled drawing of 1966 (illus. 57). Here, nevertheless, the sense of anatomical compression remains dominant. Throughout the series of drawings, compression is most evident in

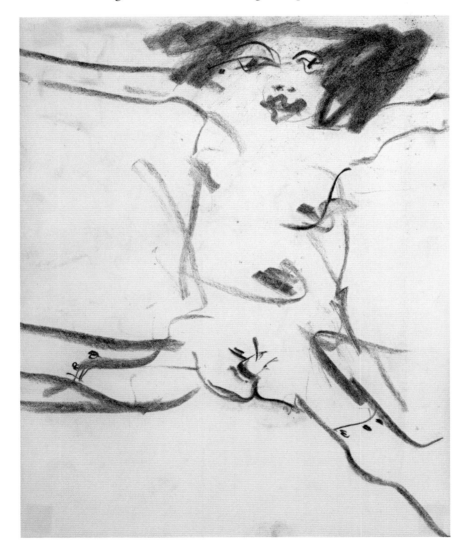

57 *Untitled*, 1966, charcoal on paper, 25.4 × 20.3 cm. The Over Holland Collection.

58 <no title>, 1965–80, charcoal on paper, 25.4 × 20.3 cm. The Willem de Kooning Foundation.

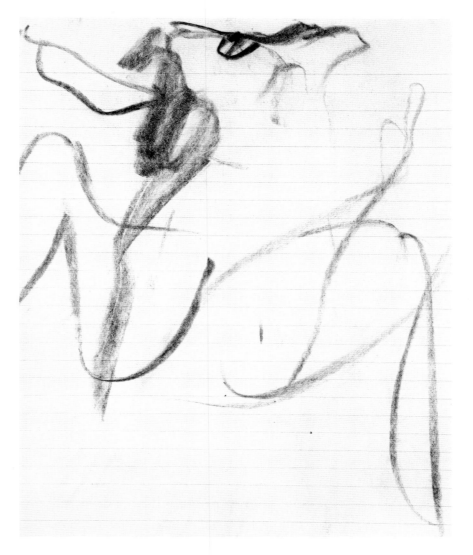

heads that make contact, logically enough, with what becomes the top edge of the sheet. There, faces are likely to appear flattened – not as if lacking illusionistic volume, but in a more physical sense, as if having been caught in a vice. Where a forehead has already struck the upper limit, the draftsman's hand has no recourse but to move laterally to add the hair, making do with the available space, similar to how a child might resolve a drawing problem. This type of decision is particularly legible in the previous example and is also an aspect of the presumed television drawing, *Reclining Woman* (see illus. 3). A great many television and eyes-closed drawings, or drawings that may have been made in a state of distraction by whatever device, manifest an extreme economy of line and gesture, with a corresponding sense of concentration. De Kooning's

untitled charcoal sketch of a spread-legged woman floats on the sheet even though her real-life counterpart may have been seated; this type is familiar in de Kooning's idiosyncratic anatomical vocabulary (illus. 58). Such drawings demonstrate the physical 'constriction' that might determine movement in a dancer or in the draftsman – Nijinsky's twist or de Kooning's.

De Kooning produced something less than what we regard as composition within a rectangular format, and something more than the mere placement of a figure against a ground imagined as neutral and limitless. As I have suggested, although he worked from the human figure, he was by no means the 'old-fashioned figure-ground draftsman' that one artist-critic called him around the time he was making his eyes-closed drawings.[352] Rather than setting forms within an implied orthogonal grid, the traditional 'ground', de Kooning set himself in sympathetic harmony with the paper's material limits and the external model's physical potential, converting his own body into a site of productive tension. Painter and photographer Susan Brockman, de Kooning's companion around 1963 to 1966, recalled that he would imagine – or more precisely, feel – in his body the internal distances between the different parts of the body he was rendering. He would stretch and bend in imitative ways, as if to 'reinvent' (a favourite word of his) an alien body within his corporal experience.[353] Hess presented a similar notion, writing of a pilot who makes the plane 'a part of himself' in order to land it.[354] De Kooning would assimilate the internal feel of another's body, in order to draw it. Merleau-Ponty once again is the source of a relevant theoretical generalization: 'My body can assume segments derived from the body of another, just as my substance passes into them; man is mirror for man.'[355]

This kinaesthetic action may well relate to de Kooning's interest in the fit of dresses, suits and shoes, which, in covering or masking the body's articulation like a second skin, both imitate and facilitate the most ordinary physical movements. The fold or crease in an item of clothing was one of the 'tiny' visual events he never tired of noting (see below, 'Glimpse').[356] Wherever clothes cover the body, they themselves are what appear to move. We stretch and bend, and our clothes stretch and bend with us, yet in a manner determined by the fabric and cut of their composition. Clothes move in response to human physicality but according to their own materiality. In 1958, de Kooning did a series of ink drawings motivated by his observation of the folds in laundered shirts (illus. 59). Four sources of physicality – body of the model, clothing of the body, instrument of drawing, body of the artist – complicate the representation of a woman or a man. Just as clothing translates the form of a body into shapes that suit the fabric, drawing translates a dress or shirt into the specific physicality of pen-and-ink, chalk, or graphite.

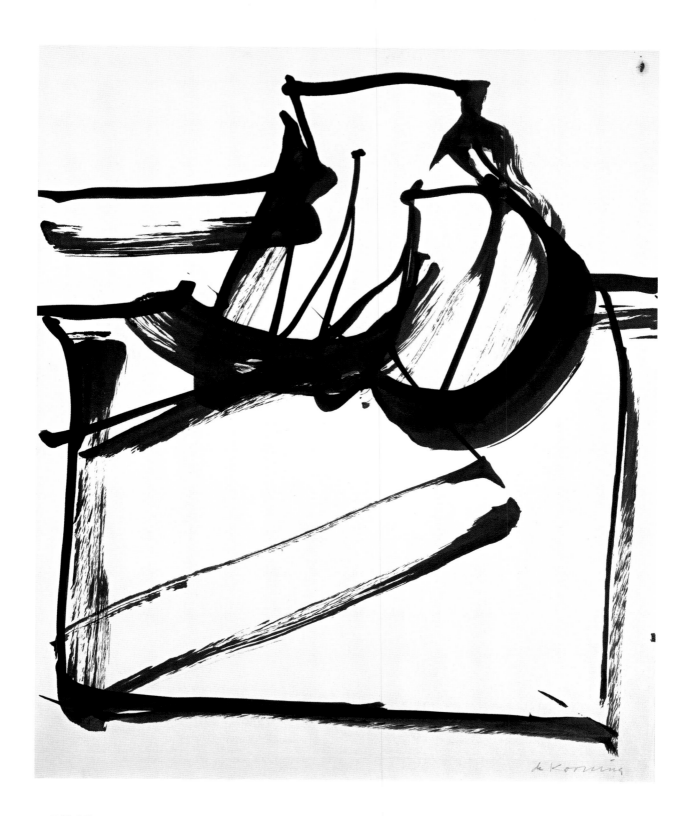

59 *Folded Shirt on Laundry Paper*, 1958, ink on paper, 42.9 × 35.2 cm. Private collection.

As clothes are to the ordinary body, so de Kooning's extraordinarily aestheticized body was to the drawings he made. If the movement we sense in these drawings belongs to the person or image represented (say, the dancer), it acquires its life only because it has assumed the fit or cut of the movement peculiar to de Kooning. This movement is counter-gravitational, as if performing a leap or dance from the body's centre of gravity with no need of grounding. In 1967, de Kooning alluded to his interest in a pose of 'jumping [that] looked kinda sexy'; yet, when drawing, he was often applying a horizontal orientation to images destined to have a vertical format.[357] Photographs confirm that while he was touching his paper blindly, its orientation was horizontal, perhaps merely the more accommodating position for work on a table or drawing board, whereas a vertical accords with work against a wall or easel.[358] When he subsequently viewed his drawing sheet with open eyes, to exercise a regulative judgement, the orientation assumed the vertical. He twisted the image in relation to his body, or perhaps twisted himself through the 90-degree turn, to mark the disjunction between creating (hands-on touching) and evaluating (seeing at a distance).

De Kooning's counter-gravitational impulse led him to turn and rotate his images, working from all possible orientations: 'Every painting should work on all four sides.'[359] This practice accords with his often-stated desire to induce a loss of balance, a floating, or a slipping. When he traced from other tracings onto works in progress, he often titled the supplemental fragment, as if it had slipped off the imaginary orthogonal grid. Working with closed eyes helped him to achieve his non-directional sensations, as did his use of hard, smooth paper or slick vellum, on which his drawing hand could glide.[360] For the same reason, he favoured watery mediums that dried especially slowly – those that could be blotted, counterproofed and, most importantly, spread freely in one direction or another. To a French interviewer, probably in 1966, he remarked: 'I try to free myself from the notion of top and bottom, left and right, from realism. Everything should float . . . The whole secret is to free yourself from gravity!'[361] He speaks of freeing *himself*, not merely the image. This remark adumbrates his 1969 reference to Nijinsky, who was counter-gravitation personified ('You have to go up and then pause a little up there', the dancer said).[362] Over the decades, de Kooning expressed a related admiration for Matisse's painting of the *Dance*; it left the impression of 'a human weight floating in water' or simply 'that floating quality'.[363] Images of floating may also explain his interest in a *New York Times* photograph of three jumping cheerleaders; it was present in his Springs studio in 1964, most likely having been brought to his attention by a friend.[364] The camera caused the girls' acrobatic bodies to appear to levitate, in part because their clothing was moving with them. Seemingly weightless, the

costumes and therefore the bodies billow rather than droop or fall. Any number of features of the cheerleaders – hair styles, bent arms, sweaters, skirts, extended legs and feet – compare to details of both the stages and the final versions of de Kooning's paintings of the period, such as *Woman, Sag Harbor* (illus. 67) and *Woman Accabonac* (illus. 74).[365] The visual effect of the cheerleader photograph suits the floating sensory mode of these works, as well as the float of the eyes-closed drawings.

In the manner of his drawings, de Kooning's paintings are acrobatic, dynamic, and changeable, because he generated them as if they were . . . drawings. If this reasoning is circular, it is because his was. For the majority of his works during the 1940s, '50s and '60s, he employed paper, vellum or cardboard, not canvas, as the primary support. He had no inhibition about introducing impurity to the process: he readily added charcoal lines to layers of oil paint or enamel; and his colouristic paint application was fundamentally linear.[366] Painting could always revert to drawing. The broad, central twist in the monotype *Blue Stroke* (illus. 10) is a drawn form as much as a painted one (and complicated by imprinting as well). 'I draw while painting', de Kooning said in 1975, 'and I don't know the difference between painting and drawing.' Then he added: 'The drawings that interest me most are made with closed eyes.'[367] These, of course, were hardly predictable, for they extended beyond the usual range of movement of the centre of gravity. The effect of a monotype was still less predictable, even though it transfers – copies, if you like – a composition already at hand. The paradox of the most alike holding the greatest surprise fascinated the artist: hence, his interest in selecting certain transfer images as independent works of art.

De Kooning's typical sticks of charcoal were quite substantial; with a diameter of one-half inch, they were as large as a paintbrush.[368] They could be used broadly or sharpened to a point, like the pencils he employed for his commercial work. It was his practice to twist a single continuous stroke not only so that its direction changed but to cause a sudden shift from blunt to fine.[369] One of the best examples of this, de Kooning's quintessential move, is found in the charcoal drawing *Untitled* of about 1970–75 (illus. 60), which may well have been done with closed or distracted eyes – 'television eyes', we might say. Near the centre, a continuous stroke in the form of a tilted *U* twists and turns in order to create a particularly dynamic shape, or rather a movement; it may be a Crucifixion, severely abstracted. Still later in his career, de Kooning would use twisting bands of colour as the constructive element of oil paintings such as *Untitled XI* (illus. 61) and *Untitled XXI* (illus. 62), in which the linear elements were disjunctive as much as they were connective. Most paintings of this type give the appearance of gestural abstraction, but de Kooning developed them from combinations and fragments of

earlier black-and-white figure drawings, often from the 1960s, both small representations on casual drawing pads and large representations traced from earlier paintings on sheets of vellum. Whether drawing or painting, we imagine de Kooning's hand, arm and torso – or our own – twisting in a fashion analogous to the charcoal line or band of colour. There need not have been much physical action on de Kooning's part; the meaning perceived in his line depends on whatever sympathetic, kinaesthetic response it elicits in a viewer. When we feel within ourselves the materiality and physicality of de Kooning's drawing, it assumes its full artistic and cultural significance. His multi-directional line, extreme in its flexibility, creates a gravitational field of its own, animating the perceptions and even the bodies of those who encounter it. It sparks an acute sensitivity in people who would otherwise remain dulled by habit and its customary, polite imagery.

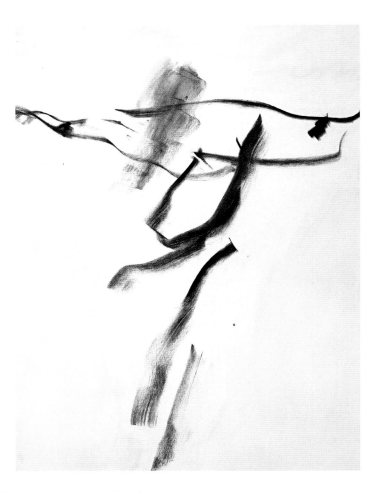

60 *Untitled, c.* 1970–75, charcoal on paper, 61.1 × 45.4 cm. The Willem de Kooning Foundation.

 Continually on guard against the accumulation of habit in himself, de Kooning insisted even late in life that when a gesture became easy or too familiar, he would cease to perform it.[370] Master of the organic blur, he found an unlikely admirer in the geometric abstractionist Josef Albers, who invited him to teach at Black Mountain College in 1948, and subsequently at Yale University in 1950.[371] A hint as to the values the two artists shared comes from Elaine de Kooning, who reviewed Albers's 1949 exhibition at the Egan Gallery (also de Kooning's gallery). From among Albers's many statements, Elaine de Kooning chose to quote this: 'I am most happy when I make a color act against its will.'[372] The remark struck her, perhaps because she realized that her husband, who had admired Nijinsky for doing 'just the opposite of what the body would naturally do', was extending the potential of line analogously, challenging pictorial gravity and the inertia resulting from centuries of compositional convention.[373] By his own account, Albers was using geometry and colour to create 'perceptual ambiguity' with forms that could be viewed spatially 'either down or up'.[374] Albers was toying

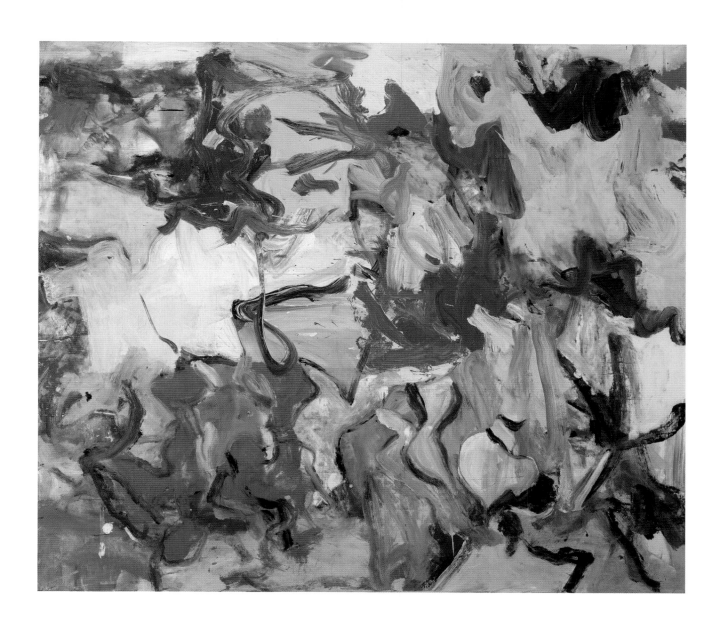

61 *Untitled xi*, 1975, oil on canvas, 195.6 × 223.5 cm. The Art Institute of Chicago.

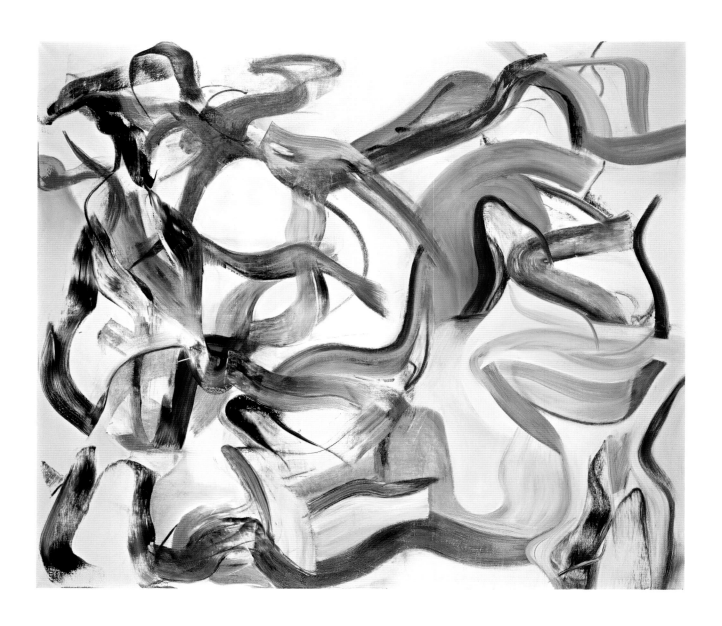

62 *Untitled xxi*, 1982, oil on canvas, 195.6 × 233.5 cm. Philadelphia Museum of Art.

with gravity, just as de Kooning would do in trying 'to free [himself] from the notion of top and bottom'.[375] In 1950, Elaine de Kooning described Albers as a 'master of optical illusion [who] will try to make a ruled line look bent or a flat color seem modeled'.[376] Through his art, Albers tested limitations, including physical limitations, both optical and muscular. He had his Black Mountain and Yale students draw under restricted, challenging conditions in order to teach them how to relate art and craft to the body, which was itself one of art's raw materials.[377] Accordingly, he had appreciated what he perceived of de Kooning's own effort: 'Those early de Koonings, that white on black . . . He worked so hard on those forms.'[378] As if in sympathy with Albers's sense of visual and kinesthetic invention, de Kooning's line moved in ways that should have been impossible, 'against its will.' More than reinventing figure drawing, he reinvented line itself. Like Albers's illusions, as well as like Nijinsky's leaps and contortions, de Kooning's drawings lent an element of naturalness to effects that would otherwise have seemed entirely contrived and artificial.

Unwhole

It was not only de Kooning's line that would 'twist'. He twisted entire images as a result of the properties of the materials he preferred to use, such as vellum, particularly suited to tracing. One of his methods combined transfer with tracing to maximize flexibility. With a sheet of transparent vellum, de Kooning would mark a charcoal tracing of the forms of an existing drawing or painting; he would then reverse the vellum to work on the back, tracing the same forms in fluid paint, being as literal or as selective as he wished. With this counter-reversed mirror image (a new positive), he could make an imprint on another sheet of vellum, providing a mirroring of the original, but now in colour (or, if coloured to begin with, then in different colours). Alternatively, he could add paint to the initial tracing and imprint a mirroring more directly.[379] The permutations had neither limiting number nor logical end.

De Kooning used a Woman in a Rowboat image extensively during the 1960s; Hess first discussed it in 1965. For an early drawing of the theme, de Kooning worked on both sides of a small transparent sheet: *Girl in Boat* was the result (illus. 63).[380] With each side mirroring the other, the image could be retraced from either orientation. Although de Kooning sometimes drew with his left hand, and sometimes also with both hands, it would be fair to assume that when he shifted the orientation of a drawing from left to right (that is, from front to back of transparent vellum), his choice of hand remained constant. Accordingly, he would experience drawing the same

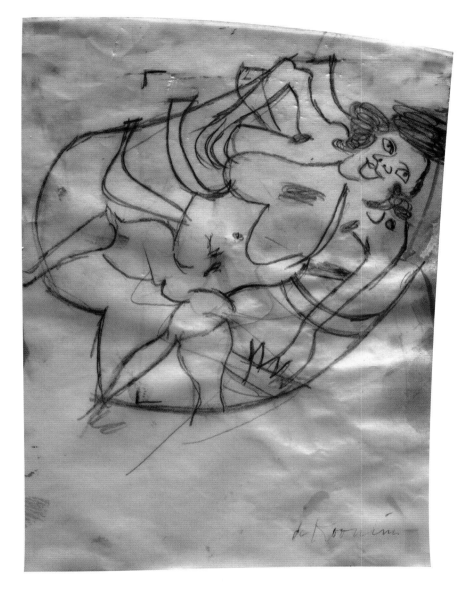

63 *Girl in Boat*, 1964, pencil on tracing paper, 23.9 × 17.8 cm. Hirshhorn Museum and Sculpture Garden, Washington, DC.

image with an entirely different, yet clearly complementary, kinaesthetic feel. His front-to-back, right-to-left, tilting-and-turning twist allowed the image to be repeatedly altered and yet preserved, as had been the case with drawings for commercial projects. In addition to his 'I can change overnight', he also said, 'You have to change to stay the same.'[381] A drawing seen from opposite sides is the same but changed. Successive changes often make it the same, while the repetitions of tracing just as often make it different. We lose our bearings with regard to what might qualify as same or different.

64 *Untitled,* 1966, charcoal
on paper, 25.4 × 20.3 cm.
The Over Holland Collection.

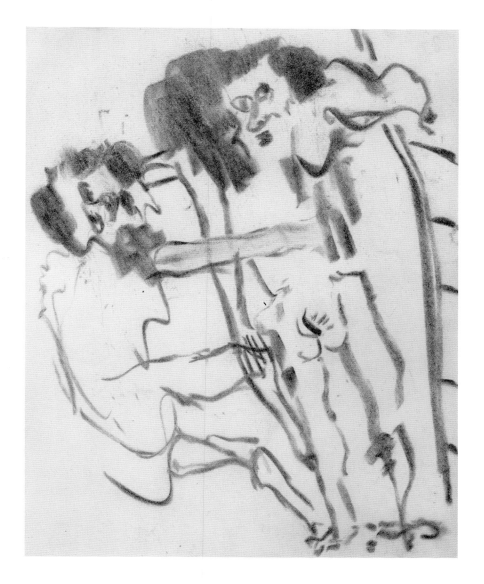

Those who knew de Kooning during the mid-1960s note that the
image of the Woman in a Rowboat occupied him more than any other at
that time.[382] Hess dated it to 1963–64; but Susan Brockman, who had often
accompanied him in Springs, recalled that de Kooning was not involved
with it until 1964, sometime after having completed the move into his new
studio.[383] In spring or summer 1964, the painter told her of having viewed a
specific scene along the beach at nearby Louse Point; most likely, he referred
to a woman and man together in a rowboat, but Brockman vaguely remem-
bered that he had also mentioned a child. He said that he planned to develop
this scene as a theme for painting. One of de Kooning's eyes-closed drawings

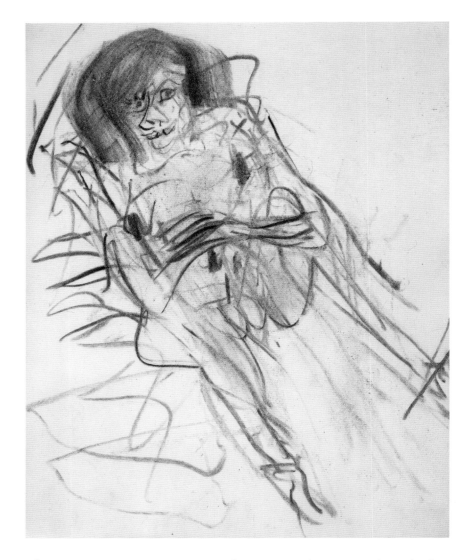

65 *Untitled,* 1966, charcoal
on paper, 25.4 × 20.3 cm.
The Over Holland Collection.

of 1966 may represent a woman and a man together in a rowboat; both
are naked (illus. 64). In any event, regardless of the number of figures present
in de Kooning's initial view, the majority of his Rowboat images involve only
the woman.

The Woman in a Rowboat image is the close relative of another of de
Kooning's common types: a woman partly sitting, partly reclining, perhaps a
sunbather in a chaise longue. With knees pulled up, the figure seems poised
to defy gravity by hovering between two fundamentally distinct postures.
Another eyes-closed drawing of 1966 is a relatively complicated instance of
this type of body, a sketch to which the artist may have contributed after
establishing blindly the initial configuration (illus. 65). Presumably, some

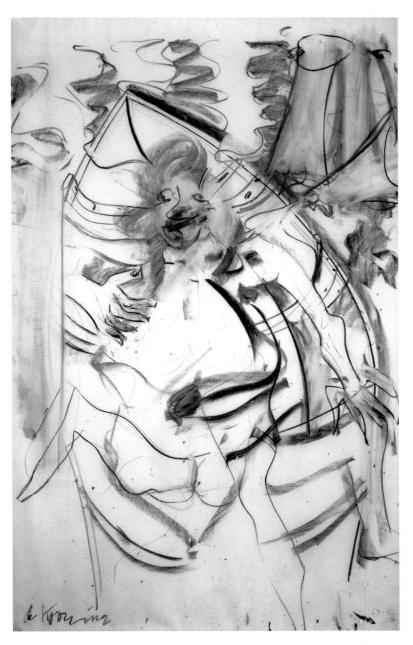

66 *Woman in a Rowboat*, 1964, charcoal on paper, 147.3 × 90.2 cm. Collection of James and Katherine Goodman.

of the key anatomical markers of this body were felt along the paper as the artist drew: two dark marks to signify nipples are farther apart than the measure of a draftsman's eyes would allow, but a hand will take a different course. A third dark mark corresponds to the figure's navel, and a vertical line below it becomes one of several candidates for a vulvic configuration, coupled with curving lines to signify buttocks. Similar alignments and distortions appear in de Kooning's eyes-open drawings: Was his eye learning from his hand? When de Kooning drew his *Woman in a Rowboat*, it was also sometimes with the knees pulled forward, legs extended to the sides so as to mimic the ribs of the boat; body and boat would resemble one another kinaesthetically. If nothing else, the act of rendering would establish their felt correspondence. In the drawing of 1966, a series of curving lines at the left of the sheet could be an enframing boat or the cushion of a chair or the folds of a blanket. The vague suggestion of an encompassing arc along the left side of the drawing causes me to think more of a boat. And sometimes the legs of this type of de Kooning figure are straightened, extending downward, rather like gunwales or even oars. In still other instances, both postures (legs bent, legs straight) become evident, though this effect seems to require the presentation of three or even four legs (*Woman in a Rowboat*, illus. 66). De Kooning led his half-reclining, half-sitting types into physically impossible positions, empathizing with several different postures simultaneously, increasing a sense of bodily constriction along with expansive movement.

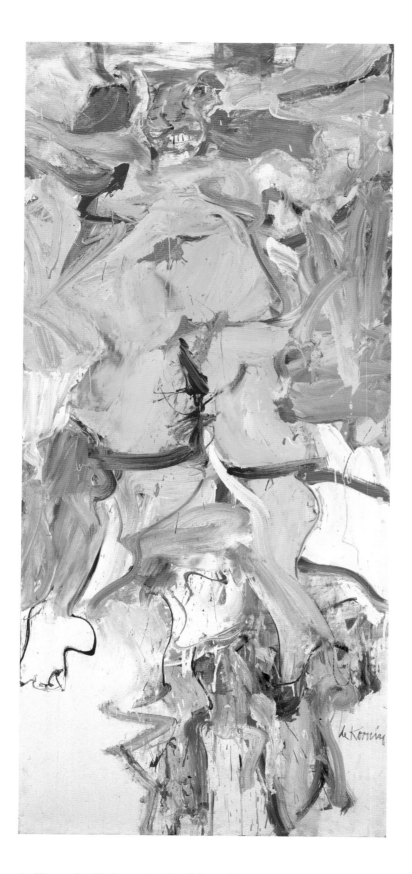

67 *Woman, Sag Harbor*, 1964, oil and charcoal on wood, 203.1 × 91.2 cm.
Hirshhorn Museum and Sculpture Garden, Washington, DC.

Developing the sense of movement sometimes meant multiplying the number of limbs.

In 1964, some large-scale drawings of the Woman in a Rowboat – the three- or four-legged type just mentioned – either generated or developed in tandem with what became one of de Kooning's most repeated images in paint, the figure perhaps first realized for exhibition as *Woman, Sag Harbor* (illus. 67). It, too, appears to combine distinct postures. Harold Diamond, de Kooning's dealer at the time, stated that the series of large paintings and equally large drawings completed in spring 1964 were 'variations on one theme, a woman in a rowboat, lying on her back. If you study the drawing closely, you will see the ambiguity of the woman's position.'[384] In May 1965, Diamond and the collector John G. Powers visited de Kooning in his studio, from which Powers took away a small variant of the *Sag Harbor* type. The collector recorded de Kooning's conversation of the day:

> He had seen a woman lying in a boat and was intrigued with the way she looked. He said if you paint a woman lying down and then stand the picture up, it seems to gain a height you can never get if you paint her standing up. He said he got a somewhat similar effect by having someone pose nude with high-heeled shoes on.

Powers reached his own apt conclusion: 'If she was lying in the boat when painted, when you stand her up she may seem to be standing, lying, sitting, or doing all these things at once.'[385]

Regarding a particularly colourful member of the series (illus. 68), Hess referred to 'light [that] bounces off the waves on to her rocking body . . . small golden strokes activating the whole surface'.[386] Although de Kooning is likely to have observed a specific woman in a rowboat on Long Island – or, according to Brockman, possibly a man, woman and child – the general concept and form are endlessly suggestive. It is entirely characteristic of de Kooning to combine references and associations in a single image, letting the complexity develop as it will. The boat itself has a vulvic shape ('the little man in the boat' is argot for clitoris), which associates the image with a number of de Kooning's paintings of the late 1960s that develop this anatomical theme; he often converted the representation of something large into something small, or vice versa, by formal analogy. Perhaps more immediately, the image relates to nativity scenes that include a Madonna and a cradled Christ child or a complete Holy Family; using his library of art books, de Kooning would have observed a similar disposition of the body in medieval and Renaissance representations of Christ within a mandorla. The link may not be as odd as it seems: according to Diamond's account, de Kooning began working on this

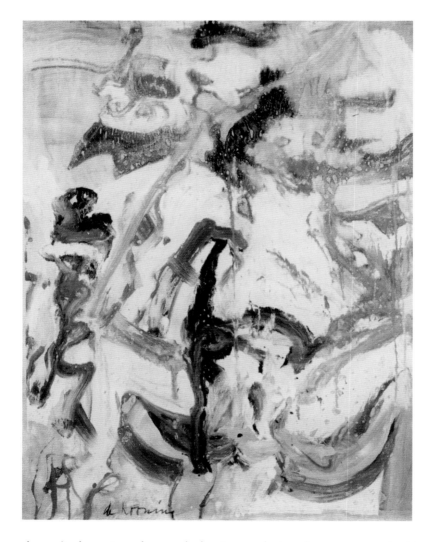

68 *Woman in a Rowboat*, 1964, oil on vellum, 120.7 × 92.1 cm. Private collection.

theme 'in late winter last year', that is, not during the warmer, sunbathing months, but either in December 1963, the Christmas season (late in the year) or in February or March 1964 (late in the winter).[387] The artist may have perceived an ironic, formal connection between recreational and religious themes through his interest in Christmas lawn displays, as well as in the Crucifixion, which he often drew. Diamond's dating agrees with Hess's (1963–64), but does not accord with Brockman's recollection that the theme developed somewhat later in 1964. She nevertheless retained the distinct impression that the Woman in a Rowboat was also a cradle at Christmas.[388] In addition, there is a formal resemblance to a Dutch wooden shoe – a specific object that de Kooning drew, along with many other types of shoe. Wooden shoes cradle the feet like a boat protecting the body from water.[389] I mention this because

water was such a freighted substance for de Kooning, who had an adult fear of open water and of boating in general. He had also suffered a frightening childhood experience of being forced into the water of a sewer or urban drain.[390] Yet he loved the light on water – 'light [that] bounces off the waves' (Hess) – as well as any sense of floating. More needs to be said about de Kooning and water. With regard to the Woman in a Rowboat, we perceive a constellation of woman, water, floating, cradling. Is it an image of sexual exposure or of maternal protection? No decision.

Like his switching from drawing to painting and painting to drawing, de Kooning's multiple thematic allusions generate contradictions. Hess sought a principle that would resolve the conceptual tension. Regarding the Woman in a Rowboat as a compositional type, he wrote: 'It forms a mandorla around the figure which is not, of course, suitable for de Kooning's paintings; its almond shape leaves the corners dead and the artist prefers to nail down his images to edges packed with shapes and suggestions.'[391] Here it may be significant that de Kooning wedged the woman of the small double-sided drawing not only into the form of a mandorla but also into the upper right corner of the sheet, as if the entire image were 'nailed down'. Hess's statement nevertheless implies that a drawing can (as de Kooning put it) 'float from the center' of the paper, like many works of the eyes-closed type, whereas a painting must cover the entire surface and fill its background. Had he theorized this insight, Hess might have said that drawing is essentially a linear, vector system and painting is essentially a tonal, raster system.[392] In other words, painting is a way of developing an image by differentiating all parts of the pictorial field, holding nothing in reserve, constituting a gridlike array of marks and colours. An example of a raster system is an illuminated television screen – all parts always filled by something, if only by the interference, the 'snow' with which de Kooning sometimes wound down an evening's experience of seeing. When drawings fill a pictorial field to its capacity, they resemble paintings. When paintings establish strong directional forces, they resemble drawings. Because any handmade drawing or painting is the consequence of physical gesture, none can lack entirely a vectorial quality, even if the artist resorts to pouring or the use of a roller. At issue is the degree to which this inherent directional character of an artist's marks might be dominated by the uniformity and neutrality of a raster (a grid) that would contain and organize those marks as interchangeable pixels (picture elements).

But de Kooning expressed no interest in theoretical distinctions of this kind. Recall that his closed-eyes effort required little explanation on his part. He simply 'found [it] helpful', this way of seeing without looking. Yet the corners of his paintings do sometimes seem empty – by Hess's reasoning, an

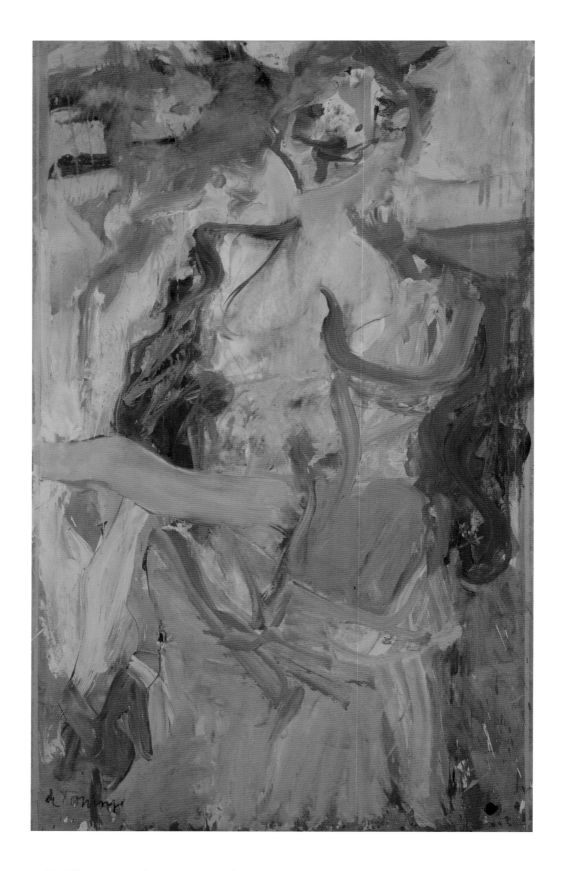

69 *Two Women*, 1964, oil on paper mounted on canvas, 153.7 × 94 cm. Private collection.

indication that the conception must derive from a drawing process. We see this effect in both the upper and lower right corners of *Two Women* (illus. 69), a large work of oil on paper (previously mentioned in passing, as an example of the literal nature of many of de Kooning's titles: 'Title'). At some point, *Two Women* was probably interacting with the similarly large drawing *Woman in a Rowboat* (illus. 66), which either guided or transferred a stage of the changing configuration of the painting. (Do we necessarily fail to grasp the integrity of de Kooning's 'work', viewing his bond of painting and drawing only in its broken state? Do we need to have viewed the process? It was life-long.) The two left-hand corners of *Two Women* are full, not empty. At the bottom left, a foot with a high-heeled shoe occupies the space – perhaps an indication that de Kooning was attaining extension and height by both of the means he explained to Powers: rotating a reclining figure into a standing one, and putting high heels on a nude. Filling this bottom left corner was logical because the axis of the central figure tilts from bottom left to top right (the boat, not absent but now barely discernible, angles bottom left to top right like the figure). To the contrary, what occurs in the space of the upper left corner is not so logical. Here we perceive an upside-down imprint of the head of a second Woman in a Rowboat, surrounded mandorla-like by the ribs of the boat. It is a head-at-the-top figure, which, given its orientation in the pictorial rectangle, has become a head-at-the-bottom.

In this fragment, the structure of the boat becomes far more evident than in the larger expanse of the rest of the picture. The inverted image is clearly an imprint transferred from the related oil-on-paper painting, *Woman in a Rowboat*, also of 1964 (illus. 68). This work elicited Hess's metaphors of watery fluidity: light 'bounces off the waves'; the body is 'rocking' (in fact, as if cradled).[393] The two paintings would have been wet in de Kooning's studio at the same time, as indicated by photographic documentation, some of which Hess included in his review of 'De Kooning's new Women' in March 1965. One studio photograph shows de Kooning in the process of applying a sheet of newspaper to a large vertical panel in order to blot or smear the wet surface; in addition, he was creating an imprint that might be applied to another large surface or simply kept as a record of the form as it existed at that moment. (He might also sign such a sheet as an independent work: see above, 'Title'.) With regard to *Two Women* specifically, Hess stated that it contained two figures, but did not broach the question of inversion, a curious omission for a writer who rarely flinched from descriptive detail. He characterized *Two Women* as a secondary derivative from a primary configuration such as *Woman, Sag Harbor*, one of several works of the time that took its oblong dimensions from door panels that de Kooning, in the process of building his new studio,

discovered he could utilize as painting supports. In addition to the newspaper imprints, Hess explained, 'transfers were made from the wet paint to heavy white "vellum" paper, sometimes to sheets as large as the ["door" painting] panel itself. One of these was completely worked over into an independent painting with two figures.'[394]

Actually, both of the heads in the transfer sheet that became the painting *Two Women* appear to have derived from a single transfer source, although with a slight delay at a somewhat different moment. My guess is that de Kooning added them in rapid succession. They do more than represent an inversion; they configure inversions of each other. 'He'd always turn paintings around . . . He loved seeing how things looked upside down.'[395] Although the upright head of *Two Women* has been substantially altered by additional painting and scraping, some of its elements still match those of the inverted head. The tilt of the figure's axis, no matter whether rightward or leftward, corresponds to the characteristic tilt of de Kooning's Woman in a Rowboat. Subsequent gestural marks have obscured the original gunwales and the disposition of the legs. De Kooning converted this painted surface back into the condition of drawing by scraping and dragging a large swath of paint from the centre to the left margin, creating a newly configured leg. His mimetic gesture, a way of drawing in paint, extends outward from the female figure's centre of gravity, as if to render the feeling of the painter's own leg being stretched. As noted, de Kooning tended to identify the centre of a drawing sheet with *his* centre of gravity and movement. This was true whether he was working on a large surface or a small one; significantly, his surfaces never became so large that they departed from the scale and range of movement of his body.

During the process of painting *Two Women*, de Kooning transformed his Woman in a Rowboat into a half-seated, half-reclining figure with crossed legs and high heels, perhaps now more party-goer than beachcomber. Elements of anatomy became directional forces, vectors. 'A girl sits there with her legs crossed', de Kooning once explained: 'I get a feeling about her . . . and try to put it down. [My] drawings are fast. Like snapshots.'[396] To grasp this painted instance of de Kooning's drawing-with-the-body, it helps to realize that when a figure has its knees pulled up, the legs appear vertically oriented (but foreshortened) when viewed from the front, while horizontally oriented when viewed from the side. Such ambiguity licenses the artist to pursue the extension of the legs in either direction, or, as was often de Kooning's impulse, in both directions, testing all possibilities. Anatomical paradoxes – violations of the order and rule of rendering anatomy – did not inhibit his sensory experimentation. Legs moving from the centre – which is the natural feeling – are not constrained by external gravity in the way that legs imagined to move from the feet would be.

70 *Clamdigger,* 1972, bronze,
146.1 × 62.2 × 53.3 cm.
Whitney Museum of American
Art, New York.

Expansive gestural marks, de Kooning's graphic vectors, are as charac-
teristic of his eyes-closed drawings as are his compressions and extensions of
anatomy. A charcoal, pencil or ink line swept across paper is similar to a path
cut through paint by a scraper: it might become an outstretched arm, a flowing
skirt or an extended leg. The same type of sweeping gesture appears in a
number of de Kooning's cast bronzes, such as *Clamdigger* (illus. 70), where it
indents the surface. During the actual modelling process for a sculpture, clay

or plaster could be added to and removed from the supportive armature at the artist's will. De Kooning sculpted in the way that he drew, imitating the feel of bodies by gesturing in character with the specific physicality of his medium. Working with clay or plaster (to be cast in bronze) he could subtract as much as add, changing the form by penetrating into it – by feel, perhaps blindly, and without finality. 'It's better than oil; I can come back the next day, break down a form, and start over.'[397] Whether in sculpture of this kind or in drawing and painting, a vectored line – drawn across, scraped out, whatever – might represent any number of insignificant but curious movements allowing the artist to identify with the imagined figure. In 1969, speaking to the journalist who elicited his 'float from the center' remark and other statements already quoted, de Kooning said: 'The figure is nothing unless you twist it around like a strange miracle.'[398] This is how the statement was published, but the journalist's notes provide a slightly different version: 'Unless you can twist it [the figure] around like a strange miracle, unless it is like a paradox, it is like nothing.'[399] Without the twist, there was nothing to feel.

The twist – the tension, the compression – activated de Kooning's sensation as he drew and painted a new series of Woman images in Springs. The feeling was analogous to tracking a set of red marks across a torso, across the abstracted painting surface of *Woman III* (illus. 43); this, too, had activated his sensation. Whether he was marking or twisting, in neither case, from his own corporal perspective, did the gesture signify violence. The violence was an arbitrary cultural connotation that suited violent individuals or the many Americans who fantasized violence, consumers of the same pulp imagery with which de Kooning sometimes toyed in titles for nominal abstractions (*Police Gazette*) but not for pictorial representations. Before it did anything else, marking or twisting as a studio practice generated sensation. Some viewers surely associated their edgy response to having witnessed a scene of violence. Those able to tolerate less certainty and closure with regard to their emotions might acknowledge that feeling was present but its sense was indeterminate (recall Greenberg's response in 1948: 'Subject'). Hess, always ready to defend de Kooning against the accusation of misogynist violence, admitted that there was a 'bloody look' to the red of *Woman, Sag Harbor* (then titled *Woman*). This redness, however, was more accurately the rose colour of 'late Rembrandts, Titians and Renoirs': 'The glow of the sun that warmed the dappled surfaces of the earlier sketches now has turned rose.' Feel the paint, Hess urged, feel the body of the paint as much as you feel the image of the body:

> Face, breasts and sex, each pulled open confront the viewer on a vertical axis suggesting a totem. But the turbulence of the paint covering the

image makes the background shapes as strong as the anatomy. . . . [It] fuses with the illusions inherent to the actions of the paint.[400]

I assume that Hess was observing how areas of viscous, fluid paint adjacent to this figure stretch and pull its elongated features to the sides of the rectangular support.

Whatever energy and 'violence' *Woman, Sag Harbor* conveys is shared equally by matter and image – yet matter is real and substantial, whereas the image is, well, imaginary. We fantasize over images far more readily than over ordinary material substances. For a painter in the studio, the situation may be different. Project yourself into that environment: you experience the sensation of paint through its manipulation. How do you experience the image? Do you test its sensation by sensing your own anatomical parts? Do you make your body the object of your sensation when you represent the body of another? Do the two sensations, the two images – self and other – ever correspond? This is one sense in which de Kooning's *Two Women* qualifies as a 'strange miracle . . . like a paradox'. Aside from containing its double in itself, it is the putative double of its maker. A paradox yields no sense, yet possesses its own sense, in the way that a grammatically, syntactically correct sentence may fail to refer to anything other than the feeling it produces. Sometimes we merely respond to the sound. De Kooning's art is unwhole. Like a word without a referent, it fails to sum up; it has no closure. The two heads of *Two Women* are present because the process brought them into being, but they have no representational logic and barely hold together as an abstraction, given how many different techniques of marking, transfer, obliteration, and removal join together in this field of matter and image. De Kooning's art creates material beings, presences, sensations, that have no corresponding concept to keep them whole in memory. We need actively to feel them to know them.

I have suggested that when de Kooning worked with eyes either closed or averted, his sensation became disjoined as well as intensified and centred. It seems that this paradoxical condition – especially obvious in the eyes-closed drawings – was an aspect of each of his representations. His twist emerged as he moved his line and even his body in imitation of the figure that interested him. He became like the other but also aware that the sensation in himself could never duplicate the other's. A difference remained. He could ponder it, seek to overcome it, exploit it, relish it with fascination. When de Kooning represented women, this difference had a cultural origin among all the physical, material origins: gender – a difference to be realized concretely whenever an ordinary man imitated the body of an ordinary woman, rather than merely looking. De Kooning's various remarks now assume broader implications:

'I was painting the woman in *me*,' he insisted when faced with accusations of misogyny in 1956, 'art isn't a wholly masculine occupation.'[401] *He* was the woman, and still the male artist. In 1975, he stated that his women were 'like caricatures', that many were 'self-portraits', that he 'never gave much thought to their proper gender'.[402] Clearly, he had difficulty describing what he was doing. Identifying himself with his art, he was representing the woman he himself might be. I think that this mimetic act served de Kooning's remarkably somatic imagination rather than merely administering to sexual desire; but the two, no doubt, relate. His mimetic travesty may have satisfied some degree of sexual fantasy, but more than this, it satisfied a lust for aesthetic sensation. Critical analysis would be overreaching, should it attempt to separate the two.

If de Kooning had let his eye dominate his hand, the result would have been conventional drawing: a female figure observed by a male artist, reinforcing the desires of a conformist male 'gaze'. Attempting to internalize the other through his bodily action, whether with eyes closed or open, de Kooning drew something new and different, neither the gendered model objectified nor the gendered self expressed. His imagery extended beyond the stabilizing centre of gravity established jointly by the clichés of popular culture and the conventions of fine art. 'The results surprise me', he said.[403] Of course they did, because they initiated sensation to areas outside culture, both high and low. For this exceptional artist who thought he was quite an ordinary man, surprise was sufficient return. It kept the centre in motion, in touch with its mobile situation.

Type

De Kooning's Woman in a Rowboat became a type, and I have referred to it by this term. It repeated itself by tracings and transfers so many times that to establish a sequence from first in its series to last would serve little purpose. De Kooning was not interested in imbuing the turns and twists of a process with sense. A type forms an array, not an order. A type is always similar, yet variable – unreliable as a precise indicator of any specific quality. In short, it is changeable. It can change overnight, from one day's painting to the next.

A 1959 film project on de Kooning's studio life on Tenth Street, before he moved to Springs, records him alluding to a type. Viewed in his work environment, he comments on a pin-up photo modelled after famous images of Marilyn Monroe. In a deadpan but slightly bemused manner, he remarks: 'I like the type more than the original.'[404] If only because of Monroe's preeminence as an American icon of beauty and stardom, this must have been a minority position in 1959. Why would de Kooning, who had no particular

quarrel with the judgements of popular taste, take this provocative, counter-intuitive view, preferring the secondary image to the primary one? Perhaps, in his idiosyncrasy, he found himself unaccountably attracted to the Monroe lookalike. But here he may also have been intuiting that the essence of a type is its variability – forever in motion and mutable, like the position of a de Kooning leg. As a derivative at least once removed from the original, the type acquires no normative value and need set no fixed standard. With precisely the kind of paradox de Kooning loved, an anonymous pin-up demonstrates that it is as much in the nature of the type to change as to stay the same. Anonymity and generality allow the type to evolve in ways unavailable to the specific model, a complete, flawless original obligated to remain true to itself. In fact, as de Kooning argued in 1964, if you see someone who looks like someone you know – the same type – then you know the original (or would it be the type?) better than otherwise.[405] It could be the sameness, but it could be the difference, that generates the understanding.

The indeterminacy of the type suits a play of distracted attention. De Kooning was creating one changing instance after another of his own type. This was so during the 1950s and '60s when he painted his various series of Woman: 'I was painting the woman in *me*' might translate into, 'I was painting *my* Woman.' A different aspect of his type appeared during the 1970s and '80s when the majority of his works tended to be seen as abstractions. Each series of works exemplifies what might be called the de Kooning type, not only because the artist's working methods during the four decades were very similar (and similar, too, to those of his earlier decades), but also because the Woman type links up with later abstractions by the meandering course that constitutes de Kooning's entire artistic output. It is as if a line of 1984 were the physical continuation of a line of 1954. This relationship is more than metaphorical because de Kooning often used drawings from his earlier decades to trace linear motifs into his late canvases. Such links work by contact – tracing, imprinting – metonymic rather than metaphoric. Yet this transfer-by-contact was transfer with change (a metonymy acting like a metaphor, as metonymies may). De Kooning was annihilating familiar categorical differences as his type continued to accumulate its variations. And he himself was changing – or not.

By chance (but appropriately), one of de Kooning's Woman types from 1954 came to illustrate the contradictory nature of the pin-up type as well as of every other group of images that relate to a type: the fact that a type adequately represents a certain category of appearance, yet bears a contingent, mutable relationship to its defining instance. The painting in question, known as *Marilyn Monroe* (illus. 71), acquired its title only after its completion, when one of de Kooning's friends suggested the connection, despite the artist's

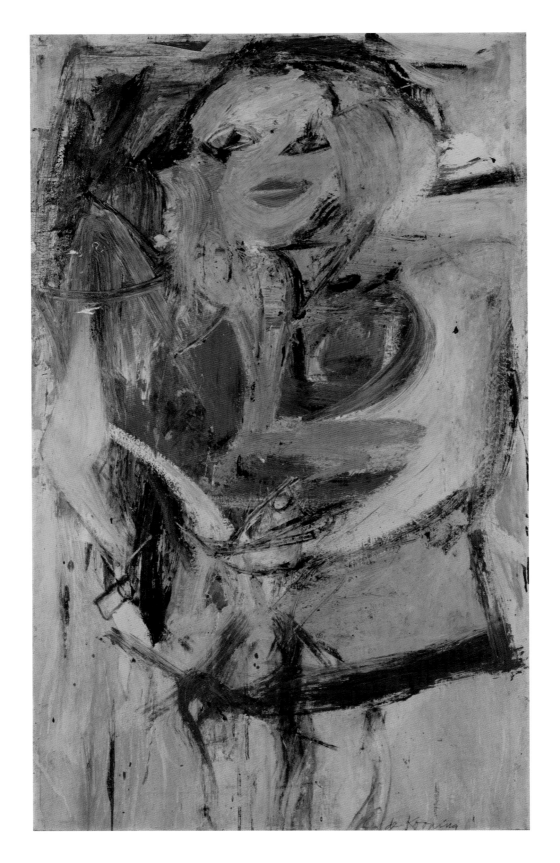

71 *Marilyn Monroe*, 1954, oil on canvas, 127 × 76.2 cm.
Neuberger Museum of Art, Purchase College, State University of New York.

never having conceived the image as a likeness of the movie star.[406] Here a particular example of the Woman type fell into the more specific Monroe-type role, crossing from one class of image to another and realizing the potential for movement and change that concerned de Kooning. Because he was as open to others' suggestions as he was to his own distraction, he had no resistance to changes in meaning that passed beyond his explicit intentions and control.

For any individual viewer, a de Kooning 'abstraction' of the 1970s or '80s, as well as those of the late 1940s or the mid-'50s – not necessarily the whole of the picture, but some part of it – might resemble something specific outside de Kooning's world of painting, just as, during the 1950s, his *Marilyn Monroe* suggested the specific person, her projected fantasy image, even before it received its title. A de Kooning 'abstraction' might evoke an element of popular imagery, or a motif from the history of art, or some curiosity of nature, or, kinaesthetically, a sense of the viewer's own physicality. None of this would be alien to the spirit of the painter's work, which, in the course of its genesis, repeatedly complicated itself by introducing alternatives to its existing motifs. De Kooning's art, whether representational or abstract, blurs the distinction between a specific image and its type, which, by one sense of the term *abstraction*, would make every picture an abstraction. And so it is. Where the conventional modernist establishes a visual order and develops it toward its most coherent expression, de Kooning traces a sequence of surprising reorientations. No wonder that he would occasionally surprise himself with an unforeseen resemblance. Anything looks like anything. His imagery came from where it came: 'On television you often see shots, as in scenes televised from Vietnam [this was 1971], that look exactly like painting. . . . Of course, it's a coincidence. Sometimes a painted portrait looks like a photograph, and sometimes a photograph looks like a portrait.'[407]

Throughout his career, de Kooning's technique fit the logic of the type: its openness, flexibility and instability. Enthusiastic supporters, such as Hess and Rosenberg, considered him a true original; those who wavered, such as Greenberg, complained that he compromised the force and meaning of those of his generation who were risking all for their radical intentions. De Kooning, however, followed no principle of originality, pursued no development from a eureka-point of origination, had no determined singularity of purpose. He was neither Newman (committed to a new beginning), Rothko (committed to a particular mode of abstraction) nor Ad Reinhardt (committed to a reduction of means). He stated that his paintings stemmed from multiple engagements with other paintings more than from any unique, natural model or any predetermined notion, either the tradition's or his, as to what to do and how things should look. When Rosenberg asked an obvious question in

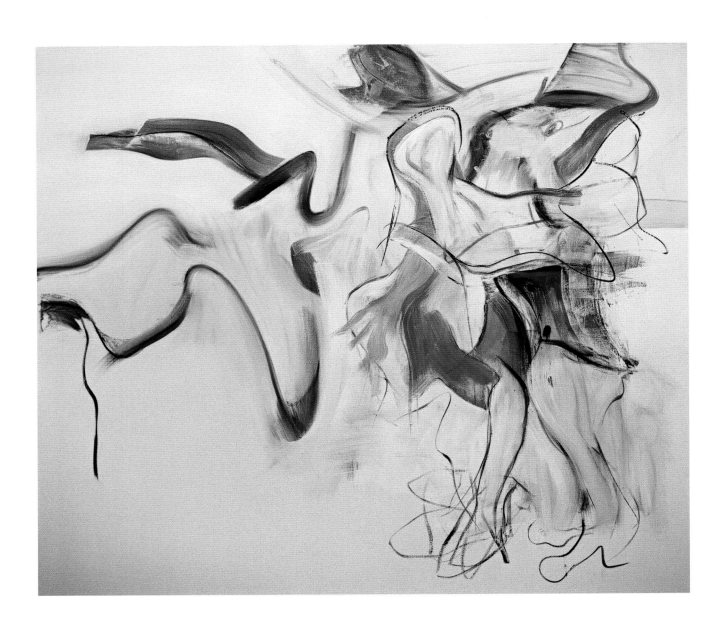

72 Studio slide, state 1 (23 July 1983) of *Untitled XXXVI*, 1983.

73 *Untitled* xxxvi, 1983, oil on canvas, 203.2 × 177.8 cm.

view of all the partisan arguments over the competing positions of the late 1960s (pop, photorealism, minimalism) – 'You don't feel that painting has a particular purpose . . . You don't care why people paint whatever they paint?' – de Kooning replied: 'The main thing is that art is a way of living – it's the way I live. It's not programmatic.'[408] Other than his existence, his lived situation, there was no origin to his art, no essence, no central plan – just a mentality and a procedure that felt right. De Kooning's attitude explains, at least in part, why he was uncomfortable with a blank canvas, preferring to get it covered quickly with marks, virtually any marks, avoiding the directive of an orderly beginning that would require being carried through to an end. Even his own inclinations were not to determine the outcome. He would begin by altering an appearance. This was his 'way of living' in aesthetic, sensory freedom. He acted as if nothing he thought or did determined the next thing he thought or did. Not to be held to his own premises, this was his freedom: to feel without the restrictions of reason, to sense outside the confines of sense. Peirce noted that an individual in this condition – failing to link premises to consequences – would never transit from a state of doubt to a state of belief.[409] De Kooning favoured doubt.

Despite the abstract appearance of his late work, the initial marks often belonged to a human figure, as indicated by an early state of *Untitled xxxvi*, a painting of 1983, where the configuration of a woman's legs and shoes, a common motif from the 1960s, is visible at bottom right (illus. 72, 73). Along with others who have studied de Kooning's process, I strongly suspect that the initial layers of drawing for his abstractions virtually always referred to the human figure or contained some other representational element. These beginnings were a mid-point: they brought de Kooning into the midst of things, where he wanted to be, with a number of competing pictorial elements already in place to distract him. If this was not enough, he had a cluster of other paintings in progress in his studio to draw his attention by their immediate proximity. Into the centre, into the work right in front of him, he would incorporate aspects of what he could see to his right and left.[410] These peripheral surfaces functioned like his sketchpad drawings, or even like his television, which provided the same kind of distraction in miniature. Distraction is the action doubt takes.

Transition

Like everything of note in experience, de Kooning's art originates in change. Change is what he kept repeating: 'I am working for weeks and weeks on end on a large picture and have to keep the paint wet so that I can change it

over and over, I mean, do the same thing over and over.'[411] To change – over and over. Transition, change itself, is the sensation de Kooning thought closest to his life, the sensation he would capture in his art. 'I have no message', he declared, refusing to acknowledge an artistic genesis or essence definitively his: 'My paintings come more from other paintings.'[412] Analogously, the meaning of life comes from life, which carries the message. In de Kooning's case, this did not imply that he drew *his* meaning from the meaning of the life of others. His repetition was, first of all, an act of repeating himself. When faced with an empty studio he fabricated a crowded environment of sketches as rapidly as possible, so he would have something with which to work, a progression without progress, something alien but his own.[413]

There are fixed transitions as well as fluid ones, transitions in motion. A fixed or definitive transition, the passage from one fixed state to another, becomes visible only after the origin and the end have been determined. Such transition marks the passage from one position to another and provides sense as a sense of direction. Transition in an artist's oeuvre indicates purpose and a meaning that can be attached to the entire creative effort. It becomes particularly difficult to attribute lines of development and points of meaningful transition to someone – by his own conception, de Kooning – who lacks fixed origins, has never been stable, continually changes direction, someone perpetually in a state of transition. When he said 'I am an eclectic painter by chance', he alluded to the tendency of his attention, his vision, to turn from one motif to another, to twist one motif into another, multiplying every ambiguity.[414]

De Kooning had an unusually long career. Despite his claims to change and to chance, art historians discern constants, lasting preferences for certain themes and technical procedures. Such invariables might be linked to a pattern of needs, desires and pleasures, the collective product of the formative conditions of the artist's life, especially the character of his childhood in Holland. De Kooning himself related his longstanding concern for water and its reflections to memories of Rotterdam, the environment of his youth: 'I was always very much interested in water . . . being in Holland near all that water.'[415] His childhood was hardly idyllic since his parents divorced when he was three and subsequently competed for his custody, with the family tension lasting for years. Perhaps such events of separation, involving siblings as well as the parents, initiated the feelings of anxiety that de Kooning suffered throughout his life, as well as his tendency toward ambiguous expression and avoidance of definitive choices.[416] Conflict and disruption in the family are also likely to have left the child to seek security and self-worth elsewhere, so that his accomplishments as an adolescent student in applied art represented emotional salvation. Art gave de Kooning

identity, purpose and a personal sense of achievement. Yet his art itself
was unstable.

As an adult, de Kooning arranged his life to facilitate his painting,
as if to maximize the time spent within this realm of success. During the
early 1960s, he devoted his resources to building his house in Springs not
for the sake of its distinctive architecture but for the artistic practice it
would accommodate; the studio space became the centre to which the living
quarters were auxiliary. The painter developed remarkably few interests, skills
or diversions unrelated to his primary activity. Friends noticed the irony of
self-imposed limitations that virtually confined him to the studio: 'Although
he lives in a beach resort, about three miles from town, Bill can neither swim
nor drive.'[417] Hess, whose various accounts of de Kooning assigned cultural
value to his idiosyncrasies, associated him with a psychological condition he
attributed also to J.-A.-D. Ingres, *delectatio morosa*, an obsessive return to
established form, insistence on a single topic (monomania); de Kooning,
Hess wrote, 'has gone back continuously to older shapes, re-creating new
ones from them, as if he were impelled to bring a whole life's work into each
section of each new picture'.[418] This should not be regarded as a sign of the
artist's frustration but is more likely the way he prolonged the pleasure of
painting, both past and present ('I can change it over and over, I mean, do
the same thing over and over').

Given the concentrated focus of his energy, it is difficult in de Kooning's
case to distinguish transition-as-change from transition-as-continuity and even
from transition-as-stasis. With regard to his practice, he was oblivious to time
and to any usual understanding of accomplishment and progress. According
to Hess, he scraped down and repainted the surface of *Woman 1* (illus. 37)
'at least fifty' times until, having been committed to a scheduled exhibition,
it finally 'escaped by truck from its creator'; on his part, de Kooning said he
'could sustain [the Woman theme] all the time because it could change all
the time.'[419] He painted and changed through the entire day, without any
but the most essential breaks in his rhythm (see 'Array'). If this behaviour was
obsessive, he nevertheless maintained enough distance to laugh at himself:
'Once, after finishing a picture, I thought I would stop for a while, take a
trip, do things . . . The next time I thought of this, I found five years had
gone by.'[420] He appears to have followed a work ethic, and he enjoyed his
occupation so immensely that it was always its own sensory and psychological
reward before bearing professional and monetary reward, though these came
with time. Work also seems to have satisfied a need for an absorbing, isolating
routine, an experiential habit of the organism that at times ran counter to the
most common forms of sensory habit. De Kooning could spend days, even
weeks, methodically preparing his colours, as if this laborious process promised

unique sensory information, a Peircean 'gain of experience'. With the aid of handmade charts, he kept elaborate formulas for creating earth hues from mineral pigments, which had the advantage of remaining wet longer than earth pigments themselves.[421]

Wetness kept his options open. Faced with a decision to be reached, de Kooning pondered every alternative, avoiding fixing on a solution. In conversation he would interrupt his own argument by taking a new direction, suddenly shifting, even reversing, the flow of his monologue with 'On the other hand . . .' or 'What I meant to say . . .'[422] He took such an open position on most issues that any rejoinder became pointless. To detractors, his reversals and double negations approached incoherence. To promoters, he was project-ing the ultimate in individual freedom, an escape from theoretically sanctioned historical imperatives. Over the years, de Kooning had, of course, become known for maintaining an ambiguous relationship to the competing demands of representation and abstraction in painting. Most other artists either regarded abstraction as a necessary path for avant-garde practice or, equally dogmatically, regarded a return to representation as a necessary position of critical resistance. De Kooning appreciated colleagues willing to take a path of no specific direc-tion. When Philip Guston exhibited primitivistic, but frankly representational, cartoon-like paintings in 1970, de Kooning was vocal in supporting this new work as an expression of personal freedom.[423] But to say that Guston's way was the way to go was not de Kooning's mode. It would be too definitive.

Devising a set of studio practices to suit his desire for reconsidering, de Kooning's physical principle was fluidity – the material analogue of conceptual change and transition.[424] Fluids tolerate instability, readily adjusting their form to an altered environment; they are transitional by nature. De Kooning preferred oil paints to acrylics because of their greater fluidity. Oils dry slowly, but they do dry; so he needed a way to keep the paint from hardening. He accomplished this with the aid of a special recipe for painting medium, mixing his pigments into a temporary emulsion of safflower oil, water, and one or more solvents. Both safflower oil and water extend the usual drying time, with the water eventually evaporating, leaving traces of bubbles in the paint surface or a pattern of wrinkles, a kind of shrinkage.[425] De Kooning could easily rework such a paint mixture because it remains wet for prolonged periods. And he could also scrape or wipe part or all of it down to a trace (to the level of a faint sketch) as often as he wanted change and freshness. Hess described the practice with narrational panache: 'De Kooning can make a big painting in a day, scrape it off in a few minutes, paint it again the next day – a painting a day for a year on the same canvas.'[426] Of course, de Kooning himself said as much: 'I can change it over and over, I mean, do the same thing over and over.'

Along with the accommodating wetness came a slipperiness (a factor of the consistency of the emulsion), which facilitated the painter's rapidly punctuated and often sweeping but light-handed brushwork.[427] To eliminate still more of the physical drag, de Kooning worked on canvases sanded to a very smooth gesso surface or on sheets of smooth, slick vellum taped or tacked to a hard surface.[428] Slickness, smoothness, slipperiness, fluidity: all conditions for rapid change. Add to this the artist's use of vellum as a transitional surface of transfer, an ideal material not only because of its double-sided transparency, but also because it was sufficiently stiff and smooth to bear heavy paint strokes. Like canvas or panel, it could be wiped or scraped down to a trace. The slick surface of large charcoal drawings on vellum caused broad erasure strokes to resemble smears and wipes of viscous paint: 'He used an eraser the way he used a paintbrush.'[429] An aspect of both painting and drawing, de Kooning's marks of erasure, beyond being signs of a process, acquired an independent visual interest. These marks have their own sense.

De Kooning painted *Woman, Sag Harbor* directly on the smooth, hard surface of a door panel, but some related works were produced on sheets of vellum of more or less the same size (approximately 80 inches in height and 36 inches in width, 203 x 91 cm). These were the sheets initially used for imprinting and tracing; they could be developed independently as paintings, eventually to be mounted on canvas or board as a more permanent support. A work of this kind, the heavily impastoed *Woman Accabonac* (illus. 74) may have begun as a tracing of one of the stages of *Woman, Sag Harbor* or another work that shares its distinctive door-panel dimensions.[430] De Kooning reworked *Woman Accabonac* many times; it was a type. A partial record of the process exists because his assistant McMahon often photographed the stage reached at the end of a day. The photographic record demonstrates that a number of other paintings derived from tracings of the intermediary images. For instance, a work on vellum with the generic title *Woman* (illus. 75) corresponds closely to one of the temporary states of *Woman Accabonac* (illus. 76). Consistent with de Kooning's practice of setting new sheets of vellum flush against wet oil paint surfaces, *Woman* combines charcoal tracing on its front side with painting and imprinting on the reverse, both sides remaining visible in the finished product because of the transparency of the paper ground.[431] Given this manner of tracing and imprinting, one painting might bring forth many others, yet not necessarily in a linear fashion. Tracing the geneaology would likely indicate incoherence, an unwhole practice, rather than revealing reason. De Kooning often doubled back by using a derivative tracing to refigure the initial surface. The template itself kept changing.

Tracings, photographs and also the monoprints on newspaper (these can also be called 'oil transfers' or simply 'pulls'), created an ever-expanding

74 *Woman Accabonac,* 1966, oil on paper on canvas, 200.7 × 88.9 cm.
Whitney Museum of American Art, New York.

75 *Woman*, 1965, oil and pencil and charcoal on paper, 201.9 × 90.1 cm.
Private collection.

76 Studio mounted photograph, state 2 of *Woman Accabonac,* 1966.

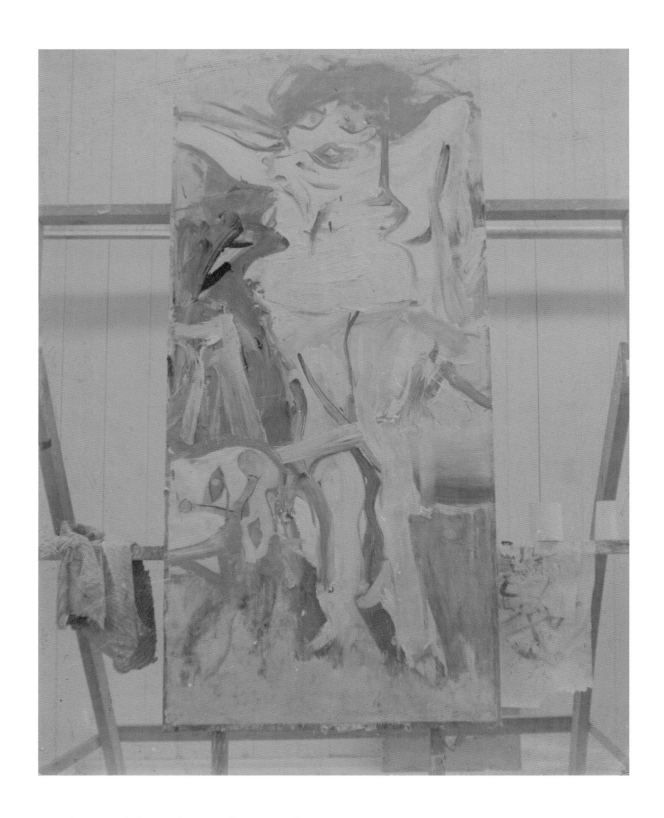

77 Studio mounted photograph, state 9 of *Woman Accabonac,* 1966.

archive in which primacy and sequence mattered little if at all.[432] The word *archive* comes to mind because the material at hand is paper. But this is an academic term and not the kind de Kooning would use – too abstract, not physical enough. With his attention to fluidity, he called his capacious environment a 'stew', or a 'soup', or 'yogurt' (punning on 'culture').[433] The painter began each work in the midst of things, drawing from and adding to the mix; and in this sense, his paintings constituted transition without owning up to an origin (others had already worked the stew pot). His studio, neatly ordered but cluttered with fragmentary paintings and drawings, many of them transfers, provided surfaces to retain all traces of the life of an image even as he wiped other surfaces nearly clean or scraped them down. De Kooning's use of transfer was not a system for exhausting possibilities but a way of holding onto everything (like keeping both parents after a divorce), avoiding any loss, any decisive exclusion.[434]

Woman Accabonac is a very physical painting. Its surface has been repeatedly torn and then patched by short strips of masking tape resembling bandages on broken skin. The borders of the painting retain longer pieces of tape used initially to hold the vellum to a door panel as its underlying support; de Kooning's paint collected at the slightly raised inside edges of these taped borders because the tape itself presented an obstacle to brushing and to flow. Covered yet visible, the various pieces of tape have become as integral a part of this work as the vellum and the paint. Nothing has been lost.

Despite the vigorous brushing and muscular scraping, the woman of de Kooning's image appears – as the artist would say with humour – both 'demure' and 'ordinary'.[435] Certain elements, but not all, suggest that the figure is seated with her legs drawn together in well-mannered fashion; the curved edge of a chair is visible at centre right.[436] In one of the intermediate states for *Woman Accabonac* (illus. 77), the figure wears what may be a short sun dress with straps. It seems that the skirt, extending to the left, metamorphosed into the bulbous shape usually described, for want of a better explanation, as one of the breasts of the final *Woman Accabonac*. But how many breasts are there? The smaller rounded shapes just below the woman's head may well be the actual breasts, and certainly the figure's breasts were placed high in the preliminary versions. It is hard to decipher the final anatomical distribution, and often equally difficult to determine whether a de Kooning figure is clothed or nude. Though it may be more provocative to think of it as flesh, a billowing shape is likely to be fabric in motion – as in the photograph of cheerleaders that de Kooning seems to have admired (see 'Centre'). You sometimes feel that it must be both, perhaps because the artist has had one sense of the figure, then the other, then the one. Sweaters, dresses, torsos and paint share for de Kooning a common property: each is a fluid, itself in motion and capable of mixing with others, in transition.

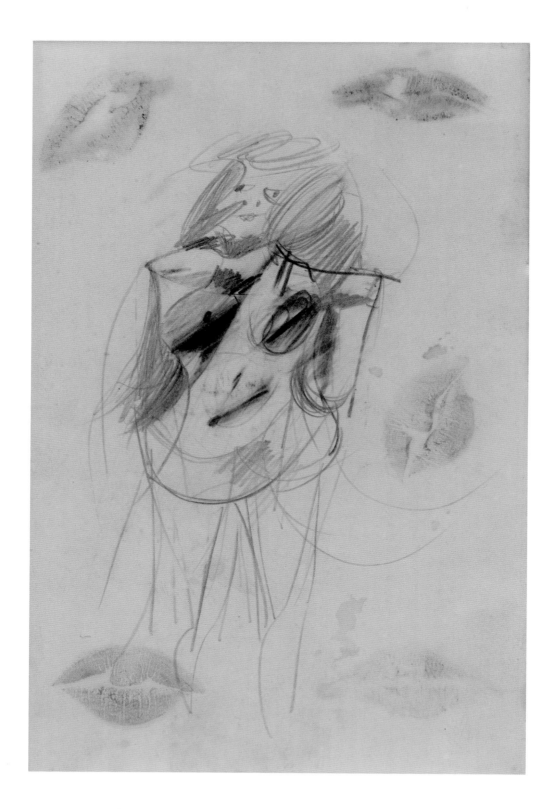

78 *Woman – Lipstick, c.* 1952, graphite, lipstick, and traces of pastel on paper, 22.5 × 15 cm.

Lipstick

Elaine de Kooning's personal art collection included a work known as *Woman – Lipstick* (illus. 78), a small graphite drawing, probably executed during the early 1950s, the time of *Woman I*. It has a unique feature: the Woman image has been surrounded by red lipstick imprints, with one imprint lying within it, tinting the torso. The image might be considered a collaborative creation, a joint representation of and by Willem and Elaine. When it was auctioned in 1989, after Elaine de Kooning's death, her explanation accompanied it: 'Bill asked me to put on lipstick & "kiss" this drawing, carefully picking the exact spots where I should press my lips, six times – each one fainter, ending finally with the mid-section (going counter-clockwise).'[437]

No further information as to what Elaine de Kooning's action accomplished is indicated: whether, at that particular moment in the couple's complicated personal history, this drawing constituted a bond of affection (Elaine often signed notes to Willem and others with lipstick kisses), a private joke of some kind, or a visual play on either gender relations or the nature of representation.[438] The lipstick imprints represent Elaine de Kooning's touch, Willem de Kooning's touch (since he guided the marking), a mouth (Elaine's or anyone's), and any part of the body or anything else that, when painted, resembles a mouth. The references to touch are indexical: they signify by contact. The references to the mouth are iconic as well as indexical: the lipstick traces have the form of a mouth and were produced by imprinting. References to anything else we might imagine as mouth-like are also iconic: they signify by resemblance of some sensory kind. In addition, each imprint represents the act of kissing and, by extension, any other physical act of pressing against a resistant surface with a relatively light touch – a specific kind of contact, a type with variations (billiard balls kiss, a warm breeze kisses the skin). Was Elaine de Kooning kissing the female figure that Willem de Kooning had drawn, as if to enact its fetishization by adding a sign of her being? Or was she adding red accents to his composition of black marks, intensifying the pictorial effect while covering and therefore completing the sheet, converting the drawing into something a bit more like a painting, as her husband often did by adding pastel or oil crayon to graphite or charcoal? Perhaps the final kiss is meant to locate a centre for the represented body, and simultaneously for its paper support.

De Kooning tended to be conscious of both kinds of centre and to conflate them; and here he was directing Elaine de Kooning's placement of the marks. Pressing lips against a piece of paper is an experience analogous to acts of painting and drawing, which press pigment and graphite into the same kind of surface. The correspondences go beyond the tactile to the

synesthetic; de Kooning believed, as do many artists, that the richness of paint in both colour and texture, as well as its malleability, elicits sensations of taste.[439] Because the act of kissing must draw its agent flush with the image, the object of its affection, perspectival distance is temporarily suspended. This is the kind of intimacy – visual, tactile, even gustatory – that de Kooning desired in his art. It is a closeness, a sensory concentration on the otherwise excluded detail. There are innumerable ways to make a mark, just as there are innumerable ways to experience the pleasures of sensuality. The point of attention – what the mark marks – can be precise and, as de Kooning sometimes said, 'tiny'.[440]

Colloquially, lipsticked lips are often called a 'painted mouth' or 'painted lips'. People seem to utter these phrases with a certain self-consciousness, as if they were making a clever metaphor, or perhaps a character judgement; for Euro-Americans, 'painting' the lips or any other part of the body connotes an aggressive and even illicit sexuality, whereas lipstick and cosmetics in themselves do not. Referring to 'painted lips' may well entail passing a judgement, but it cannot create much of a metaphor since this description is straightforward – lipstick is oil- or wax-based pigment applied externally to colour the lips, painting their surface. Invoking the capacity of cosmetics to standardize and anaesthetize the look of people, de Kooning's friend Rosenberg once alluded to 'painted lips, masks of feeling' in relation to the artist's practice of collaging bright red lips cut from magazine advertisements.[441] The most notorious example dates from 1950: de Kooning's small, intense *Woman* (illus. 79), for which the artist cut a mouth from the 'T-zone' (a combination of mouth and throat) featured in a long-running promotion for Camel cigarettes.[442]

Rosenberg subtly ironized these mass-culture lips by putting them in the category of 'academic art', presumably because photography had rendered them suited for Salon painting – perfectly beautiful, static, insipid. When de Kooning was asked about his collaged mouths, he alluded to much more: being photographic, the lips would function metaphorically ('like a pun') within the context of the painting, since they play on the difference between what custom takes to be natural and real (photographic detail) and what it takes to be imaginary (painters' inventions and liberties), even though the advertisement and the painting are both artificial constructions. The cut-and-pasted lips refer back, in a literal way, to the perfect American beauty grafted onto the artist's personal vision and visceral understanding. De Kooning also acknowledged coyly that these lips are sexualized like the ones people call painted. They are either sexual in their preexistent cultural signification or have been eroticized by the painter's immediate cut and touch. All this is implied in his statement of 1960, typically offhand: 'I cut out a lot of mouths.

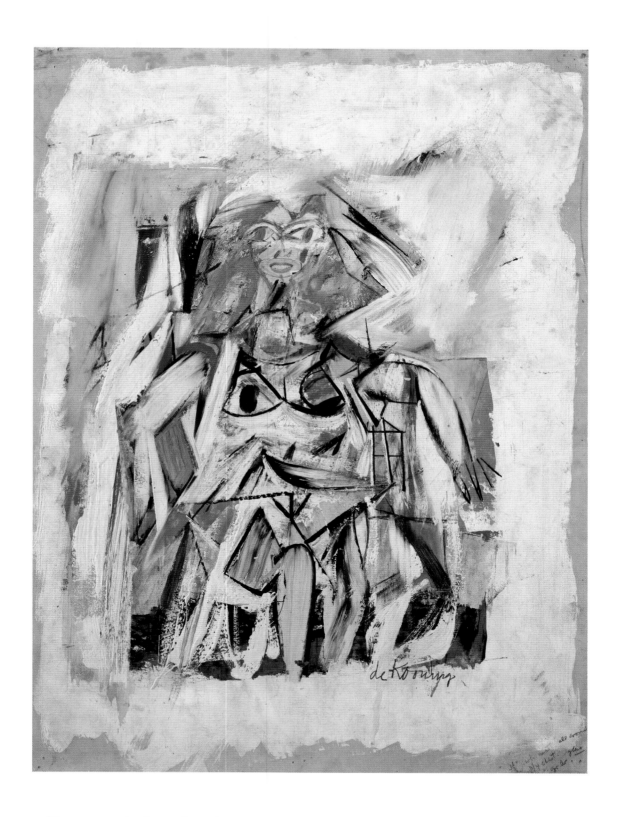

79 *Woman*, 1950, oil and cut and pasted paper on cardboard, 37.5 x 29.5 cm.
The Metropolitan Museum of Art, New York.

First of all, I felt everything ought to have a mouth. Maybe it was like a pun, maybe it's even sexual . . . I put the mouth more or less in the place [within various images of Woman] where it was supposed to be. It always turned out to be very beautiful and it helped me immensely to have this real thing . . . it was something to hang on to.'[443] It was not abstract.

The mouth is one of a number of anatomical features de Kooning habitually privileged, reaffirming the conventional sexuality of certain parts of the body or – as his act might better be conceived – investing their representation with his own, perhaps idiosyncratic, sensuality and eroticism. We recognize de Kooning's special attention to or investment in certain parts of the body since they so often receive his pictorial stress. Enhanced visibility of a given anatomical feature might derive from colour or value contrast, striking linear configurations, or a disproportionate prominence within the general scheme. De Kooning's privileged features are these: eyes, mouths, breasts, genitals, feet. The list seems to justify a conclusion Hess reached in 1959: 'The theme of sexuality . . . is a major part of de Kooning's painting.'[444] Of course, those who lodged complaints about *Woman 1* believed this also; but they were distinguishing the threat of sexuality from its pleasure. There should have been no surprise – there probably was not – when de Kooning offered a Dutch interviewer a commonplace metaphor: 'A woman has two mouths, one is the sex.'[445] Substitution and analogy characterize his painting as well as his thought: one thing changes or passes into another; transition applies to anatomy as much as to any other aspect of his art. During the greater part of his career, he traced, retraced, and exchanged his set of connotatively sexual features, which are the figurative motifs most central to his painting process.

Spread

Two of the privileged body parts, genitals and feet, require qualification. De Kooning's drawn or painted feet are peculiar; they often taper to a point or broaden to duck-like proportions or sport the highest of high-heel shoes – I will return to them. As for genitals: de Kooning used to say that the only point of interest on the male body was the penis; every other anatomical part of interest was on the female body. When nude, his male figures have penises in full view, as in the drawing *Untitled (Crucifixion)* of 1966 (illus. 80). Those who knew his art well enough were often struck by how often, with his female nudes, he featured the vagina – or, to speak more accurately, the vulva (of course, Picasso and others had this focus also).[446] Around 1965, de Kooning told Hess, 'she has to be all there', meaning that every notable

80 *Untitled (Crucifixion)*,
1966, charcoal on paper,
43.1 × 35.6 cm. Hirshhorn
Museum and Sculpture
Garden, Washington, DC.

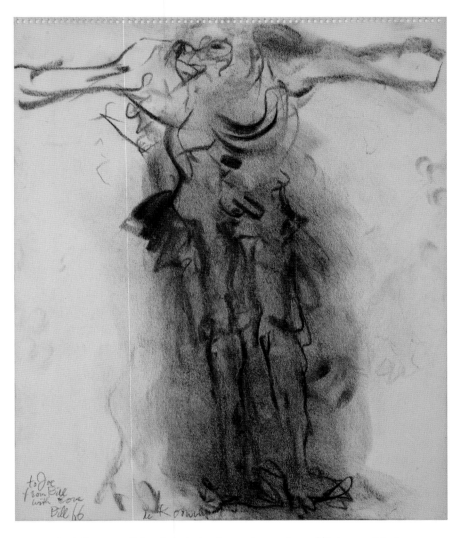

anatomical feature of the female body ought to show.[447] An untitled
painting of 1970 (illus. 81) is clearly a vulvic image and not much else in
terms of its representational reference; in fact, it is at least a double vulva,
with the more explicit anatomy within the bottom register, accented by red,
and a similar configuration resting above it, and possibly a third above that.
Drip marks indicate that at some stage the painting (oil on paper, subsequently
mounted on canvas) had a horizontal orientation. This would convert the
'figure' now at the top to a vulvic figure then at the left: two spread-legged
women, one horizontal, one vertical; or, think of it as one and the same
figure, twisted around – 'like a strange miracle', de Kooning might say.[448]
Works of this type, with or without a prurient element (prurience derives
from the attitude of the beholder) satisfied de Kooning's desire to focus on

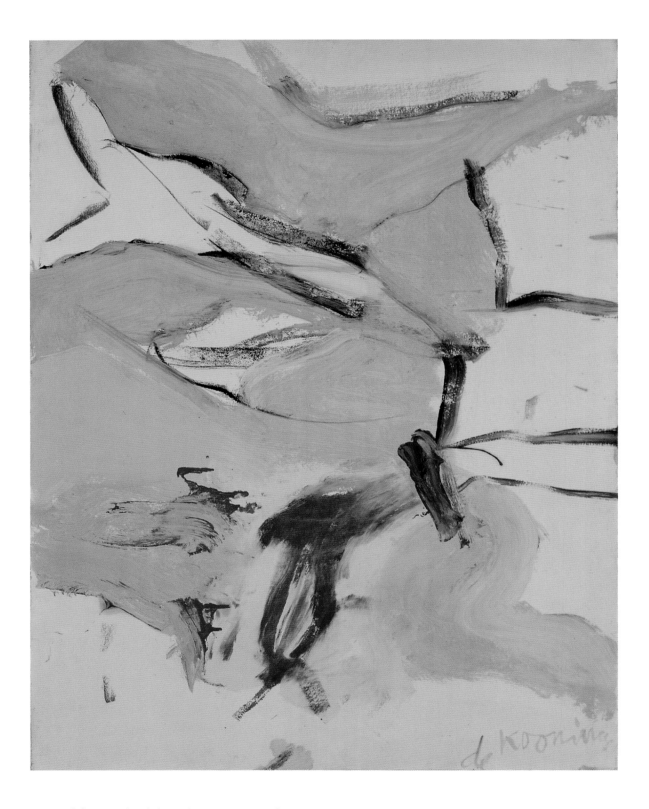

81 *Untitled,* 1970, oil and charcoal on paper mounted on canvas, 96.5 × 74.9 cm.
The Menil Collection, Houston, Texas.

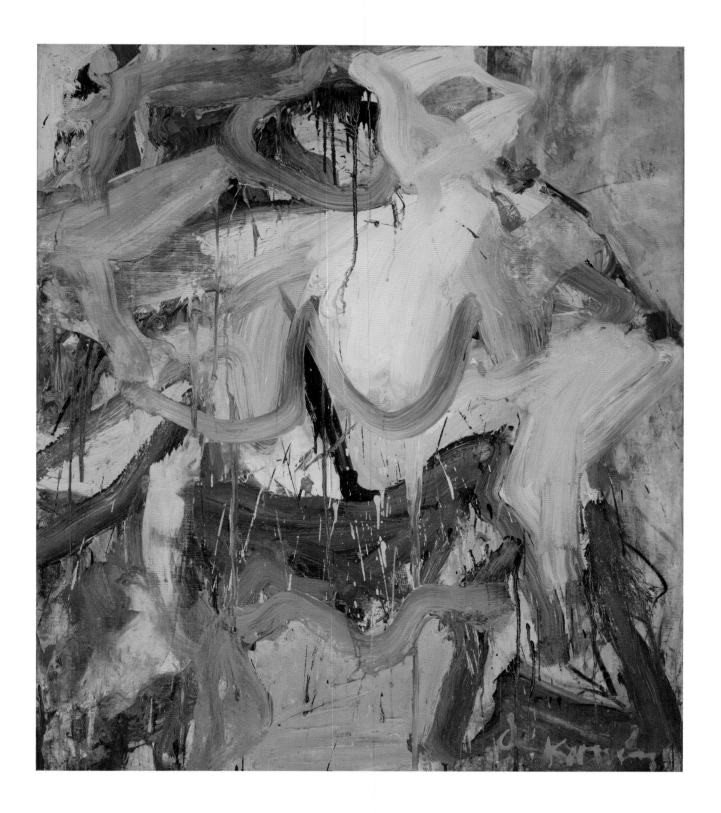

82 *Woman in Landscape* III, 1968, oil on canvas, 141 × 121.9 cm. Private collection.

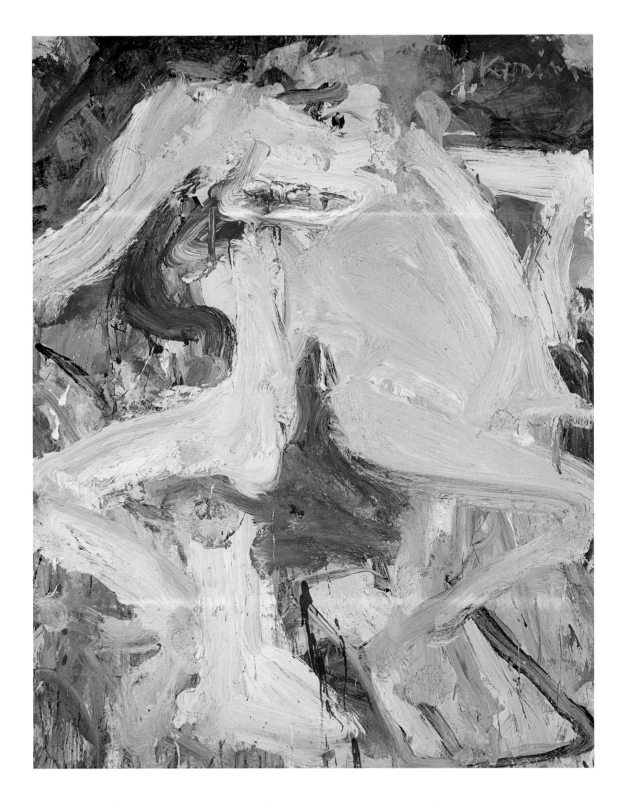

83 *Man*, 1967, oil on paper with thumbtacks laid down on canvas, 142.2 × 113.7 cm. Private collection.

details of anatomical observation. The rendering is summary and may also have been one of the painter's attempts to represent a body using very few strokes, an interest he occasionally stated.[449] From the same late-1960s period, *Woman in Landscape III* (illus. 82) is just as vulvic and a more complex image with less explicit anatomy but more of it. Here the interpreter has increased latitude: view this 'woman' as a vulvic configuration if you wish, or see 'her', or rather 'it', as gestural abstraction.

The many pictures of women with legs spread apart, both drawings and paintings, began to appear in quantity around 1964, along with a lesser but significant number of analogous pictures of men (illus. 83).[450] Most likely, de Kooning developed the spread-leg configuration to this degree of concentration while composing his pictures on the theme of Woman in a Rowboat, with which he seems to have associated this posture, integrating it with the structure of the boat (on Woman in a Rowboat, see 'Unwhole'). Whether he applied the spread-legged form to a female or male body, it marked the genital area as a focal point for all potential viewers. They notice it if only because the posture is relatively uncommon in conventional imagery. Presumably, people shun it in painting because they avoid it in their own life, in social situations, as if they were anticipating embarrassment at being recalled this way by others. Unexpected in pictures, the posture becomes all the more striking to an interpreter. Many react by not reacting; they avoid describing the pose even though observing it. De Kooning sometimes indicated the anatomical details of his spread-legged women and men with precision, in other instances only vaguely, and sometimes without any specificity whatever, so that painted man closely resembles painted woman (again, 'there isn't so much difference when you paint between a man and a woman').[451] Numerous Woman images – especially those in pencil and charcoal on paper, as well as those oils of modest dimensions in which the paint has been brought to a linear edge – present a configuration making vulva, anus and buttocks all apparent, or at least apparent enough to be easily imagined (illus. 84).

Many of de Kooning's drawings and oil paintings display a summary form of this configuration. We recognize it in a bold, thick stroke (or set of strokes) that appears as a curving *W*; sometimes it will look more like an *M* or like a *J* back to back with its mirror image. At least three variants of this stroke are visible in different positions within a complex work just mentioned, *Woman in Landscape III*. (1) Near the bottom of the canvas de Kooning drew an *M* in a wet-on-wet mixture of yellow and blue, which might be outlining a seat supporting the woman's body. My choice of the descriptive term *seat* should not be taken too literally; there need not be a chair. *Seat* applies to this detail because it can refer either to a device for sitting, such as a lawn

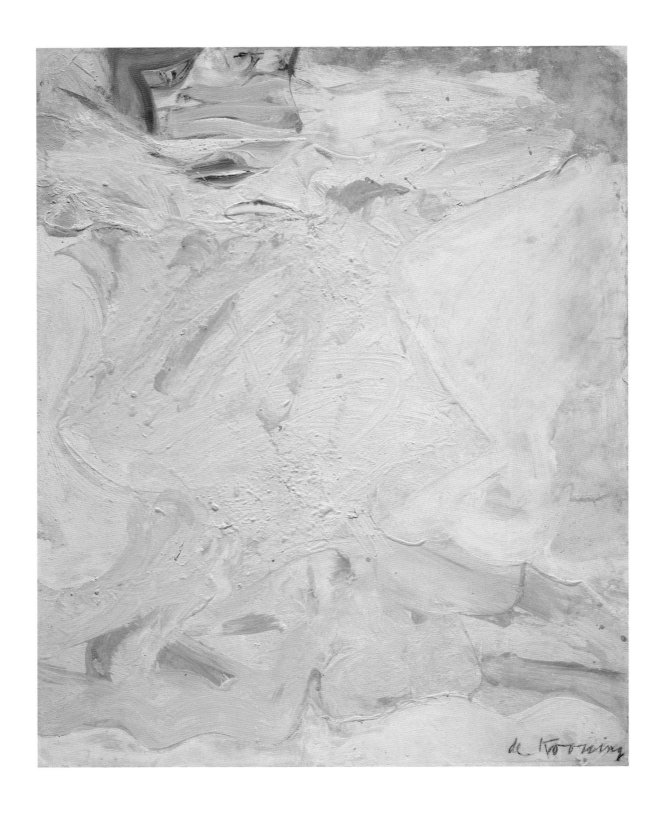

84 *Woman*, 1964, oil on paper mounted on fibreboard, 73.7 × 58.4 cm.
Hirshhorn Museum and Sculpture Garden, Washington, DC.

chair, or to that part of the body on which, and with which, a person sits. The ambiguity here results from a creative and apparently very natural play of language for which the most relevant rhetorical figure is metonymy (and secondarily, catachresis). Metonymy occurs when an active cause is substituted for its consequent effect, as in referring to lipstick traces as if they were actual lips or a kiss; the trace is the mark of the kiss, a kiss once removed. The seat of a chair is once removed from the seat of the body. Metonymy also occurs when a thing is identified by what lies contiguous to it – what touches it, contacts it, shares in its action – and this applies to both the kiss and the seat. Given de Kooning's practice, there are advantages to choosing descriptive terms subject to this kind of shifting reference, so long as they receive no more explanatory credit than they merit. These fluid terms, passing between different realms of experience, offer in themselves a sense of ambiguity and transition. (2) Above the *M* lies a reverse *J* in dark blue, partly obscured, probably once a double *J* form. Among its other actions, this mark articulates a seated figure's buttocks and thighs. In *Woman in Landscape III*, de Kooning shifted the configuration of the spread (or drawn up) legs several times so that at least three 'legs' remain visible – for him, a rather common motif. One leg reaches the left margin, while the other two end at the bottom in large high-heeled shoes, boldly contoured. (3) Above the reverse *J* is another wet-on-wet stroke of yellow and blue, assuming the form of a curving *W*. Here, within the specific figurative context, this line indicates breasts, not buttocks, and reveals the possibility of a manner of substitution (by analogy or contiguity) typical of the artist: he can transform painted eye into mouth, painted leg into arm, painted shoulders into breasts, painted breasts into buttocks. One or two strokes accomplish the most dramatic shifts in a figure's orientation, sometimes compressing the anatomy, sometimes stretching it out.

In each of its variations, de Kooning's energetic spread-leg line – most often formed by a continuous but complex directional movement (imagine the action required of hand, wrist, and arm) – becomes an effective shorthand for describing the contour of buttocks, from which the painter usually extends a figure's legs outward to left and right, with flexes at the knees. De Kooning retained his *W*, *M*, and *J* forms late into his career as a favoured motif, which, with varying degrees of effort, we discern in his densely abstracted works of the later 1970s as well as in the relatively taut compositions of the early 1980s: *Untitled I* (illus. 85); *Untitled XIV* (illus. 86); *Morning, The Springs* (illus. 87); *Untitled VI* (illus. 88). These are abstractions with the feel of bodies.

As much as from the Woman in a Rowboat, the spread-leg configuration may also derive from observations of women sitting or lying on grass, or

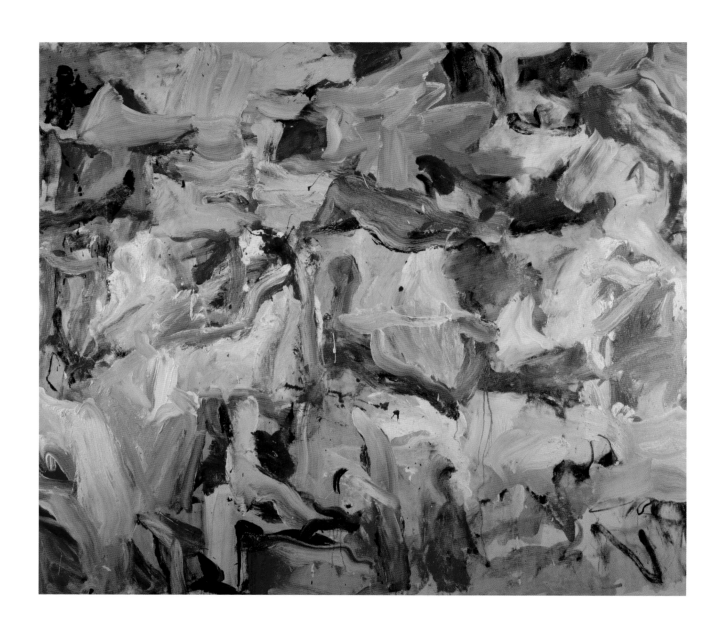

85 *Untitled I*, 1977, oil on canvas, 195.6 × 223.5 cm. Private collection.

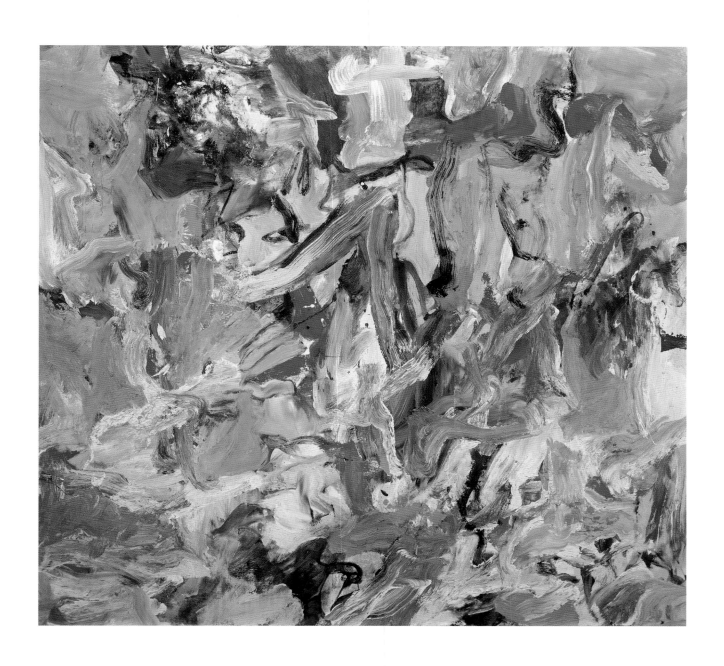

86 *Untitled* XIV, 1977, oil on canvas, 139.7 × 149.9 cm. Private collection.

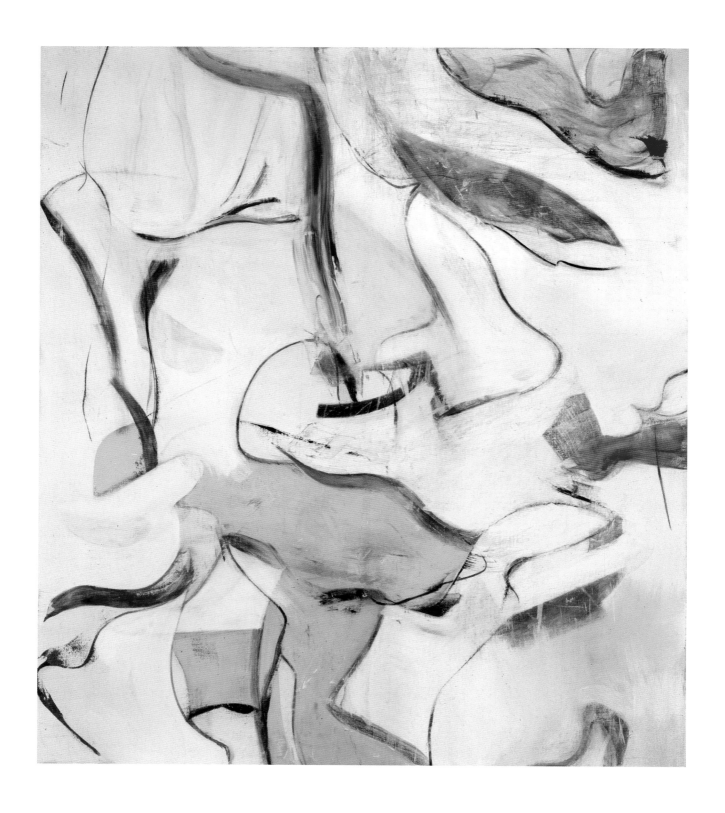

87 *Morning, The Springs*, 1983, oil on canvas, 203.5 × 177.5 cm.
Stedelijk Museum, Amsterdam.

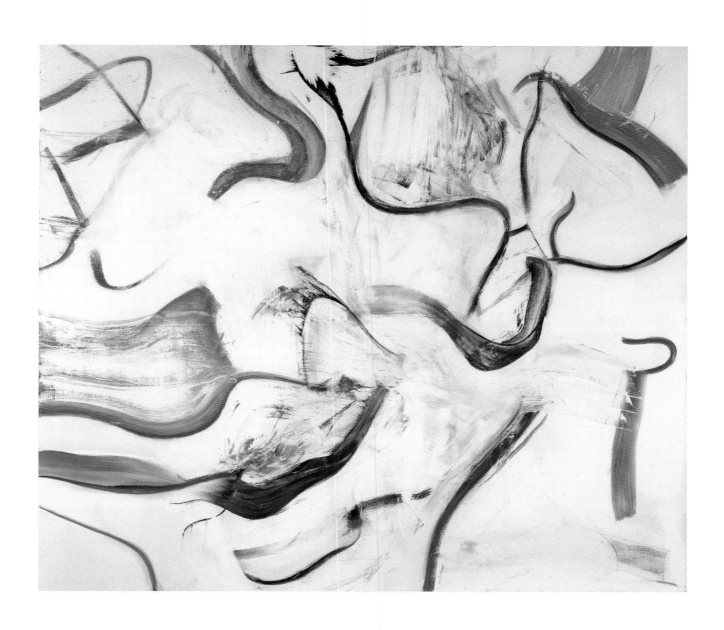

88 *Untitled VI*, 1983, oil on canvas, 195.6 × 223.5 cm. Private collection.

in lawn chairs, or on the beach – the ordinary of Long Island. Women sunbathing, whether reclining (and seen from above, like the Woman in a Rowboat) or perhaps extending their legs over the side edges of chairs, would be assuming poses like the one de Kooning kept rendering. Some of the positions assumed by women's arms in de Kooning images also relate to sunbathing: arms held in front of the face, raised and folded in back of the head, or stretched along the torso or the sides of chairs.[452] In 1968 Hess, who knew the artist's imagery as well as anyone, described a contemporary posture, women sitting with 'their knees up to their chins'.[453] Hess's verbal image is sexually charged, but it also caricatures fashions in clothing and comportment of the late 1960s – those exaggerated signs of a sexual revolution that had more to do with desire for liberties denied during the conformist 1950s than with sexual desire specifically. Hess acted not only as a critic of American conformism but as a journalist with a concern to report the peculiarities of the moment. The tone of his remark on body language is appropriate to de Kooning because he too had a caricaturist's eye for the fashions around him. 'How summer clothes – shorts, shirts – fit on the body' was, according to Hess, an element of de Kooning's observation.[454] The painter noticed all these incidentals.

Critics, including very good ones, have described de Kooning's women's legs as 'splayed'.[455] This characterization evokes specimens from a biology lab – dead things fixed in place, rather than active and reactive forces. It fails to attend to de Kooning's way of viewing and manipulating bodies and objects, and it misses much of the kinaesthetic challenge of his art. To refer instead to spread legs seems more apt because spreading is an action applied not only to parts of the body but also to artists' materials – graphite, ink, oil paint, paper, canvas, even clay. De Kooning's long-legged types, such as *Woman Accabonac* (illus. 74), are 'spread' in the sense of having their legs stretched or extended, spread out in their rendering. By metonymy, or, more radically, by tinkering with the usual agent–action relationship, the force of spreading collapses a distinction between acts of human posturing and the drawing or painting of images. De Kooning viewed things from within the personalized perspective of his studio manipulations. This is to see intimately, with the smallness and closeness he appreciated, from no farther than the end of his arm, brush or charcoal in hand.[456] With intimacy, he could succeed in drawing with eyes closed, as he sensed his hand 'slip over the paper'.[457]

Compress

To see from the end of an arm, intimately. De Kooning warned his viewers
not to mistake his active, exchangeable representations for distanced projec-
tions of objects, not to assume he maintained a division between art and
nature, with art assigned the function of fixing the form of nature. Art had its
own form: 'The drawing of a face is not a face. It's the drawing of a face.'[458]
The degree to which viewers have ignored his admonition underscores the
seductiveness of a familiar analogy, which surely affected him as much as
anyone else. It has its generative aspect and its judgemental aspect; one furthers
experience, the other blocks it. Here is the analogy: you draw out a line or
a passage of paint just as you draw out (extend, spread) your arms or legs.
By this principle, to follow a movement of paint from a distance with the
eyes induces a feeling of movement in the limbs. When a line stretches a
drawn limb too far, the naive viewer may well feel a sympathetic pain,
a violation. If the imaginative vision fixes on this violation of customary
physical comportment, the aesthetic experience terminates in displeasure
and moral disapproval. But think of spreading your own body to its maximum
extension; it will help to imagine flattening yourself as much as possible against
a resistant surface, such as a wall or a wooden panel, the same kinds of
backing used by de Kooning in his studio to support his canvases and sheets
of paper. You become thinner and cover a greater area. This stretching or
spreading makes a sentient body particularly conscious of its existence as
physical matter. De Kooning had such awareness of his body's compressed
solidity in relation to his materials' contrasting fluidity; he could convert the
one into the other through a flow of energetic drawing or painting. He could
also perform the mimetic conversion through a liberating act of imagination,
as when he described a particular bodily gesture for the Museum of Modern
Art symposium conducted in February 1951, 'What Abstract Art Means
to Me'. An element of his description has confused nearly all subsequent
interpretation; and at least two writers simply eliminated it when quoting
de Kooning's words, presumably because they realized that something was
amiss. One should give these writers credit for noticing the problem even
if suppressing it.[459]

'What Abstract Art Means to Me': not much. In de Kooning's mind,
things were never very abstract. For the symposium he established a concrete
principle: 'If I stretch my arms next to the rest of myself and wonder where my
fingers are – that is all the space I need as a painter.'[460] This was the imagina-
tive gesture. The resulting art becomes less a matter of representing other
people's bodies as observed, projected and abstracted, and more about coming
to terms with the feelings of the painter's body, its specific physicality. As we

know, it was de Kooning's custom to internalize things seen, trying to experience them in his body as a stimulus to rendering; he would attempt to feel the distance between a hip and a knee, a waist and an armpit.[461] What kind of body was he experiencing around the time of the 1951 symposium, also the time of *Woman I*? The problematic feature in his description was 'next to the rest of myself'. De Kooning imagines himself assuming an oddly compact posture, with his physical alignment corresponding to the simplest kind of pictorialism: all figure, all materiality, all positive, centred, no negative space, no perspective depth or ground. The painter refers to stretching his arms not outward in the typical gesture of an encompassing appropriation, an expansive act of drawing, but . . . 'next to the rest of' himself within a single plane. The body may be extended as straight as possible, yet volumetrically it remains within a very confined area, flattened. Conrad Fried, having often worked in de Kooning's studio, stressed the fact that the painter conceived his images as he used his paint: he wanted both to be flat on the surface, one with the surface. The image should be like paint, the material; it should be spread, or spread itself, flat.[462] Hess put the matter into the language of art history, as a choice between the flatness of abstraction and the illusionism of conventional representation: 'For de Kooning, the paint *must* be on the surface; he rejects any form of illusionism.'[463] Neither the critic nor the painter were engaging a formalist argument about space in painting; their concern was to attend to materials, to the body, to physicality in all its aspects.

To my knowledge, up to 1994, when I first referred to de Kooning's 'next to the rest of myself', no historian or critic had noted the specificity of the gesture. The descriptive passage had either been cited without qualification or mistaken for the more common image of a figure with outstretched arms (like Leonardo's Vitruvian man). Although the artist's image is of bodily containment, it nevertheless suggests, by virtue of its flattened state, the spread and yet compact enclosure of a composition like the Woman in a Rowboat, over a decade away in de Kooning's future. His posture corresponds to an attempt to fit as much as possible into a small bounded area, as if to create an economy of copiousness. This was certainly a quality of his densely painted surfaces around 1950–51 when he made the statement, whether a work was nominally abstract, like *Excavation*, or nominally representational, like *Woman I*. As with many of his descriptions and explanations, de Kooning invoked this one more than once. Its other instances confirm that he intended it to link an internalized experience of physicality to pictorial sensations, not to the disposition of an actual body in space.

De Kooning did more than describe the gesture; he performed it. When asked by collector David M. Solinger toward what effect he was struggling as he laboured over *Woman I*, de Kooning responded: 'Like this', as he drew his

arms close into his sides, stiffening his body as if it were pressed flat or stretched taut.[464] He made his body like paint. Significantly, *Woman 1* shows arms tight against the figure's torso and bordered by parallel strokes of paint, an effect of both compression and spreading: pull in, push out – de Kooning's strokes jam and pressure one another ('like a panorama squeezed together', was his metaphor in 1953).[465] Later, during a 1968 interview, de Kooning used his same gesture of compression to illustrate the effect of Alberto Giacometti's elongated yet compacted figures, which existed not only as sculptural forms but also spread out on paper or canvas surfaces. As he had done previously, he mimicked how the represented image should feel. He referred to his own custom of drawing the figure kinaesthetically while watching television; Giacometti too, he noted, had little residual need to look at a model.[466] It seems that de Kooning identified so closely with the actual materiality of paintings and drawings that the imaginative space he required for a figure was never greater or more abstract than the length and width of the working surface facing him. To sense lines spreading across a unit of paper, even when blinded or in a distracted state, was analogous to the internalized bodily sense of the measure of space from one joint to another. If there is a specific source for *Woman 1* – given de Kooning's practice, there need not be – the strong candidates would have to include a Byzantine coin pictured in Georges Duthuit's 'Matisse and Byzantine Space', an essay the painter read, probably around 1949, when it first appeared in *Transition*, a journal familiar to members of the New York School.[467] Stamped in low relief on the coin is a blocky, seated male figure, arms close to the torso, head turned very slightly to the left, legs twisted to the right, knees drawn up, all like the figure in *Woman 1* – 'There isn't so much difference when you paint between a man and a woman', de Kooning said.[468] The Byzantine man and the Rotterdam woman are compact, flattened, compressed; they are like paint.

When de Kooning reached outward, spreading paint across the intimate space at the end of his arm – to spread, extend or stretch a form or figure – his action amounted to a focusing or concentrating of sensory attention. As I have implied, his gesture was both inward and outward: into the surface, out from the centre. This compressive spreading does not dissipate or diffuse materiality but particularizes and intensifies the physical sense of a thing by involving hand and eye in its active production. If we think of de Kooning working from a model of some kind – making figures more than abstract gestures – the spread becomes a second production in a second medium, or, as he would say, the picture of a face, not a face. De Kooning treated firsts and seconds as if they could come in any sequence, any order, like Marilyn Monroe and her type. To repeat a key statement: 'A model can take many different poses, but the only thing that counts is how the hand

sets her on the paper. How she lives on the paper.'[469] The model exists in advance of the rendering, but the rendering exists in advance of the model. I think that my resort to chiasmus is a sign that criticism of de Kooning hits a wall of resistance. He is hard to figure, to control by rhetoric. Critics lacked opportunities to classify him in fashionable ways. Perhaps this was to his disadvantage within the art-historical record, which kept placing him in the past rather than in the future. In the 1960s, critics might have regarded him as a prescient pop artist of the 1950s; but they did not. In the 1970s and '80s, critics might have regarded him as a prescient poststructuralist-postmodernist of the 1960s; but they did not. (I am relieved of having to deal with what did not happen.)

De Kooning's insistent physicality, the compressive spreading, resulted in the unconventional perspective and proportion of his figures, which require more than just one look and more than a single interpretation. Many of his Woman images have broadened torsos that resemble faces, with the breasts becoming prominent eyes: *Woman*, 1952–53 (illus. 89); *Woman*, 1953 (illus. 90).[470] This curious exchange of anatomical identities can operate in both directions since a shift in context converts a face back into a torso. Imagine de Kooning constructing a figure by focusing first on the torso; because this form in isolation has no scale, it might manifest eyes with large pupils as much as breasts with large nipples. By adding head and legs at either end of such a torso-face, de Kooning reoriented the context and re-established the form as the trunk of a body. In *Woman*, 1952–53 (illus. 89), the head and legs remain undersized and summarily articulated with respect to the more complicated torso, as if to distinguish between something the artist focused or concentrated on (spread out, extended, enlarged) and what he saw peripherally in the field of observation. Alluding to conversations with de Kooning, Hess described this manner of composing a figure as conveying the 'wide, concave ellipse' of natural vision.[471] Differentiation of scale and proportion within the figure implies that the viewer's position must lie extremely close to the central torso; otherwise the perspectival ellipse would be less pronounced. A viewer feels drawn close to de Kooning's pictorial surface, into the material substance of the painting, as close as the painter worked to scrape and spread the paint along its knife-sharp edges.

As with the closeness of torsos, so with lips. When Elaine de Kooning kissed her husband's drawing, she performed a delicate but familiar act of focusing on a part of the body and spreading it out. She came up close to the drawing and pressed against its resistant surface, face to face, slightly flattening her lips to leave a spread of lipstick-red pigment. De Kooning directed his wife to position the last of her six kisses on the torso, centre of both the drawn figure and its paper support. The action drew both Elaine

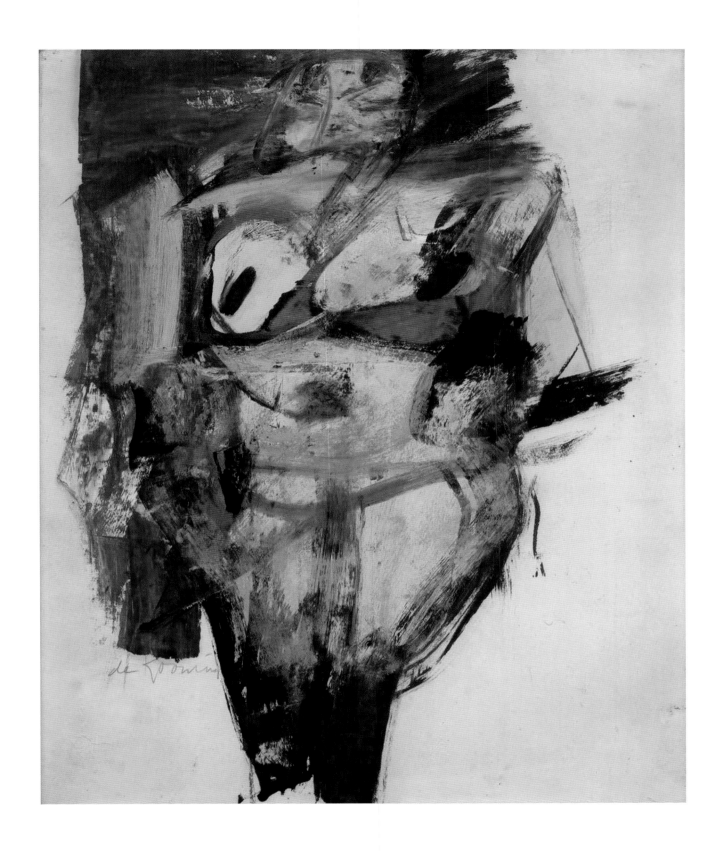

89 *Woman*, 1952–53, oil on paper on canvas, 57.2 × 48.3 cm. Private collection.

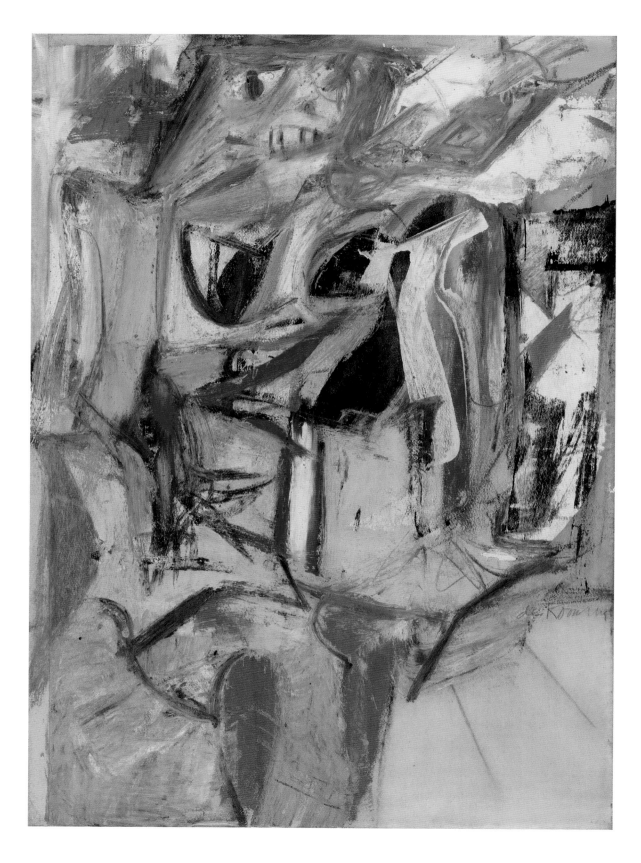

90 *Woman*, 1953, oil, enamel and charcoal on paper mounted on canvas, 78.7 × 55.9 cm. Glenstone collection.

and the implied viewer close in, twisting toward the figure and the paper. This combination of kissing and drawing simulated the effect of the spread of parts of a body, or of its entirety. Such physical action can also be represented kinaesthetically by spreading paint across a surface, extending it toward the margins. One way or another, the model lives on the paper.

Erotics

After eyes, mouths, breasts and genitals, the last of the human features de Kooning privileged is itself an extension, which, within the art tradition, usually gets pushed to a pictorial edge: feet. Beyond fine arts, within a culture of commercial imagery, feet and their shoes can occupy a centre. Some of de Kooning's paintings of the late 1960s focus on feet to the exclusion of anything else, but not to prove a high–low point or take part in carnivalesque inversion. A rhetorical opposition of high and low meant something to de Kooning's critics, much less to him. He featured feet because they were interesting. When they happened to become the single focus of a work – *East Hampton xxii* (illus. 91) – it was often because they derived, either immediately or remotely, from transfers of the lower part of paintings such as *Woman, Sag Harbor* and *Woman Accabonac*. These works assigned to feet a disproportionately large part of the figure's pictorial field. De Kooning often painted female feet in stylish high heels, sometimes with ankle straps. This is true of *Woman, Sag Harbor* (see illus. 67); some of its transfer images, naturally enough, show the shoes in reverse (*Woman – Torso*, illus. 92).

Shoes held more than casual aesthetic interest for de Kooning. They figure not only in his paintings but also, with a nagging insistence, in anecdotes and biographical details. Shoes were one of a number of themes – lipstick, another – that linked the painter to his years in New York as a commercial illustrator.[472] Like water, shoes may also have evoked the artist's Rotterdam childhood. Asked by a journalist in 1968 about his observations on returning to The Netherlands, de Kooning remarked, 'they wear better shoes'.[473] Was he being facetious or were shoes a focus of old memories (possibly both)? Traditional Dutch wooden shoes were in his studio during the 1960s, but probably only because someone considered them a proper house gift for a Dutchman; still, he chose to demonstrate techniques of illustration by drawing them.[474] As noted, the boat in the Woman in a Rowboat image is Dutch-shoe-like. We can imagine de Kooning fascinated by shoes as a child – many children are – and he had cause to remember them with pain as well, because his mother once surprised the small boy on the floor with a strong and seemingly spontaneous kick.[475] If shoes were something more

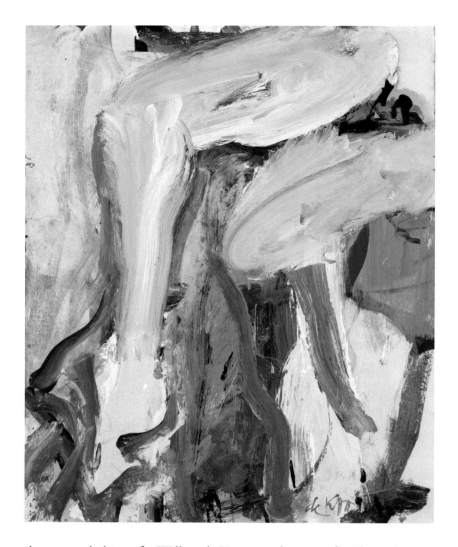

91 *East Hampton* xxii, 1968, oil on paper on canvas, 58.4 × 47 cm. Private collection.

than neutral objects for Willem de Kooning, they were for Elaine de Kooning too and formed a point of the couple's aesthetic concurrence. Elaine appreciated shoe design, enjoyed its variety, and happened to wear types Willem liked to depict: high heels, platforms, ankle straps.[476] I have already quoted John Powers's memory of his conversation with de Kooning in 1965 – the Woman in a Rowboat, high heels, how to give height to a woman's body ('Unwhole') – but elsewhere Powers gave a somewhat different, more amusing version. These are de Kooning's words: 'I pose a nude in the highest heels made so she has an upward movement – then when I paint her, I leave out the shoes.'[477] In life, the shoes were better left on. The click of actress Monica Vitti's high heels in Michelangelo Antonioni's film *L'Avventura* fascinated the artist; he even considered making a monumental sculpture based

92 *Woman – Torso*, 1964,
oil and pencil on paper on
canvas, 123.8 × 92.1 cm.
Private collection.

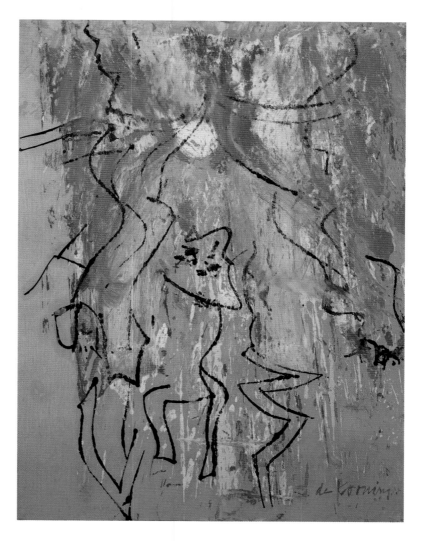

on the form of women's shoes.[478] Shoes and feet proliferate, providing circum-
stantial evidence of a foot-and-shoe fetish. But this extreme characterization
is inconsequential, even silly, unless applied to the society at large: many
people express a similar enthusiasm for shoes, and the shoe industry fashions
them accordingly. Why the shoe-lust? In de Kooning's case, his interest in
a woman's 'upward movement' is reason enough. As for his own body, he
enjoyed quality footwear; and when he received the Presidential Medal of
Freedom from Lyndon Johnson at the White House in 1964, he stared down
at the President's shoes, noticing how big the feet were.[479]

 Woman i had high heels. Friends and critics speculated that either Elaine
or Willem's mother, Cornelia Nobel Lassooy, had been the imaginary model
for the notorious painting. In public statements, Elaine distanced herself

from the elder Mrs de Kooning, perhaps in recognition that the two might be regarded as playing exchangeable roles in Willem's life. 'That ferocious woman he painted didn't come from living with me; it began when he was 3 years old', Elaine quipped: 'That was no pink, nice old lady. She could walk through a brick wall.'[480] It may be significant – although consistent with his self-deprecating humour – that de Kooning told a Dutch interviewer he would begin to paint a young woman and the figure would gradually become her mother.[481] His typical widening of torsos, breasts and buttocks would be enough to suggest a passage from youth to middle age. Whatever the putative relationship and the age, de Kooning's image of Woman frequently connotes contemporaneity (American more than Dutch). It features keenly observed elements of fashion – not only styles of shoes and lipstick, but various types of dresses and even nail polish.[482] In this respect, de Kooning represented the women and men of his generation as they saw themselves, following social codes of gender identity that may appear exaggerated by current standards. The painter's interest in women's dress and the brilliant colours of cosmetics was quite genuine, a nuanced aesthetic appreciation that he directed toward men's clothing as well.[483] Like Charles Baudelaire – who argued that great classical painters had always represented their contemporaneity, 'from costume and coiffure down to gesture, glance, and smile' – de Kooning saw his artistic heroes, a Rubens or a Bernini, as observers of body language and fashion: 'Rubens is an illustrator too.'[484] His art combines the classical tradition of female nudity with passing styles in advertising and popular imagery. He remained proud of his expertise in illustration; his engagement with mass visual culture did not originate in bourgeois chic, camp, or elitist ironies but in his vocational education and the working-class identity he preferred to maintain: 'I like Springs [as opposed to East Hampton] because I like people who work.'[485] De Kooning enjoyed explaining studio secrets in terms of popular culture, converting the ordinary into the ingenious and back again: 'I got an idea for preparing colors . . . at Howard Johnson's, the ice cream makers', he said, referring to the franchise restaurant's famous display of 28 different flavours. To his painter's eye they were 28 colours, like the colours he would arrange in common glass bowls on his studio table.[486]

From the 1950s through the late 1970s when both critics died, Hess and Rosenberg made the play of high and low culture a theme in their reviews of de Kooning, sometimes describing the pop generation as shallow followers of their friend's initiative.[487] De Kooning yoked a timeless Woman-in-art (elite culture) to a fashionable woman-on-the-beach (bourgeois culture) to a sexually stylized pinup-with-lipstick (mass culture). He combined all the conflicting features without pretending to mediate between them or transcend their differences. As Hess in particular emphasized, the painter

was all-inclusive, working toward the pleasure of an anarchic dissonance that would tolerate critical dialectic no more than utopic harmony. He not only flouted the conventions of the high academic tradition and mocked its intellectual self-importance, but also parodied the inducements to conformism coming from low culture – mass-cultural practices being no more liberating for the working and consuming middle class than those promoted by elite institutions. In 1967, Rosenberg criticized American intellectuals and political militants who were adopting the exaggerated signs of sexual difference associated with mass-culture gender identities. He concluded – in the spirit of de Kooning's 'I was painting the woman in *me*' – that 'true maleness is never without its vein of femininity'.[488]

Parading a breadth of cultural reference, Hess applied descriptive passages to de Kooning's paintings in which high and low, erudite and popular, followed one another in impressively random order: 'the Theban goddess Nut and Marilyn Monroe, Aztec dolls, Kali, Artemis-Isis, Willendorf, Jiggs's Maggie'.[489] He fantasized that de Kooning's Woman should replace the cloying models covering highway billboards and the sides of delivery trucks. The advertisers' paper confections shared the blankness of the well-mannered 'girl at the noisy party who . . . simply sits, is there, and smiles, because that is the proper thing to do in America'.[490] Hess's biting commentary appears in gender-specific form but was intended to extend to all Americans; he was making a statement against mindless conformism ('the proper thing to do'), for which artists like Willem and Elaine de Kooning represented the antitypes. Placing *Woman I* on signboards would challenge the mainstream American ethos with a countercultural ugliness that the consumer could not consume. *Ugliness* is too strong a term, however, and too oppositional, too dialectic. De Kooning's Woman is not ugly: she is a sign of disorder; or, better, she is order absented. *Woman I* sits and even smiles, but would hardly do 'the proper thing'. This painting may have become an icon of modern art, but not a proper one, for it makes people nervous. Elaine de Kooning shifted the cause of the anxiety from image to actual substance: the Woman paintings 'do have a certain ferocity, but that has to do with paint'.[491] This was her husband's position as well, and a valid one. It remains a hard sell.

I cannot recover de Kooning's psychological motivations, despite the existence of abundant documentary material to support speculation. In referring to Elaine de Kooning's kisses I chose to introduce the topic of sexuality, because a certain sexuality has long been part of the public meaning of de Kooning's imagery, no matter how he intended it. When Elaine 'kissed' Willem's drawing, this was hardly a matter of sexual gratification; instead she participated in a playful act of figuration appropriate to the environment of an artist's studio. She also contributed to Willem's curiously obsessive material

practice. Its private side is de Kooning's emotional development, his feelings about the women and men he knew, and reasons why their presence might have found its way into his representations. Its public side is something we can call, in the 1960s spirit of Susan Sontag and others, not sexuality but eroticism.

In 1964, Sontag published her hit essay 'Against Interpretation', advocating 'an erotics of art' to replace 'a hermeneutics'.[492] She contrasted the liberating pleasure of sensory experience to the distancing process of interpretive understanding. Her position suits de Kooning well. He had already made this opposition the theme of his contribution to the symposium on 'What Abstract Art Means to Me'. In his statement, abstraction becomes something intellectual and therefore detrimental; it results not from an immediate act of painting but from an artist's pondering what he has done, giving it a name, allowing it to become a doctrine and finally dogma. De Kooning sustained his points with irony and double entendre. Consider these thoughts: during the nineteenth century, painters 'were not abstract about something which was already abstract'; that is, painters were guided by intellectual theories (something 'already abstract') but did not yet use abstraction to represent them. 'When they got those strange, deep ideas, they got rid of them by painting a particular smile on one of the faces in the picture.'[493] A vacuous smile snipped the budding intellectual pretension. De Kooning's ultimate message is this: he paints what he feels like painting at the moment – high, low, whatever. The thing is to paint. A year and a half later, Rosenberg said it too, in his 'The American Action Painters': 'The big moment came when it was decided to paint . . . Just to paint.'[494] Like Rosenberg, Sontag perceived in de Kooning the liberated aesthetics and erotics she was urging upon others. She chose the painter's words of 1960, available to her in a publication of 1963, as the lead epigraph for 'Against Interpretation': 'Content is a glimpse of something, an encounter like a flash. It's very tiny – very tiny, content.'[495] A content so tiny, so ordinary, means nothing to hermeneutics. It makes sense to erotics.

Glimpse

Although de Kooning often formed his sentences with awkward syntax, English was his only fully functional language during the years of his artistic maturity.[496] Despite, or with the collusion of his odd mistakes, his cleverness in phrasing showed. He reflected flashes of verbal association to parallel his unexpected visual analogies. He could play the anti-intellectual before a group of intellectuals, ending a lengthy discussion by pronouncing a devastating judgement, adding a twist. If the 'death of painting' was the problem, then: 'Painting has always been dead, but I was never worried about it.'[497]

First, de Kooning annihilates the issue: Colleagues, listen, painting has *always* been dead! Then, he inserts his twist. No one worries over a universal fact – does Western culture worry that the sun rises in the east? – so, if painting has *always* been dead, an artist would not say, '*but* I was never worried about it.' He would say, '*and* I was never worried about it; I continue painting anyway.' Here, de Kooning's twist of *and* into *but* is subtle yet crucial. *But* implies that we would expect painters to be worried – *but* . . . not de Kooning. He becomes the exception. The linguistic slippage registers. We notice it but fail to react with an analysis that would expose a reason for our vague misgiving. It is natural, I think, for this sense of things, this nonsense of things, to go unchallenged – neither here nor there. My stress on the difference between *but* and *and* in relation to de Kooning's spontaneous phrasing is perhaps perverse, an academicism kicking in. Do I hold him to an inappropriate standard? This I cannot determine. Caught between sense and de Kooning, I am uncertain whether to smile at his remark and say 'of course' – like the passive souls that Hess, Rosenberg, and perhaps de Kooning himself were ridiculing – or to respond with a silent 'huh', an unvoiced objection. De Kooning disarmed the conventional critical language of his time by abusing it.

Visually and verbally, de Kooning's intellect jumps, creating odd linkages. Even his most factual statements can be confusing because elements appear to originate through spontaneous association, with plays on sound or semantic context. *Country bumpkin* becomes in de Kooning's rendering, 'country dumpling'.[498] His speech was self-absorbed and self-referential, as if his casual remarks were being run through a matrix of verbal and imagistic patterns comprising a psychological unconscious. Perhaps his specific word choices are like the themes of his painting: because they have deep personal significance, they trace and retrace themselves in his mind, to return over long periods of time with freshness at each iteration. Such involution of image and idea makes it especially hard to evaluate de Kooning's recorded interviews as well as the remarks his friends and acquaintances recall, which I have been quoting.[499] A given statement might represent a new version of a familiar theme in an attempt to address a new context; it might resume an old association out of mental habit, but with the original rationale obscured; or it might repeat a well-worn formulation intentionally, in order to avoid engagement with either interlocutor or topic. 'If you understand one thing, you can use it for something else. That is the way I work': de Kooning was referring to his production of visual imagery – the tracing of a thumbtack might become the nail of a thumb – but the remark applies as well to his words.[500]

The puzzling shifts in de Kooning's thought were not a phenomenon of advancing age, but a creative quirk in lifelong habits of language, a style of

verbalization that corresponded to the visual one. In his studio he transposed fragments of earlier paintings onto the surfaces of later works using tracings and oil transfer. Although this established continuity from one work to another, it was also disjunctive and created leaps across time: transition as break. Fragments of one year entered work of another to make a collage from disparate sessions and seasons of painting. The effect is analogous to verbal leaps of memory and association that individuals feel must occur outside their active control. Such practice did not project de Kooning into a distanced past or future but animated his present moment, expanding its scope: each painting had much to gain in the process, little if anything to lose. This is the antithesis of abstraction as a reductive or essentializing mode. De Kooning's abrupt shifts and expansive changes situated him within the sensitized, eroticized physical space he described for the Museum of Modern Art symposium, when he was arguing against both the metaphysical claims of abstract art and the abstractions of science and a technologically driven society.

Physicality, time, and language converge in the thick flow of de Kooning's thoughts and actions. Consider the following record of his conversation, which moves as if played on fast-forward. When art historian Sally Yard asked the painter in 1977 about his often invoked interest in Wittgenstein, he passed right on to Gertrude Stein without formally marking the transition or justifying the connection: 'Yes, I'm reading Wittgenstein now. Gertrude Stein is also marvellous, *The Making of America*, all of them.'[501] We cannot tell whether de Kooning's phrase, 'all of them', refers to all of Gertrude Stein's books or to all the Steins – Gertrude Stein, Wittgen-stein, and any others. De Kooning had actually been pondering Wittgenstein for years, not just 'now' in 1977; characteristically, he compressed the duration of events and activities into the present moment. He had also mentioned Gertrude Stein a number of times in previous interviews. Her significance for him can be understood in at least two ways: she wrote about very ordinary things (her 'content' was of the kind de Kooning would approvingly call 'little' or 'tiny'); and she was also the familiar portrait painting created by Picasso, an image possessing the authority and power de Kooning associated with motherhood as well as a visual massiveness comparable to his own *Woman 1*.[502] Was de Kooning actually reading Stein at the time of the interview? What was he doing in switching from Wittgenstein to Gertrude Stein? The primary agency may have been no more than an urge, barely controllable, to associate like with like, -stein with Stein. Similarly, he would see a thigh when focusing on a thumb.[503] Because such associations kept multiplying for him, to reconstruct the network (whether verbal or visual) becomes for the interpreter an operation without end – you do not catch up with de Kooning any faster than you catch up to the flow of possible meaning in

your own speech. From Ashton, an apt comment: 'Since the essence of de Kooning's mode is free association and its resultant metaphors, these bursts of humor in his work are natural . . . He parses his shapes in the high hopes that the pun will suddenly arrive to surprise him.'[504] Or, we might say, to rescue him from his slips and falls – one slip to save the painter from another slip.

Any attempt to determine de Kooning's psychic movements with precision would impose specific limits and inhibitions on a mind that appears to have had very few; it would also fix what must remain dynamic in human language and representation. Still, speculation can be useful, if only to divert overly straightforward interpretations of the artist's published statements. No matter how spontaneous, his remarks are rarely simple. I am not implying that de Kooning's comments yield to decoding when the effort is sustained long enough. He said that the mental and sensory state he sought was to be all-encompassing and unstable.[505] I take him at his word.

A set of his fast connections can be recovered from an interview conducted in his studio during summer 1959 with a number of friends present; little-known in its entirety, this interview generated the pithy remarks recorded in Robert Snyder's film *Sketchbook No. 1: Three Americans* (1960).[506] I choose a particular passage because Gertrude Stein, here unaccompanied by Wittgenstein, makes an appearance in the midst of it, one that would later be repeated in other interviews with apparent spontaneity (de Kooning sometimes repeated sentences virtually verbatim).[507] Responding to a suggestion that *Woman 1* possesses a 'jungle innocence', the artist's thought moves rapidly through the following sequence: (1) He is interested in 'idols' and 'goddesses' from the history of art. (2) He uses the goddesses' 'grin' to make a picture 'hilarious'; this avoids a depressive sadness. (3) His painting seems like a 'glimpse, like meeting one of those ladies.' (4) He invokes Gertrude Stein and the quality of her narration of 'ladies' lives, the 'content' of Stein's writing being 'very little'. Here de Kooning does not mean that content is lacking, but rather that Stein's subjects are themselves commonplace or inconsequential (think of using 'little people' as a synonym for 'common people'). (5) He refers to the 'idol' once again. De Kooning probably returns to the idol because he is conflating his visual image of Picasso's Gertrude Stein with Stein's significance as a writer; he also associated idols with Mesopotamian figures in the Metropolitan Museum, the location of Picasso's Stein portrait.[508] (6) He insists that he makes figures, not abstractions, however nondescript they may be. (7) He considers accusations of 'momism' and misogyny but thinks the women in his pictures look 'rather sweet'.[509] (8) He describes their creation as (nevertheless) a 'convulsive' experience, a 'personal struggle'; the expression he gives them is not a statement 'against them' but refers to the painter

himself (who, he will add a moment later, suffers the usual modern anxieties, such as fear of the nuclear bomb). (9) He notes that his images may not be 'Apollonian' (classically beautiful), but they are 'legitimate' (genuinely expressive). End of passage.

Consider a different passage from Snyder's 1959 recordings of de Kooning (transcribed by Brenda Richardson from the soundtrack of Snyder's film *A Glimpse of de Kooning* [1968], as opposed to following the edited version in the published script for *Sketchbook No. 1*):

> When I was painting those figures, I got a feeling like I came into a
> room someplace – and I was introduced to someone – just for a fleet-
> ing second, like a glimpse – I saw somebody sitting on a chair –
> I had a glimpse of this thing – you know, this happening. And I got
> interested in painting that – it's like [a] frozen glimpse . . . I watch
> out of the window, and it happens over there. Or I can sit in this chair
> – sit and think, and I have a little glimpse of something. That's the
> beginning, and I find myself staying with it – not so much with this
> particular glimpse – [but] with the emotion of it . . . Each new glimpse
> is determined by many, many, many glimpses before. It's this glimpse
> which inspires you – like an occurrence. And I notice those are always
> my moments of having an idea that maybe I could start a picture.[510]

So de Kooning's picture begins with an unforeseen 'happening . . . an occurrence' and is as much 'an emotion' as it is a scene.

When David Sylvester asked de Kooning about his Woman paintings less than a year later, the artist made many of the same associations, with greater apparent coherence, but not enough, in my opinion, to inspire a historian's confidence. The increase in coherence may simply have resulted from the editing process. The painter moves from idols, to 'tiny content', to Gertrude Stein's 'ladies', to idols again, to hilariousness, to maintaining his sanity in a difficult world.[511] If this account fails to solve the puzzle of *Woman I*, it does convey a certain mentality that during the 1960s was called 'non-linear' (reasoning without demonstrable paths of deduction), an apt description for a painter who manipulates and turns his lines and images in the most unexpected ways. From Sylvester's interview, we might pass to a second, simpler example of how de Kooning thinks. In reply to a question about contact with other painters, he speaks briefly of Gorky who came to New York from a 'no place', Armenia, yet who knew 'by nature' how to make art. De Kooning then turns to describe New York as 'really like a Byzantine city – that is really very natural too.'[512] From one nature to another; from one Byzantium (the Old World, the Orient, Armenia) to

another (New York). Like his painted figures, de Kooning's verbal analogy is all-inclusive and very compressed – comprehensive yet with no more than a glimpse of sense.[513]

Over the years, as more and more people imposed on the artist to explain his work or provide a philosophy, he developed favoured phrases, perhaps as a way of avoiding involvement in the type of analysis he found academic, even foolish. Forever unpretentious, he preferred homely, colloquial language – to which, actually, he may have been limited. Michael Sonnabend, his primary interviewer for Snyder's film, referred to him as 'undereducated and overintelligent', intending a compliment.[514] As far as de Kooning was concerned, if philosophy could be reduced to assimilable aphorisms – in the manner of Kierkegaard, Nietzsche, Wittgenstein and others he favoured – so much the better.[515] He rarely took the initiative to construct extended arguments to represent his position, and then only with the encouragement and collaboration of friends.[516] He painted out of a sense of wonder, as he stated privately to his sister in 1967; and this hardly required philosophical justification: 'I stayed in this world of childish wonder. I think that a lot of creative people never grow up.'[517]

Sylvester's interview, conducted in March 1960 and broadcast in December the same year, has become the best known of de Kooning's statements, as its richness merits. But its fame depends primarily on the fact that an edited version was created in 1963 by Hess, who published it in the journal *Location*.[518] There it appeared under the painter's name alone, with Sylvester's questions eliminated, and the circumstances of the interview indicated only by a note; this format made the entire text read as a continuous essay. Many accepted it as a polished statement of an aesthetic credo. De Kooning's earlier prose statements, such as 'What Abstract Art Means to Me', are equally informative; but since they predated the fame of his *Woman* series, the *Location* interview-essay became, for want of anything more timely, the de Kooning manifesto. Hess and Rosenberg gave it the title 'Content Is a Glimpse . . .' Each reprinted the *Location* version in his own monograph on the artist – Hess in 1968, Rosenberg in 1974 – and Sontag chose it for her primary epigraph soon after its appearance.[519]

De Kooning's words need to be unpacked. Compared with the edited version in *Location* ('Content is a glimpse of something, an encounter like a flash. It's very tiny – very tiny, content'), Sylvester's original 1960 interview gives a better syntactical indication of the artist's search for words and his attempt to paraphrase himself: 'Content, if you want to say, is a glimpse of something, an encounter, you know, like a flash. It's very tiny – very tiny, content.'[520] So de Kooning is equating content or meaning with the experience of a sudden encounter, which he had identified in 1959 as a 'happening

. . . an occurrence.' This encounter-occurrence is a 'glimpse' and, alternatively, a 'flash'. In most languages, terms for glimpse and flash are nearly synonymous; in French, for example, one possibility for *glimpse* is *éclair*, the word for lightning flash, connoting the transience of sudden illumination, whether internal or external. A glimpse is a sensory, psychic shock.

Slip

During the interview session of summer 1959 (source for the Snyder film script) de Kooning talked about slipping, about glimpsing, about 'tiny' things, all in a spirited, rambling conversation. The experience of glimpsing dominated the exchange. As we know, de Kooning associated the glimpse with the most ordinary kind of happening – somebody sitting on a chair, for example. He opposes this kind of occurrence to the things people think are more important, 'whatever happens in the newspapers'. His 'best statement' of the day (in Sonnabend's spontaneous judgement) has become familiar from its many subsequent repetitions and variations. Here is its first recorded utterance:

> When I'm falling, I am doing all right. And when I am slipping, I say, 'Hey, this is very interesting.' It is when I am standing upright that bothers me. I'm not doing so good. I'm stiff, you know . . . As a matter of fact, I'm really slipping most of the time into that glimpse. That is a wonderful sensation, I realize right now, to slip into this glimpse. I'm like a slipping glimpser.[521]

De Kooning was describing his preferred mode of vision (see also above, 'Abstract'). Some moments later he mentioned how much he enjoyed a variation on this slippage – being a passenger in a car, observing 'the things that you pass'. Pass obliquely, he might have added, for while the driver must look ahead channelled into rigid perspective, the passenger's eye can slip to the side, glancing, glimpsing.

So 'slipping glimpser' describes how de Kooning experiences things – quickly, spontaneously, obliquely, while off-balance.[522] It also describes how he performs as an artist; he provides glimpses of things, 'tiny' images, fractions of 'content', things viewed in passing, very ordinary things seen and touched with wonder. His word *tiny* conflates time and space: the content appears in a brief moment, observed only as a fragment or a detail. Such content is itself so ordinary that its interpretive significance must also be 'tiny'. Hence, de Kooning's irony: the little things bear more meaning (at least for him) than the big ones. In this respect, he admired Gertrude Stein

as a kindred spirit. Her themes were tiny: 'some kind of glimpse . . . like meeting one of [Stein's] ladies . . . The content out of this was very little.'[523] De Kooning's concentration on glimpses of tiny things gave his work its eroticism, its intensification of common sensation. It also provided and continues to provide cultural significance, the value we attach to locating details of reality that social regulation and critical theory neither foresee nor touch.

De Kooning's witty, metonymic self-description, 'slipping glimpser', invokes three salient technical aspects of his interminably changing, transitional paintings. First, he selects materials for their actual slipperiness, preferring wet emulsions and extremely smooth supports; this facilitates a quick brush stroke suitable for glimpsing rather than contemplating (de Kooning assesses, but only after acting). The viewer senses speed in the starts, stops and turns taken by the fragments of the artist's images. Second, his varied application of paint and other materials induces the viewer to notice details so small they can be no more than glimpsed: a bit of overpainted collage at the top of *Woman in a Garden* (illus. 40); offset traces of newsprint in *Attic*

93 *Secretary*, 1948, oil and charcoal on paper mounted on fibreboard, 62 × 92 cm. Hirshhorn Museum and Sculpture Garden, Washington, DC.

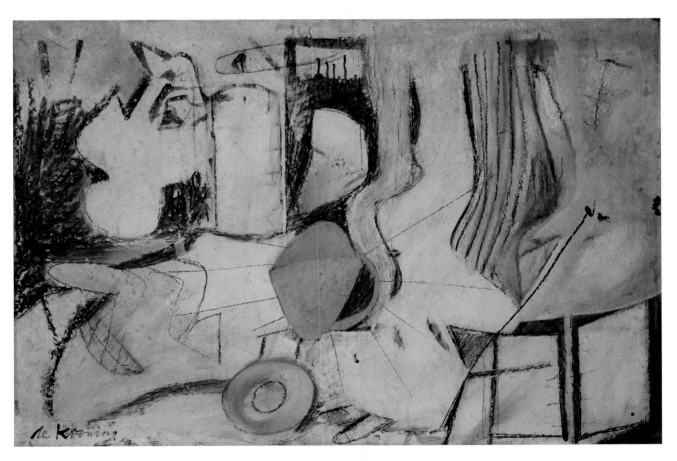

94 *Untitled* v, 1981, oil on canvas, 203.2 × 177.8 cm. Collection: Jeffrey and Susan Brotman.

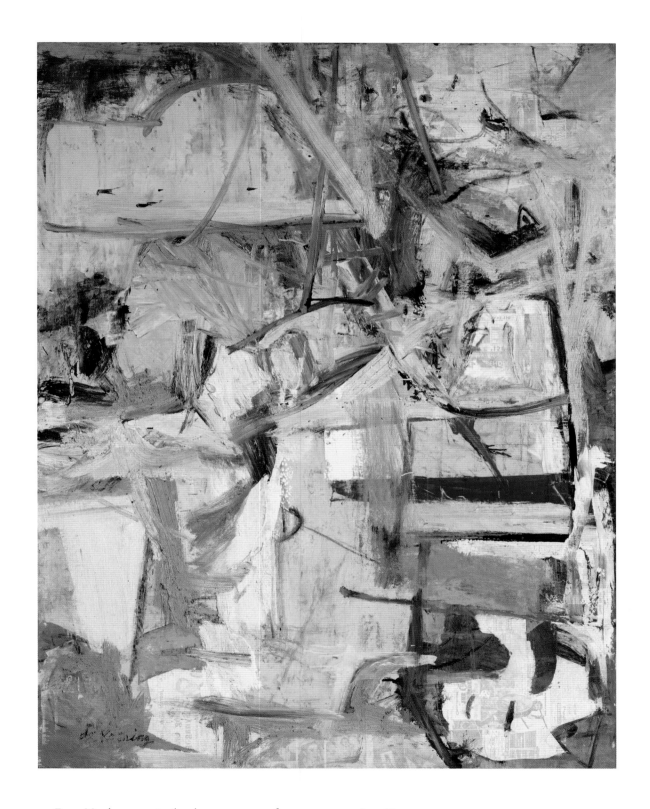

95 *Easter Monday,* 1955–6, oil and newspaper transfer on canvas, 243.8 × 188 cm.
The Metropolitan Museum of Art, New York.

(illus. 11); the texture of a visible ground in *Secretary* (illus. 93). De Kooning's pigment undergoes multiple transformations as layers of fluidity and viscosity, transparency and opacity commingle, leaving visions of their interaction: *Montauk Highway* (illus. 18); *Amityville* (illus. 41); *Untitled* v (illus. 94). Paintings by others may have many equally subtle properties, but to notice them often becomes more of a distraction than a reward. In the case of de Kooning the entirety of a work assumes the intensity of its anomalous details; the viewer experiences the paradoxical realization that observing a detail entails seeing the whole – the whole in transition.[524] Third, glimpsing evokes the suddenness or abruptness of some of de Kooning's effects. His paintings display innumerable junctures of slippage, those 'impossible' passages of which Hess spoke repeatedly, 'jumps of brush stroke' caused by masking, scraping, and blotting, as well as by the use of collage, tracing, and overlay: *Woman*, 1949 (illus. 26); *Easter Monday* (illus. 95); *Back Porch* (illus. 97).[525] A photograph taken in the de Kooning studio in November 1970 (illus. 96) shows a painting on paper set at an angle over a larger work.[526] Two pictorial themes intersect in a flash of disjunctive transition.

As suddenly as a striking linear form or combination of colours can appear in a work, all or part can slip away: 'There's always the possibility that it will be different.'[527] De Kooning is impelled to make the changes, to keep moving along; this is why being a passenger in a car can both relax and stimulate him – movement and change are being provided automatically.[528]

96 Studio Photo Album Five, photograph (November 1970).

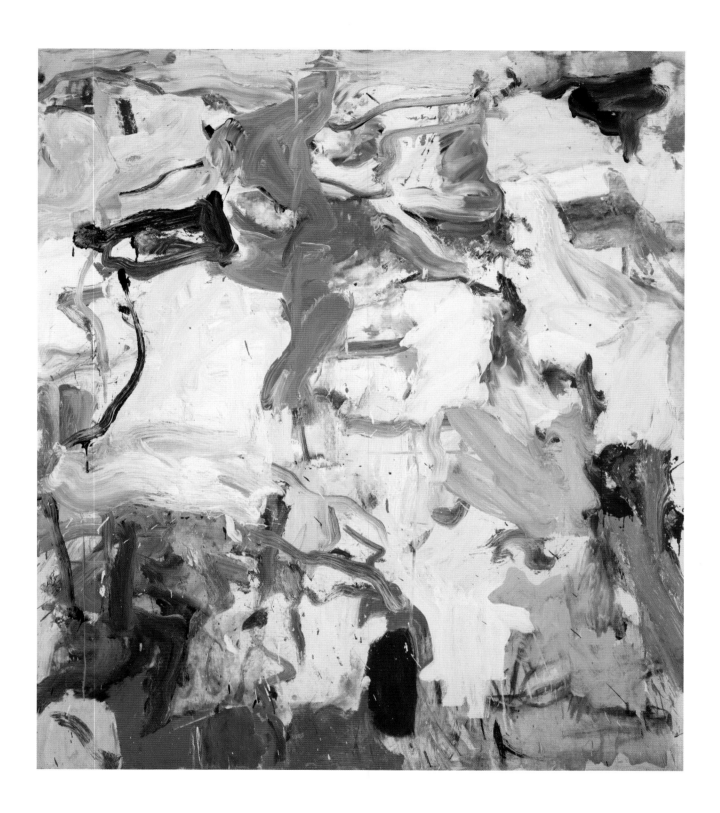

97 *Back Porch*, 1975, oil on canvas, 203.5 × 177.8 cm. Museum of Fine Arts, Houston, Texas.

And just as he never celebrated an absolute beginning, to finish an individual work never marked an end for him. The stop was instead a time to transfer attention to a new painting surface, one that might contain a very similar image. Ending and then beginning again were elements not of two works of art but of one process of transition. It did not matter whether the process was confined to a single surface – painted, scraped down, painted again – or involved passing from one canvas to another.

'We must learn to *see* more', Sontag wrote in 1964.[529] De Kooning had already done this through a practice of painting and a conduct of daily life that sustained comparable visual concentration. He marvelled at the flicker he noticed where Mondrian's black bands cross, studied how the surface of coffee meets its container, admired gasoline stains on urban sidewalks.[530] Friends noted his attention to what they would have ignored: 'a gesture, a crack, some refuse, a glow.'[531] These little visual events that fascinated him have something in common: viewed only in passing or inherently transient, they lack stability ('When I'm falling, I am doing all right'). Some phrasing from a book popular within the art world of de Kooning's era evokes the scan of his eye: 'like trying to clutch water in one's hands – the harder one grips, the faster it slips through one's fingers.'[532] De Kooning's eye might as well have been scanning the nearby bays and sea, glimpsing the light floating on and reflecting off the water. Is painting this glimpse a way of grasping it? Is it the water that slips, or do the hands?

Hands

For many years it was de Kooning's custom to bicycle through the community of Springs to Louse Point, a narrow, curving peninsula marking an uncertain boundary between inlet and ocean, sheltered enclosure and extended openness. The irregular contours of eastern Long Island, with its north and south forks, convert the Atlantic Ocean into a sequence of bays in which the water can be quite calm. To move onto Louse Point is to become increasingly aware of water and sky as well as the expansive flatness of the island itself. De Kooning noted the resemblance to the Holland of his childhood, an environment dominated by water and reflected light, but there may have been a subtler aspect to his attraction to this area.[533] Despite his interest in 'tiny' things, he wanted his vision to take in as much as possible at any given moment. Louse Point saturates vision, because land, sky and water all appear illuminated by bright yet changing light, a light that must envelop the observer as well as the unusually open scene, a light that brings everything into view because the observer requires no particular perspective, has

no need to move about in order to see, feels himself or herself at the centre.[534] The sensation can be similar to riding in an automobile, being surrounded by the passing light.

During the late 1960s, Lisa de Kooning often accompanied her father to Louse Point at the end of his working day.[535] She remembers how frequently he would gesture toward the horizon, lightly touching index finger to thumb, moving the hand horizontally, as if to draw a fine line in the air in front of him. At the same time he made a simple *ssss* sound by pushing the tongue forward while exhaling. Alternatively, he would sometimes extend a hand into the air and turn it slightly, as if to adjust a dial. These are familiar variants of seemingly natural gestures of hand and mouth; people perform them in response to seeing things that look just right to them.

Such forms of expression – involving highly refined, communicative and eroticized parts of the body, the hand and the mouth – indicate that visual sensation can generate a motor or kinesthetic response. The response itself is a 'tiny' phenomenon that passes without incident: no incident other than its own sensation, as if such gestures were adequate to the task of expressive representation. This is entirely ordinary and yet remarkable. The striking precision of a visual configuration will be felt in the body, and the feeling manifests itself, the tension releases itself, expresses itself, primarily through the hand. This is why drawing, painting or modelling with fluid, malleable materials can be such a satisfying reaction to seeing. The two sensations, visual and kinaesthetic, combine in a gestural creation – the artist's shaping of matter in a mimetic enactment of a physical relationship, real or imagined, grasped initially by the eye. A tense balance of the visual and the kinaesthetic may last only a moment, a tiny period of time, but time enough for a painter's singular gesture to represent a motif perceived as a detail of a landscape or within a salient part of a body – an arm, mouth or foot. De Kooning at Louse Point was a painter temporarily without his studio and materials. At such moments, a hand gesture in the air reassured the artist that he was present physically, actually sensing what was there; the gesture became more of a communication with himself than with others. Perhaps de Kooning was responding to the satisfying linear edge where water meets sky, or to the finely articulated contrast between the qualities of colour or of light reflected back by the two different mediums. 'I reflected upon the reflections on the water . . . I do that almost every day.'[536] He may also have been absorbed by the way light slips or glides along water – light floating like oil on water, light flowing with the speed of charcoal on vellum.

What distinguishes de Kooning's gesture from its garden variety cousin is the intensity of its motivation; to judge by the way he painted and how

thoroughly painting sustained his life, he was moved more often and more deeply than others by ordinary visual configurations. Paint 'as if every stroke might be your last', he advised Elaine Fried (de Kooning) during the late 1930s, when she was his informal student; he was stressing how each mark had its particular validity, its sensibility, and was not to be disregarded or wasted.[537] Throughout his life, it seems that his senses could be overwhelmed, his attention totally occupied, by insignificant incidents. For him, every phenomenon had its significance. The inner movement he experienced should be understood as both kinaesthetic and emotional, as well as fundamentally erotic. Such a relationship between seer and seen can be so intense as to be like love – love at first sight, of course, for which Baudelaire used the word *éclair*: again, the 'lightning flash', or, more prosaically, the 'glimpse'.[538] This love is unstable; like water, it cannot be grasped. The artist slips into it ('slipping . . . into that glimpse'), then away from it ('I lose sight of what I wanted to do, and then I am out of it').[539] This is when he would stop. His passing emotional engagement was directed toward a vast range of ephemera, human or otherwise, from the Fourteenth Street Madonna (a woman passing by), to the Woman in a Rowboat, to Mondrian's flicker, to television flicker.[540] De Kooning enjoyed the things that passed, whether moving in a car on the highway or along a Manhattan sidewalk. The studio provided the same kinds of experience: standing before his working surface, he merely needed to glance to the side, right or left, where an image of his own might become the glimpsed source of content. Virtually anything, caught in the moment, could elicit the painter's hand gesture of expressive appreciation. Drawing whatever he observed, de Kooning's hand transformed it, creating a glimpse of its own.

Lisa de Kooning's mother, painter Joan Ward, observed the extent to which de Kooning's physical refinement concentrated itself in his hands, which developed an uncanny grace: 'He handled his hands as if they had an aesthetic life of their own.'[541] Ward's statement is an apt description of hands that constitute the point of contact between lover and loved, whether one thinks of love between two people or an absorbing love of material things, erotically experienced – pressed, pulled, spread, drawn to a point (like feet at the end of a de Kooning leg). Emilie Kilgore, with whom de Kooning had a love affair during the early 1970s, remembered the artist's hands in detail: 'His thumbs hung quite close to the rest of his hand . . . He kept his hands beautifully groomed . . . Never covered in paint.'[542] What were these hands actually doing? How do their gestures feel – how do we imagine the hand action, sensing it through traces left in paint?

De Kooning worked in bursts of quick activity followed by periods of evaluation.[543] Susan Brockman noted that he held his finely tapered fingers by a stiff wrist as if they were directly attached to his arm; her description

suggests the structure of a paintbrush.[544] De Kooning liked to load a brush with a substantial amount of paint, for which his rounds and one- to four-inch housepainter's flats were well suited; he would often let the brush run dry before turning to another colour.[545] In this way he attended to what a given colour could accomplish, accepting what was 'at hand'; he also discovered where a continuous series of marks and gestures could lead. During a single work session his rhythmic repetitions created a dominant motif, yet only a temporary or intermittent one. Recall that it was typical of him to scrape down a surface after a session, ensuring a fresh beginning the next day. But this description misleads: de Kooning's new beginning would not be entirely fresh; it was already matured and worn. After removing the bulk of his additive forms by scraping, wiping, or blotting, he would recharge many of them with new colour because their traces remained visible. He turned the same movements or motifs on and off repeatedly, allowing them to interfere with one another, accumulating on each individual surface a series of twists.

This enhanced description may seem to apply quite directly to the dense, colourful works of the 1970s, such as *Untitled XI* (illus. 61), where the effects of scraping remain visible in areas of thin, blurred colour along the left side and corners. But the fundamentals of de Kooning's practice reach back through his career. In 1948, a repeated gesture in both additive and subtractive modes created the distinct materiality of *Painting* (illus. 22). At some stage of his work on this canvas, de Kooning used a stiff, sharp instrument, probably a conventional scraper, and pivoted the device against the paint surface, rotating it in a turning and dragging movement. He was twisting (here, in a literal sense). The action resulted in a number of pie-slice segments – pointed at one end, widening to an arc at the other. This type of physical feature interrupts the order of paint layers and exposes the canvas support. Subsequent passages of paint then cover some of these indented 'slices'.

How might cutting into a surface feel to someone who is also adding layers to the same surface? How do the two actions coordinate, or even turn into one another? Imagine facing *Painting* or any surface plane and extending your arm directly forward on the perpendicular. Rotate your arm 90 degrees, not by swinging it around to the side horizontally but by drawing it down and back in toward your vertical body, as if to assume the posture de Kooning associated with both *Woman I* and Giacometti. You have now shifted from the perpendicular to the parallel position – a difference like that between pushing into (perpendicular to) and slipping across (parallel to) the painting surface. Understand that your body has passed from a relationship of maximum resistance to the object in front of it, to a relationship of minimum resistance; yet it is the same body with the same capacities for movement. You are now mentally positioned to appreciate that the form of de Kooning's

243

twisting slice into *Painting* corresponds kinaesthetically to the curving but angular shapes of abstract figuration he drew across its surface – white on black, black on white. The movements, to a great extent, are the same. The drawing was his additive move, made, like the subtractive cutting and scraping, with a twist. The visual configuration drawn upon and across the surface corresponds to the tactile experience of slicing into this same surface. Such thematization of movement appears in many other works, including the paintings of the 1980s, nominally abstractions in the manner of *Painting* of 1948. In *Untitled IV* (illus. 98), material traces of the wiping, rubbing, and dragging of wet paint (reds and blues) correspond to the drawn, dragged, and spread quality of twisting bands of the same pigment. On many levels, the process of the 1980s was hardly different from what de Kooning was doing whenever he extended, compressed and spread the legs of a figure through the act of painting them. Whether classified as abstract or representational, one material gesture can suggest, and become, another.

Politics

It may seem laboured to isolate the correspondence between a painter's pictorial motif and a specific bodily movement or orientation. This is not the way historians analyse compositions to contextualize them, nor is it a formal appreciation in the usual manner of art critics, nor does it regard gesture generically enough to reach aestheticians' conclusions concerning painting as an expressive action. It also does little to further an understanding of the generalized cultural signs that de Kooning might have shared with his contemporaries: did his black mean 'black' in any connotative sense? Subtractive, negational gestures such as cutting, scraping, blotting and erasing are rarely considered proper analogues for additive, constructive strokes of pigment. Many see removals and erasures as correctives rather than fundamental contributions to an aesthetic effect. How does de Kooning's idiosyncratic set of practices bear on conventional modes of interpretation, whether a diachronic history of aesthetic form or a synchronic critique of a sociopolitical context, somehow allegorized through the work?

There are connections to be made with the type of message – part political, part metaphysical – that Rosenberg promoted in 1952, in 'The American Action Painters'. De Kooning would refrain from such associations, for fear of being typecast. But Rosenberg, at least retrospectively, linked the painter directly to his critical argument: 'De Kooning's improvisations provided the model for the concept of Action Painting.'[546] Rosenberg regarded a painter's gesture as the equivalent of any deliberate human act. The crux of the political

analogy he conceived was this: 'Each stroke had to be a decision and was answered by a new question.'[547] This is to say, a person should act independently, attending to immediate consequences and following through with whatever further action appears appropriate. For an artist, a mouth askew might be the answer to an eye oddly placed, with the depictive act, the 'stroke', following neither conventional practice nor emerging paths of modish innovation. The placement of such a mouth (or some abstract stroke) would demand a response in its turn.

The politics of Rosenberg's 'American Action Painters' concerns personal liberty and responsibility for one's choices; its metaphysics is a matter of continuity, fluidity, and vitality. One act entails another. Politics and metaphysics converged in de Kooning because he was pursuing a personal sensory lead, 'trust[ing] his work entirely to the intuitions that arise in the course of creating it.'[548] This type of political resonance was common at the time. In 1953, another writer referred to the creative practices of the New York School as 'uncoerced . . . an ethic as well as an esthetic'.[549] In a beneficial sense, de Kooning's art lacked direction; it was 'uncoerced' even with respect to a self-selected standard (there was none). By one means or another, he liberated his practice from the external interference brought by aesthetic conventions. He also liberated it from sources of internalized interference: a personal sense of design and style, a need to resolve the composition at hand, a desire for self-expression, a quest for originality. These were not de Kooning's issues.

If de Kooning epitomized independence by ignoring 'the taste bureaucracies of Modern Art' (Rosenberg's phrase), it was not for the sake of public statement. Just as he resisted involvement in cultural and art-critical wars, by all accounts he was apolitical, suspicious of every articulated political position; this is to be expected, since the politics of movements and positions is an intellectual pursuit, more hermeneutics than erotics.[550] De Kooning nevertheless voiced an occasional opinion on policies of the American government and, during the 1960s, the war in Vietnam.[551] Much more publicly, by his nearly exclusive concentration on the sensory, he became a living symbol of artistic resistance to dogmatism and conformity, whether it came from old academicisms, new ones ('taste bureaucracies'), or the self-assuring fashionable values of the crowd ('political, aesthetic, moral').[552] During the 1950s, when the leftist call for communal organization and mass action had been muted by fear of the totalitarian effect of social and intellectual conformity, de Kooning's idiosyncrasy held special appeal to critics like Rosenberg.[553]

'Being anti-traditional is just as corny as being traditional', de Kooning announced in 1958 with a typical double put-down.[554] *Corny* was one of his favourite terms along with *ordinary*; he enjoyed the ordinary, corny view of

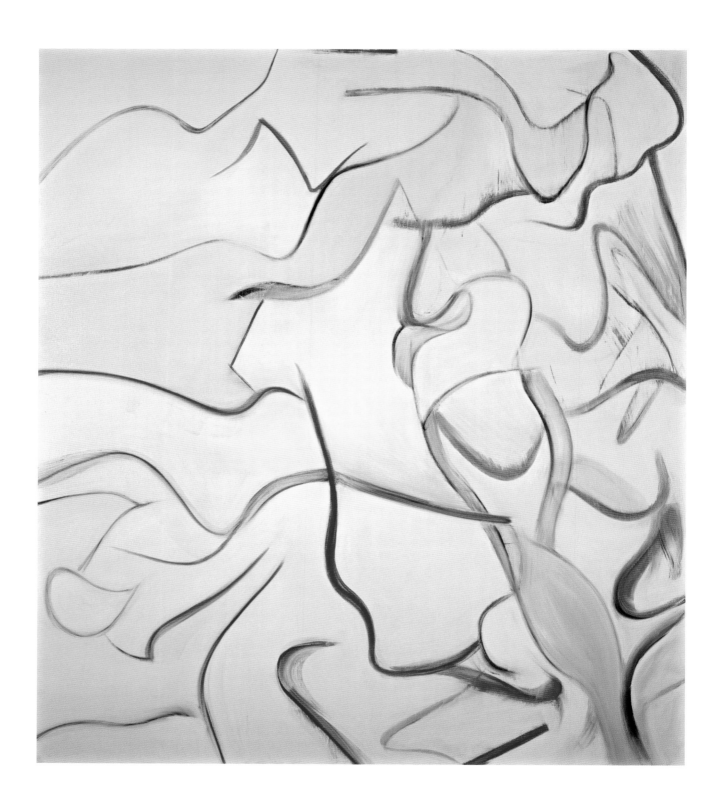

98 *Untitled* IV, 1984, oil on canvas, 223.5 × 195.6 cm.

things – a challenge to his art because the commonplace needed to be set off-balance.[555] De Kooning's position (can it be one?) rejected both ends in search of an unstable, nonconformist middle, becoming political against its own protestations. To conclude his monograph on the artist, Rosenberg (trying not to be corny) offered the intellectuals' version of it all, reflecting on Western history as it bore down on his and de Kooning's generation: 'Unbending adherence to individual spontaneity and independence is itself a quasi-political position – one condemned by Lenin, outlawed in totalitarian countries, and repugnant to bureaucrats, conformists, organization men, and programmers.'[556] In 1949, de Kooning had expressed this anti-authoritarian view directly and universally: 'The idea of order can only come from above. Order, to me, is to be ordered about and that is a limitation.'[557]

I suspect de Kooning's unbounded desire to be free of order had, like his art, the most ordinary life sources. It was not a grand concept of freedom that moved him – not worry over Lenin or the social pathology of organization men – but the mundane experience of leaving an unhappy childhood in Rotterdam, surviving poverty in New York, and finding a working peace in Springs. De Kooning knew the importance of being free of confinement and restriction. He was reacting to his mother's having ordered him about: he sailed from Holland to enter a more generous, independent life, eventually symbolized by his spacious private studio. He was rejecting the demands of aesthetics and art criticism: he painted whatever he pleased, whether abstraction or the figure. He wanted to be free of the bomb and the tragicomedy of world politics that produced it.[558] He sought little more than to live undisturbed and to paint. Chiasmus haunts the writer: it seems compulsory to add that de Kooning lived to paint, or that painting kept him living. As he himself said, 'I don't paint for a living. I paint to live.'[559]

Even with his penchant for philosophizing, Rosenberg could appreciate the mundane in de Kooning's art as an assertion of individual sensibility. He could admire, for instance, the caricatural potential of the 'gay kick' at the base of *Woman* of 1949 (illus. 26).[560] Yet, if Rosenberg was interpreting this gesture of de Kooning's paint as the pictorial equivalent of an organic gesture of a woman's body, if his phrase 'gay kick' was only half ironical, he and de Kooning may have reached the limit of their mutual understanding. De Kooning created images of this kind not so much by direct free-arm gestures, but by maskings, wipings and blottings of those gestures, by negatives as much as positives. He arrived at the 'gay kick' as a composite. As familiar as Rosenberg was with the look of de Kooning's art, he often introduced a degree of direct reference – whether mimetic or conceptual – alien to the painter's attitude and procedure. Where the writer became metaphorical, the painter might be literal. Where the writer was literal, the painter might be metaphorical.

247

De Kooning's self-image as 'slipping glimpser' is a case in point. Although Rosenberg participated in the 1959 filmed discussions that generated this phrase, he never regarded the description as literally as the painter did. This was often a problem in listening to de Kooning's words: he would seem to be speaking metaphorically when he was aiming at a more direct form of expression. Rosenberg's 1974 monograph related slipping to vision and even to subtle movements of the hand, but it also extended the concept into a metaphysics of 'self' and 'event': '[De Kooning] has found in the seasurface another metaphor for the 'slipping' of things and the self . . . The reclining figure in *Woman in a Rowboat* (1965) sinks into a sunlit reverie beneath the waves of paint that form her torso and her environment – a masterpiece of object as event.'[561] Here Rosenberg noted that slipping could be expressed metaphorically by the painter's image of water and even by material paint; yet for this critic (a poet, not a painter) slipping itself was from the start a metaphor, a concept more than an actual occurrence. For de Kooning, eyes really did slip in the light, glimpsing; and hands slipped through flows of paint. His understanding was directly material and physical.

Rosenberg applied his description, 'waves of paint', to a Woman in a Rowboat not far removed from one I previously mentioned in relation to *Two Women* (see 'Unwhole'). The 'waves of paint' in this 1964 version of the theme, *Woman in a Rowboat* (illus. 68), are remarkably fluid even within de Kooning's practice. They need not be described metaphorically. Or, perhaps we should acknowledge, once again, that de Kooning's practice has the effect of collapsing rhetorical categories; it causes metaphors to seem literal. This scene on the sea leaves little space for water, because de Kooning spread the figure over the better part of the surface, indicating the surrounding boat frame by a few strokes of green set against the woman's dominant oranges and magentas. There is water, but much of it is to be found in the painter's medium – an actual material presence rather than something represented. The brilliant pigment of *Woman in a Rowboat* floats (or was floated) on its vellum surface because de Kooning's medium – safflower oil, water, and solvents – appears to have reached a maximum wetness. The artist may have first spread water over the vellum, then added a pigment mixture to this fluid ground in order to generate the running, blurring, and beading of various parts of the image.[562] Around the time of *Woman in a Rowboat*, de Kooning told a reporter: 'I'm working on a water series. The figures are floating, like reflections in the water.'[563] He may also have used paper to transfer paint from another surface, flooding it with solvent in the process so that parts of the image became thinned and dispersed in odd ways. At least some transfer is surely in play because, like *Two Women*, this *Woman in a Rowboat* contains a second woman-and-boat configuration upside-down at the upper left centre of the composition. By analogy to *Two Women*,

it might be titled *Two Women in Two Rowboats*. *Woman in a Rowboat* spreads its image and colour the way a Long Island tide bears a film of oil along an expanse of shore, or the way the thinnest gasoline stain on a Manhattan side-walk floats an entire urban rainbow of reflections. De Kooning never tired of looking at such things: the reflections, the stains, the water, the woman in the boat. The boat is to the water as the woman is to the boat, as the entire image is to the watery paper: suspended, tentative, floating.

Woman, rowboat, and water – water as both image and constituent medium – everything floats. Applied to this kind of painting, Rosenberg's metaphysical-metaphorical slipping of 'self' and 'event' – intended, not unfairly, to enlist de Kooning into existentialist politics, to transform his glimpse into something more penetrating and even transcendent – becomes interpretive superfluity. A commonplace response – Look: it's wet, it's float-ing – adequately conveys the wonder that de Kooning experienced as he let the presence of this instability, this escape from critical and pictorial order, slip through his fingers. It slipped not because he was losing hold of it, but because slipping was 'marvelous' (his frequent word); it was a marvellous sensation to feel.[564]

Scrub

To change – over and over. De Kooning had many ways of doing it. The use of newspaper to blot, shift, or smudge wet oil paint not only produced desirably odd effects on the original surface but gave the artist what he called the 'bonus of an additional painting', the accidental monotype.[565] It often served as the vehicle for further transfer. At times the changes passed by newspaper from one area to another of the same painting; this seems to have been the case in *Two Women* and *Woman in a Rowboat*, where an image was passing between the two works as well as within them. It was typical of de Kooning to create a two-figure painting by transferring a figure painted at the left to a space kept in reserve at the right. Once he developed the second figure to a certain degree, he might transfer it back to the first by superposition. Visitors to his studio observed him working this manner in both the 1930s and the 1970s.[566] No figure is the original one within this closed circuit of production and reproduction; each becomes the model for, as well as the semblance of, the other.

Similar relationships sometimes hold between two or more figure paint-ings that appear unrelated in their final states: either they were linked at some point by newspaper or vellum transfer, or at some stage of their production, they developed in tandem, by reciprocal imitation. For example, *Woman in a*

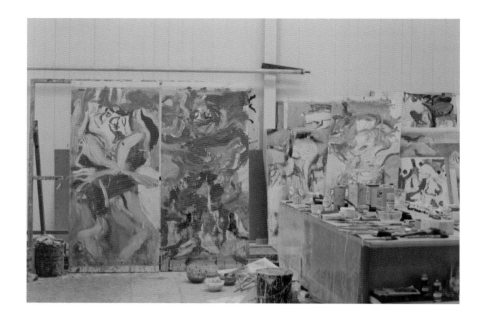

Garden (illus. 40) once held the pose of the so-called Charleston figure seen in *Untitled* (illus. 39). A studio photograph (illus. 99) shows *Woman in a Garden*, at the extreme left, as a work on vellum taped to a door panel propped up by de Kooning's studio easel; the identification of this configuration with the final one is possible because the artist never altered a narrow strip of paint along the top edge, which covers a piece of masking tape.[567] In the studio photograph, the painting *Untitled* appears leaning against the rear wall partially obscured among several works the artist was creating simultaneously. He linked these physically independent images either by actual material transfer or by looking from one to the other with a mimetic eye, using each to alter its neighbours.

Woman in a Garden displays a relatively uniform surface of brush strokes dense with paint, primarily warm colours complemented by brilliant greens toward the top and a bit of blue. Never fearing anomalies, de Kooning retained a wiped or scraped down area at left centre of the composition, a small segment of ethereal blur within the broader web of viscosity. This type of internal contrast often appears in a more pronounced way in later abstractions, such as *Untitled* (illus. 100). De Kooning repeatedly scraped the paint off this large surface so that the final state incorporates somewhat independent ranges of colour, corresponding to his activity on different days. The thin reds, blacks and whites at the top and bottom left corners, as well as the brilliant greens and yellow-greens at the bottom right corner, belong to physical levels lower than the central thick strokes of blue, black and white. It would be inconsistent with de Kooning's working methods for these specific contrasts

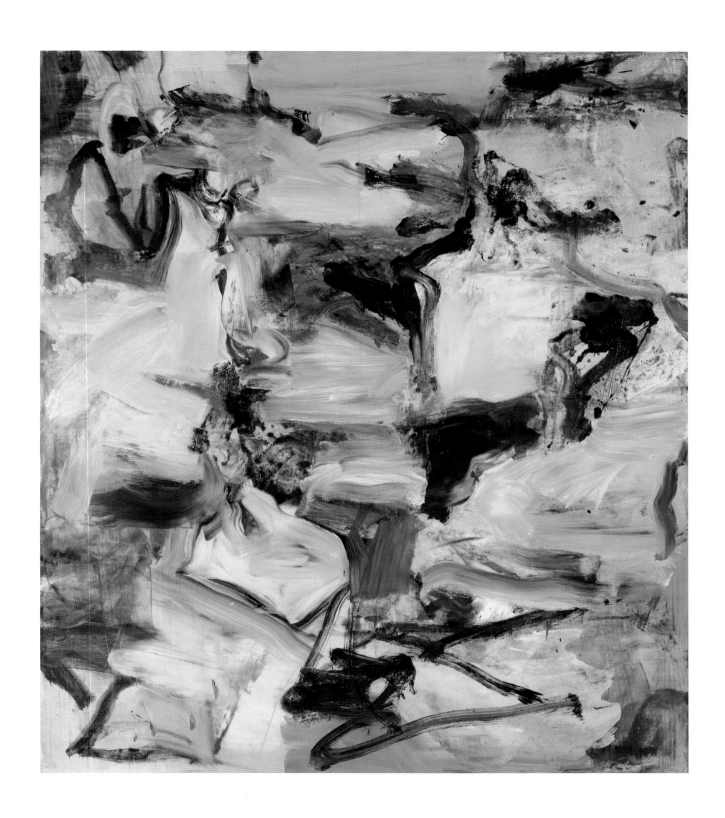

100 *Untitled,* 1977, oil on canvas, 223.5 × 195.6 cm. Private collection.

to have been preconceived; rather they emerge as inadvertent indicators of time, marking days on which different sets of colours were favoured – surface blues following after the scraped reds and greens. The pigments of *Untitled* belong to a single family tree, but one generation is supplanting another, and then another.

De Kooning expressed an attraction, even a fascination, with the thickets of scrub oak in his area of Long Island. The vegetation resonated with him, perhaps because its description fit the life and vitality of his paintings: 'The land around my place is covered with scrub oak, skinny trees . . . they die, then grow up again. So the place looks pretty much as it did centuries ago.'[568] This was a case of perpetual transfer and transiting on an evolutionary scale. It was an instance of changing 'over and over', and if brought down to a modest chronological frame, the oak was analogous to the de Kooning painting. As he told his collectors Joseph and Olga Hirshhorn in 1969, he had chosen his materials and devised his practice so he could 'do the same thing over and over'.[569] Like a forest of scrub oak through decades and even centuries, a work produced as he had painted *Untitled* would always retain enough of everything it had been to stay the same as it changed. This mix of tenses, times, and transfers sounds like a definition of the human individual: we change, but we keep our personality, our defining identity; we change, but we stay the same. An individual painting would change over the span of time of a period of human invention, the time given over to a project – perhaps a few weeks, or a few months, or in the case of *Woman 1*, two years or more. But because de Kooning transferred bits of one painting to another, there was a continuous linkage throughout his oeuvre, as there is within the community of scrub oak. The change and the sameness belong to the entire artistic life. According to Conrad Fried, who knew de Kooning from around 1938 until the painter's death, he wanted to preserve within each and every work some element that would appear unfinished. He also wanted to keep each work within the range of scale that was typical of him. By these two means, he would ensure that no one painting would ever appear as a final statement or definitive masterpiece.[570]

De Kooning referred to the scrub oak growing on and around the land he purchased in Springs as 'underbrush'; it was scruffy and irregular, entirely unlike the manicured lawns of East Hampton where each property 'looks like a park'.[571] Perhaps the underbrush provided an environment of chance visual occurrence analogous to that of lower Manhattan, hardly a controlled or parklike setting. No doubt, de Kooning found Long Island scrub oak entirely ordinary (and therefore of genuine interest to him). *Ordinary* is most likely the word he used in talking to Hess, who, when quoting the artist in his 1965 review 'De Kooning's New Women', wrote 'commonplace' instead,

a better word for the literati and intellectuals. Here, in the first of Hess's two variants (the previous statement was the second), is his report of de Kooning's thinking, not long after the artist moved into his new studio during spring 1964 – coincidentally, just turning age sixty:

> The hills around my place are covered with scrub [oak], little trees, that only last about fifty, sixty years. They die, then grow up again. So the hills look pretty much now as they did centuries ago when Indians were there. So that's timelessness. Scrub [oak]. Isn't it strange, with all the talk about the Timeless, that it really is commonplace.[572]

If there is an essence to de Kooning, it is multiple; so this home-grown philosophy of the scrub oak represents no more than a piece of a patched-up collage-like essence. But it is as good a piece as any. The artist has taken the timelessness of Zen, existentialism, Heidegger, Kierkegaard, Wittgenstein, Gertrude Stein and whoever else circulated through the Manhattan-to-Springs art community – he has taken this timelessness and rendered it as ordinary as the trees left over in a village back yard.[573] As always, de Kooning asserts the ordinary, corny view of things over intellectual, political, and social pretensions. 'They die, then grow up again': an apt description of cyclical time, timeless time, as well as a metaphor for the process of oil transfer or for a scraping down that affords the option of repeating from the traces. Like a partially scraped painting, underbrush could both alter and regenerate itself from layers underneath.

Hess concluded his 1965 review with a play on timelessness, connecting the ordinary scrub oak to the 'obvious, straight paint' de Kooning used to represent his new images of Woman, the theme itself being a 'timeless commonplace' and therefore as renewable as the underbrush. Answering to earlier questions about his use of the Woman image, de Kooning had said that he 'could sustain this thing all the time because it changed all the time'.[574] De Kooning himself changed all the time, changed by doing the same thing over and over, by repeatedly accepting a changing, passing view of things ('some fleeting thing – like when one passes something').[575] He was neither in style nor out of style.

If the underbrush renewed itself every fifty or sixty years, the painter did so around every seven years, passing – at least as the public saw his work at successive exhibitions – from figures of the early 1940s to abstractions of the late 1940s, to figures of the early 1950s, to landscapes of the late 1950s, to figures of the 1960s, to landscapes of the early 1970s, to abstractions of the late 1970s, to a different kind of organic abstraction during the 1980s. 'I'd just as soon paint some other way', he said in 1964, and could have said this in any

given year.[576] He spent his life in transit. A seven-year span accommodates history easily: neither long nor short as a life goes, it is an ordinary and comprehensible segment of time. I borrow the number from Rosenberg, who gave it a particular connotation, not quite my own. In 1952, seven years after Hiroshima and Nagasaki, the critic wrote that members of de Kooning's generation were all a certain type: 'not a young painter but a re-born one. The man may be over forty, the painter around seven . . . The big moment came when it was decided . . . just to paint.' Rosenberg was right to imply that 1945 forced a reorientation. The immediate postwar environment brought social and political change – increasing affluence even for artists, growing pressure on all classes to conform to standard values, living with Red scares, McCarthyism, and the bomb. These factors eliminated much of the ground for those who were 'trying to paint Society [or] trying to paint Art'. Both were changing. So, whether in reactive withdrawal or optimistic defiance, each artist began to paint a personal 'gesture of liberation', a final defence against an authoritarian order penetrating all levels of 'Society' as well as against a philistinism threatening to compromise 'Modern Art'.[577] The capitalization of the abstract nouns was Rosenberg's rhetorical indication that society and art had evolved into institutional dinosaurs. De Kooning smelled dinosaurs before they got anywhere near him.

Aged forty-eight in 1952, de Kooning belonged chronologically to the Rosenberg generation of 'action painters'; yet, developmentally he did not fit. During the 1930s, grand intellectual issues of either society or art failed to motivate him. Accordingly, he had no social theory, politics, or aesthetics to give up in a postwar crisis. Throughout his career, early and late, he concentrated on 'very tiny' content, sensory commonplaces that could as easily delight a child (of seven) as interest an adult: water and its reflections, the shape or shine of shoes, the twist of a hand or line, the body as a spread of paint, the spread of paint itself. From childhood to old age, de Kooning experienced a simple fascination. As he implied when explaining his life to his sister, he had been 'seven' all his years – remaking, reinventing and intensifying himself from one transitional state to another.[578]

Ideas

By the time he was in his sixties, de Kooning was old enough and successful enough to worry over being assessed, packaged into an art-historical category, and considered complete. When Hess arranged for a million-dollar commission to be offered to the artist for a mural to cover an entire wall of the twentieth-century wing in the Metropolitan Museum of Art, de Kooning

replied that he had 'no masterpiece syndrome' and immediately rejected the project.[579] Critics might think that this kind of treatment was an honour bestowed only on those important enough to receive a definitive ranking, but for the artist it signified an empty future. At the time of his 1968 retro- spective (Amsterdam and New York), he expressed his anxiety: 'These shows can sometimes mean the end of the artist . . . It's as if the art world has rolled you up in a shroud and prepared you for quick burial. But maybe I'll get some new ideas from it. I don't like to think of completion in art.'[580] Not long afterward, de Kooning made his statement about changing 'over and over': 'I am working for weeks and weeks on end on a large picture and have to keep the paint wet so that I can change it over and over, I mean, do the same thing over and over.'[581] To change over and over was tantamount to staying the same, if only because the factor of change was constant. As he often put it: 'You have to change to stay the same.'[582]

De Kooning left open some hope, a compensation, for his retrospective – 'maybe I'll get some new ideas from it.' No doubt, he meant some kind of visual idea, like a new twist on a leg. Such ideas were not to be conceptualized; a stylus or brush would create them, with or without a mind. But what about the idea of painting itself, or even the idea of paint? In 1970, filmmaker Emile de Antonio nudged de Kooning toward a concept by asking him whether he considered his painting 'painterly' – a term evoking a basic distinction between 'linear' and 'painterly' styles developed long before by art historian Heinrich Wölfflin.[583] De Kooning replied, 'Very much, yeah.' Matching de Kooning's penchant for mental mischief with his own, de Antonio followed with, 'What does "painterly" mean?' This caused the artist to hesitate just slightly, as if wondering what purpose such a question served; and he answered, 'Well, that you can see it's done with a brush.' His deadpan response is true to the concept, for a painterly painting tends to display its maker's hand. Yet here the venerable distinction between linear and painterly devolves into such an anodyne notion that pondering it seems absurd. Such absurdity never deterred de Kooning, who hinted that he thought everything was absurd: 'You take a brush and pick up some paints, make somebody's nose out of it, it's kind of absurd; but not doing it is just as absurd.'[584] De Kooning's definition of 'painterly' style guided his exchange with de Antonio (a willing participant) toward demonstrating that theories of art – as subject to shifts in perspective and orientation as a twisted drawing on vellum – are absurdities. Theories do little more than inhibit the application of sensation as the primary motivation to an artist's work. When de Kooning spoke of such matters, he used a rhetoric of reversals, a variation on chiasmus, to bring his point home. He had used this ploy many times, as when he addressed the topic of Renaissance order in 1950: 'Insofar as we understand the universe – if it can

be understood – our doings must have some desire for order in them; but from the point of view of the universe, they must be very grotesque.'[585] An artwork was a tiny thing, a little anomaly, suitably 'grotesque'.

A second exchange with de Antonio went as follows:

> De Kooning: I don't think painters have particularly bright ideas.
> De Antonio: What do they have?
> De Kooning: I guess they're talented painting things.[586]

De Kooning's reference to a lack of 'bright ideas' occurred as he recalled the Depression and how his well-meaning New York colleagues had attempted to make art relevant to social problems by depicting 'strikes and poor people'. This may have been good politics; but it was bad art, and therefore, in the long run, bad art-politics. Further in the past of modern art (de Kooning claimed) Claude Monet had been no smarter when he painted 'those haystacks at different hours of the day', a pointless conceptual exercise.[587] What mattered was what Monet or any painter did with the paint, not some notion of a haystack that underwent a series of moments. Painters were 'talented [at] painting things'. This was the essence of de Kooning's own aesthetic theory, a tautology, hardly a 'bright idea': you paint by painting. 'You can't build an aesthetic beforehand', he insisted, thinking along the same lines in the subsequent interview by Rosenberg in 1971.[588]

'You have to change to stay the same.' Although de Kooning maintained variants of this thought throughout his life ('I like the type more than the original'), it is as good a candidate for his final thought as any. We associate the statement with the last decade of his productivity, the 1980s; this is when he repeated it with the greatest frequency. Such a thought possesses ultimate openness along with its course-of-life finality: you change, but you always remain your same self, you, a person, *this* person (not some other), who changes. Was this a painter's 'bright idea', or was it a bit of absurdity de Kooning knew he could throw back at interviewers who had foolish, pretentious notions about his work? His line may be a corruption of the adage, 'The more things change, the more they stay the same.'[589] De Kooning was known for malapropisms as well as witticisms, and often the difference was indiscernible. Perhaps he meant to repeat the cliché, but it emerged garbled. The spontaneous result seems to have amused him and presumably others as well; so the expression remained with him, imprinted (a cause of his reputation for repeating himself with uncanny precision).[590] De Kooning's aberrant phrasing has no fixed origin, existing only in its frequent reiterations. His version of the adage seems to call for some kind of action, rather than resignation with respect to the perpetual state of things. He rarely left things as

they were, even when complete. His reluctance to finish led him to technical extremes as he attempted to keep his paint wet for revision (to 'do the same thing over and over'). He preserved records of his process so he could move backward as well as forward. He merely wanted to move, to change. His exhibited paintings have an unfinished look but lack a typical rhetoric of the 'unfinished' (such as artfully distributed drips and rhythmically spaced bare spots). Such a rhetoric, were it present, would convert a lack of finish into an end – this was an irony in which de Kooning took no part. It might be accurate to say that rather than finish works, he discontinued them for the sake of other works. This was his 'I just stop'. As long as he was alive and painting, he would avoid stasis. Keep moving, keep changing, stay alive.

De Kooning was long-lived. His professional career extended from the 1920s through the 1980s, and he died just shy of his ninety-third birthday in 1997. His final decade was marked by mental and physical deterioration; by mid-1990 he had given up work in the studio.[591] During the 1980s evidence of mental impairment appeared primarily as a loss of short-term memory. This disability hardly affected his production of challenging paintings, with the result that the decade became an artistic period parallel to his others, marked by de Kooning idiosyncrasy.[592] Most accounts assume that the artist suffered from Alzheimer's disease; because no autopsy was performed, this diagnosis remains inconclusive. De Kooning's deterioration affected only certain aspects of his activity, a situation to be expected with Alzheimer's, which could have left his painting function virtually intact. One medical expert comments: 'It would be completely consistent that the brushstrokes would be maintained. The concept of what he was doing would be lost. . . . If he was largely dependent on motoric and procedural memory skills, those are exactly what are preserved in the illness.'[593] Here is the great irony: in de Kooning's view, concepts were absurd; he needed none (so he believed) and did everything to remove their influence. By his own conception of art, loss of his full capacity to conceptualize would have had little bearing on his practice.

De Kooning had been an unusually heavy drinker during much of the 1960s and 1970s; by itself or in conjunction with other factors, this too may have led to gradual cognitive failing.[594] And he may simply have got too old, suffering from senility, if the generic term still applies in our age of specialized medicine. Whatever the artist's biochemical condition, in the 1980s he was still thinking clearly about his painting and conversing coherently with friends, willing at times to explain why he was doing things the way he was. In the 1990s the deterioration became extreme, and he could not have been thinking very much at all. There is little indication that he communicated with the world beyond his immediate family and caretakers.

It was no time to be planning a new painting campaign, for he was no longer painting. Nor was it the moment to fret over occupying a place in history, for a large niche was already reserved – or rather, several niches, depending on the particular interpreter's orientation. Nearly all those American artists with whom de Kooning had collaborated and competed were long deceased, and he had no one left to rival.[595] Any judgement of the artist's own contentment, assurance or mastery regarding his work of the 1980s can only be the observer's projection, but the descriptions that his assistants offered when interviewed are instructive. 'He was just treating painting like a pad of paper. He was just working it out.'[596] 'He wasn't trying to prove anything. He was just doing. It became like breathing. He just breathed them out.'[597] De Kooning now wanted his works to 'look easy' – still edgy, but easily made.[598]

By default, 'You have to change to stay the same' must have been de Kooning's approach to a 'bright idea'. He may have been referring to changing the paint itself, exchanging it by scraping it away and putting more back again. When he stated in 1969 that he would 'do the same thing over and over', his purpose was to make his painting 'look fluid . . . and fresh'.[599] This implies working back to an initial freshness, which in a sense he had always done, having long before developed the habit of scraping down his pictures after each working session so that the next day's contribution would proceed on a nearly clean slate – guided, nevertheless, by the faint traces of all the marks made to that stage in the indeterminate process. De Kooning during the 1980s was still removing excess wet paint with scrapers as he manoeuvred each painting through a series of reworkings. He was also obliterating canvases that he claimed had become too completely balanced and resolved, and hence 'boring' (his word). If the results were intended to be relatively 'easy' for viewers, he nevertheless wanted to make things difficult for himself, as he had been doing for decades.[600] 'When I am slipping, I say, "Hey, this is very interesting."' The desire to slip remained with him, even with the advent of old-age infirmity.

Reversal

By de Kooning standards, the paintings of the 1980s are relatively straightforward. As he edged each work toward a degree of completion, achieving just the right tension to suggest incompletion, he often reduced the number of colours and lines, painting out more than he allowed back in. The process left virtually all pictorial relationships in a limbo of ambiguity (or 'doubt', as he preferred to say). He used broad expanses of white, which in the hands of

a more conventional painter would probably do little more than establish a ground plane. But de Kooning often tinted the white with colour, with the effect of suggesting volume, or – as in the case of *Untitled XV* (illus. 101) – a sense of movement projected into relief, with the twisting bands of colour gaining their third dimension from scraped residues along their contours (like shadows that project forms into light). I say 'with the effect of' because the effects appear unplanned. De Kooning was still slipping. Even his purest whites, unsullied by residues of chromatic hues, operate spatially in the strangest of ways, simultaneously advancing and receding, rising and falling, to and from the coloured areas they border, as if forms drawn on wavy water. He was continuing his longstanding practice of painting a shape or even a narrow band of colour from the outside in (see above, 'Cézanne', and the description of *Untitled XXX*, 1983, 'Virtuoso'). The neutral white assumes an active role by moulding a chromatic colour (red, for instance) into a distinctive figure, though not a stable one. De Kooning never lost interest in working this way, making challenging fine art with a sign painter's hand.

With his speech as with his painting, de Kooning enjoyed the moral confusion that results from taking a cliché and applying it with flatfooted precision or thought-stopping reversal, finding a non-metaphorical use for a common metaphor. His 'You have to change to stay the same' makes staying the same a positive, noble goal – worth changing for. Otherwise it is the familiar, ironic failing that follows upon any attempt at social and political

101 *Untitled XV*, 1983, oil on canvas, 203.2 × 177.8 cm. Emily Fisher Landau Collection.

transformation, the disappointment met by anyone struggling to alter fated circumstances. With his reversal, de Kooning implied that we should actively work toward repeating ourselves rather than fall victim to the very same repetition, likely to occur anyway. One of the practical lessons artists might derive was this: attend consciously to all the little, recurring features of the mundane environment; you will be able to transform them into worthwhile experience. De Kooning viewed familiar things as unique wonders, as if his vision had no acquired habits. He strove to make his art as interesting as what the most ordinary experiences were offering.

In 1987, very late in his working career, de Kooning accomplished his creative repetition in two closely related paintings, *Quality of a Piece of Paper* (illus. 102) and *Conversation* (illus. 103). These works are types – that is, variations or changes in relation to each other – derived from the same 'original' drawing, itself a type, *Untitled* (illus. 104). The source-drawing is a type in that it represents two women vertically disposed within a horizontal format, one cross-legged and seemingly sitting, the other straight-legged and possibly reclining – a composition de Kooning repeated many times throughout several decades. (If the drawing seems indecipherable, concentrate first on the angled knees and crossed legs visible at the lower left.) From the women as recognizable types within de Kooning's oeuvre to this particular drawing of them, to the two paintings projected from the drawing, we move from type to type to type, ever changing, ever the same.[601] De Kooning rotated *Conversation* ninety degrees in relation to *Quality of a Piece of Paper* so that the upper left corner of the former corresponds to the upper right corner of the latter. This change introduces no concept worth mentioning. De Kooning applied rotation as an action, not a concept. What mattered was this: with it, he could keep changing.

History confronted twentieth-century artists with a vengeance. Theirs was an era particularly conscious of definitions, movements, and innovations – of the fact that art had become history-in-the-making. In this respect, the anxiety of those who died young, such as Gorky and Pollock, was limited; they never faced a cumulative evaluation. Although de Kooning died old, he lacked the usual worry over having left a sufficient record of originality. He loathed rankings and hierarchies. He preceded Warhol, another irreverent type, in believing that there were 'millions of painters and all pretty good' (Warhol's words); but his belief came unaccompanied by Warhol's ironic posturing (see 'Avant-garde').[602] Many of de Kooning's thoughts that may seem ironic to us were not so to him. Because he never expected to get beyond what had been done in the past, he felt that he could borrow freely not only from the Old Masters but also from his contemporaries and, most often of all, from his own previous production. A type has nothing in particular to

102 *Quality of a Piece of Paper*, 1987, oil on canvas, 177.8 × 203.2 cm. Private collection.

103 *Conversation,* 1987, oil on canvas, 203.2 × 177.8 cm. Private collector.

104 *Untitled, c.* 1980, ink on paper, 21.6 × 28.3 cm.

gain, nothing to lose in dealing with originals. 'I can open almost any book of reproductions and find a painting I could be influenced by', de Kooning told Rosenberg. His double positive – any book, any kind of influence – might well strike a more idealistic personality as a double negative, the words of a painter who had so little direction that everything led him astray, 'slipping'. 'I am an eclectic by chance', he concluded, which is to say that all things hold equal interest.[603] This is why de Kooning felt compelled to alter any canvas that seemed to establish a definitive, perfected solution to a problem. A superior result narrows the range of interest by identifying one thing as better than the alternatives. De Kooning instead sought the exceptional qualities of what was ordinary. He pursued the dubious condition of ambiguous difference. He needed the experience of change to keep *himself* changing, which was for him a proper way of staying the same, true to his desire. Change had nothing to do with claims to progress and advancement; it was the artist's state of being.

'You have the form you want', de Kooning said in 1986, 'then you lose it, then you get it again. You have to change to stay the same.'[604] At this stage, it was the lesson of his life's experience. But what had he learned from painting for so many years? Perhaps the best hypothesis is that de Kooning's final thoughts – whatever they were – must have been thoughts he had had before. Repeating himself, he reversed his progress – over and over – just as he reversed

263

105 <no title>, *c.* 1970–79, charcoal on vellum, 136.5 × 107.2 cm. Private collection.

106 <no title>, *c.* 1970–79, charcoal on vellum, 136.5 × 107.2 cm. Private collection.

his opinions. His extemporaneous remarks of 1970 in his interview with
de Antonio repeat statements he had already made in 1960 when Sylvester
interviewed him.[605] 'Time', Peirce wrote, 'consists in the relations of inter-
acting feelings.'[606] Repetition strengthens bonds of association between the
repeated qualities or feelings, generating a regulated sense of time, progress,
and evolution. But de Kooning's repetitions were *irregular* because they
appeared incongruously in new contexts, making it obvious that the second
appearance of a sign – like the second appearance of the one woman in *Two
Women* (illus. 69) – cannot have the same 'meaning'. It projects a different
sense, a different feeling. A de Kooning repetition is more change than stay-
ing the same – or, it is staying the same by changing. He put a kink in time.
In Peircean terms, his repetitions were instances of spontaneity (not regular,
not predictable). Instances of spontaneity are lacunae in time: 'It is not to be
supposed that the ideally perfect time has even yet been realized. There are no
doubt occasional lacunae and derailments.'[607] 'Perfect time' would represent
absolute stasis: no change, the termination of feeling, death.

For us, an irony emerges: those who during the 1980s and after insisted
that de Kooning had gradually lost his mind referred specifically to his repeat-
ing himself, including his making pictorial repetitions. Yet he had been
repeating himself all of his life. This was his way of changing. He had been
using the same technique of generating images by taking tracings from his
older drawings and paintings. When he generated double-sided tracings on
translucent vellum, each a copy of the other, ever widening variations resulted
(illus. 105, 106). Whether these irregularities or imperfections in repetition
were products of the material and physical nature of tracing or instead repre-
sent the artist's rapid thought process (change this line here, adjust that one
there) is undecidable. In the end as in the beginning – drawing, tracing,
painting, transferring, drawing, 'over and over' – de Kooning changed and
stayed the same.

Painting

Picasso died on 8 April 1973. In New York, numerous immediate tributes
included this: 'His greatness was in throwing out ideas, in never repeating
himself.'[608] Not every observer would have put it so generously, for many
of Picasso's images, like de Kooning's, manifested only slight variation. As we
know ('Turn'), Picasso once indicated that his innumerable changes were
directed at an unchanging end: 'All [my work] is my struggle to break with

the two-dimensional aspect.'[609] He drew this conclusion in 1956 at age seventy-five, but his 'struggle' went on; and despite being two to three decades their senior, he outlived every one of de Kooning's greatest New York School contemporaries – Gorky, Pollock, Kline, Newman, Rothko. At Picasso's death, de Kooning, who years before had identified Picasso as 'the guy to beat', remained extremely vigorous but was approaching seventy himself.[610] It may have seemed to the New York School that Picasso had been destined to live forever, with their painting remaining subject to his authority. Another tribute of 1973 stated: 'He is the last artist in this century . . . who will have been a real king during his lifetime. Now it will become a republic.'[611] Picasso appeared to take his supremacy for granted. What had beset him more than any rivalry with younger artists was his finitude, his mortality. Intimations of mortality link him to the Cézanne of around 1900 and the de Kooning of around 1980, for all three became hyper-productive as they sensed, for different reasons, their limited purchase on life.

A curious paradox emerges from the observations of two of Picasso's close friends. One of them, aware that the artist had a pronounced fear of dying, surmised: 'He thought that if he stopped working, that was death. So, that's why until his death he worked every day.' The other entertained a competing notion: 'Until his death, he had the desire to work. He used to say "I don't go out any longer in the car because some imbecile will . . . run into me and I've still got a lot of paintings to do."'[612] The first commentator states that Picasso kept working in order to avoid dying. According to the second, Picasso avoided dying in order to keep working. The chiasmus here – work to live, live to work – is collective.

Which thought should have priority? Picasso had two potential sources of anxiety: fear of dying; worry over leaving a life's work unfinished. In de Kooning's case, friends and family members hoped that painting would keep him alive, even though he disdained the dream of progress in the history of art. Those around him encouraged him to work, which stimulated him mentally. De Kooning's model Cézanne had had a different concern: despite his years, he felt he had hardly started. Picasso stated perceptively that what he liked about Cézanne was the anxiety his art projected.[613] Perhaps he was responding to the formal tensions evident in paintings like the first of Cézanne's three canvases of *Great Bathers* (illus. 107), over which the artist wrestled for a decade. Shortly after Cézanne's death in 1906, the younger painter Maurice Denis described having seen this work when it was still in the studio: 'Arms, torsos, and legs were extended and then reduced [repeatedly], acquiring inconceivable proportions.'[614] Denis's words evoke figures by the late Picasso and still more those by the late de Kooning, however abstract they may seem (*Quality of a Piece of Paper*, illus. 102; *Conversation*, illus. 103).

267

Cézanne, Picasso, de Kooning: the more things change, the more they stay the same.

 Cézanne died at age sixty-seven of complications from diabetes. He had attempted to maintain a working routine even during the final months of a fatal decline. Close to the end he told his acolyte Emile Bernard, perhaps with ironic self-deprecation, that finally he was making 'some slow progress' in his studies from nature. He doubted he would have time enough to achieve satisfying results but was determined, as he put it, 'to die painting'.[615] Cézanne's doubt held none of the fascination that 'doubt' (provocative ambiguity) would later offer de Kooning. Differing on doubt, the two painters agreed on most everything else, including the dangers of prescriptive theory, intellectual pretence, and historical type-casting. Stay clear of all that, Cézanne advised a young poet: 'An artist wishes to elevate himself intellectually as much as possible, but the man should remain obscure. Gratification ought to come [only] in working . . . No more theories! Works!'[616] His position evokes de Kooning's fear of retrospective packaging – theorization by default.

 In 1905, Cézanne wrote to Bernard: 'I owe you the truth in painting [*en peinture*], and I will tell it to you.'[617] Whatever Cézanne was saying, whether the truth would be in the process or in the result, it never happened. Bernard lamented to his wife: 'He took his secret to the grave. He wrote me that he wanted to tell me everything, and I don't know what he meant by that.'[618] Had Cézanne intended to reveal the truth of his art through the medium of painting while engaged in the act? This would be appropriate, for his visual truth changed as every painting changed. To the end, he was seeking; and he was finding only through the continuation of his activity. A sympathetic critic commented: 'We hardly dare say that Cézanne lived; no, he painted.'[619] The consuming nature of art may have been Cézanne's realization: the truth of painting shows only in its organicism, as an artist works through it. There are competing theories of art, but their concepts are unchanging. Paintings, however, change. It should not be a question of stabilizing painting by moving it toward a theoretical ideal; rather, the ideal must move to remain in accord with painting. Like language trying to keep up with experience, an ideal of art, its 'truth', never matches the actual practice. This may also have been de Kooning's unspoken end – yet it was a thought he seems to have had at an early stage, at least by the 1940s. He had no objection to repeating Cézanne's aesthetic sensations as his own de Kooning type. For de Kooning, Cézanne's art was original, as was Picasso's, as was Rubens's, as was every other form of art, every image, every scene; and he, de Kooning, was the type. In preference to Picasso, de Kooning had declared Cézanne as his influence; but this had been an arbitrary matter of strategy, a response to the critical discourse of the moment (see 'Cézanne'). De Kooning

107 Paul Cézanne, *Great Bathers*, 1895–1906, oil on canvas, 132.4 × 219.1 cm. The Barnes Foundation, Merion, Pennsylvania.

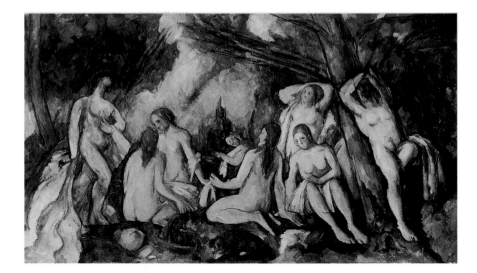

did share a significant thought with Cézanne: paint, don't think, they both seem to have been thinking, just before they stopped painting. Then they stopped. At that final moment they were still in the midst of change.

End

De Kooning had no end, no purpose to his art, save to keep living and sensing. 'I paint to live', he said.[620] He intended his art not to make sense but to be sense.

Hardly a religious man, de Kooning sometimes invoked God in order to define his own human condition. He used to say, 'Only God doesn't have to believe in himself.'[621] Like Cézanne's cryptic allusion to the truth of, or in, painting, de Kooning's statement can have no secure meaning; I can only guess at its intention. Any interpretation, of course, hinges on the experience of the interpreter. For me, de Kooning's remark recalls Heinrich von Kleist's comment on the production of aesthetic beauty and grace: 'Only a god, on this field of contest, could prove a match for matter.'[622] Matter, the forces and stuff of nature, has its way of finding its condition of beauty – like water, I suppose, which will always find its level no matter how we channel it. To tinker with matter and be certain of the outcome, you had better be a god. The combination of man and matter, the action of an artist who shapes materials, produces a more problematic situation than matter left to its own devices or matter left to a god, or to the gods, or to God. De Kooning had to 'believe in himself' because he was not God. He needed belief to compensate for the strength of his doubt: he could never know which of his creative

269

actions might lead to a desirable result. Not a *desired* result but a *desirable* one, because he had no end in view – success was to be pleased with the point you had reached, after you reached it. De Kooning was skilled at his methods; but they, in turn, were inherently uncertain. To be certain, you would need to rely on proven habits of procedure; but if the procedure were entirely predictable, you would lose the element of spontaneity and with it its grace, a kind of divine chance. Given the circumstances he acknowledged, because his art had no cause – no justification either in the past or in the future – de Kooning was left to believe in himself. He was the cause of himself. 'Artists themselves have no past', he remarked: 'They just get older.'[623] With nothing determining him and nothing to live up to, no goal to meet, he was free to let his art happen, come what may. When he was dissatisfied with his results, the situation was not a deterrant but that much more of a stimulus to continue.

Sometime around 1970, when de Kooning was in his mid-sixties and, as it turned out, with much of his art yet to be achieved, he asked a plaintive question of his assistant John McMahon: 'Where did it all go?' 'It' was the time, the life. He was already old. McMahon replied that the life had gone into painting – a response intended to console. He wondered whether Bill de Kooning would ever have wanted it otherwise. 'I guess not', the artist admitted. Then, realizing that he was hungry, de Kooning passed out of his depression, his moment of moroseness, as quickly as he had passed into it. His moods were mercurial, changeable, like his art. The two left the studio and went into town to eat.[624]

REFERENCES

1 There are many accounts of de Kooning's quip 'a million bucks': see, for example, Irving Sandler, *A Sweeper-Up After Artists: A Memoir* (New York, 2003), p. 46 (no specific source); Steven Naifeh and Gregory White Smith, *Jackson Pollock: An American Saga* (New York, 1989), p. 713 (source: Joan Ward, painter, mother of Lisa de Kooning, de Kooning's daughter); Mark Stevens and Annalyn Swan, *De Kooning: An American Master* (New York, 2004), p. 358 (source: Lee Eastman, de Kooning's lawyer). Sandler identifies 'Mrs Rockefeller' as 'Happy' (Mrs Nelson) Rockefeller. Neifeh and Smith, as well as Stevens and Swan, identify the individual in question as Blanchette (Mrs John D. III) Rockefeller: history is vague. According to Milton Resnick, de Kooning's first reference to 'breaking the ice' occurred during the opening of Pollock's gallery show in 1949; see Neifeh and Smith, *Jackson Pollock: An American Saga*, p. 598. De Kooning used the same metaphor at a memorial event held after Pollock's death in 1956; see the oral history interview with William Kienbusch, conducted by Forrest Selvig, 1 November 1968, Archives of American Art, Smithsonian Institution (courtesy Justine Price). The draft of a vituperative letter from Newman to de Kooning, probably composed in 1956, extended the 'ice' metaphor, expressing bitterness over the latter's attitude toward Pollock (The Barnett Newman Foundation, New York). Newman asked the rhetorical question, 'With all this broken ice, tell me when are you going to learn to swim?' – an allusion to de Kooning's contradictory attraction and aversion to bodies of water. The Rothko quip appears in notes Sandler took of his conversation with de Kooning, 25 April 1957; Irving Sandler papers, *c.* 1950–2000, Getty Research Institute, Los Angeles. Josef Albers's series *Homage to the Square*, with its relatively clean rectilinear geometry, often served to exemplify canonical abstract art.

2 Willem de Kooning, 'Content Is a Glimpse . . .', *Location*, 1 (Spring 1963), p. 48. The statement is an adaptation of very similar phrasing from an interview of de Kooning by David Sylvester, 'Painting as Self-Discovery', BBC broadcast, 3 December 1960, later published in David Sylvester, 'De Kooning's Women', *The Sunday Times Magazine* (London), 8 December 1968, p. 57. The actual interview took place in March 1960. Two of de Kooning's friends, Thomas B. Hess and Harold Rosenberg, were editors of *Location*; Hess edited the Sylvester interview, eliminating Sylvester's questions to give the publication the form of an essay by de Kooning. This particular quotation also appeared in 'De Kooning: Grand Style', inset to 'Vanity Fair: The New York Art Scene', *Newsweek*, 4 January 1965, p. 56. Within the context of Sylvester's actual questions, the wording of de Kooning's statement acquires more specificity. Sylvester asked about finishing, and de Kooning replied: 'Well, I always have a miserable time over it. But it is getting better now.' Then Sylvester asked a leading question: 'But what's the criterion – what is the point where you know you can stop the painting?' De Kooning would not want to admit to a

criterion, but took the word *stop* as a cue: 'Oh, I really –
I just stop . . . It sometimes turns out very good.'

3 See Anonymous, 'Big Splash', *Time*, 18 May 1959, p. 72.

4 Concerning prestige, de Kooning made a point of noting
who had privileged access to museum events and who
did not; John McMahon, de Kooning's primary assistant
from 1963 through 1975, interview by the author,
8 March 2001. Citations to interviews by the author
will henceforth include only the name of the source
and the date.

5 Milton Esterow, 'Willem de Kooning Files Suit Against
Art Dealer', *The New York Times*, 31 March 1965, p. 23.

6 Robert Goldwater, 'Art Chronicle: Masters of the New',
Partisan Review, 29 (Summer 1962), p. 417.

7 Dore Ashton, *The New York School: A Cultural Reckoning*
[1972] (Harmondsworth, 1979), p. 4.

8 De Kooning, in Sylvester, 'De Kooning's Women', p. 52.

9 'Je confondis le désenchantement avec la vérité': Jean-
Paul Sartre, *Les mots* (Paris, 1964), p. 132; *The Words*,
trans. Bernard Frechtman (New York, 1964), p. 159.

10 De Kooning, statement (23 April 1950) in Robert
Goodnough, ed., 'Artists' Sessions at Studio 35',
Modern Artists in America, ed. Robert Motherwell and
Ad Reinhardt (New York, 1951), p. 22.

11 De Kooning, in Harold Rosenberg, 'Interview with
Willem de Kooning', *ARTnews* 71 (September 1972),
p. 54. This interview-conversation was recorded in 1971,
then edited, presumably by Rosenberg, and published
in 1972. The edited version preserved the quality of
de Kooning's speech but with certain changes.

12 Willem de Kooning, 'The Renaissance and Order',
trans/formation, 1/2 (1951), p. 86.

13 De Kooning, in Sylvester, 'De Kooning's Women', p. 57.

14 Anonymous, 'De Kooning's Derring-Do', *Time*, 17
November 1967, p. 88. Apparently, the practice continued;
compare Bill Berkson, 'As Ever, de Kooning', *Art in
America*, 85 (February 1997), p. 66: 'In 1980, when I
asked if he had been reading much lately, de Kooning
told me . . . 'No, I get up and paint all day, and when I
get tired I take a drawing pad and watch television while
I draw.' See also Hervé Vanel, 'La roue de la Fortune',

Les cahiers du Musée national d'art moderne, 62 (Winter
1997), p. 37.

15 John McMahon, 29 August 1993.

16 De Kooning's words as recalled by Elaine de Kooning,
quoted in Harriet Janis and Rudi Blesh, *De Kooning*
(New York, 1960), p. 17. On lettering in paintings, see
also Thomas B. Hess, *Willem de Kooning* (New York,
1959), p. 23.

17 De Kooning's words as reported by Garner Tullis, print-
maker who worked with the artist during the 1960s and
'70s, 28 May 1993.

18 This was the opinion of Athos Zacharias, de Kooning's
studio assistant during the late 1950s, 20 September 1993.

19 John McMahon, often present when de Kooning sketched
in the evening, stressed the extraordinary speed with which
he would work, 8 March 2001.

20 A typical comment: 'Bill was wonderfully bright and
funny and totally unpretentious intellectually'; Elaine
Benson, 'Happy Birthday, Bill', *Dan's Papers*, 22 April
1994, p. 36. Buckminster Fuller remembered that while
at Black Mountain College during summer 1948, he
and de Kooning would 'talk philosophy' on drives to
Asheville to purchase supplies; see Martin Duberman,
Black Mountain: An Exploration in Community (Garden
City, NY, 1973), p. 295.

21 De Kooning, statement in conversation with Irving
Sandler, 19 February 1958, Irving Sandler papers,
Getty Research Institute.

22 Clement Greenberg [1983], in Trish Evans and Charles
Harrison, 'A Conversation with Clement Greenberg in
Three Parts', *Clement Greenberg: Late Writings*, ed.
Robert C. Morgan (Minneapolis, MN, 2003), p. 202.

23 De Kooning, 'A Desperate View' [1949], first published
in Thomas B. Hess, *Willem de Kooning* (New York: The
Museum of Modern Art, 1968), p. 15. De Kooning
presented this lecture at the 'Subjects of the Artist'
school in New York, 18 February 1949, where Robert
Motherwell read it in his stead; Elaine de Kooning
contributed substantially to the phrasing of the text
(Annalee Newman, interview by Mildred Glimcher,
5 November 1994, The Barnett Newman Foundation,

New York). A complete handwritten draft of the text exists in The Barnett Newman Foundation along with a typed copy, probably produced by Annalee Newman. The talk initially had the title, 'The Desperate View', and included an introductory sentence attributing this title as well as the motivation for the event to Barnett Newman. See also Sandler, *A Sweeper-Up After Artists*, p. 27; Natalie Edgar, ed., *Club Without Walls: Selections from the Journals of Philip Pavia* (New York, 2007), p. 56.

24 Søren Kierkegaard, *Either/Or*, trans. Howard V. Hong and Edna H. Hong, 2 vols (Princeton, NJ, 1987), II, p. 212. De Kooning referred to *Either/Or* in the recording of a conversation between Harold Rosenberg, Thomas Hess, and Willem de Kooning, taped by Betty Wolff, 2 March 1964, Thomas Hess papers, 1941–78, Archives of American Art, Smithsonian Institution (transcription by Justine Price). Susan Brockman (de Kooning's companion during much of the 1960s, 6 September 1993) recalled that she and de Kooning read Kierkegaard together, and Heidegger as well. See also below, 'Nothing'.

25 De Kooning, quoted in Irving Sandler, 'Willem de Kooning: Gesprek in de Kooning's Atelier, 16 Juni 1959', *Museumjournaal*, 13 (1968), p. 336 (summary in the original English). Like many interviewers at the time, Sandler worked from detailed notes, allowing him to report the content of de Kooning's remarks accurately, but not necessarily every word. In his published summary, he simplified de Kooning's spontaneous line of thought, eliminating the fact that he had introduced Courbet as an example. Sandler's notes record the passage in full: 'I have a vague idea – I kind of see it – and I see Courbet and Lautrec – that's a kind of image. As I paint, I find out what the clear idea is' (Irving Sandler papers, Getty Research Institute). Perhaps de Kooning meant that his vague idea for a painting, based on a direct observation, recalls images he has admired in the work of Courbet and Lautrec.

26 'Even in the early days when he was most influenced by academy standards for judging a painting, Bill never finished paintings': information from Elaine de Kooning, the artist's wife, and Rudolph Burckhardt, an early friend, as conveyed to Lee Hall; see Lee Hall, *Elaine and Bill: Portrait of a Marriage* (New York, 1993), p. 59.

27 De Kooning, statement to Irving Sandler, 16 June 1959; Irving Sandler, 'Conversations with de Kooning', *Art Journal*, 48 (Fall 1989), p. 217.

28 Lisa de Kooning, 2 May 1993. See also Lisa de Kooning, 'We used to go bicycling, my father and I . . .', *Willem de Kooning* (Zurich, 1999), n.p.

29 'I draw while I watch TV'; de Kooning, interview by Bibeb, 'Willem de Kooning: Ik vind dat alles een mond moet hebben en ik zet de mond waar ik wil', *Vrij Nederland* (Amsterdam), 5 October 1968, p. 3 (translation courtesy Mette Gieskes and Charles Cramer). 'These screaming girls [in a drawing] were observed on television, teeny boppers at a Beatles concert'; Thomas B. Hess, *Willem de Kooning: Drawings* (Greenwich, CT, 1972), p. 53. On drawing from television, see also Harold Rosenberg, *Willem de Kooning* (New York, 1974), p. 35; Thomas B. Hess, 'Willem de Kooning – New Images', *Vogue*, 168 (April 1978), p. 236; Bill Berkson, 'As Ever, de Kooning', *Art in America*, 85 (February 1997), p. 66; Vanel, 'La roue de la Fortune', p. 37. If not a television drawing, *Woman Reclining* is likely to have been made with the artist's eyes closed, a drawing practice discussed below ('Twist').

30 Merce Cunningham, 'Space, Time and Dance', *trans/formation*, I/3 (1952), p. 150.

31 The sense of an unconventional orientation may have attracted de Kooning's drawing to its present owner, the artist Georg Baselitz, who typically conceives his representational imagery upside-down and often combines two images in different orientations to the rectangular format – for example, one inverted, another sideways. Baselitz comments that eccentric methods of this sort present the artist with challenging surprises: 'you have to take what you get' when forced into unfamiliar aesthetic corners (Georg Baselitz, letter to the author, 19 September 2010).

32 Author's multiple interviews (1993–94) of John McMahon, Susan Brockman and others.

33 De Kooning, in Bibeb, 'Willem de Kooning', p. 3. According to a gossipy account of the New York art scene (there are many), if de Kooning's television provided stimulation to drawing during the late 1960s, it was also a psychological comfort, as was alcohol: 'It gets pretty lonely out here', he told John Gruen in 1969, referring to Springs; 'That's why I keep the television running . . . I turn the TV on, then I go upstairs and lie down, and then it sounds as though there were people downstairs': John Gruen, *The Party's Over Now* (New York, 1972), p. 222.

34 Willem de Kooning, 'What Abstract Art Means to Me', *The Museum of Modern Art Bulletin*, 18 (Spring 1951), p. 5.

35 Rudi Blesh, *Modern Art USA: Men, Rebellion, Conquest, 1900–1956* (New York, 1956), p. 259.

36 Comment by painter Wayne Thiebaud [1997], quoted in Irving Sandler, *A Sweeper-Up After Artists: A Memoir* (New York, 2003), p. 47.

37 De Kooning, statement (21 April 1950), 'Artists' Sessions at Studio 35', *Modern Artists in America*, p. 12.

38 Strictly speaking, *vellum* denotes animal derivatives, such as parchment, but the term more generally refers to any translucent tracing paper.

39 Many witness accounts and interviews allude to de Kooning's interest in Wittgenstein. See, for example, Rosenberg, 'Interview with Willem de Kooning', p. 55. See also below ('Glimpse'). Saul Steinberg described de Kooning's pattern of talk as 'homemade eloquence . . . What it amounts to is to be able to catch up with your thinking while talking'; Steinberg [summer 1993], quoted in Stevens and Swan, *De Kooning: An American Master*, p. 366.

40 De Kooning's words as recalled by John McMahon, 8 March 2001. He would often say 'Once you croak . . .' rather than 'Once you're dead . . .'.

41 An example of the critical trope: '[The consumer] belongs to the product and not the product to him. If he wished to change this situation he would be locked up, if he weren't locked up already'; Theodor W. Adorno, 'Commodity Music Analyzed' [1934–40], *Quasi una Fantasia: Essays on Modern Music*', trans. Rodney Livingstone (London, 1992), p. 45.

42 Artists, of course, will sometimes speak as their own critical theorists and use a critical (as opposed to an artistic) strategy; see Richard Shiff, 'Flexible Time', *Art Bulletin*, 76 (December 1994), pp. 583–7.

43 Newman, quoted in Douglas Davis, 'After 10 Years, a One-Man Show by Mr Newman', *The National Observer*, 14 April 1969, p. 20.

44 Newman, undated manuscript note, inscribed on a Metropolitan Museum of Art lecture question card, The Barnett Newman Foundation, New York.

45 Jean-Luc Nancy, 'Painting in the Grotto' (1994), *The Muses*, trans. Peggy Kamuf (Stanford, CA, 1996), p. 74. In French: 'silence calmement violent . . . L'homme en a tremblé: et ce tremblement, c'était lui'; Jean-Luc Nancy, *Les muses* (Paris, 1994), p. 127.

46 Another example of chiasmus from the same writer: 'Self outside of self, the outside standing for *self*, and [man] being surprised in face of self. Painting paints this surprise. This surprise is painting'; Nancy, 'Painting in the Grotto', *The Muses*, p. 69 (emphasis original). In French: 'La peinture peint cette surprise. Cette surprise est peinture'; *Les muses*, p. 121. 'Peinture dans la grotte' first appeared in *La part de l'oeil*, 10 (1994), pp. 161–8, where Nancy wrote only 'La peinture peint cette surprise', without adding the chiasmic 'Cette surprise est peinture.' Apparently, the chiasmic supplement proved hard to resist.

47 Elaine de Kooning, 'On the Work of Willem de Kooning' [1983–84], *The Spirit of Abstract Expressionism: Selected Writings*, ed. Rose Slivka and Marjorie Luyckx (New York, 1994), p. 228.

48 Hess, *Willem de Kooning* (1968), pp. 15–16. Here Hess presents an Adorno-like notion, not uncommon within twentieth-century critical writing and related to some of Greenberg's remarks, such as his view that art 'should deal with inconsistencies, maintaining them unresolved'; Clement Greenberg, 'Religion and the Intellectuals: A Symposium' [1950], *The Collected Essays and Criticism*, ed. John O'Brian, 4 vols (Chicago, 1986–93), III, p. 41.

49 For the Hess-de Kooning exchange, see the conversation between Harold Rosenberg, Thomas Hess and Willem de Kooning, taped by Betty Wolff, 2 March 1964, Thomas B. Hess papers, 1941–78, Archives of American Art, Smithsonian Institution, Washington, DC (transcription by Justine Price).

50 Paul M. Laporte, 'Cézanne and the Philosophy of His Time', *trans/formation*, I/2 (1951), p. 71.

51 Werner Heisenberg, 'The Quantum Theory: A Formula Which Changed the World' [1950], trans. Christian Vogel, Günther Schoen and Warren Robbins, *trans/formation*, I/3 (1952), p. 133.

52 De Kooning, 'What Abstract Art Means to Me', p. 4. The same line was quoted in Anonymous, 'Willem the Walloper', *Time*, 30 April 1951, p. 63.

53 Greenberg, 'Review of an Exhibition of Willem de Kooning' [1948], *The Collected Essays and Criticism*, II, pp. 229–30.

54 De Kooning, statement (23 April 1950), 'Artists' Sessions at Studio 35', *Modern Artists in America*, pp. 19–20.

55 De Kooning, in Rosenberg, 'Interview with Willem de Kooning', pp. 56, 58.

56 De Kooning, interview by Irving Sandler, 16 June 1959, Irving Sandler papers, Getty Research Institute.

57 See Hess, *Willem de Kooning* (1959), p. 28.

58 On the lack of distinction between drawing and painting in de Kooning's practice, see Hess, *Willem de Kooning: Drawings*, p. 13; Susan Lake and Judith Zilczer, 'Painter and Draftsman', in Judith Zilczer, ed., *Willem de Kooning from the Hirshhorn Museum Collection* (New York: Rizzoli, 1993), pp. 172–9.

59 De Kooning, in Rosenberg, 'Interview with Willem de Kooning', p. 55.

60 William Inge, introduction, *Willem de Kooning* (Los Angeles, CA, 1965), n.p. (original emphasis).

61 De Kooning, in Bibeb, 'Willem de Kooning', p. 3.

62 De Kooning, 'A Desperate View'; 'The Renaissance and Order'; 'What Abstract Art Means to Me'.

63 De Kooning, in Bibeb, 'Willem de Kooning', p. 3. 'What Abstract Art Means to Me' had been reprinted in Hess's monograph of 1968 as well as in Dutch translation for the catalogue of the retrospective held that same year at the Stedelijk Museum, Amsterdam.

64 De Kooning (1960), in Sylvester, 'De Kooning's Women', p. 57. De Kooning expressed the same thought in Bibeb, 'Willem de Kooning', p. 3.

65 Jean-Claude Lebensztejn, 'Devant les mots: de Kooning, Pollock', *Critique*, no. 565–6 (June–July 1994), pp. 434–5.

66 Thomas B. Hess, 'De Kooning Paints a Picture', *Art News*, 52 (March 1953), p. 31.

67 Huntington Hartford, 'The Public Be Damned?' (advertisement), *The New York Times*, 16 May 1955, p. 48.

68 Anonymous, 'Prisoner of the Seraglio', p. 74.

69 Lawrence Alloway, 'Art', *Nation*, 24 March 1969, p. 381.

70 Charles Sanders Peirce, 'The Architecture of Theories' [1891], *Collected Papers*, ed. Charles Hartshorne, Paul Weiss and Arthur W. Burks, 8 vols (Cambridge, MA, 1958–60), VI, p. 17.

71 De Kooning, statement (21 April 1950), 'Artists' Sessions at Studio 35', *Modern Artists in America*, p. 12.

72 Peirce, 'The Architecture of Theories', *Collected Papers*, VI, p. 18.

73 De Kooning, in Sylvester, 'De Kooning's Women', p. 52.

74 Peirce, 'Questions Concerning Certain Faculties Claimed for Man' [1868], *Collected Papers*, VI, pp. 135–6.

75 Peirce, 'The Architecture of Theories', *Collected Papers*, VI, p. 19.

76 Elaine de Kooning, 'On the Work of Willem de Kooning', *The Spirit of Abstract Expressionism: Selected Writings*, p. 228.

77 Harold Rosenberg, 'Women and Water', *The New Yorker*, 24 April 1978, 133.

78 Thomas B. Hess, 'Willem de Kooning – New Images', p. 236.

79 Theodor W. Adorno, 'Looking Back on Surrealism' [1956], trans. S. P. Dunn and Ethel Dunn, in Irving

Howe, ed., *The Idea of the Modern in Literature and the Arts* (New York, 1967), pp. 220–21.

80 Hess, 'Willem de Kooning – New Images', p. 236.

81 Sartre, *The Words*, p. 252. Introducing a de Kooning exhibition in 1965, Dore Ashton affirmed the intellectual affinity between Sartre and de Kooning by referring to an interview of Sartre concerning this passage: see Dore Ashton, 'Willem de Kooning', in Charles Chetham, ed., *Willem de Kooning* (Northampton, MA, 1965), n.p.; Jacqueline Piater, 'Jean-Paul Sartre s'explique sur "les Mots"', *Le Monde*, 18 April 1964, p. 13.

82 Peirce, 'The Architecture of Theories' [1891], *Collected Papers*, VI, p. 19.

83 Peirce, 'The Architecture of Theories', 'To Christine Ladd-Franklin, on Cosmology' [1891], *Collected Papers*, VI, p. 19, VIII, p. 214.

84 Peirce, 'Time and Thought' [1873], *Collected Papers*, VII, p. 214.

85 This observation comes from three independent sources among those who were familiar with what was happening in de Kooning's studio: Joan Ward, 25 September 1993; Conrad Fried (brother of Elaine de Kooning), 10 October 1993; John McMahon, 8 March 2001.

86 Peter Schjeldahl, 'Blue Stroke', *Village Voice*, 8 April 1997, p. 93. Schjeldahl (29 July 2010) has confirmed the approximate date of his visit with de Kooning. Perhaps quoting de Kooning, Hess had used the term *monotype* for these reverse images in 1965; Thomas B. Hess, 'De Kooning's New Women', *Art News*, 64 (March 1965), p. 64.

87 Schjeldahl, 'Blue Stroke', p. 93.

88 Peirce, 'Shock and the Sense of Change' [*c.* 1905], *Collected Papers*, I, p. 170.

89 Conrad Fried, 10 October 1993.

90 De Kooning, quoted in Charlotte Willard, 'De Kooning', *Look*, 27 May 1969, p. 58.

91 Ibrim Lassaw, in conversation with Charlotte Willard (1969); Charlotte Willard Papers, Archives of American Art, Smithsonian Institution, Washington, DC (courtesy Anne Collins Goodyear).

92 Newspaper as economy: Conrad Fried, 10 October 1993.

93 Hess, 'De Kooning's New Women', p. 64.

94 Background notes by an interviewer identified as Welch, quoted in Stevens and Swan, *De Kooning: An American Master*, p. 270. The notes were preparatory to 'Big Splash', *Time*, 18 May 1959, p. 72. In the published news item, de Kooning's words are somewhat different: 'I'm not trying to be a virtuoso, but I have to do it fast. It's not like poker, where you can build to a straight flush or something. It's like throwing dice. I can't save anything.'

95 Anonymous, 'Big Splash', p. 72.

96 De Kooning, in Bibeb, 'Willem de Kooning', p. 3.

97 According to the Dutch-American artist Joop Sanders, a longtime friend, de Kooning made the general remark: 'I always twist the torso so the back is the front and the front is the back'; quoted by Stevens and Swan, *De Kooning: An American Master*, p. 547 (from the authors' interviews of Sanders between 31 October 1990 and 13 March 1993).

98 Rudy Burckhardt, recalling de Kooning's attitude during the 1930s, 'Long Ago with Willem de Kooning', *Art Journal*, 48 (Fall 1989), p. 216. On formal analogies between Picasso and de Kooning, see David Sylvester, 'Flesh Was the Reason', in Marla Prather, ed., *Willem de Kooning: Paintings* (Washington, DC, 1994), pp. 17–22.

99 De Kooning, in Sylvester, 'De Kooning's Women', p. 52.

100 Picasso, statement to Christian Zervos, 1935; see Marie-Laure Bernadac and Androula Michael, eds, *Picasso: Propos sur l'art* (Paris, 1998), p. 33. (In cases where no translator is credited, as here, the translation is by the author.)

101 Picasso, quoted in Jaime Sabartès, *Picasso à Antibes* (Paris, 1948), p. 29.

102 On the interesting case of Picasso using a living body as a painting surface, see Richard Shiff, 'Breath of Modernism (Metonymic Drift)', in Terry Smith, ed., *In Visible Touch: Modernism and Masculinity* (Chicago, 1997), pp. 189–91.

103 Conrad Fried, 4 October 1993, stressed de Kooning's concern with keeping images flat on the pictorial surface.

104 Picasso, quoted in Alexander Liberman, 'Picasso', *Vogue*, 1 November 1956, p. 134. For extended analysis of Picasso's 'break with the two-dimensional aspect', see Leo Steinberg, 'The Algerian Women and Picasso at Large', *Other Criteria: Confrontations with Twentieth-Century Art* (London, 1972), pp. 125–234; Richard Shiff, 'The Young Painter', in Terence Maloon, ed., *Picasso: The Last Decades* (Sydney, 2002), pp. 25–41.

105 Playing off a famous remark of Picasso's, Hess epitomized the difference by identifying de Kooning with seeking and Picasso with finding; see Thomas B. Hess, introduction to the exhibition catalogue, *Recent Paintings by Willem de Kooning* (New York, 1962), n.p.

106 See Amei Wallach, 'Jasper Johns at the Top of His Form' [1988], in Kirk Varnedoe, ed., *Jasper Johns: Writings, Sketchbook Notes, Interviews* (New York, 1996), p. 226. Curiously, Irving Sandler hit on the same metaphor when Grace Hartigan observed that de Kooning's large abstraction, *Excavation*, seemed to contain figures: 'If that was so then he had melted them all down'; Sandler, *A Sweeper-Up After Artists: A Memoir*, p. 53.

107 'Pour savoir ce qu'on veut dessiner, il faut commencer à le faire': from conversations of around 1943–46, reviewed for publication in 1960; see Brassaï, *Conversations avec Picasso* (Paris, 1964), p. 80. Picasso expressed a similar view with regard to his sculpture of the 1930s: 'When you work you don't know what is going to come out of it. It is not indecision; the fact is it changes while you are at work'; see Roland Penrose, *Picasso: His Life and Work* (Berkeley, CA, 1981), p. 270.

108 Picasso, quoted in André Verdet, *Entretiens, notes et écrits sur la peinture: Braque, Léger, Matisse, Picasso* (Paris, 1978), p. 199.

109 De Kooning, in Rosenberg, 'Interview with Willem de Kooning', p. 55; in Bibeb, 'Willem de Kooning', p. 3.

110 Brassaï, *Conversations avec Picasso*, p. 80.

111 De Kooning, interview by Emile de Antonio, 1970, in *Painters Painting*, film produced and directed by Emile de Antonio, Turin Film Corp., 1972, Mystic Fire Videotape (New York, 1989).

112 De Kooning, quoted in David L. Shirey, 'Don Quixote in Springs', *Time*, 20 November 1967, p. 80.

113 De Kooning, quoted in Sam Hunter, 'De Kooning: Je dessine les yeux fermés', *Galerie Jardin des Arts*, 152 (November 1975), p. 70.

114 A relatively early drawing of two male figures (*c.* 1938) has the title *Self-portrait with Imaginary Brother*.

115 Elaine de Kooning, 9 September 1988, statement regarding Willem de Kooning's *Attic*, Object Record Sheet, The Metropolitan Museum of Art, New York.

116 De Kooning, statement (16 June 1959) quoted in Irving Sandler, 'Conversations with de Kooning', *Art Journal*, 48 (Fall 1989), p. 217.

117 De Kooning, as paraphrased in Hess, 'De Kooning Paints a Picture', p. 67.

118 John McMahon confirmed that titles for works on newsprint had been derived in this manner, 6 June 1993.

119 A concrete example: the first collector of *Big Gains* interpreted the female figure on the sheet as if it had been designed to fit precisely the connotations of the areas of print left visible, and as if the figure itself had not derived from another surface. The image, supposedly, was violent and 'bloody' by association with the Klan; the newspaper illustration of a handbag must belong to the depicted woman; the position of a listing of births could be associated with the woman's belly, and so on. See John G. Powers, '12 Paintings from the Powers' Collection', *Aspen*, no. 3 (1965–66), n.p.

120 De Kooning, in Rosenberg, 'Interview with Willem de Kooning', p. 57. See also de Kooning, statement in Gaby Rodgers, 'Willem de Kooning: The Artist at 74', *LI: Newsday's Magazine for Long Island*, 21 May 1978, p. 36. When de Kooning did have something on his mind – the death of President Kennedy – the corresponding image acquired no more than a generic title, *Reclining Man* (1963). In this respect, it had 'no message', no public message, because de Kooning left no obvious bits of evidence to be deciphered. On interpreting the circumstances of the production of this work, see Judith Zilczer, 'Identifying Willem de Kooning's *Reclining*

Man', *American Art*, 12 (Summer 1998), pp. 26–35. Susan Brockman, de Kooning's companion at the time, and John McMahon, his studio assistant, independently indicated the nature of this work to Zilczer in interviews of 1993 (pp. 29, 35 n.6).

121 Alfred H. Barr, Jr, 'Gorky, De Kooning, Pollock', *Art News*, 49 (Summer 1950), p. 60.

122 For Egan's exchanges with Barr, see The Museum of Modern Art archive file for *Painting 1948* (acquisition no. 238.48). Barr's travel schedule had made it impossible for him to view the exhibition in Egan's gallery. In a letter to Thomas Hess, 23 May 1961 (Archives of American Art, William C. Seitz Papers), Barr recalls that it was Arb who stirred his interest in de Kooning in 1947. Arb confirms this: 'In 1947 and 1948 I often discussed my ideas about Bill's art with Alfred' (Renée M. Arb, letter to the author, 17 June 2005). Barr had also read a longer version of Arb's laudatory account of de Kooning's work; the shorter, published version is R[enée] A[rb], 'Spotlight On: De Kooning', *Art News*, 47 (April 1948), p. 33.

123 Anonymous [Renée Arb], 'William DeKooning [*sic*]', *Magazine of Art*, 41 (February 1948), p. 54. At times, it seems that de Kooning used the name William, at least during the 1940s, which may explain the confusion of names in some of the early reviews; see Guus Vreeburg, *Two Letters (1946, 1948) by Willem de Kooning to his Father* (Rotterdam, 2004), p. 44 n.21.

124 De Kooning's words and thinking as recalled by Elaine de Kooning (1983–84), recorded by Edvard Lieber; see Edvard Lieber, *Willem de Kooning: Reflections in the Studio* (New York, 2000), pp. 31, 122 n.52. See also Charles F. Stuckey, 'Bill de Kooning and Joe Christmas', *Art in America*, 68 (March 1980), pp. 70–71. Sometimes a painting received its title from a source beyond the inner circle. Elaine de Kooning recalled that *Orestes* had been named by the editors of the magazine *Tiger's Eye* when they reproduced it: 'It was not inappropriate . . . but Bill was in no way thinking about Orestes or Greek mythology with which he is not acquainted'; Elaine de Kooning, interview by Phyllis Tuchman, 27

August 1981, Archives of American Art, Smithsonian Institution. See also Prather, *Willem de Kooning: Paintings*, pp. 96, 103 nn. 25, 26.

125 Conrad Fried, 4 October 1993.

126 Renée M. Arb, letter to the author, 17 June 2005.

127 Arb, 'Spotlight On: De Kooning', p. 33.

128 Clement Greenberg, in Russell W. Davenport, ed., 'A *Life* Round Table on Modern Art', *Life*, 25 (11 October 1948), p. 62.

129 Gijs van Hensbergen, *Guernica: The Biography of a Twentieth-Century Icon* (London, 2004), p. 165.

130 Paul Gauguin, letter to Charles Morice, July 1901, in Maurice Malingue, ed., *Lettres de Gauguin à sa femme et à ses amis* (Paris, 1946), p. 301.

131 Paul Gauguin, *Avant et après* (Taravao, 1989), p. 8. Gauguin dated this manuscript 1903.

132 James Johnson Sweeney, in Davenport, 'A *Life* Round Table on Modern Art', p. 62.

133 Anonymous (David L. Shirey?), 'De Kooning's Year', *Newsweek*, 10 March 1969, p. 93.

134 De Kooning, statement (22 April 1950), 'Artists' Sessions at Studio 35', *Modern Artists in America*, p. 14.

135 De Kooning, in Sylvester, 'De Kooning's Women', p. 52.

136 De Kooning, in Rosenberg, 'Interview with Willem de Kooning', p. 57.

137 According to Edvard Lieber (representing Willem and Elaine de Kooning, letter to Teresa Spillane, 3 February 1988, The Willem de Kooning Foundation, New York), 'neither Mr nor Mrs de Kooning recall an instance when he titled a work *before* painting it.'

138 'For years [de Kooning] has been haunted by an image from William Faulkner's novel "Light in August" . . . "I'd like to paint [the Faulkner character] Joe Christmas one of these days"'; Shirey (incorporating a statement from his conversation with de Kooning), 'Don Quixote in Springs', p. 80.

139 Stuckey, 'Bill de Kooning and Joe Christmas', p. 67. Stuckey does not expect to discover an ultimate, precise reference for every de Kooning title, but does argue that there must be a connection. The problem is that for de Kooning, as with language itself, everything connects

to everything. David Anfam takes a position similar to
Stuckey's, arguing that despite 'debate about the authen-
ticity of de Kooning's titles . . . their thematics are too
consistent for them to be deemed ad hoc or irrelevant';
David Anfam, 'De Kooning, Bosch and Bruegel: Some
Fundamental Themes', *Burlington Magazine*, 145
(October 2003), p. 713 n. 47. But matters of consistency
remain relative to a person's standards for consistency;
de Kooning favoured inconsistency.

140 According to Ashton, de Kooning was a well-known
figure within the New York art scene at least by 1943,
known for the intensity and peculiarity of his studio
practice; Ashton, *The New York School: A Cultural
Reckoning*, p. 166. According to Fried, it was not until
about a decade later, after the notoriety of *Woman 1*,
that de Kooning felt the kind of pressure associated
with being a publicly recognized figure, including the
demand that he explain himself (Conrad Fried, 10
October 1993).

141 Greenberg, in Davenport, 'A *Life* Round Table on
Modern Art', p. 62.

142 Manny Farber, 'Art', *The Nation*, 171 (11 November
1950), p. 445. On the Janis show, see Stevens and
Swan, *De Kooning: An American Master*, p. 317.

143 The detractors are a diverse group. See, for example,
Hilton Kramer, 'De Kooning's Pompier Expression-
ism', *The New York Times*, 19 November 1967, D31:
'the triumph of rhetoric over syntax . . . forcing upon
sheer painterliness functions it is helpless to discharge.'
Or Donald Judd, 'Abstract Expressionism' [1983],
in *Complete Writings 1975–1986* (Eindhoven, 1987),
p. 40: 'basically old-fashioned expressionism enlarged
and enlivened . . . the old picture of nature distorted
by the artists' feelings.' Or T. J. Clark, *Farewell to an
Idea: Episodes from a History of Modernism* (New Haven,
CT, 1999), p. 393: 'male braggadocio', misplaced in
the Woman paintings (undermined by the charge of
misogyny), better projected via 'cliché landscape or
townscape formats' (*Merritt Parkway*).

144 For a view of the exhibition Farber was reviewing,
including de Kooning's *Woman*, see Prather, *Willem*

de Kooning: Paintings, p. 98, fig. 5.

145 De Kooning's words as reported by Garner Tullis, 28
May 1993.

146 Farber, 'Art', pp. 445–6.

147 De Kooning, in Sylvester, 'De Kooning's Women',
p. 52.

148 De Kooning's words as recalled by Elaine de Kooning,
quoted in Janis and Blesh, *De Kooning*, p. 17.

149 Farber, 'Art', p. 445.

150 Gus Falk, de Kooning's student during summer 1948
at Black Mountain College, interview by Mark Stevens
and Annalyn Swan, 28 July 1992; see Stevens and
Swan, *De Kooning: An American Master*, p. 294.

151 Sandler, *A Sweeper-Up After Artists: A Memoir*, p. 53.

152 Farber, 'Art', p. 445.

153 Hess, *Willem de Kooning* (1968), pp. 15–16.

154 Farber, 'Art', p. 445.

155 Stephanie Hanor describes Farber's work of around
1950: 'Thinner, stainlike paint application brings actual
texture of support and material into finished product;
abstract content suggests ribbons, flags, or targets';
Stephanie Hanor, ed., *Manny Farber: About Face*
(San Diego, CA, 2003), p. 52.

156 David Sylvester, 'The Venice Biennale', *The Nation*, 171
(9 September 1950), p. 233. See also David Sylvester,
'Mr. Sylvester Replies', *The Nation*, 171 (25 November
1950), p. 492. 'Utterly obtuse': David Sylvester,
'Curriculum Vitae', *About Modern Art: Critical Essays
1948-96* (London, 1996), p. 20.

157 Anonymous, introduction to David Sylvester, 'De Koon-
ing's Women', *The Sunday Times Magazine* (London),
6 December 1968, p. 44.

158 Andy Warhol, statement in 'What Is Pop Art? Interviews
by G. R. Swenson – Part 1', *Art News*, 62 (November
1963), p. 26.

159 Greenberg, 'The European View of American Art'
[1950], *Collected Essays and Criticism*, III, p. 62.

160 Farber, 'Art', p. 445.

161 Arb, 'Spotlight On: De Kooning', p. 33.

162 Newman 'likes to shock other artists': T[homas] B.
H[ess], 'Barnett Newman', *Art News*, 49 (March 1950),

p. 48. Hess intended this remark as irony not praise, though he would soon become one of Newman's supporters.

163 Hess, *Willem de Kooning* (1968), p. 15.

164 On de Kooning's familiarity with Kierkegaard, see Pat Passlof, '1948', *Art Journal*, 48 (Fall 1989), p. 229. During the 1940s, de Kooning's friend Rosenberg often referred to Kierkegaard; for example, Harold Rosenberg, 'Notes on Identity: With Special Reference to the Mixed Philosopher, Søren Kierkegaard', *View*, 6 (May 1946), pp. 7–8. For the intellectual context, see also Norbert Guterman, 'Neither-Nor', *Partisan Review*, 10 (March–April 1943), pp. 134–42. The introduction of 1953 to a new paperback edition of *Fear and Trembling* and *The Sickness unto Death* referred to these two texts as 'in greater demand than any other works of Kierkegaard'; Walter Lowrie, 'Translator's Note', in Søren Kierkegaard, *Fear and Trembling and The Sickness Unto Death* (Garden City, NY, 1954), p. 5. Kierkegaard was one of four philosophical thinkers featured in William Barrett, *Irrational Man: A Study in Existential Philosophy* (New York, 1958). Barrett participated in discussions with the New York School artists. See also above, 'Array'.

165 On the tension between Janis and de Kooning over this matter, see Hess, *Willem de Kooning* (1968), p. 74; Stevens and Swan, *De Kooning: An American Master*, pp. 337, 662; Hall, *Elaine and Bill: Portrait of a Marriage*, p. 216.

166 Anonymous, 'Big City Dames', *Time*, 6 April 1953, p. 80.

167 For the first quotation, see Hess, *Willem de Kooning* (1968), p. 47; for the second quotation, see de Kooning, 'What Abstract Art Means to Me', p. 5. In 1969, Charlotte Willard attributed to de Kooning a variant of the first statement, 'Every abstraction has its likeness', although her interview notes do not contain it: see Charlotte Willard, 'De Kooning', *Look*, 27 May 1969, p. 56; Charlotte Willard Papers, Archives of American Art, Smithsonian Institution, Washington, DC (courtesy Anne Collins Goodyear).

168 De Kooning, 'What Abstract Art Means to Me', p. 6 (emphasis added). De Kooning was hardly alone in resisting a more rigid, oppositional definition of abstraction, as this statement by a contemporary, the art historian George Heard Hamilton, indicates: 'The underlying tendency today is to think in terms of abstractions, which may or may not find expression in a naturalistic technique'; Hamilton, in Robert Goldwater, ed., 'A Symposium: The State of American Art', *Magazine of Art*, 42 (March 1949), p. 93.

169 De Kooning, statement in Aline B. Louchheim, 'Six Abstractionists Defend Their Art', *The New York Times Magazine*, 21 January 1951, p. 17.

170 Herman Cherry, quoted by Charlotte Willard, interview notes for an article published in *Look* in 1969, Charlotte Willard Papers, Archives of American Art, Smithsonian Institution, Washington, DC (courtesy Anne Collins Goodyear).

171 Sandler, *A Sweeper-Up After Artists: A Memoir*, p. 53.

172 Janis and Blesh, *De Kooning*, plates 27–32, following p. 32. Ashton would have disputed the Janis and Blesh caption, with its implication of a passage from biomorphic to geometric: 'The abstracting intelligence here is always *bio* and not *geo*'; Dore Ashton, 'Willem de Kooning: Homo Faber', *Arts Magazine*, 50 (January 1976), p. 60 (original emphasis).

173 Hess, 'De Kooning Paints a Picture', p. 66.

174 Hess, *Willem de Kooning: Drawings*, p. 30.

175 De Kooning, 'What Abstract Art Means to Me', p. 6.

176 Barr, 'Gorky, De Kooning, Pollock', pp. 23, 60.

177 Barr, 'Gorky, De Kooning, Pollock', pp. 23, 60.

178 De Kooning, in Louchheim, 'Six Abstractionists Defend Their Art', p. 17.

179 Erle Loran, *Cézanne's Composition: Analysis of His Form with Diagrams and Photographs of His Motifs* [1943] (Berkeley, CA, 2006), p. 7.

180 See Paul Cézanne, letter to his son Paul, 8 September 1906, in John Rewald, ed., *Paul Cézanne, correspondance* (Paris, 1978), p. 324.

181 Cézanne's words as recalled, not necessarily verbatim, by Joachim Gasquet, *Cézanne* [1921] (Paris, 1926), p. 132.

182 The anecdote is Harold Rosenberg's, as reported in Hess, *Willem de Kooning* (1959), p. 15. De Kooning lectured on Cézanne while teaching at Black Mountain College during summer 1948; see Passlof, '1948', p. 229.

183 Paul Gauguin, letter to Emile Schuffenecker, 14 August 1888, in Victor Merlhès, ed., *Correspondance de Paul Gauguin, 1873–1888* (Paris, 1984), p. 210.

184 Greenberg, 'The European View of American Art' [1950], *Collected Essays and Criticism*, III, p. 62.

185 Greenberg, '"American-Type" Painting' [1955], *Collected Essays and Criticism*, III, p. 222; Clement Greenberg, '"American-Type" Painting' (1958), *Art and Culture* (Boston, MA, 1961), pp. 213–14.

186 Ben Heller, 'Introduction', *Toward a New Abstraction* (New York, 1963), p. 7.

187 Loran, *Cézanne's Composition*, p. 7.

188 De Kooning, in Rosenberg, 'Interview with Willem de Kooning', p. 55. The sources for de Kooning's sense of Cézanne may be variants of two statements attributed to him by admiring young writers: 'The artist doesn't directly perceive [by intellect] all the relationships; he feels them': Léo Larguier, *Le dimanche avec Paul Cézanne* (Paris, 1925), p. 137; 'Each brushstroke should correspond, here, on my canvas, to a [single] breath of the world, to its spark of illumination, there, on [my model]. We must live in harmonious union – my model, my paints, and me – articulating the very moment that passes' (Gasquet, *Cézanne*, p. 195). A related interpretation of Cézanne appeared in Maurice Merleau-Ponty, 'Cézanne's Doubt' [1945], *Sense and Non-Sense*, trans. Hubert L. Dreyfus and Patricia Allen Dreyfus (Evanston, IL, 1964), pp. 14–15.

189 On de Kooning and Picasso, see Burckhardt, 'Long Ago with Willem de Kooning', p. 222; David Sylvester, 'Flesh Was the Reason', in Prather, *Willem de Kooning: Paintings*, pp. 17–19. In the transcript of de Kooning's interview (The Willem de Kooning Foundation, New York), Rosenberg mentions the writings of Cubist theorists Albert Gleizes and Jean Metzinger, a reference omitted from the published version.

190 De Kooning, 'What Abstract Art Means to Me', p. 7.

191 Greenberg, 'A Critical Exchange with Fairfield Porter on "American-Type" Painting' [1955], *The Collected Essays and Criticism*, III, p. 240.

192 Gruen, *The Party's Over Now*, p. 181.

193 See de Kooning's remarks as quoted in Jeffrey Potter, *To a Violent Grave: An Oral Biography of Jackson Pollock* (New York, 1985), p. 183.

194 Greenberg, 'How Art Writing Earns Its Bad Name' [1962], *Collected Essays and Criticism*, IV, p. 136.

195 Greenberg, 'After Abstract Expressionism' [1962], *Collected Essays and Criticism*, IV, pp. 124, 128 (order of phrases altered).

196 De Kooning, in Rosenberg, 'Interview with Willem de Kooning', p. 55. On interpreting de Kooning's opposition to cubism and abstract art as a conflict between his eclecticism (like a stew) and their essentialism (like a bouillon cube), see Jean-Claude Lebensztejn, 'Brouillon Kubique', *Les cahiers du Musée national d'art moderne*, 61 (Autumn 1997), pp. 5–19.

197 A youthful work by de Kooning suggests remote formal links to Cézanne, but is exceptional; see Judith Zilczer, *Willem de Kooning from the Hirshhorn Museum Collection* (Washington, DC, 1993), p. 13, fig. 1.

198 De Kooning, quoted in Anonymous, 'Prisoner of the Seraglio', p. 74. Quoted also by Willard, 'De Kooning', p. 54. Among the New York critics, Ashton obviously sympathized with the Rosenberg–de Kooning line: 'With his forms, de Kooning is *feeling* his way *into* spaces, and not making models'; Ashton, 'Willem de Kooning: Homo Faber', p. 60 (original emphasis).

199 De Kooning, 'A Desperate View', in Hess, *Willem de Kooning* (1968), p. 15.

200 See Rosenberg's statement in Rosenberg, 'Interview with Willem de Kooning', p. 55. Rosenberg and de Kooning referred the 'Don't think, look!' notion to Wittgenstein.

201 De Kooning, in Bibeb, 'Willem de Kooning', p. 3; de Kooning, quoted in Anonymous, 'Willem the Walloper', p. 63. See also Hess, 'De Kooning Paints a Picture', p. 31: 'He needs such doubt to keep off-balance.'

202 De Kooning, in Rosenberg, 'Interview with Willem de Kooning', p. 55 (order of phrases altered for clarity).

203 In a succession of writings on de Kooning, Hess stressed ambiguity and multiplicity as his interpretive theme, apparently influenced by a similar focus in the literary analysis of the New Critics of the 1930s, '40s and '50s, such as Cleanth Brooks, William Wimsatt, R. P. Blackmur (cited directly by Hess) and William Empson (author of the famous *Seven Types of Ambiguity*, 1930). See Thomas B. Hess, *Abstract Painting: Background and American Phase* (New York, 1951), pp. 103–4 ('shapes become ambiguously interpretable . . . this continual outpouring of ambiguity'); 'De Kooning Paints a Picture', p. 32 ('the painter makes ambiguity into actuality'). Ambiguity is the dominant interpretive theme within Hess's monographic study, *Willem de Kooning* (1959), pp. 7–31. According to Conrad Fried, *doubt* was the term de Kooning used for the concept, in preference to *ambiguity*, a more complicated word (Conrad Fried, 10 Octorber 1993). Greenberg also presented ambiguity as a factor of significance in interpreting de Kooning's art ('Review of an Exhibition of Willem de Kooning' [1948], *Collected Essays and Criticism*, II, p. 229). I discuss de Kooning's patterns of thought in greater detail below; see 'Transition' and the sections following it.

204 Merleau-Ponty, 'Cézanne's Doubt', p. 9. The earlier translation, which is abridged, is by Juliet Bigney, *Partisan Review*, 13 (1946), pp. 464–78.

205 Cézanne, letter to Émile Bernard, 21 September 1906, in Rewald, *Paul Cézanne, correspondance*, pp. 326–7. Like de Kooning, Cézanne had a great sense of irony. Possibly, his reference to 'slow progress' expresses a false modesty. In this instance, however, he would seem sincere, given his rapidly failing health and awareness that many aspects of his cumulative artistic project remained incomplete. In his summary account a year later, Bernard attributed the unsatisfying state of Cézanne's art to the painter's own doubt: 'If he had acted without so many doubts over what could be better . . . he would have given us magisterial works. . . . [He believed] that what he had done up to the present was only the beginning of what he would produce, if he were to live many years more'; Émile Bernard, 'Souvenirs sur Paul Cézanne et letters inédites', *Mercure de France*, 69 (1 October 1907), pp. 395, 399.

206 See Elaine de Kooning, 'De Kooning Memories' [1983], *The Spirit of Abstract Expressionism: Selected Writings*, p. 214.

207 De Kooning, in Bibeb, 'Willem de Kooning', p. 3.

208 Compare Hess, 'De Kooning Paints a Picture', p. 31: 'He needs such doubt to keep off-balance.' See also Tom Ferrara, 'One Giant Leap', in Kara Vander Weg, ed., *Willem de Kooning: A Centennial Exhibition* (New York, 2004), pp. 129–30.

209 Edmond Jaloux, *Les saisons littéraires*, 2 vols (Fribourg, 1942), I, p. 75.

210 De Kooning was born in 1904, Merleau-Ponty in 1908.

211 Maurice Merleau-Ponty, 'Eye and Mind' [1961], in *The Primacy of Perception and Other Essays*, ed. James M. Edie, trans. Carleton Dallery (Evanston, IL, 1964), p. 185.

212 Merleau-Ponty, 'Cézanne's Doubt', p. 20.

213 Françoise Gilot and Carlton Lake, *Life with Picasso* (New York, 1964), pp. 124–5.

214 See Hess, *Willem de Kooning* (1959), pp. 21–2.

215 Compare Rudy Burckhardt's account of de Kooning's early practice; see Zilczer, 'De Kooning and Urban Expressionism', *Willem de Kooning from the Hirshhorn Museum Collection*, p. 21.

216 De Kooning's words, in indirect quotation by Edwin Denby, 'Notes on Nijinsky Photographs', in Paul Magriel, ed., *Nijinsky: An Illustrated Monograph* (London, 1948), p. 17. I thank 'S Again' for alerting me to this text.

217 Merleau-Ponty, 'Eye and Mind', *The Primacy of Perception*, p. 185.

218 Ashton, 'Willem de Kooning: Homo Faber', p. 59 (original emphasis).

219 Modified scrapers: John McMahon, letter to the author, 11 March 1997.

220 Ashton, 'Willem de Kooning: Homo Faber', p. 58.

221 I tend to think that each de Kooning form is specific,

belonging to his momentary experience of a specific body, even when he uses very similar forms repeatedly. It may nevertheless be the case that he sometimes had generic types in mind. When I asked Lisa de Kooning (24 April 2004) about the drawing of a male figure with eyeglasses, which to me seemed quite individualized, she replied that it represented no particular person; she believed instead that her father had intended it as an American type, perhaps a businessman going to work.

222 De Kooning, interview by Emile de Antonio, 1970, in *Painters Painting*, film.

223 De Kooning, in Rosenberg, p. 55. The unedited transcript is rougher and perhaps truer to de Kooning's enthused speech: 'If I ever saw any minimalism, there it was. It doesn't say nothing!' Bernini's art had impressed de Kooning on his visit to Rome in 1969.

224 Burckhardt, 'Long Ago with Willem de Kooning', p. 223.

225 Hess, *Willem de Kooning* (1968), p. 102.

226 De Kooning, in Rosenberg, 'Interview with Willem de Kooning', p. 55.

227 Willem de Kooning, audiotaped statement, interview by Michael C. Sonnabend and Kenneth Snelson, summer 1959, typescript, The Willem de Kooning Foundation, New York.

228 John Ashbery, 'Willem de Kooning: A Suite of New Lithographs Translates His Famous Brushstroke into Black and White', *ARTnews Annual*, 37 (1971), p. 119.

229 De Kooning, as paraphrased in Hess, 'De Kooning Paints a Picture', p. 67.

230 'If I make a big painting I want it to be intimate . . . To make a big painting look small is . . . very difficult': de Kooning, in Rosenberg, 'Interview with Willem de Kooning', p. 56. On preferring things small, see also de Kooning, letters to Joseph and Olga Hirshhorn, 13 May 1965 and undated [January 1969?], in Zilczer, *Willem de Kooning from the Hirshhorn Museum Collection*, pp. 159, 167.

231 Joan Ward, 25 September 1993; see also Hess, *Willem de Kooning* (1959), p. 27.

232 See Zilczer, *Willem de Kooning from the Hirshhorn Museum Collection*, p. 182 n.76; Prather, *Willem de Kooning: Paintings*, p. 101. What Finkelstein observed in *Excavation* reminded him of Picasso's *Three Dancers* of 1925.

233 Louis Finkelstein, 'Marin and DeKooning [*sic*]', *Magazine of Art*, 43 (October 1950), p. 205.

234 Willem de Kooning, 'The Renaissance and Order', pp. 86–7.

235 De Kooning, 'The Renaissance and Order', p. 86.

236 De Kooning, 'What Abstract Art Means to Me', pp. 4–6.

237 De Kooning, statement (23 April 1950), 'Artists' Sessions at Studio 35', *Modern Artists in America*, p. 20.

238 On the exchange between Greenberg and de Kooning, see Thomas B. Hess, *De Kooning: Recent Paintings* (New York, 1967), p. 40; Hess, *Willem de Kooning* (1968), p. 74; Clement Greenberg, interview by Ann Hindry, December 1983, in Claire Stoullig, ed., *Willem de Kooning* (Paris, 1984), p. 232. Ironically, Greenberg often stated his preference for representational figure painting as opposed to abstraction; see, for example, his statement in a late interview, distinguishing historical exigencies from personal taste: 'I can't choose what to like and not like. My prejudice is towards realistic [representational] art . . . but I'm forced, compelled to like abstract art most in this time'; 'Clement Greenberg with Peter Fuller', ed. Linda Saunders, *Modern Painters*, 4 (Winter 1991), p. 20. Even at a relatively early moment, when he was especially enthusiastic about developments in American abstract art, he lamented the absence of explicit representation: 'I think it is one of the *tragedies* of our time that great painting has to do without a "recognizable" subject matter'; Greenberg, 'A *Life* Round Table on Modern Art', p. 78 (italics in original).

239 De Kooning becomes quite insistent on this matter in a discussion with Rosenberg and Hess in 1964, using 'I don't paint goldfish . . . You have to paint the goldfish' as his example of the absurdity of adhering to a negative principle: De Kooning, conversation between Harold Rosenberg, Thomas Hess, and Willem de Kooning, taped by Betty Wolff, 2 March 1964, Thomas B. Hess papers, Archives of American Art.

240 De Kooning, 'What Abstract Art Means to Me', p. 8.

241 Erle Loran, recalling his conversation with de Kooning, interview by Herschel Chipp, 18 June 1981, Erle Loran papers, Archives of American Art, Smithsonian Institution.

242 See Katherine Kuh, 'The Story of a Picture', *Saturday Review*, 29 March 1969, p. 38. In preparation for her article, Kuh questioned de Kooning concerning his memory of working on *Excavation*, and the published information is her paraphrase of what he told her. The black-and-white film *Bitter Rice* (in Italian, *Riso amaro*), directed by Giuseppe de Santis, was released in 1949. It played in American theatres not long after release.

243 Anfam, 'De Kooning, Bosch and Bruegel: Some Fundamental Themes', p. 714. For Elaine de Kooning's recollection, see Lieber, *Willem de Kooning: Reflections in the Studio*, p. 34.

244 De Kooning, in Rosenberg, 'Interview with Willem de Kooning', p. 54.

245 Celia Marriott, noting de Kooning's allusion to *Bitter Rice*, suggested that *Excavation* could be regarded as an anticipation of the *Woman* paintings of the 1950s; Celia Marriott, 'Iconography in de Kooning's *Excavation*', *Bulletin of the Art Institute of Chicago*, 69 (January–February 1975), p. 16.

246 De Kooning, in Rosenberg, 'Interview with Willem de Kooning', p. 57.

247 See Hess, 'De Kooning Paints a Picture', p. 32, fig. 4; see also various passages of *Bitter Rice*, in which hats are prominent visual elements.

248 *Idea* is the term within Kuh's paraphrase of de Kooning's statement to her (Kuh, 'The Story of a Picture', p. 38); she did not set it within quotation marks, and I do not know whether, or how, de Kooning used *idea* in this context. He often said that artists lacked bright ideas (see below, 'Ideas').

249 T. W. Adorno, *Quarterly of Film, Radio and Television*, 8 (Spring 1954), pp. 229–30.

250 De Kooning, quoted in Hess, 'De Kooning's New Women', 65. Here, de Kooning was referring to his practice around 1964–5. It was typical of him to associate specific colours with actual objects and substances.

251 Peirce, 'The Architecture of Theories', *Collected Papers*, VI, p. 19.

252 De Kooning, quoted in Ferrara, 'One Giant Leap', p. 130.

253 See the account in Hess, 'De Kooning Paints a Picture', pp. 30–33, 64. See also Hess's correction concerning the timing, as indicated to Sally Yard (5 December 1977); Sally Yard, *Willem de Kooning Works, Writings and Interviews* (Barcelona, 2007), p. 55 n.93.

254 De Kooning, quoted in George Dickerson, 'Willem de Kooning', unedited manuscript dated 3 September 1964, Thomas B. Hess papers, Archives of American Art, p. 13 (italics in original). Whether because of Dickerson, Dickerson's editor, or de Kooning himself (unlikely), these words were eliminated from Dickerson's published article, 'The Strange Eye and Art of de Kooning', *Saturday Evening Post*, 21 November 1964, pp. 68–71.

255 See Hess, 'De Kooning Paints a Picture', p. 66; Hess, *De Kooning: Recent Paintings*, p. 20.

256 De Kooning, quoted in George Dickerson, 'Willem de Kooning', unedited manuscript dated 3 September 1964, Thomas B. Hess papers, Archives of American Art, pp. 15–16. This statement did not appear in Dickerson's published article.

257 De Kooning [1953], quoted in Hess, *Willem de Kooning* (1968), p. 100.

258 Arb, statement to the author, 17 June 2005. From the late 1970s until his death in 1994, I often conversed with Greenberg; I too had the impression that de Kooning's personality was one that Greenberg found unappealing (but there were many others equally unappealing).

259 Greenberg, 'Review of an Exhibition of Willem de Kooning' [1948], *Collected Essays and Criticism*, II, p. 229. See also Elaine de Kooning, 'On the Work of Willem de Kooning', *The Spirit of Abstract Expressionism: Selected Writings*, p. 228.

260 Greenberg, 'Henri Rousseau and Modern Art' [1946], *Collected Essays and Criticism*, II, pp. 93–5.

261 See, for example, C[larence] J. Bulliet, *Apples and*

Madonnas: Emotional Expression in Modern Art (Chicago, 1927).

262 Roger Fry, *Cézanne: A Study of His Development* [1927] (Chicago, 1989).

263 Greenberg, 'A Critical Exchange with Fairfield Porter on '"American-Type' Painting"', *Collected Essays and Criticism*, III, p. 240 (italics in original).

264 Greenberg, 'Review of an Exhibition of Willem de Kooning', *Collected Essays and Criticism*, II, pp. 228–9.

265 Greenberg, 'Foreward to an Exhibition of Willem de Kooning' [1953], *Collected Essays and Criticism*, III, p. 122.

266 Greenberg, '"American-Type" Painting' [1955], *Collected Essays and Criticism*, III, p. 222.

267 See Harold Rosenberg, 'Masculinity: Real and Put On', *Vogue*, November 1967, pp. 106–7, 159.

268 De Kooning, in Rosenberg, 'Interview with Willem de Kooning', p. 57.

269 De Kooning, in Hunter, 'De Kooning: Je dessine les yeux fermés', p. 70. On de Kooning's 'enjoyment of women', see Rose C. S. Slivka, 'Willem de Kooning', *Art Journal*, 48 (Fall 1989), p. 220.

270 Anonymous, 'Prisoner of the Seraglio', p. 74.

271 Brett Bourbon, 'Can I Drive My Car from Its Form to Its Movement?' *Common Knowledge*, 16 (Fall 2010), p. 412 (original emphasis).

272 Ludwig Wittgenstein, *Zettel*, eds G.E.M. Anscombe and G. H. von Wright, trans. G.E.M. Anscombe (Berkeley, CA, 1970), p. 71 (translation modified by the author).

273 Winthrop Sergeant, 'Fifty Years of American Women', *Life*, 28 (2 January 1950), pp. 64–7. De Kooning's allusion to this issue of *Life* concerned a reference to the importance of Marcel Duchamp in the magazine's account of the Armory Show; see de Kooning, 'The Renaissance and Order', p. 86. Hess referred to this issue of *Life* as 'being discussed at the time', noting that de Kooning's mention of Duchamp did not reflect a personal preference; Hess, *De Kooning: Recent Paintings*, p. 40.

274 On the 'woman problem' and *Woman I*, see Cornelia

H. Butler, 'The Woman Problem: On the Contemporaneity of de Kooning's Women', in Cornelia H. Butler and Paul Schimmel, eds, *Willem de Kooning: Tracing the Figure* (Los Angeles, 2002), pp. 181–91.

275 De Kooning, quoted in Selden Rodman, *Conversations with Artists* (New York, 1961), p. 102 (original emphasis). De Kooning's statement may have been paraphrased rather than quoted directly; it resembles a number of similar statements he made on various occasions.

276 John McMahon, 25 February 1994, 8 March 2001.

277 Hess, 'De Kooning Paints a Picture', p. 66; Elaine de Kooning, statement to George Dickerson [1964], in Dickerson, 'Willem de Kooning', pp. 13–14.

278 Ashton, 'Willem de Kooning: Homo Faber', p. 61.

279 James Fitzsimmons, 'Art', *Arts and Architecture*, 70 (May 1953), p. 8.

280 Grace Hartigan, statement in Cindy Nemser, *Art Talk: Conversations with 12 Women Artists* (New York, 1975), pp. 158–9. Elaine de Kooning said the same: '[The Woman paintings] do have a certain ferocity, but that has to do with paint' (Elaine de Kooning, recorded in the film *De Kooning on de Kooning*, directed by Charlotte Zwerin, produced by Courtney Sale, Direct Cinema, New York, 1981).

281 James Fitzsimmons, 'Art', *Arts and Architecture*, 71 (February 1954), p. 4. In an editorial capacity in 1967, Fitzsimmons proposed to commission from Harold Rosenberg a comprehensive account of de Kooning's art, evidence of Fitzsimmons's longstanding interest (letter from Fitzsimmons to Rosenberg, 1 January 1967, 'Harold Rosenberg Papers, 1923–1984', Getty Research Institute, Research Library, Special Collections, Los Angeles).

282 James Fitzsimmons, 'On the "peintures sauvages" of Joan Miró', *Miró: 'peintures sauvages' 1934 to 1953* (New York, 1958), n.p.

283 Sidney Geist, 'Work in Progress', *Art Digest*, 27 (1 April 1953), p. 15.

284 Fitzsimmons, 'Art' [May 1953], pp. 4, 6 (italics in original; sentence order altered). On a number of similar statements of the period, see Marcia Brennan,

Modernism's Masculine Subjects: Matisse, the New York School, and Post-Painterly Abstraction (Cambridge, MA, 2004), pp. 46–75. On de Kooning's art and infantilism, see also Richard Wollheim, *Painting as an Art* (Princeton, NJ, 1987), pp. 348–50. As a more recent stage in the interpretive sexualization of de Kooning's Woman imagery, see Carol Duncan, 'The MOMA's Hot Mamas', *Art Journal*, 48 (Summer 1989), pp. 171–8.

285 'There is also a refusal to work with ideas that are too clear . . . de Kooning has it in him to attain to a more clarified art': Greenberg, 'Review of an Exhibition of Willem de Kooning', *Collected Essays and Criticism*, II, pp. 229–30.

286 Fitzsimmons, 'Art' [May 1953], pp. 4, 6.

287 Greenberg, 'After Abstract Expressionism' [1962], *Collected Essays and Criticism*, IV, p. 124. This statement originally appeared in *Art International* (6 [25 October 1962], 25), for which Fitzsimmons served as editor. Despite his 'I am not a formalist', he and Greenberg were on excellent terms; see Greenberg's memorial statement in Michael Peppiatt, ed., 'A Tribute to James Fitzsimmons, Editor and Publisher (1919–1985)', *Art International* (Winter 1988), pp. 42–3.

288 De Kooning, quoted in Anonymous, 'Willem the Walloper', p. 63.

289 See, for example, Alfred H. Barr, Jr, *Cubism and Abstract Art* [1936] (Cambridge, MA, 1986), p. 11; 'Introduction', *The New American Painting* (New York, 1959), p. 17. See also, Thomas B. Hess, *Abstract Painting: Background and American Phase* (New York, 1951), p. 27.

290 'In our everyday life we experience not solid and immediate facts but stereotypes of meaning . . . To quite small circles the appeal of modern art – notably painting and sculpture, but also of the crafts – lies in the fact that in an impersonal, a scheduled, a machined world, they represent the personal and the spontaneous. They are the opposite of the stereotyped and the banalized': C. Wright Mills, 'The Man in the Middle', *Industrial Design*, 5 (November 1958), pp. 70, 75.

291 Meyer Schapiro, 'The Liberating Quality of Avant-Garde Art', *Art News*, 56 (Summer 1957), pp. 36–42.

On Schapiro's connection to *Woman 1*, see Hess, 'De Kooning Paints a Picture', p. 30.

292 Greenberg, 'Henri Rousseau and Modern Art', *Collected Essays and Criticism*, II, pp. 93–5. On Greenberg's argument, see Shiff, 'Breath of Modernism (Metonymic Drift)', pp. 184–213; Richard Shiff, 'Homeopathic Criticism', *Common Knowledge*, 7 (Winter 1998), pp. 4–13.

293 Dore Ashton, 'Willem de Kooning', in Charles Chetham, ed., *Willem de Kooning* (Northampton, MA, 1965), n.p.

294 Hess, 'De Kooning's New Women', p. 37.

295 Alfred H. Barr, Jr, *Cubism and Abstract Art* [1936] (Cambridge, MA, 1986), p. 11.

296 Alfred H. Barr, Jr, 'Introduction', *The New American Painting*, p. 17.

297 Hess, *Abstract Painting: Background and American Phase*, p. 27.

298 Sam Hunter, 'By Groups and Singly', *The New York Times*, 25 April 1948, section X, p. 11.

299 De Kooning, statement (22 April 1950), 'Artists' Sessions at Studio 35', *Modern Artists in America*, pp. 12–13.

300 Compare Hess, 'De Kooning Paints a Picture', p. 65.

301 See Elaine de Kooning, 'Edwin Denby Remembered – Part 1', *Ballet Review*, 12 (Spring 1984), p. 30.

302 De Kooning's method of commercial illustration is described below ('Virtuoso'). For examples of his commercial work, see *Harper's Bazaar*, 1 March 1940, p. 81; *Life*, 1 February 1943, p. 97; *Life*, 1 March 1943, p. 59.

303 'By noon [of opening day], 19 of the show's 22 oils were sold . . . At week's end a new de Kooning was not to be had': Anonymous, 'Big Splash', p. 72.

304 Hess, *Willem de Kooning* (1959), p. 31. When Ad Reinhardt drew a cartoon of the art world viewed as a horse race, he named Hess as de Kooning's jockey; Pollock had two jockeys, Clement Greenberg and James Johnson Sweeney: Ad Reinhardt, 'Museum Racing Form', *trans/formation*, 1/2 (1951), p. 89.

305 Helen Frankenthaler, in Irving Sandler, ed., 'Is There a New Academy? (Part 1)', *Art News*, 58 (Summer 1959), p. 34.

306 See Greenberg, 'After Abstract Expressionism' [1962], *Collected Essays and Criticism*, IV, pp. 121–34.

307 Barnett Newman, in Dorothy Gees Seckler, 'Frontiers of Space', *Art in America*, 50 (Summer 1962), p. 86. In a letter to Jean Lipman, editor of *Art in America*, 9 July 1962 (The Barnett Newman Foundation, New York), Newman confirmed that it was his intent 'not to discuss any names' directly.

308 Newman, in Seckler, 'Frontiers of Space', p. 83.

309 De Kooning, quoted in Anonymous, 'Big Splash', p. 72.

310 De Kooning, audiotaped statement, interview by Michael C. Sonnabend and Kenneth Snelson, summer 1959, typescript, The Willem de Kooning Foundation, New York. De Kooning's comments from this and another taped interview from summer 1959 became the audio for Robert Snyder's two films, *Sketchbook No. 1*, 1960, and *A Glimpse of de Kooning*, 1968.

311 James Fitzsimmons, 'Art Exhibition at Sidney Janis Gallery', *Arts and Architecture*, 70 (May 1953), p. 7.

312 Arb, 'Spotlight On: De Kooning', p. 33.

313 John McMahon, 25 June 1993.

314 Conrad Fried, letter to the author, 5 September 1993. Painter Connie Fox, longtime friend of Elaine de Kooning, 3 September 1993, also remembered de Kooning's special brushes.

315 On de Kooning's early experience with liners or stripers, see Judith Lynn Wolfe, *The Young Willem de Kooning: Early Life, Training and Work, 1904–1926* (Ann Arbor, MI, 1996), p. 117.

316 Hess, *Willem de Kooning Drawings*, p. 13. See also Susan Lake and Judith Zilczer, 'Painter and Draftsman', in Zilczer, *Willem de Kooning from the Hirshhorn Museum Collection*, pp. 172–9. According to Conrad Fried, 10 October 1993, de Kooning usually avoided using white enamel because he knew it would eventually yellow.

317 Hess, *Abstract Painting: Background and American Phase*, p. 100.

318 Concerning his perfectionism: it was de Kooning's custom to rework paintings even when they were admired by others; during the 1930s and '40s 'he kept destroying beautiful paintings'; see Elaine de Kooning, 'Edwin Denby Remembered – Part 1', p. 30.

319 Conrad Fried, 5 September 1993, remembered witnessing such procedure and recounted these details.

320 Hess, 'De Kooning Paints a Picture', p. 65. See also Hess, *Abstract Painting: Background and American Phase*, p. 107.

321 De Kooning's recollection, as reported by Ferrara, 'One Giant Leap', p. 130.

322 Hess, *Willem de Kooning* (1959), p. 117.

323 Hess, 'De Kooning's New Women', p. 65.

324 De Kooning's words, as recalled by Ferrara, 'One Giant Leap', p. 130.

325 Ferrara, 'One Giant Leap', p. 130.

326 De Kooning [1969], quoted in Gruen, *The Party's Over Now*, p. 224.

327 John McMahon, 8 March 2001.

328 Words of Henri Matisse, as recorded in 'Sarah Stein's Notes' [1908], in Jack Flam, ed., *Matisse on Art* (Berkeley, CA, 1995), p. 50 (emphasis added).

329 Richard Serra, statement in *Richard Serra: Line Drawings* (New York, 2002), p. 7. See also James Lawrence, 'Convertible Facts: Richard Serra's *Rounds, Out-of-Rounds*, and *Solids*', in Eckhard Schneider, ed., *Richard Serra Drawings: Work Comes Out of Work* (Bregenz, 2008), pp. 32–41.

330 Hess, 'De Kooning Paints a Picture', p. 65.

331 De Kooning, quoted in Paul Hellmann, 'De verloren zoon zit goed', *Algemeen Dagblad* (Rotterdam), 24 December 1976, p. 25 (translation courtesy Mette Gieskes).

332 De Kooning, statement in *De Kooning Drawings* (New York, 1967), n.p. The first ellipsis within the quotation is original, implying that an anonymous editor shortened a longer statement. A photograph by Hans Namuth, July 1963, shows the artist drawing with closed eyes, maintaining his orientation, as Judith Wolfe noted, 'with one finger held to the center of the paper'; see Judith Wolfe, 'Glimpses of a Master', *Willem de Kooning: Works from 1951–1981* (East Hampton, NY, 1981), p. 14.

333 De Kooning, in Willard, 'De Kooning', p. 58.

334 The difference in the pace of life in Manhattan and Springs, city and country, became a common motif

in the criticism of de Kooning's work of the 1960s; see, for example, Hess, 'De Kooning's New Women', p. 63.

335 Rosenberg, *Willem de Kooning*, p. 35. See also Hess, 'Willem de Kooning – New Images', p. 236: 'Sometimes, de Kooning draws with his left hand, or while watching television, or with his eyes closed.'

336 Hess, 'De Kooning's New Women', p. 64.

337 Hess, *Willem de Kooning* (1968), p. 15.

338 Hess, *Willem de Kooning* (1959), p. 7.

339 Picasso's words, as recalled by Herbert Read, 'Picasso at 75' (letter to the editor), *London Times*, 27 October 1956, p. 7.

340 See Klaus Kertess, 'Painting Language', *Willem de Kooning: In Process* (Fort Lauderdale, FL, 2000), n.p. Concerning the specifics of de Kooning's interest in comics, Kertess cites his interview of Tom Ferrara, 13–14 March 1999. See also Hess, *Willem de Kooning* (1959), p. 29; de Kooning, in Hunter, 'De Kooning: Je dessine les yeux fermés', p. 70. A de Kooning lithograph of 1971 assumed the title *Minnie Mouse*.

341 On Rockwell, see Avis Berman, 'Willem de Kooning: "I am only halfway through"', *ARTnews*, 80 (February 1982), p. 71.

342 De Kooning, in Hunter, 'De Kooning: "Je dessine les yeux fermés"', p. 69.

343 On Matisse and Soutine, see de Kooning's statement in Margaret Statts and Lucas Matthiessen, 'The Genetics of Art', *Quest/77*, 1 (March/April 1977), p. 70: 'I've always been crazy about Soutine . . . the lushness of the paint. He builds up a surface that looks like a material, like a substance. There's a kind of transfiguration, a certain fleshiness, in his work . . . Years ago when I first saw Matisse's *Moroccans*, I flipped.' On Mondrian: 'The Neo-Plasticists didn't want anything [from nature] left over [in the painting] . . . I am completely weary of their ideas now'; Willem de Kooning, 'What Abstract Art Means to Me', p. 5.

344 De Kooning, in *De Kooning Drawings*, n.p.

345 See Wolfe, 'Glimpses of a Master', *Willem de Kooning: Works from 1951–1981*, p. 14.

346 De Kooning, in Willard, 'De Kooning', p. 58.

347 De Kooning, statements recorded in Willard, 'Interviews for [*Look*] article', *c.* January 1969, Charlotte Willard Papers, Archives of American Art, Smithsonian Institution, Washington, DC (Courtesy of Anne Collins Goodyear).

348 See Denby, 'Notes on Nijinsky Photographs', in *Nijinsky: An Illustrated Monograph*, p. 17.

349 Emmanuel Levinas, *Of God Who Comes to Mind*, trans. Bettina Bergo (Stanford, CA, 1998), p. 23.

350 Merleau-Ponty, 'Eye and Mind', *The Primacy of Perception*, p. 185.

351 Elaine de Kooning, in Connie Fox, Bill King, and Frazier Dougherty, *De Kooning at the Whitney with Elaine de Kooning*, New York, 1984, videotape.

352 Walter Darby Bannard, 'Willem de Kooning's Retrospective at the Museum of Modern Art', *Artforum*, 7 (April 1969), p. 43.

353 Susan Brockman, 26 September 1993.

354 Hess, *Willem de Kooning Drawings*, p. 15.

355 Merleau-Ponty, 'Eye and Mind', *The Primacy of Perception*, p. 168.

356 During the late 1930s, de Kooning constructed a male manikin, dressed it in his own trousers, and, wishing to preserve a specific pattern of folds, used glue to make the pattern permanent; see Hess, *Willem de Kooning: Drawings*, p. 22.

357 De Kooning, quoted in notes taken by Ann Ray Martin, 1 November 1967, for an unpublished article in *Newsweek*; see Stevens and Swan, *De Kooning: An American Master*, p. 498.

358 See photographs taken by Hans Namuth, reproduced in Wolfe, 'Glimpses of a Master', *Willem de Kooning: Works from 1951–1981*, p. 14. Hess refers to 'figure drawings of 1966' (not necessarily limited to the closed-eyes type) for which de Kooning 'would hold the drawing pad horizontally when making a woman who stands vertically on the page'; Hess, *Willem de Kooning: Drawings*, p. 55.

359 Ruth Kligman, who observed de Kooning during the late 1950s, stating de Kooning's views in an interview by Mark Stevens and Annalyn Swan, 4 June 1993,

quoted in Stevens and Swan, *De Kooning: An American Master*, p. 405. David Christian, who assisted de Kooning during the early 1970s, indicated that the artist applied analogous methods to his sculptural work: 'For the smaller figures, he didn't like the feet standing on the ground. He liked to be able to work on them all the way around. He even talked about making a large sculpture on a free-hanging armature suspended from the ceiling'; Christian, interviewed by Judith Wolfe, April 1981, quoted in Wolfe, 'Glimpses of a Master', *Willem de Kooning: Works from 1951–1981*, p. 15.

360 The so-called vellum that de Kooning favoured was not an animal product but a relatively thick, translucent tracing paper of a type suitable for architectural drafting.

361 De Kooning, in Daniel Frasnay, *The Artist's World* (New York, 1969), p. 221.

362 Nijinsky's words in 1909, reportedly his reply when asked how it was that he appeared to remain suspended while jumping; see Richard Buckle, *Nijinsky* (London, 1971), p. 92. For images of Nijinsky jumping – during his prime as a costumed dancer in 1910, as well as in 1939 wearing an ordinary suit of clothes – see Martine Kahane, ed., *Nijinsky 1889–1950* (Paris, 2000), pp. 107, 145.

363 De Kooning, quoted in notes taken by Philip Pavia at a meeting of The Club, 25 April 1951; Natalie Edgar, ed., *Club Without Walls: Selections from the Journals of Philip Pavia* (New York, 2007), p. 82; and de Kooning, quoted by Tom Ferrara (recalling the 1980s), 'Remembering de Kooning', *Willem de Kooning 1981– 1986* (New York, 2007), p. 75. See also Gary Garrels, 'Three Toads in the Garden: Line, Color, and Form', in Gary Garrels, ed., *Willem de Kooning: The Late Paintings, the 1980s* (San Francisco, CA, 1995), p. 15.

364 John McMahon, 25 June 1993. The image of cheer-leaders appeared in *The New York Times*, 21 March 1964, p. 19. A photograph by Hans Namuth documents its presence in de Kooning's studio; see 'Willem de Kooning, East Hampton', *Location*, 1 (Summer 1964), p. 31.

365 The general resemblance to de Kooning's figures was first noted in Lucy R. Lippard, 'Three Generations of Women: De Kooning's First Retrospective', *Art International*, 9 (20 November 1965), p. 30.

366 When, in his late works, de Kooning was creating complex networks of twisting bands of colour, he referred to such elements simply as 'lines'; Tom Ferrara, 9 December 1996.

367 De Kooning, in Hunter, 'De Kooning: "Je dessine les yeux fermés"', p. 69.

368 Conrad Fried, 10 October 1993.

369 A similar shift or twist in the character of a line could be accomplished with de Kooning's use of the liner brush; see Hess, *Willem de Kooning: Drawings*, p. 17.

370 Tom Ferrara, 9 December 1996.

371 According to Bernard Chaet (5 May 2001), who began teaching at Yale in 1951, it was not unusual for Albers to appreciate and hire painters from 'another camp', provided he saw exceptional quality in their work.

372 Elaine de Kooning, 'Albers', *Art News*, 47 (February 1949), p. 15.

373 De Kooning's words, in indirect quotation by Denby, 'Notes on Nijinsky Photographs', in *Nijinsky: An Illustrated Monograph*, p. 17.

374 See George Heard Hamilton, *Joseph Albers: Paintings, Prints, Projects* (New Haven, CT, 1956), p. 28; John H. Holloway and John A. Weil, 'A Conversation with Josef Albers', *Leonardo*, 3 (October 1970), p. 463.

375 De Kooning, in Frasnay, *The Artist's World*, p. 221.

376 Elaine de Kooning, 'Albers Paints a Picture', *Art News*, 49 (November 1950), p. 41.

377 Elaine de Kooning, 'De Kooning Memories', *The Spirit of Abstract Expressionism: Selected Writings*, p. 212; William P. Reimann, a student of Albers during the 1950s, 14 and 15 December 2000.

378 Josef Albers, quoted in Neil Welliver, 'Albers on Albers', *Art News*, 64 (January 1966), p. 51.

379 John McMahon, 25 June 1993.

380 On the emergence of the theme, see Hess, 'De Kooning's New Women', p. 64.

381 De Kooning, statement in Richard Marshall, *50 New York Artists* (San Francisco, CA, 1986), p. 34.

382 Susan Brockman, 28 August 1993; John McMahon, 6 June 1993; Allan Stone, dealer and friend of de Kooning, especially during the 1960s, 13 July 1993; James Goodman, art dealer, friend of de Kooning, 14 June 1993.

383 Hess, 'De Kooning's New Women', p. 64.

384 Harold Diamond, letter to Betty Freeman, 24 October 1964.

385 John G. Powers, note affixed to the back of de Kooning's *Sag Harbor* (1965) referring to Powers's conversation with de Kooning, 9 May 1965; published in Bob Monk, ed., *Willem de Kooning: Mostly Women, Drawings and Paintings from the John and Kimiko Powers Collection* (New York, 2000), p. 82. On posing a nude in high-heeled shoes, see also Powers, '12 Paintings from the Powers' Collection', n.p.

386 Hess, 'De Kooning's New Women', p. 64.

387 Diamond, letter to Betty Freeman, 24 October 1964.

388 Susan Brockman, 28 August 1993.

389 An additional factor of resemblance was suggested by Joop Sanders, 10 September 1993: the cage-like or rib-like structures of early Giacometti sculptures, which de Kooning admired.

390 The are many accounts of de Kooning's fear of water. I received many first-hand details from Conrad Fried (interviews by the author, 10 October 1993, 17 January 1997). See also Amei Wallach, 'My Dinners with de Kooning', *Newsday*, 24 April 1994, p. 24. Wallach reports that de Kooning was shoved into a sewer by an older child to recover a lost marble. This child maliciously replaced the sewer grating, leaving de Kooning trapped below; he was rescued by 'an old lady . . . She saved my life.' Several accounts of de Kooning's painful experiences with water are collected in Wolfe, *The Young Willem de Kooning: Early Life, Training and Work, 1904–1926*, pp. 48–9.

391 Hess, *Willem de Kooning: Drawings*, p. 52.

392 At times Hess did use the word *vector* in reference to the directional force of de Kooning's line, but not to distinguish this from other modes of graphic rendering; see, for example, Hess, *Willem de Kooning Drawings*, pp. 13, 44.

393 Hess, 'De Kooning's New Women', p. 64.

394 Hess, 'De Kooning's New Women', pp. 38 (studio photograph), 64.

395 Ruth Kligman, interview by Stevens and Swan, 4 June 1993, quoted in Stevens and Swan, *De Kooning: An American Master*, p. 405.

396 De Kooning, in Willard, 'De Kooning', p. 58.

397 De Kooning, quoted in Douglas Davis, 'De Kooning on the Upswing', *Newsweek*, 4 September 1972, p. 70.

398 De Kooning, in Willard, 'De Kooning', p. 58.

399 De Kooning, in Willard, 'Interviews for [*Look*] article', *c.* January 1969, Charlotte Willard Papers, Archives of American Art, Smithsonian Institution, Washington, DC (courtesy of Anne Collins Goodyear). According to Tom Ferrara, 9 December 1996, de Kooning maintained this attitude to the end of his career, being dissatisfied with his work whenever it failed to present a contradiction.

400 Hess, 'De Kooning's New Women', pp. 64–5. On 'violence' in de Kooning's paintings of the 1960s, see also Andrew Forge, 'De Kooning in Retrospect', *Art News*, 68 (March 1969), pp. 44, 62.

401 De Kooning, in Rodman, *Conversations with Artists*, p. 102.

402 De Kooning, in Hunter, 'De Kooning: "Je dessine les yeux fermés"', p. 70.

403 De Kooning, in Hunter, 'De Kooning: "Je dessine les yeux fermés"', p. 69.

404 De Kooning's words, printed film script for *Sketchbook No. 1: Three Americans: Willem de Kooning, Buckminster Fuller, Igor Stravinsky*, produced and directed by Robert Snyder with the editors of *Time*, written by Michael Sonnabend (New York, 1960), n.p. The complete audiotape passage is as follows (de Kooning referring to the calendar nude on his studio wall): 'Not the same as Marilyn Monroe. Maybe I like this one more than Marilyn Monroe. In other words, I like the type more as the original version.' With a linguistic quirkiness typical of him, de Kooning substituted *as* for *than*. Yet he could also mean that the type should be given the cultural status of the original because it can be consid-

ered the better of the two – better in its ordinariness.

405 Susan Brockman, 6 September 1993, recalled de Kooning's argument and associated it with a talk he gave at Southampton College, a newly opened branch of Long Island University, on 1 October 1964.

406 On the fortuitous resemblance of de Kooning's *Woman* to Marilyn Monroe, see Selden Rodman, *Conversations with Artists*, p. 104; Hess, *Willem de Kooning Drawings*, p. 41. During 1954, the year of her marriage to Joe DiMaggio and subsequent divorce, Marilyn Monroe was an especially newsworthy character and a particularly common cultural reference; it is not surprising that her presence would be evoked by an anonymous image of a woman with blond hair and red lips.

407 De Kooning, in Rosenberg, 'Interview with Willem de Kooning', p. 57.

408 De Kooning, in Rosenberg, 'Interview with Willem de Kooning', p. 57.

409 Peirce, 'Time and Thought', *Collected Papers*, VII, p. 212.

410 De Kooning 'liked taking an image from his immediate right or left in the studio': Conrad Fried, 10 October 1993.

411 Willem de Kooning, letter to Joseph and Olga Hirshhorn, undated, in Zilczer, *Willem de Kooning from the Hirshhorn Museum Collection*, p. 167. I have regularized de Kooning's punctuation (compare Zilczer, p. 151). Zilczer estimates the date of the letter as January 1969.

412 De Kooning, in Rosenberg, 'Interview with Willem de Kooning', p. 57.

413 See Elaine de Kooning's account of her husband's experience at Black Mountain College during summer 1948; Elaine de Kooning, 'De Kooning Memories', *The Spirit of Abstract Expressionism: Selected Writings*, pp. 212–13.

414 De Kooning, in Rosenberg, 'Interview with Willem de Kooning', p. 54. See also de Kooning, statements in Gaby Rodgers, 'Willem de Kooning: The Artist at 74', p. 36.

415 De Kooning, in Rosenberg, 'Interview with Willem de Kooning', p. 57. See also de Kooning, in Shirey, 'Don Quixote in Springs', p. 80.

416 On the family, see Elaine de Kooning's account in Curtis

Bill Pepper, 'The Indomitable de Kooning', *New York Times Magazine*, 20 November 1983, p. 70; de Kooning, in Rodgers, 'Willem de Kooning: The Artist at 74', p. 21. Substantial accounts are found in Wolfe, *The Young Willem de Kooning: Early Life, Training and Work, 1904–1926*, esp. pp. 22–53; Lieber, *Willem de Kooning: Reflections in the Studio*; and Stevens and Swan, *De Kooning: An American Master*. Having left The Netherlands in 1926, de Kooning did not revisit his native country until 1968; despite his attraction to watery landscape, he had little affection for Holland as a place to live: Lisa de Kooning, 23 September 1993; Robert Storr, who discussed Holland with the artist in 1986, 19 September 1993; see also, de Kooning, letter to Joseph H. Hirshhorn, 18 May 1964, in Zilczer, *Willem de Kooning from the Hirshhorn Museum Collection*, p. 152. On de Kooning's anxiety: Conrad Fried, 10 October 1993, stated that the artist's anxiety attacks, which involved palpitations, did not become severe until the early 1950s, following his public success. In a letter to his sister Marie van Meurs, 2 December 1967, de Kooning referred to having suffered from 'a terrible state of anxiety' during the 1940s; quoted in Wolfe, *The Young Willem de Kooning: Early Life, Training and Work, 1904–1926*, p. 405.

417 Herman Cherry, 'Willem de Kooning', *Art Journal*, 48 (Fall 1989), p. 230. De Kooning's preferred excursions were to nearby Louse Point by bicycle from the studio in Springs and, as an automobile passenger, along Long Island highways.

418 Thomas B. Hess, 'Ingres', *Art News Annual*, 22 (1953), p. 182; Hess, *Willem de Kooning* (1959), p. 15.

419 Hess, 'De Kooning Paints a Picture', p. 30; Hess, 'De Kooning's New Women', p. 64; de Kooning, in Sylvester, 'De Kooning's Women', p. 52.

420 De Kooning, in Storm de Hirsch, 'A Talk with de Kooning', *Intro Bulletin*, 1 (October 1955), p. 1.

421 John McMahon, 14 July 1993. The charts were still in de Kooning's studio at the time of his death. See also Shirey, 'Don Quixote in Springs', p. 80; Hess, *De Kooning: Recent Paintings*, p. 32; Emile de Antonio and Mitch Tuchman, *Painters Painting: A Candid History*

of the Modern Art Scene, 1940–1970 (New York, 1984), p. 55.

422 Joan Ward, 25 September 1993; John McMahon, 6 June 1993, 29 August 1993. Both McMahon and Allan Stone (13 July 1993) remember how frequently de Kooning would change the subject during conversation. This is evident even in published interviews, despite the editing.

423 See Philip Guston, quoted in Jan Butterfield, 'A Very Anxious Fix: Philip Guston', *Images and Issues*, 1 (Summer 1980), p. 31.

424 Art historians' accounts of de Kooning's technique have relied primarily on Hess's writings. For a succinct statement on technique, see Hess, *Willem de Kooning: Drawings*, pp. 16–17. Hess stresses the use of oil and water emulsions (which stay wet especially long), slick paper surfaces, liner brushes, and techniques of tearing and cutting, all of which he associates with speed and freshness. For a technical examination of de Kooning's materials and procedures see Susan Lake and Judith Zilczer, 'Painter and Draftsman', in Zilczer, *Willem de Kooning from the Hirshhorn Museum Collection*, pp. 172–9.

425 Witness accounts of de Kooning's medium vary, apparently according to the time of the observation. John McMahon (25 June, 14 July 1993) remembered the medium in use during de Kooning's first years in the Springs studio: safflower oil (which McMahon purchased in large quantities from local food markets), water, and gum turpentine or mineral spirits (with the possible addition of damar varnish and small amounts of other oils or solvents); the safflower oil replaced linseed oil in use during previous years. De Kooning himself stated: 'Safflower oil stays wet a long time, it doesn't dry like linseed oil, I can work longer' (in Rodgers, 'Willem de Kooning: The Artist at 74', p. 21). According to Conrad Fried, 10 October 1993, during the late 1960s de Kooning often used equal parts of safflower oil and water, a particularly wet mixture that resulted in his most extreme cases of wrinkling and shrinkage within the paint surface. When he turned

to work in clay in 1969, he expressed again his interest in maintaining wetness and a capacity for change; see Stella Rosemarch, 'De Kooning on Clay', *Craft Horizons*, 32 (December 1972), p. 35. Several witnesses recalled that de Kooning's medium during the 1950s and '60s consisted of safflower oil, water and benzine (Joan Ward, 2 May 1993; Joop Sanders, 10 September 1993; Athos Zacharias, 20 September 1993). Hess, too, referred to benzine as the solvent, as well as to kerosene; see Hess, *De Kooning: Recent Paintings*, p. 33; Hess, 'Willem de Kooning – New Images', p. 236. McMahon stated that de Kooning may have experimented during the 1960s and '70s with solvents such as benzine and kerosene but used them primarily to clean brushes; this was confirmed by Conrad Fried, as well as by Tom Ferrara, 30 June 1993. Robert Dash (friend of Willem and Elaine de Kooning, 12 September 1993) recalled a combination of linseed oil, turpentine and benzine in use during the late 1960s; he emphasized that de Kooning was so concerned with liquidity that he would experiment with traditionally incompatible ingredients. According to Jay Krueger, Conservator of Modern Paintings at the National Gallery of Art, Washington, DC, many painters used benzine and turpentine interchangeably during the 1960s, with no appreciable difference in effect (Krueger investigated de Kooning's methods in connection with the artist's retrospective at the National Gallery of Art in 1994).

426 Hess, *Willem de Kooning* (1959), p. 25. See also Elaine de Kooning, 'De Kooning Memories', *The Spirit of Abstract Expressionism: Selected Writings*, pp. 212–13.

427 During the 1960s, experimenting with de Kooning's medium at his suggestion, Joan Ward (2 May 1993) found it so slippery she 'could not keep the brush on the canvas'. De Kooning nevertheless achieved the degree of paint viscosity needed to prevent it from sliding down the vertical support surface as he worked, which was a specific concern (John McMahon, 14 July 1993).

428 De Kooning designed his studio environment in Springs to be entirely hard and smooth like his preferred drawing and painting surfaces, constructing it of metals, glass

and hardwoods, with terrazzo flooring.

429 Elaine de Kooning, in Fox, King, and Dougherty, *De Kooning at the Whitney with Elaine de Kooning*, videotape. Tom Ferrara, 30 June 1993, confirmed de Kooning's interest in effects of erasure on vellum.

430 According to Kimiko and John Powers (as cited in Zilczer, *Willem de Kooning from the Hirshhorn Museum Collection*, p. 161 n.14), de Kooning, dissatisfied with doors ordered for the Springs studio because they were hollow, decided to use them as painting surfaces; both John McMahon (25 June 1993) and Susan Brockman (31 August 1993) confirmed this. Hess's variant account ('De Kooning's New Women', p. 37; *De Kooning: Recent Paintings*, p. 17) is inaccurate.

431 John McMahon, 30 June 1993, recalled that, during the 1960s, when de Kooning had worked a sheet of vellum from both sides, he would sometimes apply a protective coating to the back, then spray white pigment on it; when the vellum was mounted on canvas, the paint or charcoal on the back side would show through to the front and remain part of the image, just as de Kooning had seen it.

432 Roger Anthony of The Willem de Kooning Foundation initiated the use of 'oil transfer' as the designation for independent imprints or blottings derived from the wet oil surfaces of works in progress. See also Hess, 'De Kooning's New Women', p. 64; Hess, *Willem de Kooning: Drawings*, pp. 14–15.

433 De Kooning, as recorded in Snyder, *Sketchbook No. 1: Three Americans: Willem de Kooning, Buckminster Fuller, Igor Stravinsky*, n.p.; de Kooning, 'Content Is a Glimpse . . .', p. 48.

434 '[De Kooning's] urge is to include everything, to give nothing up, even if it means working in a turmoil of contradictions' (Hess, *De Kooning: Recent Paintings*, p. 20). See also Thomas B. Hess, 'US Painting: Some Recent Directions', *Art News Annual*, 25 (1956), p. 98.

435 Susan Brockman, 10 August 1993.

436 Referring to works of the 1960s, Hess (*De Kooning: Recent Paintings*, p. 17) wrote: 'de Kooning's Woman is almost always depicted as seated.'

437 Christie's auction catalogue, 'Contemporary Drawings, Watercolors and Collages', New York, 8 November 1989, note to cat. 136. Edvard Lieber (letter to the author, 28 August 1993) confirms that Elaine de Kooning wrote this note in August 1985. The drawing also contains traces of pink pastel in the figure's torso and hair.

438 According to Conrad Fried, 10 October 1993, Elaine de Kooning recalled that *Woman – Lipstick* had been produced in a spirit of play; Fried attests to Elaine's practice of leaving lipstick imprints on notes. On signing with a kiss, see also Vreeburg, *Two Letters (1946, 1948) by Willem de Kooning to his Father*, p. 21.

439 John McMahon, 6 June 1993. Conrad Fried, 10 October 1993, confirmed how much de Kooning liked every sensory aspect of paint, including its smell and touch.

440 On de Kooning's 'intimate proportions' and the association of 'intimate' with 'commonplace' and 'ordinary', see Hess, 'De Kooning Paints a Picture', pp. 32, 64, 66.

441 Harold Rosenberg, 'Painting Is a Way of Living', *The New Yorker*, 16 February 1963, p. 136.

442 See Hess, 'De Kooning Paints a Picture', p. 66; Hess, *Willem de Kooning* (1959), p. 21; Hess, *Willem de Kooning* (1968), pp. 77–9.

443 De Kooning, in Sylvester, 'De Kooning's Women', p. 57. In a later interview de Kooning said: 'I find that everyone has to have a mouth, and I put the mouth where I want' (Bibeb, 'Willem de Kooning', p. 3). See also Hess, 'De Kooning Paints a Picture', p. 66; de Kooning, interview by Emile de Antonio, 1970, in de Antonio and Tuchman, *Painters Painting: A Candid History of the Modern Art Scene, 1940–1970*, p. 53.

444 Hess, *Willem de Kooning* (1959), p. 30. See also Thomas B. Hess, 'Pinup and Icon', *Woman as Sex Object: Studies in Erotic Art, 1730–1970*, ed. Thomas B. Hess and Linda Nochlin (New York, 1972), p. 229.

445 De Kooning, in Bibeb, 'Willem de Kooning', p. 3. De Kooning continues, 'A man has something else, a fascinating thing.'

446 Fred Genis, printmaker who worked with de Kooning during the early 1970s, 14 January 1999; John

McMahon, 8 March 2001. See also, de Kooning, in Bibeb, 'Willem de Kooning', p. 3. Clarence and Dorothy Barnes (Long Island store proprietors, interview by Mark Stevens and Annalyn Swan, 6 August 1991) recalled de Kooning referring to his 1960s images: 'Can't you see? Here's a *cunt*. And there's a *penis*. Didn't you know that I'm *cunt* crazy?'; quoted in Stevens and Swan, *De Kooning: An American Master*, p. 486 (emphasis original).

447 De Kooning, quoted in Hess, 'De Kooning's New Women', p. 65.

448 De Kooning, in Willard, 'De Kooning', p. 58.

449 John McMahon, 25 June 1993.

450 Some of de Kooning's sculptures show the same pose, such as a small bronze of 1969, *Untitled VI*.

451 De Kooning, in de Antonio and Tuchman, *Painters Painting: A Candid History of the Modern Art Scene, 1940–1970*, p. 53. De Kooning expressed fascination with (male) figures on horseback, generic cases of spread-leggedness, both painted and sculpted: see William Barrett, *The Truants: Adventures among the Intellectuals* (New York, 1982), p. 142; Peter Schjeldahl, 'De Kooning's Sculptures: Amplified Touch', *Art in America*, 62 (March–April 1974), pp. 61–2.

452 De Kooning himself was not a sunbather; see Hess, *Willem de Kooning* (1968), p. 122.

453 Hess, *Willem de Kooning* (1968), p. 124.

454 Hess, *De Kooning: Recent Paintings*, p. 30.

455 Although I find the term *splayed* misleading, it succeeds in connoting an ungainliness that de Kooning found preferable to conventional beauty; with similar effect, a number of critics have referred to his figures as 'squatting'. For examples of 'splayed', see Harry F. Gaugh, *Willem de Kooning* (New York, 1983), p. 77; Schjeldahl, 'De Kooning's Sculptures: Amplified Touch', p. 62; for 'squatting', see Forge, 'De Kooning in Retrospect', p. 44. The two descriptive terms appear in a single paragraph in Hess (*De Kooning: Recent Paintings*, p. 21), but applied somewhat differently: de Kooning's Woman sometimes assumes a 'half-squatting position . . . with her knees spread wide'; and her feet may look 'long, splayed, flattened'. In 1978, Hess referred to a 'froglike squat [that] exposes as much genitalia as possible'; Thomas B. Hess, 'The Flying Hollander of Easthampton, L.I.', *New York*, 20 February 1978, p. 68.

456 Joan Ward (25 September 1993) emphasized de Kooning's interest in small things, including his use of a reducing glass to make his larger works appear small.

457 De Kooning, in Hunter, 'De Kooning: "Je dessine les yeux fermés"', p. 69.

458 De Kooning, in Rosenberg, 'Interview with Willem de Kooning', p. 56.

459 See Blesh, *Modern Art USA: Men, Rebellion, Conquest, 1900–1956*, p. 261; David Rosand, 'Proclaiming Flesh', *Times Literary Supplement*, 17 February 1984, p. 167.

460 De Kooning, 'What Abstract Art Means to Me', p. 7. It was de Kooning's custom to explore an idea through mimicking something seen: 'He could take in an idea only as a visual image'; Barrett, *The Truants: Adventures among the Intellectuals*, p. 141.

461 Using examples of this sort, Susan Brockman explained de Kooning's mentality and sense of inner feeling, 26 September 1993.

462 Conrad Fried, 4 October 1993.

463 Hess, *De Kooning: Recent Paintings*, p. 39 (original emphasis). Also relevant is Hess's report (quoted above, 'Title') that *Woman I* reminded de Kooning of a landscape, 'with arms like lanes and a body of hills and fields, all brought up close to the surface, like a panorama squeezed together'; Hess, 'De Kooning Paints a Picture', p. 67.

464 The exchange took place in de Kooning's studio during the period of his work on *Woman I* (1950–52). David M. Solinger was an early collector of de Kooning's art, beginning in the late 1940s. He had a vivid memory of de Kooning's gesture and performed it himself during our interview, 4 May 1993.

465 De Kooning, as paraphrased in Hess, 'De Kooning Paints a Picture', p. 67.

466 De Kooning, in Bibeb, 'Willem de Kooning', p. 3. According to Elaine de Kooning, her husband's admi-

ration for Giacometti was sparked by a 1948 exhibition at the Pierre Matisse Gallery; see Sally Yard, *Willem de Kooning: The First Twenty-Six Years in New York – 1927–1952* (New York, 1986), pp. 181–2.

467 Georges Duthuit, 'Matisse and Byzantine Space', *Transition Forty-Nine*, no. 5 (1949), pp. 20–37; the illustration of the coin appears opposite page 33. De Kooning mentioned Duthuit's essay when interviewed by Sally Yard, 14 October 1976 (Yard, *Willem de Kooning: The First Twenty-Six Years in New York – 1927–1952*, pp. 183, 227 n.247). The interview itself does not make clear whether de Kooning was referring to a reading experience long past or a recent one. On Duthuit, de Kooning, *Woman 1*, and more, see Glenn Peers, 'Utopia and Heterotopia: Byzantine Modernisms in America', in Karl Fugelso, *Defining Neomedievalism(s)* (Cambridge, 2010), pp. 77–113.

468 De Kooning, interview by Emile de Antonio, 1970, in *Painters Painting*, film.

469 De Kooning, in Bibeb, 'Willem de Kooning', p. 3.

470 See Forge, 'De Kooning in Retrospect', p. 61.

471 Hess, *Willem de Kooning: Drawings*, p. 19.

472 Joop Sanders, 10 September 1993, recalled that de Kooning had worked on advertisement layouts for both shoes and lipstick.

473 See Friso Endt, 'Royal Welcome for Prodigal de Kooning', *Life International*, 28 October 1968, p. 72.

474 Lisa de Kooning, 23 September 1993, John McMahon, 8 September 1993, and Susan Brockman, 26 September 1993, all recalled the Dutch shoes. De Kooning's illusionistic rendering of them exhibits a combination of angularity and curvature characteristic of his abstract linear style. Those close to the artist believe he would not himself have sought out a nostalgic item. Nevertheless, Joan Ward, 25 September 1993, remembered that during the early 1970s, for whatever reason, de Kooning wanted to find an old-fashioned shoe-shine box.

475 According to Robert Dash, 12 September 1993, de Kooning recounted the incident in 1986. The artist remembered the mother of his childhood as stern and unwilling to let him do things in his own way or at his own pace (Conrad Fried, 10 October 1993, 27 January 1997). His sister and half-brother regarded their mother as a 'tyrant'; see Ken Wilkie, 'Willem de Kooning: Portrait of a Modern Master', *Holland Herald*, 17 (March 1982), p. 24.

476 Connie Fox, 3 September 1993.

477 Powers, '12 Paintings from the Powers' Collection', n.p.

478 Monica Vitti: Susan Brockman, 6 September 1993. Sculpture: Schjeldahl, 'De Kooning's Sculptures: Amplified Touch', p. 61.

479 John McMahon, 21 January 1994.

480 Elaine de Kooning, in Pepper, 'The Indomitable de Kooning', p. 70. The de Koonings were visited by Willem's mother during summer 1954, which afforded a first-hand experience of the mother-effect (Elaine de Kooning, unpublished interview by Ann Gibson, 3 October 1987).

481 De Kooning, in Bibeb, 'Willem de Kooning', p. 3.

482 Elaine de Kooning stated that her nail polish had inspired the corresponding feature in one of her husband's oil paintings of the 1940s (Edvard Lieber, 28 August 1993).

483 Susan Brockman, 28 August 1993; John McMahon, 8 September 1993.

484 Charles Baudelaire, 'The Painter of Modern Life' [1859–60], in *The Painter of Modern Life and Other Essays*, ed. and trans. Jonathan Mayne (London, 1964), p. 13. On Rubens: de Kooning, in Rosenberg, 'Interview with Willem de Kooning', p. 54. On Bernini: de Kooning, quoted in Bert Schierbeek, 'Willem de Kooning', in Edy de Wilde, ed., *Willem de Kooning* (Amsterdam, 1968), n.p. De Kooning was also fond of the figural poses in Watteau, Boucher, and Fragonard (Susan Brockman, 26 September 1993). Rosenberg's account of de Kooning's *Woman 1* as, among other things, an attractively dressed Fourteenth Street shopper and a 'madonna studied in a reproduction' recalls the Baudelairean formula for modern beauty, a combination of the transitory and eternal; Harold Rosenberg, 'De Kooning', *Vogue*, 15 September 1964, p. 186.

485 De Kooning, in Rosenberg, 'Interview with Willem de Kooning', p. 57.

486 De Kooning, in Schierbeek, 'Willem de Kooning', n.p. John McMahon, 14 July 1993, recalled the purchase of a large number of bowls in 1964.

487 See Thomas B. Hess, 'Pop and Public', *Art News*, 62 (November 1963), pp. 23, 59–60; Hess, 'De Kooning's New Women', p. 36; Rosenberg, 'De Kooning' (*Vogue*), p. 186. De Kooning and his critic-friends were sensitive on the topic of pop art because they believed it had attracted undeserved attention, drawing the art market away from the older generation (Allan Stone, 13 July 1993); de Kooning himself thought pop art had 'no innocence' (Susan Brockman, 6 September 1993). Hess particularly resented the claim that abstract expressionism amounted to little more than a passing style, as implied by Robert Indiana, in 'What is Pop Art? Interviews by G. R. Swenson – Part I', p. 27. Hess argued that de Kooning led the way in introducing popular imagery into postwar American painting (Hess, *De Kooning: Recent Paintings*, pp. 17, 20).

488 Harold Rosenberg, 'Masculinity: Real and Put On', *Vogue*, 15 November 1967, p. 159; de Kooning (1956), in Rodman, *Conversations with Artists*, p. 102. The remarks of Rosenberg and de Kooning may reflect C. G. Jung's popular theory of the anima, the inherited unconscious feminine in all men, no matter how masculine. On the anima, a concept first developed in 1916, see C. G. Jung, 'The Relations Between the Ego and the Unconscious', *Two Essays on Analytical Psychology* (New York, 1966), pp. 188–211. Jung stated that 'an inherited collective image of woman exists in a man's unconscious, with the help of which he apprehends the nature of woman' (p. 190). De Kooning's knowledge of Jung probably had multiple sources, including the painter John Graham, a friend from early years in New York; see Irving Sandler, *The Triumph of American Painting: A History of Abstract Expressionism* (New York, 1970), pp. 22–3.

489 Hess, *Willem de Kooning* (1959), p. 29 ('Maggie' is a comic-strip character). De Kooning's eclecticism allowed him to admire the art of Norman Rockwell along with that of his abstract expressionist friends; see Berman, 'Willem de Kooning: "I am only halfway through"', p. 71.

490 Hess, 'De Kooning Paints a Picture', p. 66; see also Hess, *De Kooning: Recent Paintings*, p. 20.

491 Elaine de Kooning, recorded in the film *De Kooning on de Kooning*, Charlotte Zerwin, director and Courtney Sale, producer, 1981. See also Hess, *Willem de Kooning: Drawings*, p. 45.

492 Susan Sontag, 'Against Interpretation', *Evergreen Review*, 8 (December 1964), p. 93. Lynne Cooke, extending a direction set by Andrew Forge (Forge, 'De Kooning in Retrospect'), related the eroticism of de Kooning's work to the writings of Norman O. Brown as well as to Sontag; see Lynne Cooke, 'De Kooning and the Pastoral: The Interrupted Idyll', in Zilczer, *Willem de Kooning from the Hirshhorn Museum Collection*, pp. 89–109.

493 De Kooning, 'What Abstract Art Means to Me', p. 5.

494 Harold Rosenberg, 'The American Action Painters', *Art News*, 51 (December 1952), p. 23.

495 Sontag, 'Against Interpretation', p. 76. Sontag's source was de Kooning, 'Content Is a Glimpse . . .', p. 47.

496 De Kooning, in Schierbeek, 'Willem de Kooning', n.p.: 'You know, now that I am sixty, Dutch words come back to me, but I still dream in English.' When de Kooning's mother visited in 1954, he spoke only pidgin Dutch with her. Native Dutch speakers noticed no desire on his part to converse in Dutch and do not believe he thought in Dutch, although he would sometimes interject Dutch expressions (Fred Genis, 4 September 1993; Joop Sanders, 10 September 1993; Conrad Fried, 10 October 1993). Selden Rodman, who interviewed de Kooning in 1956, reasoned that his 'still imperfect command of English contributes to a hesitancy to be explicit about his own paintings' (Rodman, *Conversations with Artists*, p. 101). A lack of explicit explanation would, however, be consistent with de Kooning's fundamental attitude toward experience.

497 De Kooning, final word in a series of group interviews

conducted in 1970 for the Emile de Antonio film *Painters Painting*; de Antonio and Tuchman, *Painters Painting: A Candid History of the Modern Art Scene, 1940–1970*, p. 163.

498 De Kooning, in Sylvester, 'De Kooning's Women', p. 57.

499 From the mid-1950s through the late 1970s de Kooning struggled with alcoholism. Good humored and pleasantly witty most of the time, he could be deeply insulting when intoxicated. The idiosyncrasies of his language and his tendency to punning, however, appear not to have been factors of his habit of drinking (Elaine de Kooning, unpublished interview by Ann Gibson, 3 October 1987; Allan Stone, 13 July 1993; John McMahon, 6 June 1993; Barrett, *The Truants: Adventures among the Intellectuals*, p. 142). De Kooning's 1968 Dutch interview bears the subtitle, 'Drinking is a terrific thing if you have it under control'; he referred to drinking as an antidote to his heavy smoking since alcohol reopened the blood vessels closed by nicotine (Bibeb, 'Willem de Kooning', p. 3).

500 De Kooning, 'Content Is a Glimpse . . .', p. 48.

501 De Kooning, interview by Sally Yard, 27 March 1977, typescript, The Willem de Kooning Foundation, New York. De Kooning mistook the title of Gertrude Stein's book, which is not *The Making of America* but *The Making of Americans* (1925). He indicated what he appreciated in Stein's thematics; it is also possible he was attracted to her plain speaking and plays on repetition.

502 The association of massiveness with motherhood is a common one, derived from the infantile experience of being very close to something very big. De Kooning suggested an indirect link between *Woman I* and his mother when he remarked that this painting reminded him of his childhood (Rosenberg, 'Interview with Willem de Kooning', p. 57). Susan Brockman, 13 August 1993, suggested a third possibility for Gertrude Stein's importance to de Kooning, based on her memories of his conversations: Stein had recreated her very ordinary *name* by causing it to be associated with her own artistry.

503 See Hess, *Willem de Kooning: Drawings*, p. 30.

504 Ashton, 'Willem de Kooning: Homo Faber', p. 61.

505 See de Kooning, as recorded in Snyder, *Sketchbook No. 1: Three Americans: Willem de Kooning, Buckminster Fuller, Igor Stravinsky*, n.p.; see also Hess, *Willem de Kooning* (1959), p. 27.

506 The source of my quotations from the 1959 interview is a transcription by Marie-Anne Sichère, typescript on deposit at The Willem de Kooning Foundation, New York. It corresponds to the audiotape of two recording sessions, one known as 'Soirée' (July 1959), the other as 'Inner Monologue' (Summer 1959). Michael Sonnabend (30 September 1993), as a friend of de Kooning, arranged the meetings so that Robert Snyder could record the painter on film. Participants at 'Soirée' included Sonnabend, Snyder, Kenneth Snelson (as cameraman), Harold Rosenberg, Thomas Hess, Franz Kline, Herman Cherry, Ludwig Sander, Edwin Denby and Fairfield Porter; 'Inner Monologue' involved only Sonnabend and Snelson and was audiotaped but not filmed (Robert Snyder, 3 October 1993). Hess's recently published *Willem de Kooning* (1959) was a topic of discussion. Statements by de Kooning in the 1959 interview became the audio for Snyder's two films, *Sketchbook No. 1*, 1960, and *A Glimpse of de Kooning*, 1968. Snyder recorded de Kooning both in his Broadway, Manhattan, studio and in East Hampton, but did not use the East Hampton soundtrack because the painter had been drinking too much at the time.

507 Susan Brockman, 31 August 1993.

508 See de Kooning, 'What Abstract Art Means to Me', p. 7.

509 Concerning de Kooning's sensitivity to 'momism', associated with the writings of Philip Wylie, see his remarks in de Hirsch, 'A Talk with de Kooning', p. 1. On Wylie and 'momism', see Cécile Whiting, 'Borrowed Spots: The Gendering of Comic Books, Lichtenstein's Paintings, and Dishwasher Detergent', *American Art*, 6 (Spring 1992), p. 25.

510 See Brenda Richardson, *Willem de Kooning: Vellums* (New York, 2001), p. 22.

511 De Kooning, in Sylvester, 'De Kooning's Women', pp. 52, 57.

512 De Kooning, in Sylvester, 'De Kooning's Women', p. 51.

513 Further compression: de Kooning's reference to the Byzantine may also reflect his interest in Duthuit's essay, 'Matisse and Byzantine Space' (already mentioned in connection with *Woman 1*; see 'Compress'). On de Kooning, Duthuit and analogies between Byzantium and New York as urban spaces, see Zilczer, 'De Kooning and Urban Expressionism', *Willem de Kooning from the Hirshhorn Museum Collection*, pp. 41–2, 56.

514 Michael Sonnabend, 30 September 1993.

515 Wittgenstein's writings, presented as a sequence of somewhat freestanding paragraphs, have a gnomic concentration, which de Kooning is likely to have appreciated. During the 1960s and '70s the artist read and reread Wittgenstein's paragraphs, apparently without tiring of the mental energy required, despite his failure to grasp their meaning through some comprehensive understanding of the philosopher's project. Joan Ward (2 May 1993) reported that de Kooning read Wittgenstein at the breakfast table 'very slowly', almost word by word, pondering short sections of it for extended periods of time. John McMahon (6 June 1993) stated that the artist admitted to having trouble understanding Wittgenstein's writing but was attracted to its complexity and, in general, enjoyed anything difficult. During the late 1960s and early '70s, McMahon often observed de Kooning with a book by Wittgenstein open at the breakfast table, but the page was always the same. See also Cherry, 'Willem de Kooning', p. 230; Gaugh, *Willem de Kooning*, p. 8 (based on Gaugh's interview of Elaine de Kooning, 2 December 1982).

516 De Kooning's letters to Joseph Hirshhorn (in Zilczer, *Willem de Kooning from the Hirshhorn Museum Collection*, pp. 152–3, 155–62, 164, 166–9) indicate that his casual writing in English lacked the usual refinements. This reinforces the likelihood of collaborative work on de Kooning's early essays, with one or more friends adjusting some of the language.

517 De Kooning, letter to his sister Marie van Meurs, 2 December 1967; quoted in Wolfe, *The Young Willem de Kooning: Early Life, Training and Work, 1904–1926*, p. 405.

518 See Reference 2 above (p. 271).

519 Hess, *Willem de Kooning* (1968), pp. 146–50; Rosenberg, *Willem de Kooning*, pp. 201–8.

520 De Kooning, 'Content Is a Glimpse . . .', p. 47; de Kooning, in Sylvester, 'De Kooning's Women', p. 57. In 1967, Hess reduced de Kooning's statement to 'Content is very small; it is a glimpse', but nevertheless retained the quotation marks; Hess, *De Kooning: Recent Paintings*, p. 39.

521 De Kooning as recorded in 1959, Sichère typescript, The Willem de Kooning Foundation.

522 Hess ('De Kooning Paints a Picture', p. 31) had already described de Kooning as 'prefer[ring] to keep off-balance'; see also Hess, *Willem de Kooning* (1959), p. 27.

523 Compare de Kooning's remark concerning Gertrude Stein's women and his own, as quoted in Bibeb, 'Willem de Kooning', p. 3: 'Insignificance [the ordinary], that's what I wanted to express.'

524 De Kooning once criticized his dealer Sidney Janis for complimenting him on an isolated part of a painting; he believed this indicated a failure to understand his art (Joan Ward, 25 September 1993).

525 Hess, 'De Kooning Paints a Picture', p. 65; Hess, 'De Kooning's New Women', p. 64; Hess, *De Kooning: Recent Paintings*, p. 20.

526 Compare the description of this practice in Hess, *Willem de Kooning* (1968), p. 47.

527 De Kooning, quoted in Berman, 'Willem de Kooning: "I am only halfway through"', p. 71.

528 De Kooning's passenger status is consistent with the passivity others observed in him. He often behaved as if he had no clear preferences or would not assert them; Cherry ('Willem de Kooning', p. 230) put this trait in a positive light: 'He is not judgmental, he accepts whatever happens.'

529 Sontag, 'Against Interpretation', p. 93 (original emphasis). Compare de Kooning, in Rosenberg, 'Interview with Willem de Kooning', p. 57: 'I see [historical works of art] with my eyes [as opposed to intellect].'

530 Rosenberg, 'Interview with Willem de Kooning', p. 56 (Mondrian); John McMahon, 25 June, 29 August 1993 (coffee); Elaine de Kooning, 'Edwin Denby Remembered – Part 1', p. 30 (gasoline).

531 Edwin Denby, 'My Friend de Kooning' [November 1963], *Art News Annual*, 29 (1964), p. 93.

532 Alan W. Watts, *The Spirit of Zen* [1935] (London, 1958), p. 46.

533 Shirey, 'Don Quixote in Springs', p. 80. See also Hess, *De Kooning: Recent Paintings*, p. 23; Rosenberg, 'Interview with Willem de Kooning', p. 57; Hellmann, 'De verloren zoon zit goed', p. 25.

534 It seems that a quality of light could help satisfy de Kooning's desire to be within what he observes, to be intimately connected with it; this might explain an otherwise cryptic remark he made in 1983 concerning his move from New York to Springs: 'I came out here for the light. To be close to it. To be in it as much as possible. Because I am nature, too' (de Kooning, in Pepper, 'The Indomitable de Kooning', p. 90). As a thought characteristic of members of de Kooning's generation, this statement should be compared not to Pollock's having said, 'I am nature': Bruce Glaser, 'Jackson Pollock: An Interview with Lee Krasner', *Arts Magazine*, 41 (April 1967), p. 38, but to his wish to be 'in' his painting: Jackson Pollock, 'My Painting', *Possibilities*, 1 (Winter 1947–8), p. 79; it should also be related to Barnett Newman's feeling that he became part of a living aesthetic environment when he visited the Ohio Indian mounds (Newman, 'Ohio, 1949', *Selected Writings and Interviews*, pp. 174–5). See also de Kooning, 'The Renaissance and Order', p. 86: '[The artist] became, in a way, the idea, the center, and the vanishing point himself – and all at the same time.'

535 Lisa de Kooning, 2 May, 23 September 1993. See also Rosenberg, 'Interview with Willem de Kooning', p. 58.

536 De Kooning, in Rosenberg, 'Interview with Willem de Kooning', p. 58.

537 De Kooning's advice during the late 1930s, as recalled by Elaine de Kooning, in Fox, King, and Dougherty, *De Kooning at the Whitney with Elaine de Kooning*,

videotape. See also Hall, *Elaine and Bill: Portrait of a Marriage*, p. 60.

538 Charles Baudelaire, 'A une passante [To a Passer-by]' [1860–61], *Oeuvres complètes*, ed. Claude Pichois, 2 vols (Paris, 1975–6), I, pp. 92–3.

539 De Kooning, as recorded in Snyder, *Sketchbook No. 1: Three Americans: Willem de Kooning, Buckminster Fuller, Igor Stravinsky*, n.p.; de Kooning, statement (22 April 1950), 'Artists' Sessions at Studio 35', *Modern Artists in America*, p. 12.

540 See Rosenberg, 'De Kooning', *Vogue*, p. 186.

541 Joan Ward, 2 May 1993. See also George Dickerson, 'The Strange Eye and Art of de Kooning', *Saturday Evening Post*, 21 November 1964, p. 70.

542 Emilie Kilgore, quoted from interviews by Mark Stevens and Annalyn Swan, 24–6 July 2003, in Stevens and Swan, *De Kooning: An American Master*, p. 542.

543 Elaine de Kooning, in Fox, King and Dougherty, *De Kooning at the Whitney with Elaine de Kooning*, videotape; John McMahon, 6 June 1993. See also Sandler, *A Sweeper-Up After Artists: A Memoir*, p. 53.

544 Susan Brockman, 10, 28 August 1993.

545 On types of brush: Conrad Fried, 10 October 1993; John McMahon, 30 June 1993; Tom Ferrara, 4 May 1993; Athos Zacharias, 20 September 1993.

546 Rosenberg, 'Painting Is a Way of Living', p. 134. See also Hess, *Willem de Kooning* (1959), p. 27.

547 Rosenberg, 'The American Action Painters', p. 48. On the political message of Rosenberg's 1952 essay, see Fred Orton, 'Action, Revolution, and Painting', *Oxford Art Journal*, XIV/2 (1991), pp. 3–17.

548 Rosenberg, 'Painting Is a Way of Living', p. 126.

549 William Seitz, 'Spirit, Time and "Abstract Expressionism"', *Magazine of Art*, 46 (February 1953), p. 87.

550 Hess, *Willem de Kooning* (1959), p. 12; Rosenberg, 'Painting Is a Way of Living', p. 126; Rosenberg, *Willem de Kooning*, pp. 23–4, 35; Rudy Burckhardt, interview by Paul Mattick (16 November 1990), 'Romance, Gangsters, and Cowboys', *Juni: Magazin für Kultur und Politik*, nos. 2–3 (1991), p. 40; Conrad Fried, 10 October 1993.

551 De Kooning, 'Inner Monologue' (Sichère typescript, The Willem de Kooning Foundation); Bibeb, 'Willem de Kooning', p. 3. In politics as elsewhere de Kooning kept an open mind and disapproved of those who dismissed government positions without considering them fully (Joan Ward, 25 September 1993).

552 Rosenberg, 'The American Action Painters', pp. 50, 23.

553 Compare like-minded discussions of Franz Kline's art as independent and self-referential: Robert Goodnough, 'Kline Paints a Picture', *Art News*, 51 (December 1952), p. 36 ('pictures that will show what he, as an individual, feels about art'); Elaine de Kooning, 'Franz Kline: Painter of His Own Life', *Art News*, 61 (November 1962), p. 29 ('His work is complete, independent; it is all there, in front of you'). Such allusions to existential stance should not be mistaken for formalist pronouncements.

554 De Kooning, interview by T. H. [Thomas Hess], 'Is Today's Artist with or against the Past?' *Art News*, 57 (June-July-August 1958), p. 27.

555 On de Kooning's use of *corny* and *ordinary*: Susan Brockman, 31 August 1993; John McMahon, 29 August 1993; Joan Ward, 25 September 1993. See also de Kooning, in de Hirsch, 'A Talk with de Kooning', p. 3.

556 Rosenberg, *Willem de Kooning*, p. 36. Compare Rosenberg, 'Painting Is a Way of Living', 126; Harold Rosenberg, 'Women and Water', *The New Yorker*, 24 April 1978, p. 132.

557 De Kooning, 'A Desperate View', in Hess, *Willem de Kooning* (1968), p. 15.

558 On aesthetics, see de Kooning, 'What Abstract Art Means to Me', pp. 4–8. On the bomb and politics, see de Kooning, 'Inner Monologue' (Sichère typescript, The Willem de Kooning Foundation). Although de Kooning wished to emigrate from Holland, his first choice may not have been New York but Berlin because of the advanced state of commercial design there in the 1920s; Conrad Fried (10 October 1993) heard the artist express this view in conversation with Gorky around 1938. On the early interest in Paris, see the conversation between Harold Rosenberg, Thomas Hess, and Willem de Kooning, taped by Betty Wolff, 2 March 1964, Thomas B. Hess papers, Archives of American Art.

559 Wallach, 'My Dinners with de Kooning', p. 9.

560 Rosenberg, *Willem de Kooning*, p. 30.

561 Rosenberg, *Willem de Kooning*, p. 34.

562 Allan Stone, original owner of *Woman in a Rowboat*, remembered that de Kooning spoke about floating oil pigment on water so that it would settle on a paper ground (13 July 1993). Such technique may be related to marbling, which the artist learned as an apprentice in Rotterdam; see Wolfe, *The Young Willem de Kooning: Early Life, Training and Work, 1904–1926*, pp. 120–22. John McMahon, 29 August 1993, considered de Kooning's knowledge of marbling relevant to his mature technique.

563 De Kooning, quoted in Charlotte Willard, 'In the Art Galleries', *New York Post Magazine*, 23 August 1964, p. 14.

564 John McMahon, 8 March 2001.

565 Willem de Kooning, quoted in Joseph Liss, '"His House Had Many Mansions": Willem de Kooning Remembers Mark Rothko', *ARTnews*, 78 (January 1979), p. 41.

566 Transferring oil paint around 1976: Garner Tullis, 28 May 1993. Transferring pastel in the late 1930s: Conrad Fried, 4 October 1993.

567 Roger Anthony of The Willem de Kooning Foundation made this identification. There may also be an unretouched segment near the upper left margin. In addition, Anthony has traced a number of independent images of heads to the artist's use of oil transfer at this stage of *Woman in a Garden*. The tendency to associate the pose of *Untitled* and similar images with the Charleston may derive from commentary in Hess, *De Kooning: Recent Paintings*, p. 21.

568 De Kooning, quoted in Hess, *De Kooning: Recent Paintings*, p. 24. This is a variant of a statement first reported in Hess, 'De Kooning's New Women', p. 65.

569 De Kooning, letter to Joseph and Olga Hirshhorn, undated (January 1969?), in Zilczer, *Willem de Kooning from the Hirshhorn Museum Collection*, p. 167.

570 Conrad Fried, 10 October 1993.

571 De Kooning, in Rosenberg, 'Interview with Willem de Kooning', p. 57.

572 Hess, 'De Kooning's New Women', p. 65. Hess wrote 'scrub-pine' rather than 'scrub oak', an inaccuracy he corrected in his second version of the statement while making additional, seemingly wilful changes; see Hess, *De Kooning: Recent Paintings*, p. 24. See also Hess, 'Willem de Kooning – New Images', p. 236 ('scruffy second growth . . . burning down and sprouting back').

573 One of de Kooning's favoured images was of a space left over: see Hess, *De Kooning: Recent Paintings*, p. 39; Barrett, *The Truants: Adventures among the Intellectuals*, p. 144.

574 Hess, 'De Kooning's New Women', p. 65.

575 De Kooning, in Sylvester, 'De Kooning's Women', p. 52.

576 De Kooning, quoted in Edwin Denby, 'Willem de Kooning' [1957], *Dancers, Buildings and People in the Streets* (New York, 1965), p. 276.

577 Rosenberg, 'The American Action Painters', pp. 23 (typographic emphasis eliminated), 49.

578 See de Kooning, letter to his sister Marie van Meurs, 2 December 1967; quoted in Wolfe, *The Young Willem de Kooning: Early Life, Training and Work, 1904–1926*, p. 405.

579 De Kooning's words, recalled by Conrad Fried, 10 October 1993.

580 De Kooning, quoted in Anonymous, 'The Native Returns', *Newsweek*, 7 October 1968, p. 116.

581 De Kooning, letter to Joseph and Olga Hirshhorn, undated (January 1969?), in Zilczer, *Willem de Kooning from the Hirshhorn Museum Collection*, p. 167.

582 The statement appears under de Kooning's authorship in a brief text he prepared in late 1985 or early 1986 for Richard Marshall, *50 New York Artists*, p. 34. Richard Marshall (10 December 1996) believes that Elaine de Kooning probably collaborated on the text, which reads in its entirety as follows: 'If you write down a sentence and you don't like it, but that's what you wanted to say, you say it again in another way.

Once you start doing it and you find how difficult it is, you get interested. You have it, then you lose it again, and then you get it again. You have to change to stay the same.' Tom Ferrara (30 June 1993, 9 December 1996) confirmed that de Kooning was in the habit of making the 'You have to change . . .' remark as a statement complete in itself. He had uttered the same words when interviewed by Judith Wolfe, 14 April 1981; see Wolfe, 'Glimpses of a Master', *Willem de Kooning: Works from 1951–1981*, p. 16.

583 Heinrich Wölfflin, *Principles of Art History* [original German edn 1915], trans. M. D. Hottinger (New York, 1950). The term *painterly* (*malerisch*) became familiar in de Kooning's circle through its frequent use by Greenberg, among others.

584 De Kooning, interview by Emile de Antonio, 1970, in *Painters Painting*, film.

585 De Kooning, 'The Renaissance and Order', p. 87.

586 De Kooning, interview by Emile de Antonio, 1970, in *Painters Painting*, film.

587 De Kooning, interview by Emile de Antonio, 1970, in de Antonio and Tuchman, *Painters Painting: A Candid History of the Modern Art Scene, 1940–1970*, p. 41. The film *Painters Painting* and the book of the same title edit de Antonio's interview of de Kooning differently. The previously quoted exchanges appear in the film but not in the book.

588 De Kooning, in Rosenberg, 'Interview with Willem de Kooning', p. 55. Newman said virtually the same thing: 'I do all paintings – all my paintings – by painting them. I [have] no preconceived notion' (Barnett Newman, interview by Alan Solomon, 20 May 1966, unedited transcript, Alan Solomon Papers, Archives of American Art, Smithsonian Institution, Washington, DC).

589 The 'original' for this 'type' is Alphonse Karr, 'Les guêpes', January 1849, *Les guêpes (sixième série)* (Paris: Michel Lévy frères, 1862), p. 305: 'Plus ça change – plus c'est la même chose.' De Kooning's statement also recalls Ecclesiastes (1:9): 'That which hath been is that which shall be, and that which hath been done is that which shall be done; and there is nothing new under the sun.'

590 Susan Brockman, 31 August 1993.

591 See Gary Garrells, 'Three Toads in the Garden: Line, Color, and Form', in *Willem de Kooning: The Late Paintings, the 1980s* (San Francisco, CA, 1995), p. 33. For photographic documentation of de Kooning's activity in his studio in 1989, see Lieber, *Willem de Kooning: Reflections in the Studio*, pp. 98–105, 111–12.

592 See Robert Storr, 'At Last Light', in *Willem de Kooning: The Late Paintings, the 1980s*, p. 50.

593 Jeffrey L. Cummings, Alzheimer Disease Research Center, University of California, Los Angeles, quoted in Kay Larson, 'The de Kooning Dilemma', *ARTnews*, 94 (December 1995), p. 111. See also Catherine Barnett, 'The Conundrum of Willem de Kooning', *Art and Antiques*, 6 (November 1989), pp. 72–3. Barnett consulted a number of medical experts, whose generally inconclusive evaluations included these: 'The positive view would be that de Kooning is not able to know consciously what he's doing yet aspects of subconscious activity are still driving him to paint like a genius' (Antonio Damasio, University of Iowa College of Medicine). 'The rule is people maintain their skills . . . Initiative would be lost, because that's found in the front part of the brain [which] allows you to change the pattern; without it you just reproduce the same pattern over and over and over again' (Serge Gauthier, McGill Center for Studies on Aging). '[Dementia] is not an all-or-none process' (David Drachman, University of Massachusetts Medical Center).

594 See Storr, 'At Last Light', *Willem de Kooning: The Late Paintings, the 1980s*, pp. 48–51.

595 De Kooning's greatest ally-competitors died in their forties, fifties and sixties: Gorky in 1948, Pollock in 1956, Kline in 1962, Newman and Rothko in 1970.

596 Robert Chapman (in de Kooning's studio from 1982 through 1990), quoted in Storr, 'At Last Light', *Willem de Kooning: The Late Paintings, the 1980s*, p. 47.

597 Tom Ferrara (in de Kooning's studio from 1980 through 1987), quoted in Storr, 'At Last Light', *Willem de Kooning: The Late Paintings, the 1980s*, p. 53.

598 Tom Ferrara, 9 December 1996.

599 De Kooning, letter to Joseph and Olga Hirshhorn, undated (January 1969?), in Zilczer, *Willem de Kooning from the Hirshhorn Museum Collection*, p. 167.

600 Tom Ferrara (referring to the 1980s), 9 December 1996; John McMahon (referring to the early 1970s), 8 March 2001.

601 Roger Anthony and Amy Schichtel of The Willem de Kooning Foundation matched the two paintings (as well as a third) to the drawing; see Klaus Kertess, *Willem de Kooning: In Process* (Fort Lauderdale: Museum of Art, Fort Lauderdale, 2000), n.p.

602 Warhol, in 'What Is Pop Art? Interviews by G. R. Swenson – Part 1', p. 26. De Kooning's 'You have to change to stay the same' has the effect of removing the irony from Warhol's equation of Pop to 'liking things' and to a related desire for 'being a machine', because – as Warhol says in 'What Is Pop Art?' – 'you do the same thing every time. You do it over and over again.'

603 De Kooning, in Rosenberg, 'Interview with Willem de Kooning', p. 54.

604 De Kooning, in Marshall, *50 New York Artists*, p. 34.

605 To Sylvester, de Kooning commented on the absurdity of painting a nose and the fact that artists' ideas were not so 'bright'; and with regard to his continuing use of the theme of Woman, he said: 'I could sustain this thing all the time because it could change all the time' (Sylvester, 'De Kooning's Women', p. 57).

606 Peirce, 'To Christine Ladd-Franklin, on Cosmology' [1891], *Collected Writings*, VIII, p. 215.

607 Peirce, 'To Christine Ladd-Franklin, on Cosmology', *Collected Writings*, VIII, p. 215.

608 Henry Geldzahler, quoted in 'Museum Is Thronged in Spontaneous Tribute', *New York Times*, 9 April 1973, p. 47. Here 'throwing out' is used in the sense of 'suggesting'.

609 Picasso, quoted in Liberman, 'Picasso', p. 134.

610 De Kooning in the 1930s, as remembered by Burckhardt, 'Long Ago with Willem de Kooning', p. 216.

611 Robert Motherwell, quoted in 'Museum is Thronged in Spontaneous Tribute', *The New York Times*, 9 April 1973, p. 47.

612 Brassaï and Edouard Pignon, 'Picasso on Death' [1979],

in Marilyn McCully, ed., *A Picasso Anthology: Documents, Criticism, Reminiscences* (Princeton, NJ, 1982), p. 277. See also Hélène Parmelin, *Voyage en Picasso* (Paris, 1980), p. 145.

613 Picasso, statement to Christian Zervos, 'Conversation avec Picasso' [1935], *Picasso: Propos sur l'art*, p. 36.

614 Maurice Denis, 'Cézanne', *L'Occident*, 12 (September 1907), p. 128.

615 Cézanne, letter to Émile Bernard, 21 September 1906, in Rewald, *Paul Cézanne, correspondance*, pp. 326–7.

616 Cézanne, letter to Joachim Gasquet, 30 April 1896, *Paul Cézanne, correspondance*, p. 249; Cézanne's words, recollection of Joachim Gasquet (not necessarily verbatim), in Gasquet, *Cézanne*, p. 132.

617 Cézanne, letter to Émile Bernard, 23 October 1905, *Paul Cézanne, correspondance*, p. 315.

618 Émile Bernard, letter to Mme Bernard, 25 October 1906, 'Lettres inédites du peintre Emile Bernard à sa femme à propos de la mort de son ami', *Art-Documents* (Geneva), no. 33 (June 1953), p. 13 (emphasis eliminated).

619 Charles Morice, 'Paul Cézanne', *Mercure de France,* 65 (15 February 1907), p. 577.

620 De Kooning, in Wallach, 'My Dinners with de Kooning', p. 9.

621 Susan Brockman, 31 August 1993.

622 Heinrich von Kleist, 'On the Puppet Theater' [1810], *An Abyss Deep Enough: Letters of Heinrich von Kleist with a Selection of Essays and Anecdotes*, ed. and trans. Philip B. Miller (New York, 1982), p. 214.

623 De Kooning, in Berman, 'Willem de Kooning: "I am only halfway through"', p. 71.

624 John McMahon, 8 March 2001.

SELECT BIBLIOGRAPHY

Ashton, Dore, 'Willem de Kooning: Homo Faber', *Arts Magazine*, 50 (January 1976), pp. 58–61

——, and Willem de Kooning, *Willem de Kooning*, exh. cat., Smith College Museum of Art (Northampton, MA, 1965)

Auping, Michael, et al., *Abstract Expressionism: The Critical Developments*, exh. cat., Albright-Knox Gallery (New York, 1987)

Balken, Debra Bricker, et al., *Action/Abstraction: Pollock, de Kooning, and American Art, 1940– 1976*, exh. cat., Jewish Museum, New York (New Haven, CT, 2008)

Brugger, Ingried, Florian Steininger, et al., *Willem de Kooning*, exh. cat., BA – CA Kunstforum; Wolfratshausen (Vienna, 2005)

Butler, Cornelia H., Paul Schimmel, Richard Shiff and Anne M. Wagner. *Willem de Kooning: Tracing the Figure*, exh. cat., MOCA, Los Angeles (Princeton, NJ, and Oxford, 2002)

Cateforis, David, *Willem de Kooning* (New York, 1994)

Cummings, Paul, Jörn Merkert, and Claire Stoullig. *Willem de Kooning: Drawings, Paintings, Sculpture – New York, Berlin, Paris*, exh. cat., Whitney Museum of American Art (New York, 1983)

De Kooning, Willem, *Willem de Kooning: het Noordatlantisch licht, 1960–1983 (The North Atlantic Light, 1960–1983)*, exh. cat., Stedelijk Museum (Amsterdam, 1983), essay by Carter Ratcliff

——, *Willem de Kooning: Mostly Women – Drawings and Paintings from the John and Kimiko Powers Collection*, exh. cat., Gagosian Gallery (New York, 2000), essay by Robert Rosenblum

——, *Willem de Kooning: The Late Paintings, The 1980s*, exh. cat., San Francisco Museum of Modern Art; Walker Art Center, Minneapolis (San Francisco, CA, 1995), essays by Gary Garrels and Robert Storr

——, *Willem de Kooning: Vellums*, exh. cat. Mitchell-Innes Nash, New York (New York, 2001), essay by Brenda Richardson

——, and Enrique Juncosa. *Willem de Kooning*, exh. cat., Institut Valencia d'Art Modern, Valencia; Fundación 'la Caixa', Madrid, (Madrid, 2001)

——, Marie-Anne Sichère, and Yves Michaud, *Écrits et propos/ Willem de Kooning* (Paris, 1992)

——, Bernhard Bürgi, Klaus Kertess et al., *De Kooning: Paintings, 1960–1980*, exh. cat., Kunstmuseum Basel (Ostfildern-Ruit, Hatje Cantz, New York, 2005)

Gaugh, Harry F., *Willem de Kooning* (New York, 1983)

Hall, Lee, *Elaine and Bill, Portrait of a Marriage: The Lives of Willem and Elaine de Kooning* (New York, 1993)

Hess, Thomas B., *Abstract Painting: Background and American Phase* (New York, 1951)

——, 'De Kooning's New Women', *Art News*, 64 (March 1965), pp. 36–8, 63–5

——, 'De Kooning Paints a Picture'. *Art News*, 52 (March 1953), pp. 30–33, 64

——, *Willem de Kooning: Drawings* (Greenwich, CT, 1972)

——, *Willem de Kooning* (New York, 1959)

——, *Willem de Kooning*, exh. cat., The Museum of Modern Art (New York, 1968)

——, *Willem de Kooning: Recent Paintings*, exh. cat., Knoedler & Co., New York (New York, 1967)

Janis, Harriet Grossman, *De Kooning* (New York, 1960)

Kertess, Klaus, *Willem de Kooning: Drawing Seeing / Seeing Drawing*, exh. cat., The Drawing Center, New York (Santa Fe and New York, 1998)

——, *Willem de Kooning: In Process*, exh. cat., Museum of Art, Fort Lauderdale (Fort Lauderdale, FL, 2000)

Lake, Susan, Willem de Kooning and Michael Schilling, *Willem de Kooning: The Artist's Materials* (Los Angeles, 2010)

Lieber, Edvard, *Willem de Kooning: Reflections in the Studio* (New York, 2000)

Neuner, Stefan, *Maskierung der Malerei: Jasper Johns nach Willem de Kooning* (Paderborn, 2008)

Rosenberg, Harold, *Willem de Kooning* (New York, 1974)

Schjeldahl, Peter, 'De Kooning's Sculpture: Amplified Touch', *Art in America*, 62 (March/April 1974), pp. 59–63

——, 'Letters' [on Herzl Emanuel and de Kooning's sculpture], *Art in America*, 62 (July/August 1974), p. 112

Shiff, Richard, *Willem de Kooning: A Centennial Exhibition*, exh. cat., Gagosian Gallery, New York (New York, 2004)

——, and Willem de Kooning, *Willem de Kooning: Paintings 1983–1984*, exh. cat., Matthew Marks Gallery, New York (New York, 1997)

Stevens, Mark, and Annalyn Swan, *De Kooning: An American Master* (New York, 2004)

Sylvester, David, Richard Shiff and Marla Prather, *Willem de Kooning: Paintings*, exh. cat., National Gallery of Art, Washington, DC (New Haven and London, 1994)

Vanel, Hervé, 'La roue de la fortune: la dernière période de Willem de Kooning et sa réception critique', *Cahiers du Musée national d'art moderne*, 62 (1997), pp. 26–49

Waldman, Diane, *Willem de Kooning in East Hampton*, exh. cat., Solomon R. Guggenheim Museum, New York (New York, 1978)

——, *Willem de Kooning*, exh. cat., National Museum of American Art, Smithsonian Institution (New York, 1988)

Wolfe, Judith Lynn, 'The Young Willem de Kooning: Early Life, Training and Work, 1904–1926', PhD dissertation, University of Michigan, Ann Arbor, MI (1996)

——, *Willem de Kooning, Works from 1951–1981*, exh. cat., Guild Hall of East Hampton (East Hampton, NY, 1981)

Yard, Sally, *Willem de Kooning* (Barcelona and New York, 1997)

——, 'Willem de Kooning: The First Twenty-Six Years in New York, 1927–1952', PhD dissertation, Princeton University, Princeton, NJ (1980)

——, Willem de Kooning, James T. Valliere et al., *Willem de Kooning: Work, Writings, Interviews* (Barcelona, 2007)

Zilczer, Judith, *Willem de Kooning: From the Hirshhorn Museum Collection*, exh. cat., Hirshhorn Museum and Sculpture Garden, Smithsonian Institution (Washington, DC, and New York, 1993)

ACKNOWLEDGEMENTS

I became a Willem de Kooning admirer as a teenager making occasional visits to New York museums and galleries. His art remains an undiminished source of memorable sensation; and this book, by its nature a conceptualization of sensation, attempts to leave the sensation as is.

I owe the origin of this study to Lisa de Kooning, who in 1993 generously guided me through her father's studio, shared her many insights into his working habits, and allowed me to investigate the physical space and the material equipment that had been essential elements of his creative process, counterparts to the intangibles of his thought and sensation. Lisa de Kooning's mother, artist Joan Ward, was also welcoming and richly informative. During succeeding years, many who had been close to Willem de Kooning at various periods of his life shared their memories in interviews; their aid is acknowledged in the numerous endnotes to this book. All gave freely of their time; there were a few to whom I returned repeatedly and, I hope, did not irritate by doing so: John McMahon, Susan Brockman, Tom Ferrara, Conrad Fried, and Connie Fox.

Through my years of publishing on de Kooning's art, I have been guided by the expertise of two endlessly gracious professionals at the Willem de Kooning Foundation in New York, Amy Schichtel and Roger Anthony, with whom I have often exchanged hypotheses about the novel course of de Kooning's practice. I always feel that I bring to these ongoing conversations far less than I take from them, a gift from Amy and Roger. During the final stages of my project, they were especially generous about checking factual details and aiding the process of gathering illustrational material.

It is no exaggeration to say that they made completion of this project possible. I am deeply grateful to several others at the Foundation who contributed to checking and refining aspects of the text and images: Ricki Moskowitz, Tim McCarthy, Leigh Hill, Emily Lober, and Kristen Gaylord.

My first major de Kooning project was an essay for the artist's retrospective at the National Gallery of Art, Washington, in 1994, curated by Marla Prather, an ideal collaborator. Marla's insights, as well as those of David Sylvester and Nan Rosenthal, associated with the exhibition, will be reflected in many of these pages, as will, even more so, the thinking of my graduate assistant at the time, Katy Siegel, whose aesthetic intuition was (and is) infallible.

I owe sincere thanks to the intellectual contributions of a number of other graduate students at The University of Texas at Austin who became involved in de Kooning research between 1994 and 2011. This group includes those who served as my assistants as well as those working independently on the New York School: Katie Anania, Megan Granda Barr, Charlotte Cousins, Catherine Craft, Alexander Dumbadze, Katie Robinson Edwards, Rina Faletti, Mette Gieskes, Saundra Goldman, Anne Collins Goodyear, Caitlin Haskell, Valerie Hellstein, Adrian Kohn, James Lawrence, Roja Najafi, Justine Price, Lane Relyea, and Michael Schreyach. During the final stages of writing and preparation, Jason A. Goldstein handled a great crush of work deftly, inventively and tirelessly, accomplishing far more than I would have thought possible; he has my deepest gratitude.

I received various kinds of encouraging material and moral support from Sherry Smith, Malou Flato and John

Taliaferro, the Austin Community Foundation, the Getty
Grant Program, and the Effie Marie Cain Regents Chair
in Art at The University of Texas at Austin. I thank these
individuals and institutions for their timely and essential aid.

Between Sense and de Kooning is dedicated to Leo
Steinberg, a friend and mentor of many years, who died
while the text was in press. We had discussed de Kooning
on numerous occasions. Leo would have told me what was
wrong with this book. Others will too, but not as eloquently.

PHOTO ACKNOWLEDGEMENTS

The author and publishers wish to express their thanks to the below sources of illustrative material and/or permission to reproduce it. Some collection information not fully placeable in the captions is also given below.

Albright-Knox Art Gallery, Buffalo, NY (gift of Seymour H. Knox, Jr, 1955 – photo Albright-Knox Art Gallery / Art Resource, NY / Scala, Florence): 42; © ARS, NY, and DACS, London 2011: 53; Art Gallery of Toronto, Ontario (given in loving memory of Saidye Rosner Bronfman by her family, 1996): 32; The Art Institute of Chicago (photos © The Art Institute of Chicago): 35 (Mr and Mrs Frank G. Logan Purchase Prize Fund, restricted gifts of Edgar J. Kaufmann, Jr, and Mr and Mrs Noah Goldowsky, Jr, 1952.1), Walter Aitken Endowment – 1983.792), 48 (gift of Katharine Kuh – 1986.138), 61 (through prior bequests of John J. Ireland and Joseph Winterbotham; Barnes Foundation, Merion Station, PA: 107; © Barnett Newman Foundation / ARS, NY, and DACS, London 2011: 28, 47; photo The Bridgeman Art Library: 17; photos Chris Burke (courtesy The Willem de Kooning Foundation, New York): 39, 62, 73; photo © Christie's Images Limited 2007: 83; photo © Christie's Images / The Bridgeman Art Library: 92; The Cleveland Museum of Art (Contemporary Collection of The Cleveland Museum of Art, 1964.1): 25; photos Peter Cox: 55, 56, 57, 64, 65; The Detroit Institute of Arts, gift of W. Hawkins Ferry: 17; photo © 2011 Digital Image Museum Associates / LACMA / Art Resource NY / Scala, Florence: 18; photo Tom Ferrara: 72; Emily Fisher Landau Collection (photo courtesy Fisher Landau Center

for Art, Long Island City, NY): 101; photo Jim Frank: 71; photos courtesy Gagosian Gallery: 20, 53, 89; Glenstone Collection: 90; collection of James and Katherine Goodman (photo courtesy of the James Goodman Gallery, New York): 66; Peggy Guggenheim Collection, Venice (Solomon R. Guggenheim Collection, NY – 76.2553, PG 158): 12; Hirshhorn Museum and Sculpture Garden (Smithsonian Institution), Washington, DC: 7 (gift of the artist through the Joseph H. Hirshhorn Foundation, 1972, Accession Number 72.89), 31 (gift of the Joseph H. Hirshhorn Foundation, 1966, Accession Number 66.1197.A-B), 36 (gift of the Joseph H. Hirshhorn Foundation, 1966, Accession Number 66.1197.A-B), 63 (gift of Joseph H. Hirshhorn, 1966, Accession Number 66.1214), 67 (gift of Joseph H. Hirshhorn, 1966, Accession Number 66.1209), 80 (the Joseph H. Hirshhorn Bequest, 1981, Accession Number 86.1344), 84 (gift of Joseph H. Hirshhorn, 1966, Accession Number 66.1212), 93 (gift of Joseph H. Hirshhorn, 1966, Accession Number 66.1193); photos © 2011 Lisa de Kooning: 72, 76, 77, 96, 99; photos courtesy L&M Arts: 44, 45, 69, 85, 86, 94; Frances Lehman Loeb Art Centre, Vassar College, Poughkeepsie, NY (gift of Mrs Richard Deutsch [Katherine W. Sanford, class of 1940], 1953.2.5): 5; photo Linda McCartney, © 1968 Paul McCartney: 1; McNay Art Museum, San Antonio, TX (bequest of Robert H. Halff): 4; Martin Z. Margulies Collection (photo courtesy The Martin Z. Margulies Foundation / The Warehouse): 29; The Menil Collection, Houston, TX (photo Hickey-Robertson, Houston): 81; The Metropolitan Museum of Art, New York (images ©

DATE DUE			

HIGHSMITH